RAY JOHNSON

correspondences

Exhibition organized by **Donna De Salvo**
Edited by **Donna De Salvo** and **Catherine Gudis**

Wexner Center for the Arts
The Ohio State University, Columbus, Ohio

Flammarion Paris – New York

This book is published in association with the exhibition, *Ray Johnson: Correspondences*, curated by Donna De Salvo and organized by the Wexner Center for the Arts, The Ohio State University, Columbus, Ohio.

The exhibition and book have been made possible through the support of The Andy Warhol Foundation for the Visual Arts, Inc., the Elizabeth Firestone Graham Foundation, The Judith Rothschild Foundation, the Ohio Arts Council, Chuck and Joyce Shenk, the Fifth Floor Foundation and the Wexner Center Foundation. Special thanks to The Estate of Ray Johnson and Richard L. Feigen & Co., New York.

EXHIBITION ITINERARY

Whitney Museum of American Art
New York
January 14–March 21, 1999

Wexner Center for the Arts
The Ohio State University, Columbus, Ohio
September 17–December 31, 2000

Edited by Catherine Gudis and John Farmer
Designed by Barbara Glauber
and Beverly Joel/Heavy Meta, New York

Published by Wexner Center for the Arts
The Ohio State University
1871 North High Street
Columbus, Ohio 43210-1393
and
Flammarion, Paris—New York
26, rue Racine
75006 Paris

Copyright © 1999 Flammarion and
Wexner Center for the Arts, The Ohio State
University, Columbus, Ohio

Library of Congress Catalog
Card Number: 99-62202
ISBN: 1-881390-21-7 softcover
ISBN: 2-08013-663-1 hardcover
Printed and bound in France.

Unless otherwise indicated, all reproduced works are courtesy of The Estate of Ray Johnson and Richard L. Feigen & Co., New York and are mixed-media collage. Additional caption information and credits appear on pp. 216–220.

Front cover:
Untitled (Woman in Carriage),
ca. 1957–58 (detail)
11 x 7¼

Back cover, endsheets, and frontispiece:
Undated mailings

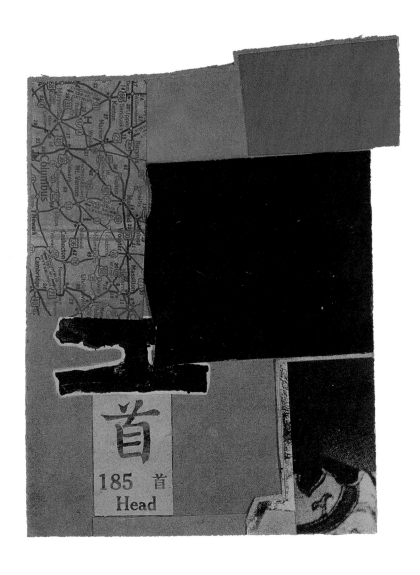

Untitled (185 Head), 1957-58
5¹⁄₈ x 4
William S. Wilson

foreword

AS MUSEUMS REASSESS THEIR SOCIETAL ROLE AT THE END OF THE CENTURY, it is especially fitting that we consider the voices of those who have dared to query and even critique our hallowed practices, protocols, and canons. The artist Ray Johnson (1927–95) is surely one such interrogator who, with equal measure of sly wit and aesthetic acuity, took aim at both the popular and elite cultural icons of his day. Throughout five decades of artistic production, Johnson worked— from within and without the art world—to playfully if pointedly subvert the venerated institutions and traditions of art making, interpretation, and display.

 Ray Johnson: Correspondences attempts to trace the trajectory of Johnson's transgressive strategies, which often seemed to revel in the gesture and the transaction as much as in the work of art itself. Both this book and the exhibition that it complements are long overdue investigations of this important though elusive American artist. Johnson was in many ways the quintessential artist's artist—respected and admired by peers for his protean imagination and creative energy, but never attaining recognition beyond the confines of the art world. Indeed, as *New York Times* critic Grace Glueck once commented, Johnson was "New York's most famous unknown artist," a statement the artist later recycled into his work with characteristic amusement.

 Johnson's paradoxical relationship to fame and to the institutions of art, culture, and mass media has been much remarked upon. Though simultaneously attracted and repelled by the machinery and machinations of celebrity, Johnson was far from the outsider looking longingly in; if anything he was the consummate insider for whom calculated distance was both weapon and shield. He would deliberately sabotage his own exhibitions—or pull out of them at the last moment. And when he did participate, his contributions were certain to confound expectations and ruffle the feathers of the cultural establishment, even while he sought its attention and esteem.

 Ray Johnson: Correspondences at long last confers that coveted gaze and unequivocally demonstrates, as never before, Johnson's mastery of the two-dimensional visual field. While his métier of choice was collage and correspondence, there was nothing remotely

chance-like or indeterminate about his approach. Indeed, Johnson's work betrays a choreographer's mania for manipulation and the graphic precision of a fine calligrapher. Though his debt to Josef Albers, Marcel Duchamp, and Joseph Cornell is apparent, Johnson invented a truly original visual language, imbued with his inimitable mix of the elegiac, the quixotic, the oracular, and the irreverent.

Fluxus promoter and Johnson friend Dick Higgins dubbed Johnson's practice "intermedia," alluding to its performative aspects and its adamant refusal to respect categories and distinctions. In that light, Johnson can be seen as a particularly appropriate subject for the Wexner Center with its mission as a "laboratory for the contemporary arts in all media." The center's lively program of exhibitions, performances, films, and video screenings features emerging artists alongside those who have entered the art historical pantheon. True to form, Johnson manages to personify that very duality: he produced works that easily qualify for the master class while stubbornly remaining an ever-emergent figure.

Knowing of Johnson's lifelong ambivalence about exhibitions of his work, we pursued this project with considerable probity and trepidation but also with enormous conviction as to its timeliness and merit. That the result has been so thoughtfully and meticulously achieved is thanks entirely to Donna De Salvo, Wexner Center Curator at Large, who organized the exhibition and coedited this anthology. Her particular interest and expertise in the art of the 1950s and 1960s, and especially in the intersections between Pop art and Abstract Expressionism, make her an ideal choice for investigating Johnson and his remarkable oeuvre. Donna's profound regard and respect for the artist's legacy and his family, friends, and colleagues are evident throughout this volume, and her enthusiasm infectiously drew others into Johnson's world. Catherine Gudis, coeditor and project manager for this publication, has been an invaluable colleague and partner throughout the endeavor, bringing abundant intellectual, editorial, and organizational talents to the realization of this book. We're proud that it marks the most comprehensive overview of Johnson's lifework to date.

A project of this scope quite naturally draws on the cooperation, collaboration, and expertise of numerous individuals and institutions. While acknowledgments elsewhere in this volume note many such significant contributions, in a few cases our special gratitude bears repeating here.

The exhibition and this monograph could not have been accomplished without the extraordinary generosity, encouragement, and spirited participation of The Estate of Ray Johnson, represented by Richard L. Feigen & Co., New York. Executor Janet Giffra, Richard L. Feigen, and Frances Beatty, Vice President of Richard L. Feigen & Co., New York provided De Salvo and other scholars with access to many previously unseen or long unseen Johnson works, and we thank them for their cooperation in this regard. Richard L. Feigen and Frances Beatty devoted signi-

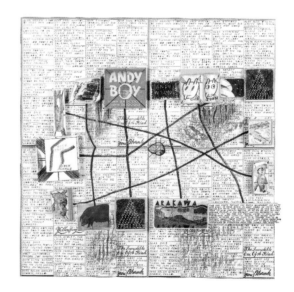

Untitled (Andy Boy), ca. 1976
15¾ x 16

8

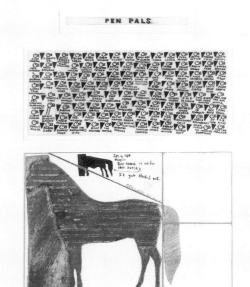

Pen Pals, 1969
16¼ x 13
Richard L. Feigen, New York

ficant additional resources to the project, including the substantial energy and expertise of their staff, among them Archivist Muffet Jones, who prepared the selected chronology and exhibition history in this volume.

We are enormously grateful to essayists Mason Klein, Lucy R. Lippard, Henry Martin, Sharla Sava, Wendy Steiner, Jonathan Weinberg, and William S. Wilson, each of whom has contributed insightful and quite moving glimpses into Ray Johnson's persona and practice. Individually and collectively they have calibrated and vividly relayed the idiosyncratic pulse of Johnson's creative circuitry. Barbara Glauber and Beverly Joel of Heavy Meta created an appropriately elegant yet playful design for this book.

Wilson, a longtime Johnson correspondent and chronicler, also delved into his personal trove of artworks and other materials as a generous lender to the exhibition. We offer our thanks to him, as well as toall the other individual and institutional lenders who have so graciously contributed to this endeavor, allowing it to be a truly encompassing survey.

We are especially appreciative of the outstanding cooperation of two other partners in this endeavor: Flammarion, Paris, and the Whitney Museum of American Art, New York. We're very pleased to be joining Flammarion as copublishers of this volume and appreciate the efforts of Suzanne Tise, Director, Départment Styles et Design, International Publishing, and her colleagues to bring the book to a wide audience internationally. We thank Director Maxwell L. Anderson and Deputy Director Willard Holmes for their commitment to premiering the exhibition at the Whitney Museum, a fitting venue given Johnson's longstanding participation in the New York arts community.

Ray Johnson: Correspondences was made possible by the generous support of The Andy Warhol Foundation for the Visual Arts, Inc., the Elizabeth Firestone Graham Foundation, The Judith Rothschild Foundation, the Ohio Arts Council, Chuck and Joyce Shenk, and the Wexner Center Foundation. We are exceptionally grateful for their participation and patronage in this long-delayed assessment and celebration of Johnson's creative achievements and legacy.

Sherri Geldin
Director

9

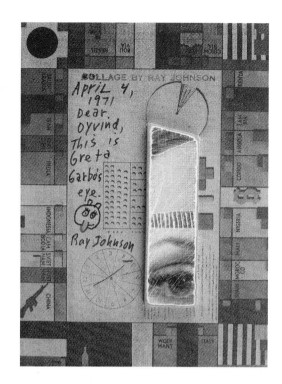

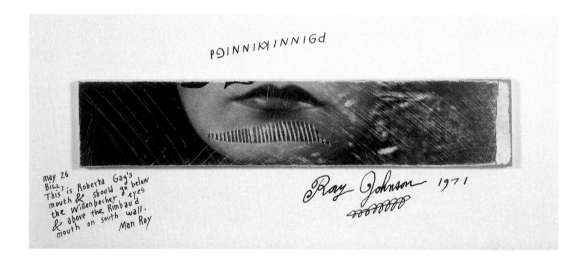

Untitled (Oyvind Fahlstrom Eye), 1972
6¾ x 4⅞
John Willenbecher

Untitled (Roberta Gag's Nose), 1971
1⅝ x 12¼
William S. Wilson

Untitled (Greta Garbo's Lips), 1971
5⅝ x 13¼
William S. Wilson

introduction

11

RAY JOHNSON: CORRESPONDENCES PRESENTS MULTIPLE PERSPECTIVES on the collages, correspondence art, and performance events of an artist who made it his life's work to confound. Like the anthropological figure of the trickster, Johnson's works are slippery, elusive, difficult to pin down. This is their sly delight.

For Johnson, fiction and nonfiction, the unpredictable elements of chance and carefully planned orchestrations, were equivalent. His source materials included the coincidental and purposeful correspondences between words and pictures, people and things, extraordinary and banal events. The results are often perplexing and visually beautiful. Alternately they can be viscerally jarring and just plain funny. Johnson's trick, then, is to cast a finely woven net over worlds of his own creation, spun to lure willing audiences into a web of associations they need not recognize in order to enter.

This book offers a glimpse into this world of references and jokes that were the daily habit of the riddler. It reproduces a selection of artworks and artifacts from private and public collections and from the artist's estate, represented by Richard L. Feigen & Co., New York. Most of these works have never been previously published. They span Johnson's career, from his early abstractions and his graphic design broadsides of the 1940s and 1950s, to his New York Correspondence School mailings and performances of the 1960s and 1970s and his silhouette-laden collages of the 1980s and 1990s.

Like the clusters of collages and mail art reproduced here, the texts that follow are also essays, in the literal sense of the word. They are initial explorations, attempts or inquiries rather than singular answers to perplexing riddles. Nevertheless, the texts are pathbreaking in their critical foray into a body of work whose availability, to date, has been quite circumscribed. Taken together, the texts and illustrations sketch out a multitude of possible paths for future critics and historians to take in mapping the formal and historical trajectory of Johnson's career as a collagist and correspondent.

The book is organized in two parts. The first five essays—presented in rough chronological order according to the works they address—are by a younger generation of critics

and historians than those who were part of Johnson's social circle. Their texts were written especially for this volume and offer a range of perspectives, some speculative and others more historically rooted in their approach. It is important to note that all five authors first saw most of the artworks, letters, and biographical documents discussed in their essays only after being invited to contribute to this volume in the summer of 1998. Richard L. Feigen & Co., New York and William S. Wilson, Johnson's lifelong friend and his foremost collector and critic, graciously opened their archives to the editors and authors of this volume. They have helped bring a wealth of historically significant material to public attention, opening an overstuffed suitcase of artistic production that still requires much unpacking.

As Wilson's collection exemplifies, Johnson made connections to and between his friends and acquaintances through the personal references that populate his collages and correspondence. The second half of *Ray Johnson: Correspondences* presents reflections on and critical readings of the artist's work by such individuals. Their connections to the names and events populating Johnson's work (and, indeed, each of them is among those referenced) offer an insider's perspective. Their contributions fortify the kaleidoscopic nature of this project and the fluidity of meaning, which—here as elsewhere—is always oriented by the unique perspectives and relationships of objects and subjects.

The first of the critical essays in the first part of the book is an overview of Johnson's career by Wexner Center Curator at Large, Donna De Salvo, coeditor of this volume and curator of the exhibition. Her essay charts formal developments in Johnson's collage work from the 1950s to the 1990s, investigating the ways in which his laboriously inked, sanded, montaged, and painted surfaces and rigorously formal compositions were abstract expressions— exhaustive inquiries into the abstract nature of visual communication. By suggesting the coexistence of his painterly, Pop, and process-oriented strategies, De Salvo shows Johnson's works to be fundamentally uncategorizable. Recognizing this, she points to the aesthetic rewards of luxuriating in their material lushness and wry conceptual punning.

Mason Klein's essay adds to De Salvo's initial provision of an art historical and cultural context for Johnson's practices. He places the artist in "the modernist shadow of Baudelaire, Rimbaud, Mallarmé, and, most importantly, Marcel Duchamp," and explores Johnson's waging of "a muted, elegant, and private war against conformity." Both Klein and Wendy Steiner align Johnson with "the literary and visual model of a transgressive modernism" as well as the "indeterminancy and humor" of postmodernism. Steiner focuses attention on Johnson's strivings, through his collages and correspondence art, to address the fragmentation and disconnection that have been the preoccupation of other twentieth-century predecessors, such as Gertrude Stein and Thomas Pynchon. Steiner likens Johnson's mania for lists and the genre of portraiture to Stein's attempts to write a "history of everybody" in *The Making of Americans* and aptly notes the similarities between Johnson's NYCS and Pynchon's secret, alternative mail system in the *The Crying of Lot 49* (both of which date from around the same time and explore the vagaries of meaning and engagement).

Johnson's typologizing of personalities, gender, and sexual anatomy, which Steiner notes are sometimes unsympathetic, is also considered by Jonathan Weinberg. Both essayists look at the "superimposition of identities" in Johnson's work. Weinberg focuses on references to gay sexuality and the codings of Johnson's private and public correspondence. He also looks at

Johnson's Camp sensibility and fascination with celebrity and fame, contrasting elements of it to the work of the artist's contemporary and friend, Andy Warhol. Weinberg's essay calls our attention to the need for further study and synthetic interpretation of the artistic milieu of gay culture—open, coded, and closeted—of the 1950s and 1960s, the social context of Johnson's work, which he plays upon for some of his most gleefully sexual and scatalogical associations.

Johnson's use of the firings and misfirings of communication are also implicit in Sharla Sava's essay on the New York Correspondence School. Sava explores Johnson's ambivalence to the institutions of art by looking at the historically groundbreaking 1970 Whitney Museum of American Art exhibition of Johnson's "school" of mail art. She sees this as a key to the problematic nature of avant-garde practices, including those of Conceptual art, performance, and Fluxus, to which Johnson was connected in various ways. The paradoxical nature of Johnson's practice and his relationship to the art world is summarized in her quotation of a Johnson mailing: "Dear Whitney Museum: I hate you. Love, Ray Johnson."

Lucy R. Lippard's essay begins the second part of the book. She writes from the perspective of a contemporary and a sometimes-recipient and subject of Johnson's mailings, a participant in the same artistic milieu. She considers the resistance of Johnson's work to classifications of Surrealism, Pop, and Conceptual art, although she notes "he shared with all three movements an iconoclasm aimed at transcending and even changing the commercial nature of the art world."

William S. Wilson, with whom the artist regularly exchanged ideas, art, and writings, offers a close reading of Johnson's text, "Is Marianne Moore Marianne Moore?" He ponders the genesis of some of the references embedded in the text and suggests the multiplicity of interpretative routes one may take in scrutinizing them. In so doing, Wilson offers additional frameworks for also considering Johnson's series of collages that use the theme of Marianne Moore.

Another close friend of Johnson's was Henry Martin, who met the artist prior to moving to Italy in the 1960s and who remained a great champion and critic of his work in Europe. The interview reproduced here was originally published in the Italian journal, *Lotta Poetica*, in 1984. As Martin explains, the interview was his attempt to record Johnson's work. He suggests that the best way to try and "make sense of" Johnson is "to reveal the world in the way in which he saw it...to allow him to continue to make sense on his own."

Helping make sense of Johnson's work in a more documentary fashion is the illustrated and annotated chronology that rounds out the book. It is compiled by Muffet Jones, who has served as the archivist of the artist's estate at Richard L. Feigen & Co., New York for the last four years. She honors Johnson's claim that "The NYCS has no history, only a present," yet recognizes the value of compiling data to assist today's audiences in understanding yesterday's present. The bibliography and list of works that follows Jones's chronology are also indebted to her exhaustive efforts.

Johnson's work is in itself a treasure of cultural and historical references. Our hope is that by presenting his art and the artifacts related to his lifelong production of collaged, drawn, photocopied, and performed works, *Ray Johnson: Correspondences* will provide audiences with a glimpse of the formal and narrative props in the riddler's retinue. The trick is not to unmask the magician but, rather, to get caught up in his spell.

Donna De Salvo
Catherine Gudis

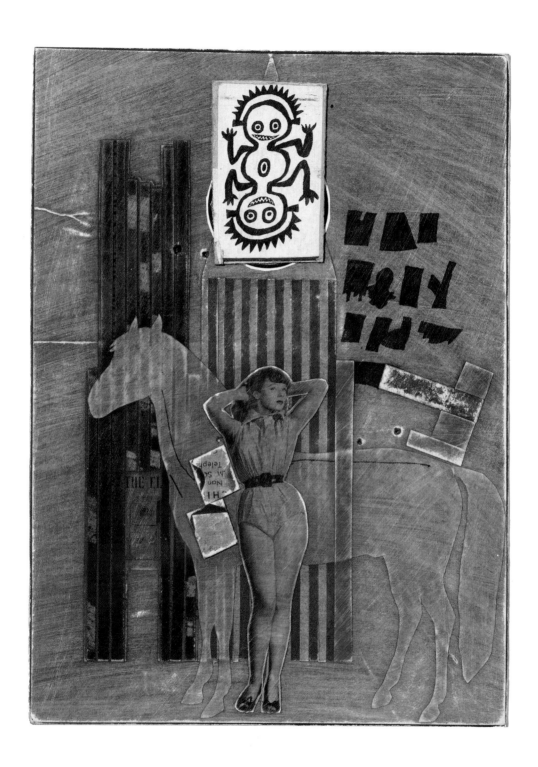

Movie Star with Horse, 1958
16½ x 13½

Donna De Salvo

CORRESPONDENCES

```
My work is like driving a car.
I'm always switching gears.
                —Ray Johnson
```

RAY JOHNSON VIEWED THE WORLD as a series of endless correspondences, and over his nearly fifty-year career created a chain of works that succeeded in blurring the categorical distinctions between life and art, fact and fiction, abstraction and representation. Adopting a nonlinear, stream-of-consciousness stance, Johnson crafted an approach that allowed the random, coincidental, and ephemeral to occupy the same plane of critical consideration as more traditional and universal concerns. His prodigious output—the full extent of which is not yet fully known— included collages, sculpture, books, performance events, correspondence art, music, photographs, and graphic design. All were essential parts of a whole, threads of a complex web of events woven to wed the otherwise disparate elements representative of life's lived experiences.

 Because Johnson so freely moved from one idea to the next, his body of work, as well as the man himself, have resisted categorization, especially in terms of a single genre or approach. His primary medium, however, was collage, and his raw materials were the planned and unintended correspondences he observed—formal, conceptual, and social—between images, objects, people, and events. Through a daily ritual of collage-making, or what he once referred to as the "ceremony," Johnson produced thousands of complex collages, laboriously gluing, painting, and sanding them, and then sending them out into the world.[1] In these works, he

reflected upon the banal and extraordinary elements of everyday
life and people and the subjective associations that interconnect
them. All was grist for his mill, worthy of commentary, parody, a
short riff, or a recurrent visitation. Tracing the comings and
goings of his mind, his work was a chart of his own subjective
associations, as well as his reflections on the preoccupations of
twentieth-century popular culture in general, including its obsession with celebrity, myth,
glamour, information—all subjects of particular interest to many other artists in the postwar era.

Considered by many as a paradigmatic medium for the twentieth century,
collage became for Johnson the ultimate metaphor for the way he experienced the world. Through
collage, he created a seemingly unending array of juxtapositions using the material evidence
of the world—what he would find in newspapers or on the street, receive through the mail,
hear in a phone conversation, or come across in a motel room on his way to give a lecture about
his work. As his friend William S. Wilson has written, his "collages resemble moments of
meaning in life."[2] The visual and verbal ensembles in these collages, as well as in his mechanically
reproduced mailings and commercial design work, could be highly playful, with a powerful
graphic immediacy, but they just as frequently functioned as enigmatic allusions or messages,
oblique references whose meanings relied on the relationships between participants. Merging his
correspondence and collage activities, Johnson went beyond Cubist and Surrealist approaches
to create a network in which works of art and people become intertwined. In this way, his project
can be seen to track the tenuousness of human communication, the poetics of exchange,
and the relationship between the artist and his audience. By examining specific aspects of this
production, it is possible to see how Johnson ultimately extended the possibilities of collage
as system by expanding the compositional network beyond the parameters of an individual work
and into the world at large.

For Johnson, collage functioned not only as a structural system, but also as a
paradigm for communication. As early as the 1940s, when he was a teenager in Detroit, he
used the collage process to offer up an embellished view of his adolescent experiences. In a series
of letters and postcards he exchanged with his high-school friend Arthur Secunda in 1943
(above), the young Johnson's written report of neighborhood news and his latest movie star loves
is juxtaposed with illustrations, newspaper clippings, and other collaged fragments.[3] The diaristic
nature of these early letters, with word and image functioning equally as transmitters of
information, foreshadows his later collages; indeed, he would refer to his correspondence with
Secunda as marking the start of his career in correspondence art. And although he had yet to
evolve a formal structure that seamlessly integrated word and image, these early missives suggest
his awareness that combining the two produced something more compelling than either one alone.

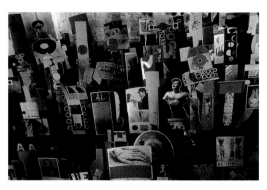

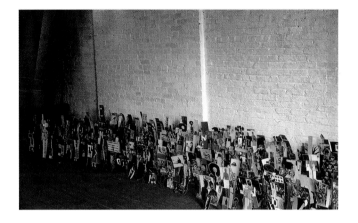

edged the spectator. But if collage was an essential element in the development of Rauschenberg's Combines, as well as in the equally revolutionary development of Johnson's correspondence art, herein lies an important difference between the two artists. Rauschenberg's Combines were made primarily for the context of the gallery and museum, while Johnson has been described as "the master of collage on a portable scale." Johnson's radical contribution was to expand the compositional network beyond the confines of a single collage and take it to the world. If Rauschenberg introduced life into art, Johnson introduced art into life.

The desire to work in the gap between art and life inspired a variety of neo-avant-garde practices in the 1950s and early 1960s. These ranged from the Happenings of Kaprow, Jim Dine, and Claes Oldenburg, which merged the discrete work of art with the larger environment of which it was an integral part, to the collaborative projects of groups such as The Living Theatre, opened by Judith Malina and Julian Beck in 1951, which conflated the spectacles of theater and life through a wide array of experimental productions. These practices expanded the performative gestures of painting and of the theater more forcibly into public life and offered critiques of the institutions responsible for artistic interpretation. Johnson's activities, like Happenings, Fluxus Events, and Living Theatre productions, placed new demands on their audiences, who now became not just passive receivers but active producers of meaning.[10]

After his abandonment of painting, Johnson's first collages were irregularly shaped works made of cut-up strips of paper and found materials, such as *Untitled* (1953, p. 17). This work is comprised of several parts that have been attached with string. Although its overall form is abstract, it retains certain representational elements noticeable only on close inspection, as their text is partially obscured by paint. In effect, Johnson emphasized the abstract nature of both word and picture. Increasingly, Johnson collaged onto these irregularly shaped supports images from magazines, newspapers, and other sources. These were shown in informal, and usually private assemblages, installations, and performances. For example, he displayed them in groups on the walls of his apartment or in installations in other untraditional spaces, as when he inserted them between the floorboards of a downtown New York warehouse in 1955 (above). He brought them into the outside world by placing them on doorsteps or by using them to cover the body of a friend, the art critic Suzi Gablik.[11] And, as in his earlier exchanges with Secunda, he also sent these composite works to people through the mail. In fact, decrying the need for a pure logic to his activities or evident reason for his distribution schemes, he used the U.S. Postal Service to distribute thousands upon thousands of letters and mailings. "A correspondence will reassert itself," he claimed, and his spontaneous gestures served as the vectors that

19

created new relationships and new players with whom he exchanged words and images, and through whom he continually expanded his network.[12] This move was as significant to his practice as Kaprow's transformation of his action-collages into Happenings.[13]

Johnson's ambivalence for the institutions of the art world and marketplace led him to develop other ways of circulating and exhibiting his work, either through the mail or in performances and installations on the street or elsewhere. For instance, he might agree to show someone work at a stop off the Long Island Expressway, the highway connecting his Locust Valley, Long Island, residence (from 1968 to 1995) to Manhattan. Like a traveling salesman, he was known to meet a client somewhere with a suitcase full of collages in hand, or to visit the home of a potential collector, and one by one, present a selection of works chosen specifically for that individual. When he did agree to exhibit his work, he favored highly pristine and carefully chosen installations. These machinations, as well as his sharp-witted commentaries in his works, drew attention to the systems of the art world—the power of the dealer, the critic, and the museum—to not only institutionalize art, but to mold it to fit prefabricated expectations.

Indeed, throughout his career, Johnson created his own systems of distribution, promotion, and commentary, thus subverting the conventional channels of the gallery and the museum. He created mythical exhibitions at nonexistent galleries that were nevertheless based on factual events. In 1961, he participated in *Gang Bang*, a group exhibition at the Batman Gallery in San Francisco, which also included works by Conner, Jay De Feo, Herms, Mike McClure, and others. Later that year, with the participation of Dorothy Podber and other artists, he invented the mythical Robin Gallery (below) and distributed authentic looking announcement cards for fictional exhibitions. The name was partly a response to the Batman Gallery, as well as a play on the famous Reuben Gallery, where numerous artists associated with Happenings and Pop art exhibited. (Johnson had been included in *Below* Z, an exhibition presented at the gallery from December 18, 1959, through January 5, 1960, but he later renounced his participation.) He often sent out mailings that mimicked the promotional materials often written by galleries about their artists, with the effect of creating an aura of mystery

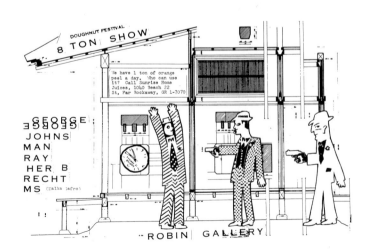

Mailing, ca. 1961

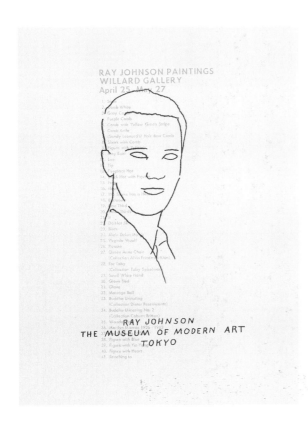

RAY JOHNSON PAINTINGS
WILLARD GALLERY
April 25–May 27

RAY JOHNSON
THE MUSEUM OF MODERN ART
TOKYO

Mailing, ca. 1970s

about himself. For his 1966 "retrospective" at the Willard Gallery, he produced a mailing that took one bit of factual information as its basis, the exhibition's checklist. But he transformed this checklist by overlaying onto it the phrase "The Museum of Modern Art, Tokyo" (left), again referring to an institution at which he had never shown. In the 1970s, he superimposed over this already altered image a line drawing traced from a high-school photograph of himself. Reminiscent of the earlier art comics of his friend Ad Reinhardt, Johnson also offered his own histories of the art world, remarking, "history is a very loose subject in which anybody can declare that anything happened at any time at all."[14]

In this regard, the critic Harold Rosenberg's discussion of collage is worth considering. As he wrote in his essay, "Collage: Philosophy of Put-Togethers," in 1975, "The mingling of object and image in collage, of given fact and conscious artifice, corresponds to the illusion-producing processes of contemporary civilization." Rosenberg went on to suggest that "in advertisements, news stories, films, and political campaigns, lumps of unassailable data are implanted in preconceived formats in order to make the entire fabrication credible. Documents waved at hearings by Joseph McCarthy to substantiate his fictive accusations were a version of collage, as is the corpse of Lenin, inserted by Stalin in the Moscow mausoleum to authenticate his own contrived ideology. Twentieth-century fictions are rarely made up of the whole cloth, perhaps because the public has been trained to have faith in 'information.' Collage is the primary formula of the aesthetics of mystification developed in our time."[15]

By 1955, Johnson had arrived at a standardized size for his collages, as well as a new name. Using sheets of discarded shirt cardboard measuring 11 x 8 inches, the dimensions of a standard sheet of paper, he created compositions that included fragments from magazines and newspapers. The resulting collages typically feature logos from Camel and Lucky Strike cigarette packs, Chinese ideograms, maps, and menus, among other images. Searching for a new term for these works, he asked his friend Norman Solomon what word he was reading in a dictionary. The word was *osmosis*, the meaning of which suggests permeability and flow, qualities that could describe the collages themselves, which, as Johnson wrote, "continually change, like the news in the paper or the images on a movie screen."[16] From this word, Johnson created *moticos*, an anagram of the word *osmotic* (the adjectival form of osmosis). He created lists of individuals to whom he mailed printed flyers announcing the availability of his moticos—the lists included museum curators, directors, dealers, and others—and they

21

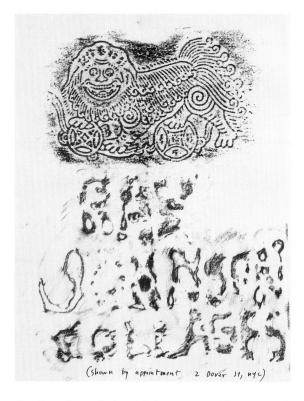

were also the subject of a 1955 article in *The Village Voice*. Johnson would use this word, as well, to signify the invented language of abstract marks he used in many of his works.

The meticulously crafted surfaces of Johnson's moticos present viewers with images spanning the beautiful and the grotesque, the ideal and the reviled, the popular and the esoteric. Continually updating his inventory of fragments from existing information systems—newspapers, magazines, tabloids, photographs, and comic strips—and those of his own making, he devoted much time and labor to making these complexly structured objects, which ask for prolonged engagement with the viewer. Most of them manifest a striking formal integrity, a sense of order that belies the morass of stimuli they contain. In Johnson's world of moticos, literary figures such as Eudora Welty (p. 33) stand side by side with celebrities such as James Dean, Marlon Brando, and Marilyn Monroe, just as they might on the page of a newspaper or magazine.

Constructed from the simplest of materials, the translucent, mute, even deadpan surfaces of these collages comment on the abstract nature of words, pictures, and communication. *Untitled (Easter)* (1955/85/88/89/94, p. 41) is one such work. It features an engraving depicting a man using a chisel-like tool to carve into the surface of a rock, though the words he has recorded remain a mystery. (In 1982, Johnson discovered that Joseph Cornell had used the exact same engraving in a 1933 collage, a correspondence he relished.)[17] The collage also serves as a record of actions, ranging from the discovery of the engraving that has been pasted down, to the sanding, painting, and scratching, mimicking writing, that forms the surface of the work. Several years later Johnson reworked the collage, each time adding a new date to record the action.

Johnson's collages also present networks of individual signs capable of multiple interpretations. For instance, *Movie Star with Horse* (1958, p. 14) is comprised of found materials as well as painterly marks. For this tightly engineered work, Johnson collaged fragments of paper, some cut from magazines and newspapers, onto the cardboard support. He created the surface through delicate washes of paint and further modulated it with sandpaper, which he used the way most artists might use a brush. He assembled many things—images of a movie star in

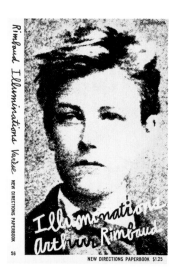

Book jacket design, 1956

classic "cheesecake" pose, a telephone, a pictogram, a horse, and a series of moticos, all transmitters of messages, communication networks waiting to be decoded by whoever should come across them.

Glyph-like moticos such as those in *Movie Star with Horse* appear in many of Johnson's collages of this period; they cover photographs of figures such as Elvis Presley, James Dean, and Eudora Welty, among others. Suggestive of writing, they are, in essence, an index to his collages, silhouettes he traced and reduced from the irregular shapes of his cardboard forms. They are exceedingly cryptic, and when combined with photographic images, the abstract nature

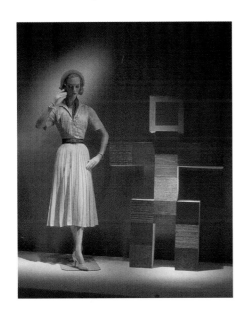

of Johnson's moticos seems to define the photographic image not as a purveyor of truth, but as a signifier of fantasy and myth, its meaning continually subject to manipulation. Johnson had become acquainted with the possibilities inherent in reprographic techniques through his work as a free-lance designer. In 1956, he created a cover for an enlarged and expanded edition of Arthur Rimbaud's *Illuminations* (p. 22), published by New Directions, in which he enlarged the photograph of the poet so as to reveal its underlying structure of Ben-Day dots. *Untitled (James Dean in the Rain)* (ca. 1955–58, p. 32), combines moticos with photo-graphic images that offer two versions of the tragic star, small and large. Conflating the visual and verbal in this way, Johnson further blurs the line between fiction and fact.[18]

23

One of Johnson's most often reproduced collages, *Elvis Presley # I* (ca. 1956–57, p. 94) also combines an appropriated photograph of a pop hero with moticos.[19] Wilson has discussed this work, which has also been exhibited with the title *Oedipus*, as the artist's response to Abstract Expressionism. About the work Johnson himself has said, "I'm the only painter in New York whose drips mean anything." His challenge to the heroic mythos of Abstract Expressionism is somewhat analogous to Larry Rivers's parody of the macho hero in *Washington Crossing the Delaware* (1953). It may also reference an increasingly mythological role for the artist created through popular magazines, such as *Life* and *Harper's Bazaar*, which regularly reported on the comings and goings of the art world. (*Life*'s pages featured numerous artists, including an infamous portrait of Jackson Pollock painting with the subtitle "Jack the Dripper," and Johnson himself had been featured with his Boza Mansion group in *Harper's*.)[20]

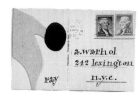
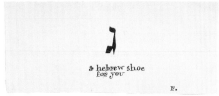

**Correspondence by Ray Johnson
to Andy Warhol**, 1956
The Archives of the Andy Warhol Museum, Pittsburgh;
Founding Collection, Contribution
The Andy Warhol Foundation for the Visual Arts, Inc.

The conflation of the private language of mark-making with the more common experience signaled by the publicity photograph also suggests other readings of Johnson's *Elvis*. It is worth comparing Johnson's image with Andy Warhol's collage of Elvis (ca. 1956), in which he appears as a gold boot, beneath which is written Elvis's name. The two artists knew one another from their work in commercial design, and Johnson mailed a work to Warhol entitled *A Hebrew Shoe for You* (above) in response to Warhol's portfolio, *A la Recherche du Shoe Perdu* (1955). Warhol targeted his collage of Elvis to several subcultures, including his customers in the shoe industry, as well as, and perhaps simultaneously, his gay friends. Johnson's *Elvis* equally functions on dual levels. Selecting a photographic and a public image, he used the mythic hero of Elvis to address the death of the mythic hero of Abstract Expressionism. The image also has a charged eroticism—a homoeroticism that seems quite at odds with the machismo of the New York School. Ultimately, each artist retains in the image of Elvis the sense that it is a mirror on which viewers may project their own particular desires.

By the late 1950s, Johnson was increasingly erasing much of the informational content of his collages by superimposing patterns over images, as in *Untitled (Woman in Carriage)* (ca. 1957–58, p. 35), or by applying paint washes to the pictorial surface, as in *Untitled (Motico 30)* (ca. 1955–60, p. 36). These techniques largely transformed the underlying collage elements into shapes not unlike his silhouetted moticos. *Side by Side* (1959, below) juxtaposes printed silhouetted moticos with slightly raised counterparts, signaling a shift toward increasingly abstract works. In these, as well as in many works of the 1960s, cardboard components, which have also been referred to as tessarae, form the basis for the work. He arranged these individual units to form larger collages, some suggestive of his works of the early 1950s, such as *Untitled* (1953).

Beyond the overall shape of the collages, their individual components are painted and heavily sanded, some retaining the ghost of a Lucky Strike emblem (p. 36) or the silhouette of a motico. These abstract constructions eventually served as the background on which Johnson would explore an enormous array of themes, especially the complexity and tenuousness of identity.

In many ways, Johnson's kaleidoscopic vision of the world as seen through collage seems best suited to explore the subject of human identity, a theme he pursued

Side by Side, 1959
18 × 22

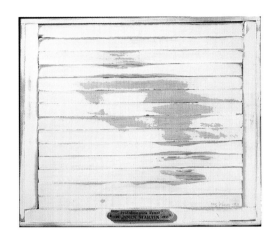

Balshazzar's Feast, 1964
Construction of wood, paint, and metal,
18 x 18 x 3

with great fervor. The same visual strategies that created permutations of Lucky Strike emblems and moticos were now pressed into service to transform people into dollar bills (pp. 110–115) and potato mashers, as well as silhouettes drawn from life. Johnson also continued his use of photographic imagery. In 1967, he produced the first of many works including a photograph of himself, *Mask I* (p. 160), *II, III.* These collages tells us very little about their subject: although the sitter's eyes peer mysteriously out toward us, the rest of the face is obscured by cardboard blocks covered with the imperceptible language of moticos. The only discernible marks are comb-like shapes referring to the Op paintings of the British artist Bridget Riley and Marcel Duchamp's readymade, *Comb* (1916). To heighten the illusory effect, Johnson has applied a wash over the photographic surface, which he then sandpapered.

One year later, in 1968, Johnson created another portrait, titled *Duchamp with Star Haircut* (1968, p. 27) featuring a photograph of a person wearing a black watchman's cap with a sheriff's badge. In this work, he referred to Duchamp's famous photograph of himself as his female alter-ego, Rrose Sélavy, and to Georges de Zayas's 1921 photograph of the back of the artist's head with a star cut into his hair; he partially obliterated the photograph through the sanding process. Since Johnson used various strategies to disguise the individual's identity, it is unclear who the sitter is: Duchamp? Johnson? or someone else? She is actually the secretary of the New York Correspondence School, whose identity might only be discerned by those who were a part of that network and might recognize her from the watchman's cap and sheriff's badge.[21]

With *Rene Magritte* (1971, p. 117), Johnson paid homage to another European modernist, the Surrealist painter who had died the year the portrait was made. This collage, however, uses a photograph of Montgomery Clift as a stand-in for the artist. Johnson's inclusion of Magritte's name suggests his famous statement, "This is not a pipe," further reinforced by the use of Clift's photograph. But in contrast to *Duchamp with Star Haircut*, this collage expands the notion of the network beyond two individuals. It includes a network of names that reads not unlike one of the seating charts from Johnson's NYCS meetings. Littered with the names of film stars, art stars, NYCS members, and literary figures, each is represented by a fetus-like mark—a form on its way to becoming.

Throughout his career, Johnson also further expanded the notion of the network through the repeated use of certain motifs as well as through collages that related to one another. In 1971, he presented a series of collages in an exhibition entitled *Dollar Bills and Famous People Memorials*, which included his rendition of Magritte. This group of collages seems to have

been inspired largely by the fact that the individuals honored, such as the writer Yukio Mishima and the singer Janis Joplin, had recently died (Mishima committed ritual suicide at the height of his career, and Joplin died of a drug overdose). Johnson's portrait of Mishima and another celebrity, the silent film star, Anna Mae Wong, are united in their use of text and ink images, as well as the drawing of a man's back, based on a photograph of the artist Karl Wirsum, a member of the NYCS (pp. 140, 118, 119). Johnson had held meetings for Wong, in which the fashion model Naomi Sims portrayed her, and sent out printed mailings announcing the event (p. 146). Further extending the connection, he produced a collage entitled *Anna May Wong's Mother's Potato Masher* (1972). These endless levels of correspondences, each impacting on the next and leading to ever new configurations, were the hallmark of Johnson's practice.

In 1972, Johnson produced a series of collages devoted to the theme of "Ray Johnson's History of the Betty Parsons Gallery," which he exhibited at the gallery that same year (pp. 66–68). Each of the collages in the exhibition is named for a specific artist who had shown at the gallery. However, Johnson also felt free to insert one named for the photographer Diane Arbus (p. 69), who had not. Together, they comprise an homage to the legendary dealer, who consistently promoted a range of artists, including nearly all of the most well known Abstract Expressionists. In his review of the exhibition for the *Nation*, the critic Lawrence Alloway wrote: "In Ray Johnson's collages words and images are inextricable; the denotation of proper names and the chains of visual associations tangle and unravel. These collages are not designed to be seen in a single, all encompassing glance, like a Motherwell collage; on the contrary, they are intricate and discursive, a nest of clues that solicit attention. Johnson merely explained the work by saying he was name dropping."[22]

During this same period, Johnson began to develop other ways of connecting with people, beyond the NYCS. For example, he mailed individuals letters enrolling them in fan clubs he created—the Cher Fan Club, the Shelley Duvall Fan Club, the Edie Beal Fan Club, the Deadpan

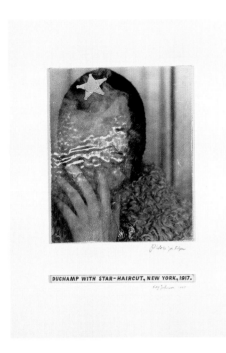

Duchamp with Star Haircut, 1968
15½ x 11¾
Jedermann, N.A.

Fan Club—that were phantoms, created entirely through
rubber stamps and existing only on paper. He used his
fan clubs and galleries, as well as the NYCS, as a way of joining
people in coincidental ways. As in his earlier images of Elvis
and James Dean, and his portrayals of art world heros, he used
these strategies to parody and explore the illlusory nature of celebrity, fame, and human identity.

In 1976, Johnson embarked on a major series of portrait collages based on
the silhouettes of people he had asked to pose for him.[23] The list reads like a who's who of the
New York art and literary worlds. He discussed these images in relationship to the silhouetted
moticos he developed during the 1950s, which he once placed on the body of a friend. The
silhouetted image created by the outline of the sitter exists as a background, a framing device, as
well as an index. It contains some factual evidence, the person's outline, along with an array
of abstract shapes and images that may or may not have a connection with the sitter. *Untitled
(Wolf with Zodiac)* (1976–87, p. 157) fuses Warhol's outline with painted shapes and collage
elements in an abstract composition that reads like camouflage. Johnson often produced as many
as thirty or forty portraits of a single individual, believing his or her personality to be multifaceted.
He also extended this approach to his own self-portraits, combining his images with the profiles
of Duchamp (p. 163) and Cornell. The interlocking parts of these collages create a unified
pictorial surface, but without fixed meaning.

Johnson's kaleidoscopic view of the world fractured everything into a correspon-
dence, its direction ultimately determined by individual desire and inclination. As David Bourdon
wrote, his collages "are the equivalent of Rorschach inkblot tests that can be interpreted in
almost as many ways as there are individuals to examine them." This statement is as true of the
artist as it is of his work. Johnson placed himself at the center of a system of individuals—each
with his or her own interpretations, inclinations, and opinions—and created works that allowed
for those differences of opinion. The age of digital technology in which we now find ourselves
offers a comparable allure of connection. Johnson's communication network, filled with announce-
ment cards and histories of the world, makes the comparison to the Internet inevitable. In both
worlds, fact and fiction mix quite easily, putting the user on guard. As Nicholas Negroponte has
written in his book *Being Digital*, "in the post-information age, we often have the audience the size
of one. Everything is made to order, and information is extremely personalized."[24]

In the last few years of his life, between 1991 and 1994, Johnson produced a
series of small works, more paintings than collages, that depict stages which seem to exist for an
audience of one. Made on discarded cardboard, they are unlike the far more complicated
collages for which he is best known. Each work features a single image placed on center stage;

27

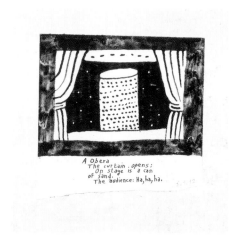

A Obera
The curtain opens:
On stage is a can
of sand.
The audience: Ha, ha, ha.

Untitled (Can of Sand), 1992
Tempera on cardboard, 7½ x 7½

the images range from autobiographical references from the artist's early years, such as Josef Albers and the Coca-Cola logo, to ones with far more mysterious connotations, such as a can of sand (above). Beneath this image is a legend that reads, "The curtain opens. The can of sand appears. The audience says, 'Ha, ha.'" These enigmatic works suggest another way of framing the world, as Johnson's earlier motico panels had once reflected a view of postwar America created through its scraps. In certain ways, they also seem to crystallize the problematic nature of his quest. They are both distant and intimate, perhaps evoking Johnson's beliefs about the personal experience of art and the desirability of being able to have an audience of one— something that can never be accomplished through a public exhibition, in which the face of the viewer is often anonymous. They also seem to leave us with the uncanny feeling that Johnson is looking at us while we are looking at him.

Ultimately, the thousands of missives Johnson sent into circulation were a kind of fuel that enabled his network to move and expand. Collectively, they suggest both archive and time capsule, with its contents spread around the world. Unlike the work of other artists, notably Gerhard Richter, whose ever-expanding *Atlas* meticulously catalogues the artist's interests and influences, Johnson's project emphasizes the messiness of such things. It also comments on the fugitive nature of fame, glamour, celebrity, career, and finally, existence itself. As Wilson points out, "the chain of resemblances constructs a structure that has no foundation, it stretches across emptiness, but it stands, a fullness that eerily reminds one of the emptiness it is supposed to divert attention from."[25]

In the end, one is struck by the enormous collection of work Johnson left us with, some of them purposefully created for a public audience, and thus capable of existing on their own within the context of art history. Others, more private works, came about as the result of specific relationships and are still best understood by those who received them. Indeed, the richest perspectives on the artist are still to be offered by those who sustained long-term correspondences and friendships with him, including Wilson, Henry Martin, and many others. These individuals bring to Johnson's project a visceral experience of the work that will never be possible for those in the "public" sphere, for whom the artist has become an historical figure. Johnson created a situation in which each recipient of his mail art feels, in effect, that he or she might possess the key to this vast storehouse of words and images, and that, by extension, we might all become drawn into their conspiracies of text and image. Nonetheless, by engaging in a formal analysis of Johnson's project, with an acceptance of its unresolvability, it becomes possible for those outside the network to begin to see how Johnson advanced his ideas about the possibilities and limitations of language—both verbal and visual—and the conflation of audience and network that was one of the end results of his experimentation with collage.

Although I never met Ray Johnson, I knew him from a few brief phone calls and through correspondence. I first made contact with him during the course of my research for the exhibition *Hand-Painted Pop: American Art in Transition, 1955–62*, organized by Paul Schimmel and myself for The Museum of Contemporary Art in Los Angeles. I asked Johnson for information about the works he had produced during this period; in response to this initial call, he began sending me photo-copied mailings with reproductions of some of his earlier collages with headlines such as "Pre-Pop Shop" or "Taoist-art School." While we were never able to arrange a personal meeting, Johnson did enroll me in the New York Correspondence School and sent me periodic mailings. We reconnected, as it were, when I was organizing the exhibition *Face Value: American Portraits* for The Parrish Art Museum. I felt Johnson's approach to portraiture had much in common with that of very contemporary figures, such as Cindy Sherman, and wished to include his work in the exhibition and catalogue, which I subsequently did. I received approximately twenty letters, either sent by Johnson or at his direction, as well as several small packages containing items such as a lamp shade. Johnson died during the show's organization and did not live to see its presentation in the summer of 1995.

1. Johnson used the word *ceremony* to describe his collage process, in the context of a discussion about his use of rubber stamps: "I use them as verbal information. I was explaining how my oldest rubber stamp reading 'Collage by Ray Johnson' as to how and where and why I use and stamp it, which in the collage process, or ceremony, after I apply tape or glue to a surface, which technically makes it a collage"; transcribed interview conducted by John Held, Jr., at the Mid-York Library System, Utica, N.Y., December 2, 1977.

2. William S. Wilson, in "Vibration and reverberation," *Collage* (Palermo, Italy) 6, no. 13 (September 1966); 58–59

3. Secunda was Johnson's high school friend in Detroit; after high school, they began corresponding by postcard and letter and continued to correspond until Johnson's death.

4. For an extensive discussion of Albers's curriculum at Black Mountain College, see Mary Emma Harris, *The Arts at Black Mountain College* (Cambridge, Mass.: MIT Press, 1987), especially 78–84.

5. William S. Wilson, *Ray Johnson, Black Mountain College Dossiers*, no. 4 (1997), 66.

6. Lippold recalled that Johnson used a palette knife to make his paintings; a photograph taken sometime in the early 1950s shows the artist using this instrument. Lippold also remembered that Johnson had made paintings of a single color, notably orange; interview with Muffet Jones.

7. Although Johnson rarely acknowledged direct influences in his work, he did describe the following exchange with Cage in a 1968 interview: "I was doing very severely geometric paintings based on square units, rectangular and square units that I methodically filled in with color mosaics. And these paintings took me many, many months to complete. And one day having this pencil drawing groundwork for a painting I suddenly thought of putting straight pins through the back of the cardboard into the picture. And John Cage was a neighbor of mine. When I was doing it I rushed over to show him what I was doing, 'I have this terrific idea to put pins through the middle of every square from the back and pins will all stick through.' He was quite shocked because I had changed the idea of what it was I was doing. I had made this foundation that I was going to fill in all these colors and this was to be a painting. And I changed horses in midstream and I was suddenly going to so something else. And he disapproved. I don't know why"; Ray Johnson, interview with Sevim Fesci, April 17, 1968, Archives of American Art, New York, p. 13.

8. Among the first were a series of collages sent in 1953 to Isabelle Fisher, a dancer with whom he was particularly taken. One featured a magazine fragment depicting a woman leaping through the air, a reference to its recipient, combined with another, the word *Zen*, fragmented from *Jantzen*, a maker of women's swim-wear and most likely an advertisement that had appeared in a fashion magazine. Over the course of one month, he sent postcards, each one with a different image from the comic strip *The Little King*, thus disrupting the narrative.

9. The entire quote reads: "Any number of details in Rauschenberg's works suggest his enormous respect for Abstract Expressionist painting. His art of parts, however, is fundamentally at odds with the quest for the whole fundamental to Abstract Expressionism"; Charles Stuckey, "Rauschenberg's Everything, Everywhere Era," in Robert *Rauschenberg: A Retrospective*, exh. cat. (New York: The Solomon R. Guggenheim Foundation, 1997), 35.

10. Johnson participated in numerous events organized by the Living Theatre, including the design of playbills and announcements, and also engaged in a correspondence with its founders. By 1957, he had also corresponded with Jiro Yoshihara, founder of the Gutai group.

11. The photographs were included in the article "700 Collages by Ray Johnson," with text by Suzi Gablik, in *Location* (New York) 1, no. 2 (Summer 1964): 55–58.

12. Interview with Held.

13. For more information on Kaprow and Happenings, see Allan Kaprow, *Assemblage, Environments, and Happenings* (New York: Abrams, 1966); Kaprow, *Essays on the Blurring of Art and Life*, ed. Jeff Kelley (Berkeley: University of California Press, 1993); Michael Kirby, *Happenings: An Illustrated Anthology* (New York: Dutton, 1965); Richard Kostelanetz, *The Theatre of Mixed Means: An Introduction to Happenings, Kinetic Environments, and Other Mixed-Means Performances* (New York: Dial Press, 1968); Mariellen R. Sandford, ed., *Happenings and Other Acts* (London: Routledge, 1995).

14. Ray Johnson, in Henry Martin, "Should an Eyelash Last Forever? An Interview with Ray Johnson," in this volume, 190.

15. Quoted in Katherine Hoffman, ed., *Collage: Critical Views* (Ann Arbor: UMI Research Press, 1989).

16. According to Norman Solomon, email to author, September 26, 1998, when Johnson was searching for a name for his new collages, he asked Solomon for suggestions. Solomon, who had just finished reading Hans Ruesch's *Top of the World* (1950), suggested "Eskimos." Johnson asked for another suggestion, and Solomon said, "Mexicos." Johnson then asked Solomon what word he was studying in the dictionary at that moment. It was "osmotics." Johnson then replied, "I think I'll call them moticos."

17. In a letter of November 22, 1982, to Lynda Roscoe Hartigan at the National Museum of American Art, Washington D.C., Johnson mentions he had recently learned that Joseph Cornell used the same engraving in one of his collages in 1933.

18. Johnson worked as a freelance commercial designer in the late 1940s and 1950s, producing book covers for New Directions and illustrations for women's fashion magazines. He also created several store window displays, such as those for Andrew Geller Shoes, in New York.

19. In 1957, Johnson composed "Funeral Music for Elvis Presley," a taped collage using music by Earl Brown.

20. "Four Artists in a 'Mansion,'" *Harper's Bazaar*, May 1952. In 1951, an article on Rauschenberg had also appeared in *Life*.

21. In a report from the New York Correspondence School, Johnson is described wearing a "Duchamp star show cap all Nile-green with the Betty Davis bangs ss [sic] sewn-on to Arturo Schwarz lecture which was brilliant at the Modern Museum about Duchamp and Alchemy." There are countless references to Duchamp in Johnson's collages and correspondence. In the Schwarz collage, Johnson uses the letter "R"—the first letter of "R. Mutt," the signature on Duchamp's work *Fountain*, included in the American Society of Independent Artists exhibition at the Armory in New York in 1917.

22. Lawrence Alloway, "Ray Johnson's History of the Betty Parsons Gallery, in *The Nation*, February 5, 1973, 190.

23. Johnson either telephoned or wrote to the individuals he wished to portray. In a letter to Marion Javits in which he asked her to pose, Johnson describes the process: "It is a simple situation of my arriving with my small light and I draw your cast shadow on the wall on my paper. Jacob Javits could be drawn seated. But it has to be done in a completely darkened room. It takes just a few minutes each. And is very quick. This is how I have done the initial pencil sketch of the 290 people listed on the enclosed *Those Who Posed* page. The pencil sketch is just the first step of the portrait process. I do in my studio a secondary ink line tracing paper drawing, and then a series of variation portraits as described by Nina ffrench-frazier about my last exhibition of Portraits at the Brooks/Iolas Gallery." See also, Nina ffrench-frazier, "Ray Johnson," *Arts Magazine* 1, no. 10 (June 1978): 8.

24. Nicholas Negroponte, *Being Digital* (New York: Knopf, 1995), 13.

25. William S. Wilson, "Reference and Relation," *Ray Johnson Ray Johnson* (New York: Between Books, 1977), back cover.

Industrial design

Interiors

NOVEMBER 1947

Cover design,
Interiors, 1947

Calm Center, ca. 1951
Oil on wood
28 x 28
Richard Lippold

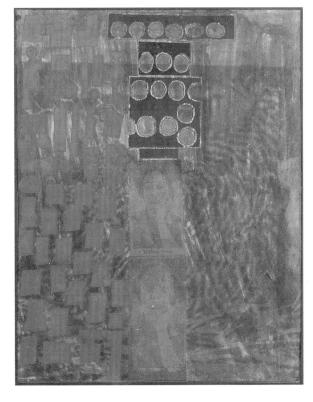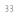

James Dean, 1958
10½ x 7½
Henry Martin and Berty Skuber, Fiè allo
Sciliar, Italy

Untitled (Eudora Welty), ca. 1955–56
9 x 7
Denver Art Museum, Gift of the Stanton
Kreider Collection

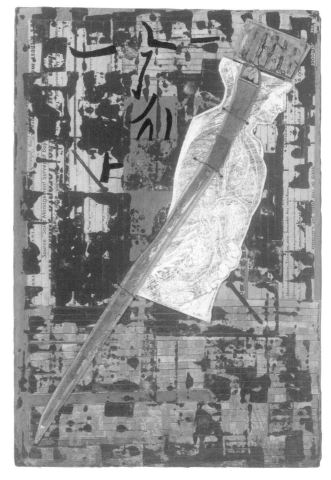

34

Shirley Temple, 1958
9¾ x 7½
Henry Martin and Berty Skuber,
Fiè allo Sciliar, Italy

Blood, 1958
11 x 7¼
William Kistler

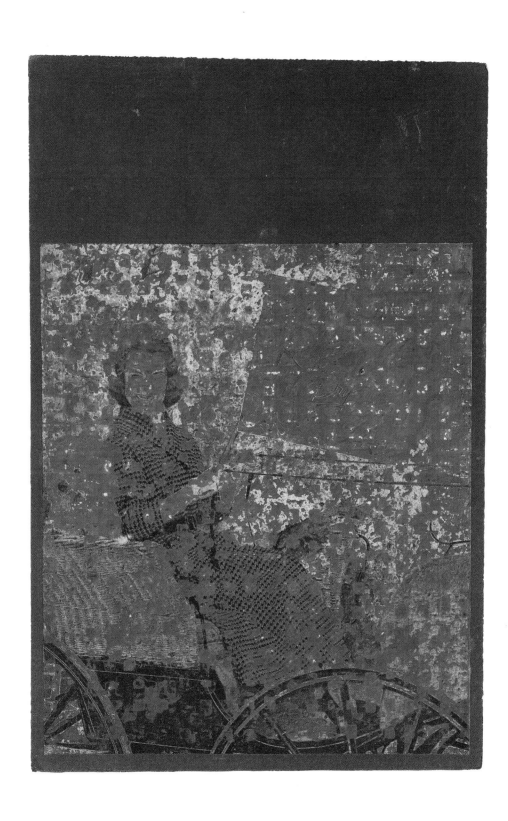

Untitled (Woman in Carriage),
ca. 1957–58
11 x 7¼

36

Untitled (Motico 30), ca. 1955–60

11 x 7½

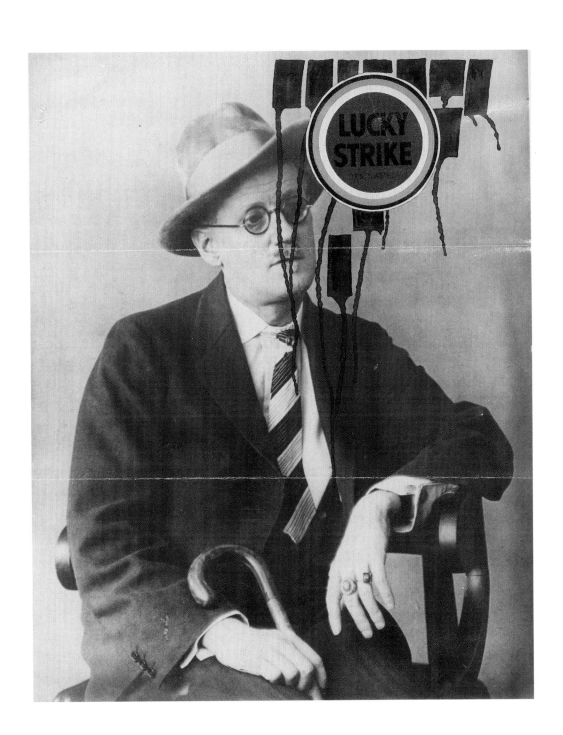

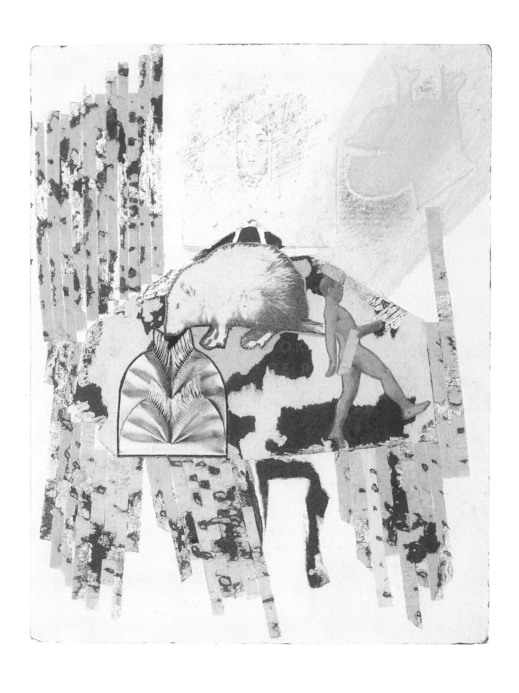

40

Walking Man, 1958
9³/₈ x 7³/₈
William S. Wilson

Untitled (Easter), 1955/85/88/89/94
15 x 11½

Gregory Corso Poem, 1958
9 x 7¼
Private collection

address). And in the 1950s Guy Debord and others associated with the Situationist International, Johnson's contemporaries, wandered the streets of Paris as postwar flâneurs in strolls they called *dérives* (drifts). As the critic Greil Marcus has written, the *dérive* "was a matter of opening one's consciousness to the (so to speak) unconsciousness of urban space; the *dérive* meant a solo or collective passage down city streets, a surrender to and then pursuit of alleys of attraction, boulevards of repulsion, until the city itself became a field of what [was] called 'psychogeography,' where every building, route, and decoration expanded with meaning or disappeared for the lack of it."[7] Each incarnation of the flâneur has expanded the concept of the urban artist as cultural spectator and remapped the labyrinthine route of his or her topography, the terrain that intersects the artist's life and work.

Johnson was a singular blend of such a lineage, charting his own path through the art world, essentially via his mail art, otherwise known as the NYCS. As a virtual chronicler of

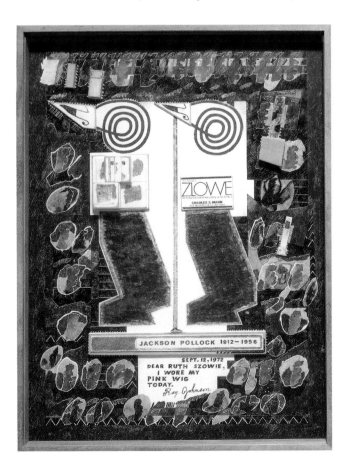

his period, his ubiquitous activities but invisible presence in the art world reinvoke Baudelaire's remark that the flâneur is "a prince who is everywhere in possession of his incognito."[8] He was an artist who enveloped more than just his missives, whose artistic and social practice coincided in a manner that realized a freedom of interaction, which, like that of the flâneur, rendered him independent, unclassifiable.

The same freedom of interaction is evident in much of Johnson's work—an inherently unfinishable collage process of stream of consciousness in which he created a seemingly infinite series of allusive correspondences between shapes, numbers, words, names, ducks, bunny heads, fetuses, and so on. The transgression of the object or form in space, as well as that of language; the invocation of the synthesizing principle of correspondences; the elision of abstraction and representation; and the tendency to deny the possibility of finite meaning are all elements of Johnson's

45

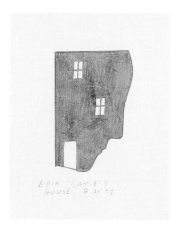

Untitled (Erik Satie's House), 1994
Ink on paper, 7 x 6

work. Together, they collectively evoke the precedents of the work of Baudelaire and other Symbolist precursors.

Much of the content of Johnson's collages remains hidden, obscure. As the viewer's eye skitters from one object to the next, it is strangely drawn toward the periphery of forms. The detailed contours of these shapes are accentuated by his deceptively intricate draftsmanship, which, either in India ink or colored inks, produces shapes that veer between representation and abstraction. The mandrake root, a recurrent favorite, for example, with its allusions to legs and trunk, can as easily metamorphose into the inkblot enigmas of the Rorschach test or correspond to numerous other objects or figures, as in *Marcel Duchamp* or *Teeny Weeny* (both 1972).[9] Inspecting any of these groups of parading minutiae for the slightest mutation, one ironically searches—within collages that are nothing but a morass of minuscule difference—for distinctions among seemingly identical forms.

It is not just the object or form in space that is transgressed in the artist's work, but language itself. Johnson attenuates and distorts the ability of words to identify and name things in the world. Verbal language, for him, is as pliable, oblique, and changing as is a shadow to an object. A literal example of this correspondence occurs in *Robin Richman said people in Houston call their chateaus shadows* (1967, p. 44). By changing the spelling of *chateaux* to *chateaus*, Johnson not only exceeds the homophone of the title but calls attention to the "toes" he depicts, cartoonlike, in the center of the collage. Their elongation is a further reference to the attenuation that is equally a function of shadows and language, both of which intersect in the image that appears alongside the toes—that is, their "shadows," whose slight inflection makes them seem to face each other, engaged in a "chat."

Such a demonstration of the figurative plasticity of language slides further along a deepening scale of reference by invoking that most transcendent medium of the arts—music—as the "chatting shadows" become themselves the black keys of a piano whose entire keyboard is depicted below, accompanied, of course, by its shadow. Johnson thus invokes the synthesizing principle of correspondences, as postulated by Baudelaire in his sonnet "Correspondences," when he wrote, "There are odors succulent as young flesh, sweet as flutes, and green as any grass, while others—rich, corrupt, and masterful—possess the power of such infinite things as incense, amber, benjamin and musk, to praise the senses' raptures and the mind's."[10] In his allusion to music, Johnson reminds us of the centrality of this Symbolist metaphor, which for Baudelaire expressed ideas of universal harmony, the equivalence between sensations elicited by perfumes, colors, sounds.

Resonating throughout his oeuvre, this notion of correspondence aligns Johnson's work with other modernists who sought to defer the illusory grasp of a subject's finite meaning. Within the collage's universe of inclusion, then, the idea of difference, which generally

46

Untitled (For Daniel
Spoerri), 1989
Ink on paper, 11 x 8½

Untitled (Broken
Glass), 1988
Ink on paper, 11 x 8½

Untitled (The Cracked
Dish), 1989
Ink on paper, 11 x 8½

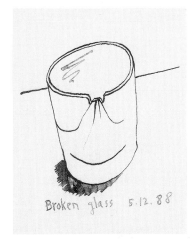

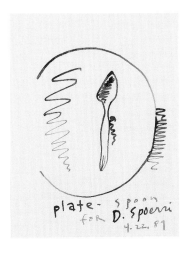

exists between pairs, sets, or groups of things, is invariably resolved, albeit only momentarily, on some formal or semantic level. Johnson renders obsolete the idea that his collages are about specific subjects. If they can be said to be about something, it would be the continuum of correspondence between multiple levels of signification.[11] In *Naomi Sims Fingernails* (1973), for instance, nail clippings (a repeated motif and another example of his childlike, atavisticcollecting of something marginal), hover above the segmentation of a snake. It is both their similarity and mutual reference to the process of collage, with its cutting, pasting, and segmented growth, that is the subject of the work. Similarly, *Dear Ruth Szowie* (1972, p. 45) is an inventory of pairs: identical potato mashers (which Johnson uses to symbolically "mash" everything into a state of correspondence), cubic forms, and even the repeated angles in the capital lettering of *Szowie*. We pass back and forth between the world of substance and the world of structure, accompanied by a parade of morphing fetal forms that regress further into a squadron of multicolored and faceted egglike objects. Even in his early purist paintings, of which few remain, Johnson was keenly aware of the dynamic virtues of the miniature, its blend of observation and imagination.[12] At a time when most of his contemporaries, from Claes Oldenburg to James Rosenquist to Andy Warhol, were enlarging the image to mythic dimensions (a typical strategy of Pop art), Johnson's scale remained resolutely small. An early example is *Calm Center* (ca. 1951, p. 30), a grid (a structure that would undergird much of his oeuvre), comprising forty-nine intricately designed 4-inch-square geometries over a 28-by-28-inch surface. It presents an overall configuration that is a phenomenology of similarity and difference. This diverse ensemble of uninflected colored patterns of lines and squares creates an opticality and movement that produces a constantly changing dialectic of surface and depth. It is as if one is looking through a microscope, the detailed enlargement of each square a different power and view of the same object. Seventeen years later, Johnson would deface this painting, first drawing a dotted heart in

47

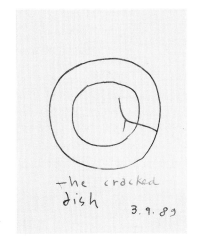

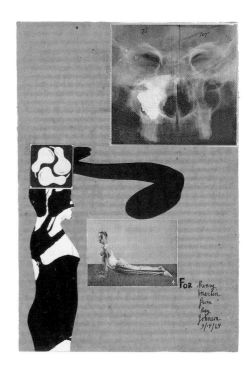

Untitled, 1964
11 x 7⁹/₁₆
Henry Martin and Berty Skuber,
Fiè allo Sciliar, Italy

the work's centered black square, and then covering it with a white feather.[13] The placement of a feather over a heart no doubt symbolizes both the sublime and fickle nature of love (and indeed Johnson gave the work to Richard Lippold, with whom he was romantically involved at the time).

 This gesture carries implications, as well, regarding the changes that would occur in Johnson's work after he ceased to paint as such in the mid-1950s. The central square of *Calm Center* acted as a unifying compositional device, the center of the painting's geometric universe that pulled everything kaleidoscopically surrounding it together. Within geometry's measurable space, time and the imagination often follow an ordered and certain path, and Johnson always wanted to subvert geometry's rationalist expectation. The feather's wafting Symbolist associations represent a wholly different, less functionalist, occupation of space and of the imagination, where the interrelationships of form and meaning are not bound by rules.

 In place of geometric abstract painting, whose multiplicity of hue and visual effect depended on the interaction of colors, Johnson turned wholeheartedly to collage in the mid-1950s. Extrapolating on the ambiguities of visual and spatial perception, which he had learned from Josef Albers, with whom he had studied while at Black Mountain College in North Carolina from 1945 to 1948, Johnson began to exploit the subjective potential of language and the syntax of collage. It was not just Johnson's acute sense of design that reflected the Bauhaus master's influence but the former's continuing exploitation of the simultaneous presence of the specific and the ambiguous. For, despite the constancy of the laws governing color perception, Albers's meticulous examination of visual perception was founded on his belief in the variable, unpredictable nature of visual perception. Johnson's shift away from geometric abstraction reveals his commitment to an aesthetic enterprise that was at once far-reaching and more personal. Indeed, this Symbolist meditation, employing the constellation of language and the emergence of the most paltry of form, encompassed a conception of grandeur that was equally grounded in intimacy, in the smallest recesses of the self.

 Johnson produced countless collages throughout the late 1950s and early 1960s that continued to concentrate on the repeated but varied surface effects of objects. He heightened these effects by cutting printed or painted paper into narrow strips—echoing the elaborate geometries of color and line of his earlier painting—which he would then reassemble on a cardboard mount, often adding calligraphy. These irregularly shaped collages, which he called *moticos* (an anagram of osmotic, referring to the process of absorption or diffusion as a result of

48

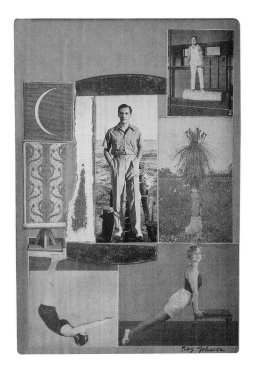

Untitled (Gymnastics), 1958
12½ x 8½
Francesca and Massimo Valsecchi

pressure), are comprised of cut-outs from newspapers and magazines, ink drawings, and pieces of painstakingly painted and sanded pieces of paperboard. Resembling the paraphernalia of a child's game or the personal items of someone's collection of oddities, moticos could either be configured with other forms or simply stand alone.

Johnson's act of cutting up, reducing forms to fragments and language to its component letters, as in *Gregory Corso Poem* (1958, p. 42), involved a process of miniaturization. As he wrote, "The moticos were the little black silhouettes I did, and they were a miniature cataloguing of actual free-form collage fragments. I'd take a box of fragments, which were all different shapes, and then I would draw each thing in India ink. Each fragment was about ten inches high, and the drawing would reduce it to about one inch high, and I'd cover pages with them."[14] At the same time as he miniaturized, he would also magnify reproduced images until whatever was represented on the surface was no longer identifiable. He cut these scraped and abraded fragments into strips, added them to collages, or filed them away, mostly according to size, until he would further alter and rearrange them. As a collage grew, it could, as easily as any of its parts, be cut down. The extent to which he savored the minuscule and the marginal is evident as late as his "Broken Glass" series of the 1980s (p. 47), which consists of drawings of damaged plates and dishes, as well as in his redrawn classified pages, whose filigree of graphic penmanship echoes ad nauseum the thoughts, utterances, and banalities of tabloids the world over. In the best of his collage tradition, Johnson recycled the overlooked (doodles) or unpleasant (tabloids) or snubbed (comic books, cartoons) byproducts of culture.[15]

Throughout the 1950s and 1960s, abstraction constantly jostled with representation, flirting with figuration, so as to produce a tense malleability. This sensibility continually tested the nonverbal visual interaction of objects and shapes. Relating the artist's interest in "primitive rituals and forms" to what he saw as "a deep-rooted belief in animism," the critic David Bourdon, Johnson's longtime friend, wrote in "Notes on a Letterhead": "Johnson seems to detect personalities in all sorts of animate and inanimate things, such strong personalities, in fact, that he makes little distinction between persons and things."[16] This equivalency is evident in the isolated, almost studied, circular path of analogical forms in such early collages as *Untitled (Gymnastics)* (1958, above), *Untitled (Turquoise Moticos)* (ca. 1956–59), and *Moticos Panel 19 (Fuschia Figures)* (1953–59). In *Untitled (Gymnastics)*, for example, a full-length image of a Hollywood-type leading man is seen standing suavely on a pier before a distant horizon. The image

49

ONE TV, 1964
5⅜ x 3⅞
William S. Wilson

Untitled (CAT), ca. 1955–58
11 x 7½

is bordered by a portal, which serves as the framework of the dream and whose lintel alludes to the setting sun. The man is the pivotal subject around which a circular movement of romantic figures (women and men stretching and diving) and objects (tropical growth, crescent moon, wrought-iron arabesque) constellate. Illustrating Johnson's effort to make his analogical treatment more accessible, the artist capitalizes on the various similarities of unlike things by integrating and uniting them within monochromatic fields of colors, evoking the binding structure of the Surrealist dream.

Indeed, Johnson maintained an abiding and intense relationship with the aesthetics of Symbolism, Dada, and Surrealism. Rather than derivative, his experiments continually transformed and reinterpreted these earlier movements. While Johnson's collages of the 1950s, for example, reflect an aestheticized Dada and Surrealist structure, in which the metamorphosis of form is essentially defined by analogy and spatial disposition by a kind of oneiric reconstruction, as in *Untitled (Gymnastics)*, his collages of the mid-1960s became sparer in their combination of visual and linguistic elements. Yet their correspondences are often less seen than imagined, suggesting Johnson's kinship with the Symbolist notion of equivalencies. This is evidenced, in part, by his concrete use of color to express thoughts and in his increasingly allusive, often literary, mode of correspondence, as in *Untitled (CAT)* (ca. 1955–58, above), where the letters float in a field of color. It is also evident in the similar fracturing of words in such obvious homages as *Untitled (Rimbaud)* (1956, p. 177) or *Untitled (RIM ART BAUD)* (1956, p. 51). Johnson adopted a more open, less composed syntax—a radicalism more characteristic of his NYCS, in which a significantly freer, more abstract understanding of correspondence prevailed—a Mallarméan aesthetic which, while turning its back on the real, affirms the essential relationships among things.

A modest collage, cryptically entitled *ONE TV* (1964, above), illustrates this new direction. It consists of a vertical strip of three postmarked Japanese stamps of a fisherman casting his net into a translucent, moonlit sea, amidst a group of feeding pelicans. To the right of the stamps, written in lilting, ink-block letters, are the words *ONE TV*, similarly aligned, one above the other. Although still somewhat typical of Johnson's early, spare style, the collage's economy of means belies both its conceptual range and reference, as well as the complex discontinuities that would characterize Johnson's mature style.

ONE TV's three repeated images of water literally reflect a central metaphoric theme—ocean, flow, fluids, flux—in Johnson's oeuvre, which carried an epistemological

50

Untitled (RIM ART BAUD), 1956
6 x 5
William S. Wilson

significance for him and probably contributed in part to his chosen method of suicide by drowning.[17] His oceanic system of mail art functioned for him in mythic terms. Its boundless system could, like water, reach anywhere. His NYCS, represented here by stamps and postmarks, became another total immersion, in which he invested, or divested, his identity—as yet another flow and virtual erotic dis-semination—in the obvious inclusion of his signature within the postmark.

Water, for Johnson, was the equivalent of the Symbolist *esprit*, the unattainable heights that Mallarmé and his followers had sought in "L'Azure, L'Azure, L'Azure, L'Azure," in their quest to exceed a limited, relativistic mode of communication. In fact, the spirit of the poet's *Un Coup de dés* (A Throw of the Dice) is reflected in the unfathomable watery depths of *ONE TV*: just as the fisherman chances a "throw" of the net, the artist chances a correspondence between word and image. Fishing becomes a metaphor for the space of the collage, where elements plucked from their origins become "fish out of water." Despite its natural condition of fragmentation, television's universal and continuous leveling absorption of difference functions here as a metaphor for water, for a sublime unbounded system that swallows everything up.[18]

It is also not by chance that Johnson invoked the specter of television in the title of this collage. Within its imposed and secure domestic boundaries, television automatically organizes its myriad discursive realities, allowing one to seamlessly interact with the outside world, without real contact, without ever feeling that something in one's environment has changed, without having to make sense of anything. And within this safe, continuous exchange of place, there is a kind of visual osmosis—an elimination of boundaries—as space and time merge, as objects and situations flow together, absorbed within a limitless totality. But television's homogenizing effect is perpetuated by its static and normalizing geometry, which regulates perspective. The familiar, then, while ever changing, remains familiar. Rarely is there a disruption of perspective, a destabilizing disjuncture of the visual, beyond the incessant and arbitrary fragmentation of the narrative. Indeed, we defend against not just the intrusiveness of the box, its universal introduction of every imaginable horror into our midst, but against its unrelenting assimilation of all that is different.

The boundaries that exist in Johnson's labyrinthine remapping of the world, however, retain evidence of their displacement. While *ONE TV* is typically allusive, it is also, like *Naomi Sims Fingernails*, self-reflexive, not just in its use of repetition, but in its elaboration of collage as a process of extracting something from one context and placing it in, and possibly next to, another. The stamps' perforation refers to the pinking, or sheared edges, that Johnson often drew onto an image—a reminder that the fragment has been cut away from its origins; to serial repetition, which the artist employed to examine issues of resemblance and identity;

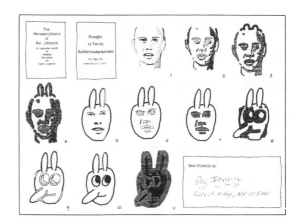

Gene Laughter, "The Metamorphosis
of Ray Johnson: A Computer Study
of Modern Evolution,"
Rubberstampmadness 4, no. 16 (July/
August 1984): back cover.

and to the numerical postage figure of 100 yen, whose isolated double zeros resemble the eyes of his emblematic bunny head.

On one level, Johnson claimed that, despite their endlessly different names, these cartoon characters were personifications of himself, of the way he felt on a given day. (In 1984, the mail art publication *Rubberstampmadness* cleverly illustrated Johnson's morphological development of his bunny head in a rather detailed mutation called *The Metamorphosis of Ray Johnson: A Computer Study of Modern Evolution by Gene Laughter* [above].) Beyond this facile identification, the fact remains that Johnson, unlike other collagists whom he admired, from Max Ernst to Joseph Cornell, did include himself, directly or otherwise, repeatedly in his work. How then, in the context of his "childlike" persona and negotiation of the world, does this egocentric reconstitution of the self operate?

The answer involves the various ways in which Johnson's work becomes more personal after the mid-1960s, despite the fact that it also becomes more conceptual. The writer and Johnson afficionado and correspondent Henry Martin has described the NYCS as fostering "relationships with a tendency towards intimacy…where true experiences are shared… [and where there is] real participation in a secret libidinal charge."[19] Furthermore, Johnson related to space and objects as children do, kinesthetically. Hence his fascination with boundaries, his focus on the contours of objects, and his incorporation of architectural elements, which, like a child's building blocks, function as tesserae and, when assembled together, resemble ancient monuments, totems, buildings, or furniture, as in the bureau in *Wanda Gag* (1967) or as in *Massage Ball* (1967), in which the central form, a pyramid, is supported by a trio of cubes with window-like surfaces.

The depth to which our bodies register and record the experience of shelter and enclosure—starting with the fundamental equation between womb and room—is illuminated in Gaston Bachelard's *The Poetics of Space*. The philosopher writes: "In short, the house we were born in has engraved within us the hierarchy of the various functions of inhabiting. We are the diagram of the functions of inhabiting that particular house, and all the other houses are but variations on a fundamental theme. The word habit is too worn a word to express this passionate liaison of our bodies, which do not forget, with an unforgettable house."[20] A telling photograph of Johnson (p. 53) sitting on the porch of his house in Locust Valley, Long Island, reminds us that he had a symbolic identification with the home. Framed by the quaint yet elaborate architectural details, Johnson, perfectly ensconced beside his toy house, which has been described as tiny and resembling a dollhouse, peers intently out at the viewer from an environment uncannily reminiscent of one of his collages.[21]

The rekindling of this visceral home is expressed through a constant focus on

52

the body's extremities—on toes, feet, hands, breasts, heads, fingernails—as well as on objects that protect and line the body, *doubling* those parts of the anatomy—hats, condoms, boots, combs. Such accouterments not only envelop and recast the body's form but take its shape. They become its double. With such proxy, the body need not remain whole. It can become a body in pieces, each a self-subsistent fragment, a part of the greater and initial experience of structure. It is this reliving of the familiar, nurturing, initial experience of the geometry of the house that allows one to become lost within it, as if a discrete part of it—a room, a stairwell, a corner—were secure and autonomous enough.

The fragmentation and lack of coordination of the body also relate to its kinetic struggle towards a sensed unity, as it is experienced, visually, in the mirror. The psychoanalyst Jacques Lacan called this ego-forming identification the mirror stage—the moment in childhood development when children, not yet fully coordinated, begin to relate to their own bodily unity and autonomy when they first see their own reflections in the mirror. While concerned primarily with issues of resemblance, Johnson's constant mirroring of pairs, as well as his endless disassemblage of form into contiguous fragments, such as the teeth-like objects within the heart in *Valentine for Joseph Cornell* (1971, p. 54), may also be understood in such terms. This reference may also suggest the artist's resistance to the notion of a fixed subject or identity. This resistance may be inferred, for example, from the pentimenti of faded numbers, animal images, and building blocks in *Barnett N* (1969–72, p. 54), whose letters of the alphabet are not only distressed but become dislodged from their surfaces and hover above the blocks, along with a series of elephant heads (typical of

53

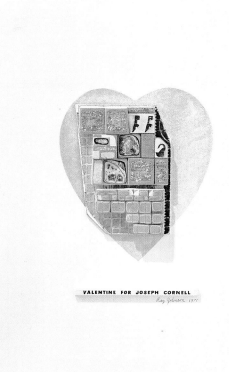

VALENTINE FOR JOSEPH CORNELL
Ray Johnson 1971

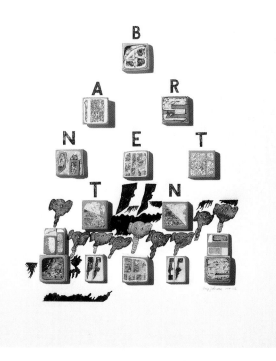

those illustrated on children's blocks). Even the integrity of the elephants' identity seems in jeopardy of being lost, as their contours drawn in ink begin to ebb into an indistinguishable mass, as lost as the disenfranchised letters of the alphabet.[22]

From objects that dematerialize to those that aggregate into some larger form, as in *Untitled (Ad Reinhardt Bird)* (1972, p. 55), it is not so much fantasy (with its goal-oriented desire) as it is the daydream that Johnson evokes. He does so in the halting, abrupt contact with images, in the dissipation of the passing thought, in the quintessential doodling, in the slightly hypnotic, rhythmic quality of repetition, which fluctuates from the marvelous to the boring. Such is the starry-eyed subject of *Untitled (Ray Johnson with Duchamp)* (1974–78/85, p. 163), where a disproportionately large photograph of one half of the artist's face is revealed, its riveting eye gazing out intensely, surrounded by the darkness of space. Obscuring the other half is a group of abstract forms that surround two silhouettes of Duchamp, while below them a photograph of a sleek, dark wood tribal mask with a long bunny ear growing out of it deepens the work's sense of mystery and reverie. The dual nature of the artist's meditation, as both inwardly and outwardly directed, is again amplified—significantly inflected, however, by the presence of Duchamp, an artist of no minor import to either Johnson or his generation. Bachelard has argued that "it is on the plane of the daydream and not on that of facts that childhood remains alive and poetically useful within us."[23] The coexistence of both, however, informs Johnson's art. Between his silhouette portraits (taken from life) and his collages, it would seem that he was seeking to meld the phenomenological, that which sees, intuits, and records the things of the world, and the intellectual, which organizes that information and abstracts it into some form. In the twentieth century, this synthesis is no more profoundly realized than in Duchamp's oeuvre. Through his

optical experimentation with stereoscopy in 1918 or his investigation of the indexical nature
of imagery, as in his painting *Tu m'* (1918), Duchamp understood that vision not only reveals itself
to us, in latent ways, but that it does so, at times, through anamorphosis, the acute distortion
of perspective. Anamorphosis can easily render the original represented object opaque and
unidentifiable, inasmuch as something becomes seen as other than it is.

 Johnson, eager always to get beyond convention, was moreover fascinated by the
undoing of the familiar notion of an object. Remarking once on a painting by Francis Bacon,
he said: "I think it's the sphinx that interests me more than the...painting of the sphinx, because
I recently saw a photograph of the sphinx seen in profile, which was the first time I had ever
seen it that way, it's usually seen frontally and in profile it looks like some odd kind of puppet
shape. It's very deformed and people always photograph the sphinx as they look at it frontally
because one tries to see form rather than unform—like a portraiture concept of the nineteenth

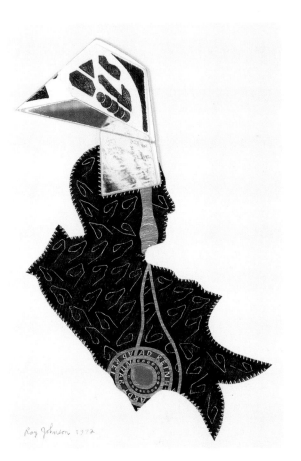

century, of Grecian wholeness, which is one
viewpoint—but the unform is there as well."[24] Or, as
the artist's close friend William S. Wilson wrote, "If
an unsophisticated person...asked Ray a question,
he might well answer it simply, but if a person were
twisted with too many prior assumptions that
interfered with honest immediacies, Ray was likely
to reply at a tangent that did not intersect with or
combine with the question."[25]

 This tangent re-echoes in
Johnson's silhouette portraits. These images yield a
telling but faint index of their sitter's reality, yet
within their inviting contours, the fact of identity is
always obscured. Facts, for Johnson, are as thin
as his lines, since they are always subject to
imaginative revision.[26] Invariably, any sense of the
individual unravels into abstract and sundry details
that provide little personal illumination. Again, if
Johnson's meanings are not always clear ("I deal in
invisibilities and anonymities"),[27] his rejection
of transparency or an overriding sense of truth was
somewhat mollified by his devotion to these "little
interrelated things,"[28] which provide his works

55

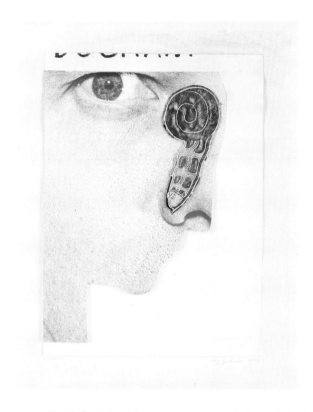

Ducham, 1977
17 x 13½
Christo and Jeanne-Claude, New York

with their puzzle-like order. Within these determined if obscure correspondences, "There is a great amount of consideration and planning...all possibilities of arrangement—blocks of material get sorted and rearranged."[29]

Such strategies are quintessentially Duchampian. Duchamp spent his entire career reinventing himself and his work in multidimensional ways. He defied classification. Many of his formal devices and conceptual strategies provided an aesthetic precedent for Johnson and much of his generation: among them, his ingenious skewing of both linguistic and linear perspective, use of shadows (*Tu m'*), silhouettes (*Self-Portrait in Profile*, 1958), cut-out contours (*Door for Gradiva*, 1937), and significant references to water (*Eau et Gaz à Tous les Étages* [Water and Gas at Every Floor], 1958).[30] But in addition to the numerous inclusions of Duchamp's profile and name, the motif that appears perhaps more often than any other in Johnson's oeuvre (in nearly 130, mostly uncompleted, works), is the outline of the central figure from Duchamp's permanent tableau-assemblage installation, *Etant donnés: 1. la chute d'eau 2. le gaz d'éclairage* (Given 1. The Waterfall 2. The Illuminating Gas, 1946–66), a work that had evolved, intermittently and secretively, over the course of two decades.

Beyond the obvious delight he took in Duchamp's particular engagement of language, through his punning, homophonic, and alliterative procedures, it is not surprisingthat Johnson would respond to *Etant donnés* (a hyperrealistic conversion of its abstract pendant, *The Bride Stripped Bare by Her Bachelors, Even [The Large Glass]*, 1915–23, right). Its voyeuristic aspect alone would have sufficed for the fetishistic Johnson. Its principal subject, a recumbent female figure, cloaked only in silence, is seen through two peepholes in an aged barn door. Because the work remains unmarked and unlabeled, its very presence is known only after viewers stumble onto it. The cropped view of the woman's body, composed of a stretched and perforated vellum (a process of manufacture with which he clearly identified), is similar to many of Johnson's fragmented, silhouetted forms.

In his own way Johnson questioned Duchamp's hauntingly obscure depiction of a figure whose silhouette on the one

Marcel Duchamp
The Bride Stripped Bare by Her Bachelors, Even (The Large Glass), 1915–23
Oil and lead wire on glass, 109¼ x 69⅛
Philadelphia Museum of Art: Bequest of Katherine S. Dreier

56

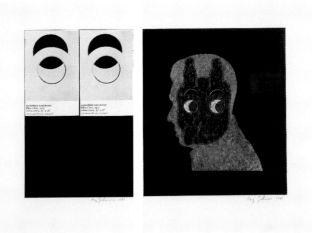

Untitled (Diptych), 1981
Left: 8 x 5⅛; right: 8 x 6½
Sarah-Ann and Wynn Kramarsky

hand resembles police outlines of dead bodies and on the other challenges the a priori determinants of vision. For *Etant donnés*, despite its hyperrealism, presents a variety of optical cues that make us reconsider the assumptions which we take for granted in vision. Its projection of a unified spatial recession, on closer examination, belies a fundamentally ambiguous organization, characteristic of collage. The sfumato-like palpability of the atmosphere in the background, for example, obscures the distinction between the figure's originating, full-scale dimension of depth and the pictorially foreshortened placement of the body within the contiguous, illusory spatial representation of the multimedia (handpainted, photographic, and sculptural) background.

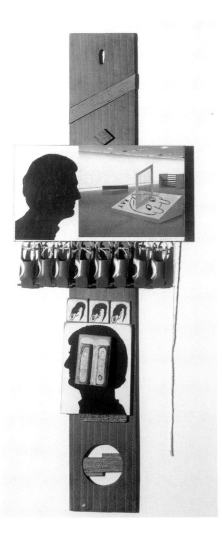

It is rather an understanding of discrete, separate forms in space that Duchamp emphasizes, as one peers into the tableau's interior, and perceives the peculiar, almost cut-out form of the figure awkwardly pressed against a pile of branches.[31] It was just such a perceptual and symbolic fusion that interested Johnson, a simultaneous conjunction and dispersion of form that, like the effects of his scissors or of his conceptual "potato masher" cuts, loosens and flattens things until they begin to share some structure.

Even in Johnson's denser, encrusted collages, there is a sense of dissolution that ultimately mitigates the works' seeming excess. Whatever the private, whimsical source of the artist's discursive elaboration of an idea or image, its eventual abandonment or metamorphosis parodies the need to rationalize, or make meaning out of the world— to name. Providing no more biographical information than the abstract perimeters of the years a certain person lived, such as "Antonio Gaudí 1852–1926," Johnson's homages or lists of names ultimately no more illuminate their subjects that do his parades of morphing fetuses their accompanying names. Along with a host of other rhetorical strategies that undermine a coherent subject matter, his captioning remains symbolic, the pseudobiographical information of the eviscerated terms of existence, such as place, name, time. Similarly, while his freehand-traced silhouette portraits begin as indices of individuals, they function as molds (like the plaster-cast figure in *Etant Donnés*, itself a mold) that are

Green Snake, 1979
30¾ x 14¾
William Kistler

57

Untitled (Sealed box), ca. 1970
Wood, paper, and metal,
20 x 24 x 2½
Denver Art Museum,
Gift of Naomi Sims and
Michael Findlay

never cast. It is in this sense that the
incognito flâneur Johnson's own dissolution, his suicide or
self-mashing, may be likened to a kind of Duchampian subversion of identity.

Just as the linguist Ferdinand de Saussure defined the arbitrary and differential
terms of language, "in the linguistic system there are only differences, *without positive terms*,"
Johnson, like Duchamp, ultimately sought to define the space and meanings of his collages as
dependent both on an eccentric source of information and a system
of differences that are themselves arbitrary.[32] While less systematically critical than Duchamp
to the notion of an inviolable self or identity, what we witness in Johnson's enigmatic metamor-
phoses, repetitions, quotations, or evanescent portraits is his own resistance to and need to
escape from the forces of History, its restrictive narratives and powerful initiations of order.
In his childlike refusal to conform, Johnson rejects the hierarchies and details of biography and
instead focuses on the leveling of death. In this sense, his universal correspondence and
democratization of the world, his indifference to names, origins, identity, and ultimately to life,
resonates with Duchamp's understanding that the symbolic or figurative "I" can never be
more than a linguistic illusion, a figure of speech that marks our hopeless descent into language
and our illusory attempt to name ourselves in this sea of words.

Until his final sighting by two young girls, on Friday, January 13, 1995,
backstroking against the tide in the waters off Sag Harbor Cove, Johnson's elusive identity, his
loss of origins in the endless flow of his collages, his merging of myth and everyday experience, and
his kaleidoscopic consciousness aligned him with the literary and visual model of a transgressive
modernism from Baudelaire to Duchamp.[33] But his refusal of narrative in favor of a dislocation
of time and space, as he perpetually altered, fragmented, and combined works; globally embraced
high and low culture; and arbitrarily recycled and disseminated information also aligned him
with the vicissitudes of modern and postmodern modes of visual communication. It placed him
squarely within a universe constructed through the ephemeral fields of movies, radio, satellite
television, and cyberspace that would come to characterize the look, sensibility, and philosophy of
the United States at the end of the twentieth century.

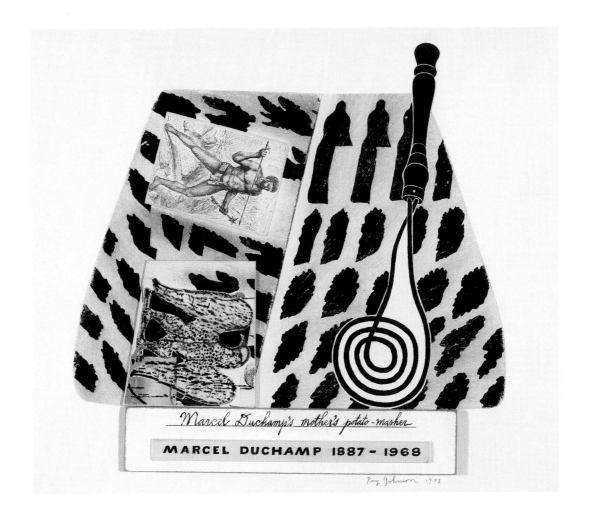

Marcel Duchamp's Mother's Potato Masher, 1973
19³/₄ x 14⁷/₈
Virginia Museum of Fine Arts
Gift of BEST Products, Inc.

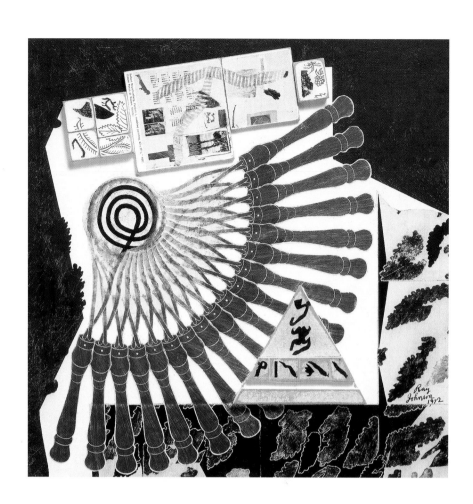

62

Eighteen Potato Mashers, 1972
14½ x 14½
Piero Grunstein, Milan

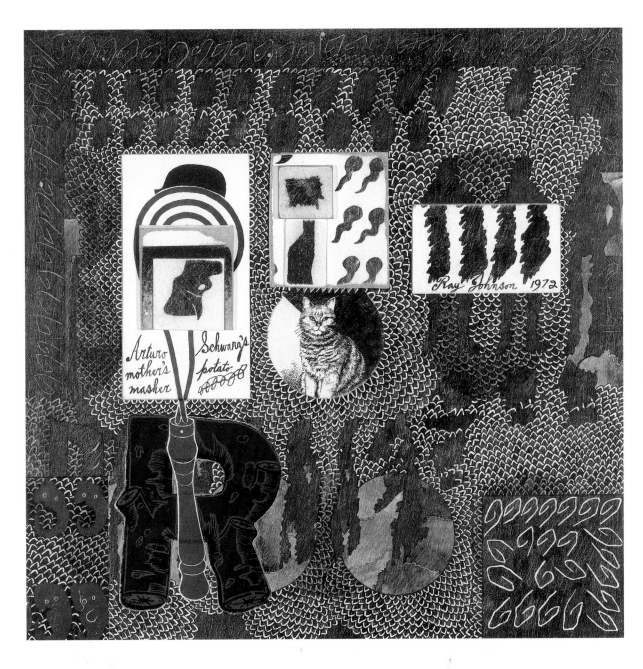

Arturo Schwarz's Mother's
Potato Masher, 1972

37 × 37
The Rita and Arturo Schwarz Collection of Contemporary
Art, Tel Aviv Museum of Art

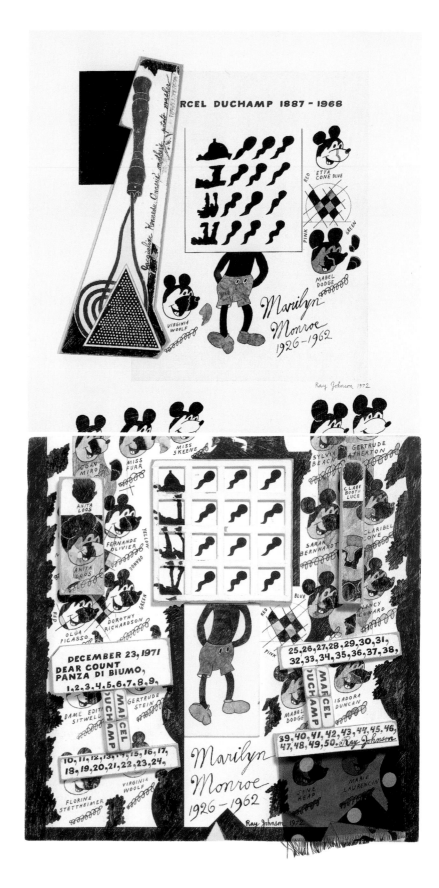

64

Jacqueline Kennedy Onassis'
Mother's Potato Masher, 1972
14½ x 14½
Maria Teresa Incisetto Collection, Naples

Marilyn Monroe, 1972
14½ x 14½
Piero Grunstein, Milan

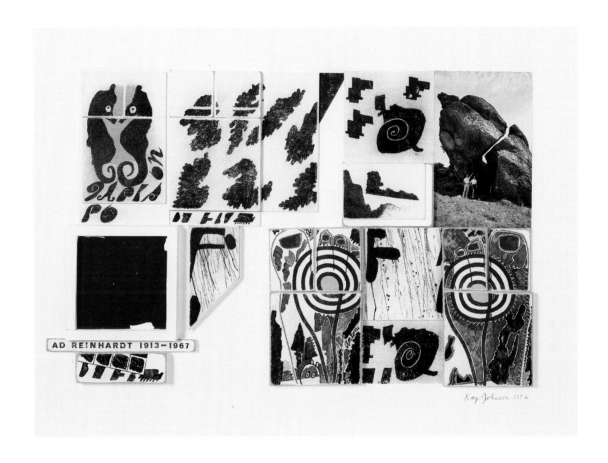

Seahorses, 1972
15½ x 20½
Frieder Burda

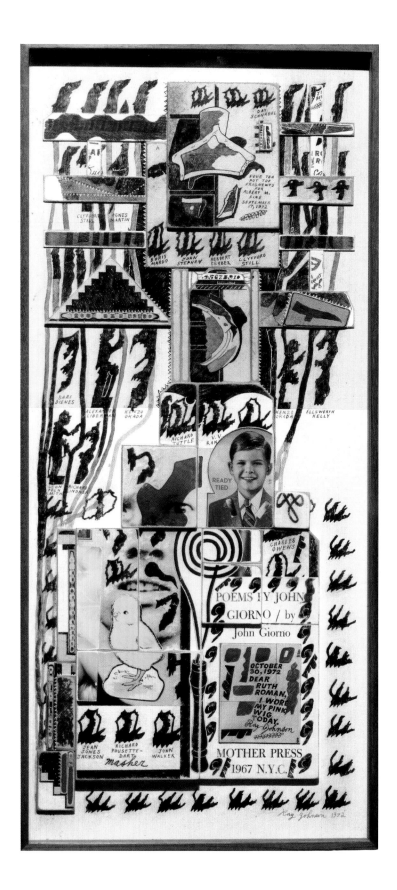

Richard Pousette-Dart Masher, 1972
30½ x 14

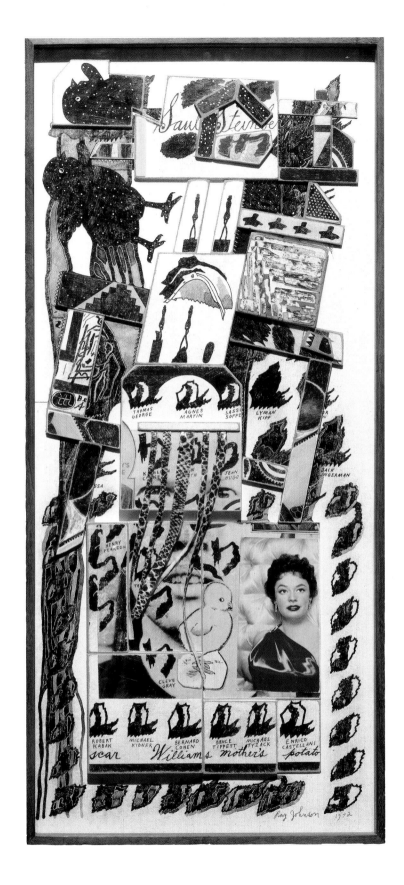

Saul Steinberg, 1972
30½ x 14

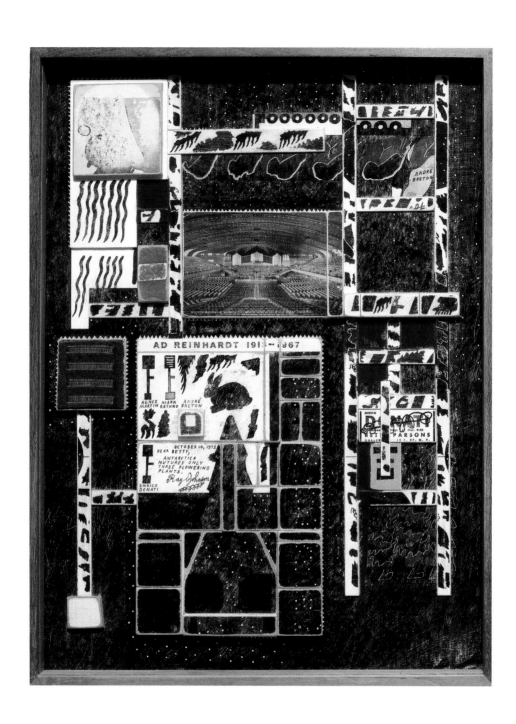

Andre Breton, 1972
19³⁄₄ x 14³⁄₄
Hirshhorn Museum and Sculpture Garden, Smithsonian
Institution, Washington, D.C.,
Bequest of Joseph H. Hirshhorn, 1986

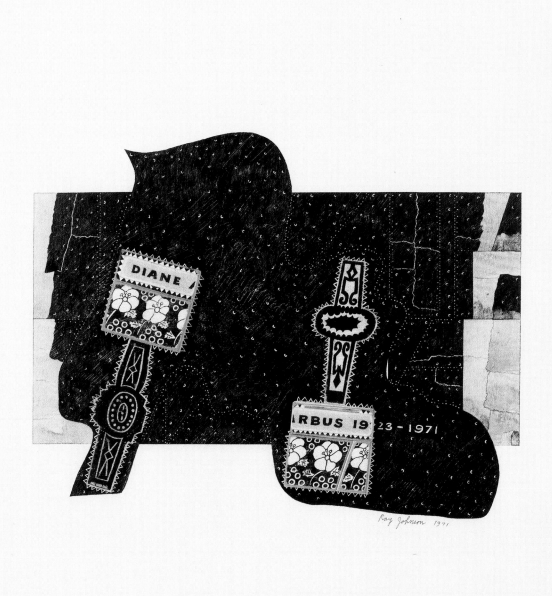

Diane Arbus, 1971
22 x 18½

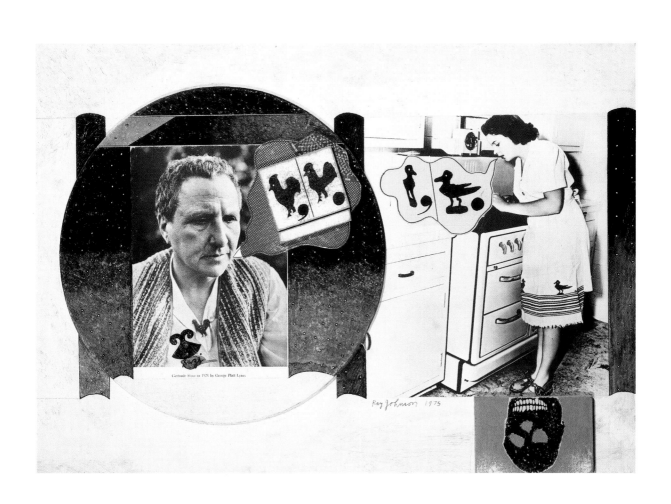

Untitled (Gertrude Stein), 1975

16 x 23¼

Wendy Steiner

THE WEBMASTER'S SOLO:
RAY JOHNSON INVITES US TO THE DANCE

MODERNISM LAUNCHED A CENTURY OF THOUGHTS ABOUT CONNECTION, a cross-cultural meditation on parts and wholes. Gestaltists proclaimed the whole greater than the sum of its parts, with interrelation the value added. In Synthetic Cubism, unpromising scraps and scribbles coalesced into compositional wholes in the collage, a form invented to investigate connection. With modernism, the art gallery became a realm of readymade magic, transmuting bicycle parts into bulls without the slightest formal alteration and plumbing fixtures into fountains of aesthetic wisdom. Excerpts from reality became wholes in the museum.

Soon Structuralists—the Napoléons of totalization—were overrunning the humanities and the social and biological sciences, unstoppable until their Waterloo at the hands of Deconstruction. For them, the elements of any human product were arranged in minimal pairs through binary oppositions, with combinatory rules a syntax that governed kinship systems, artworks, and language alike—a "deep structure" that was the mind. The human world was textual, and it was as predictable for the novelist James Joyce as for the linguist Roman Jakobson to trace "text" through its etymology to "woven" (Latin *textum*), a woman's work performed by men as they plow the furrows of their text-fields, trapping meaning and value in webs of connection. Though the web might come unraveled, the weaving and unweaving, as with Penelope's tapestry, created a marriage, a unity, all the more perdurable.

Of course, this brave new world of modernist wholeness had its underside. For every triumph of Cubist collage there was a pile of Dadaist *Merz* that refused to coalesce. "I can

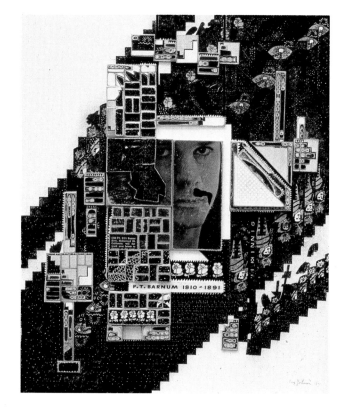

connect/Nothing with nothing," laments T. S. Eliot's Thames maiden in *The Waste Land*, adrift in the "heap of broken images" that is the modern condition.[1] Equally disturbing was the possibility that the images were too connected, trapped in a continually repeating plot with a preordained ending: "Streets that follow like a tedious argument/Of insidious intent/To lead you to an overwhelming question."[2] If "Things fall apart; the center cannot hold,"[3] there can be no meaning or value, but if all centers tame their circumferences by the same deathly geometry, then meaning is mechanical, threatening, without hope.

Kurt Gödel's proof that no system can be both complete and consistent offered considerable relief to this modernist anxiety. Indeed, the widespread deconstruction of heroic or obsessional theories of connection was the precondition for postmodern indeterminacy and humor, including the "What, me worry?" of Pop art, Fluxus, and Ray Johnson's New York Correspondence School of Art. Johnson's school of one produced a "correspondence" that was more like the sound of one hand clapping: a suitable activity for the only student in his self-styled Buddha University. Irritating, childish, banal, at the same time Johnson displayed an impressive tenacity. There has not been such an unsentimental exploration of dis/connection since Gertrude Stein, postmodernism's great precursor. And amazingly, given Johnson's marginality, his closest analogue in contemporary art is the canonic Thomas Pynchon, a genius of entropic disintegration and paranoid totalization, both. The curators Phyllis Stigliano and Janice Parente beautifully described Johnson's world as "a place part Land of Serendip and part Labyrinth."[4]

It is not by accident that Johnson's two genres were correspondence art and collage. Modernism invented the collage to explore formal wholeness, the play of randomness and intentionality, the limits between art and reality or art and garbage. Correspondence art focuses on the pragmatics of art—the gap between artist and audience that is a special case of the problem of intersubjectivity. Both forms seem to overcome obstacles to wholeness—correspondence art by involving the audience in an equal and continuing interaction with the artist, and collage by bodily assembling disparate elements in a unified whole. Johnson, evoking these magical goals, let them fail and keep failing in a deadpan pathos relieved by good design.[5] In doing so, he

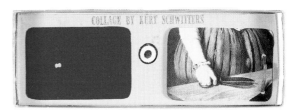

Untitled (Wiss
Pinking Shears box), ca. 1950–60
2¾ x 7⅝ x ⅝

provided a condensed summary of twentieth-century struggles with wholeness, for he had absorbed this history and become it. He is fundamentally "osmotic," as his coinage *moticos* suggests.

Johnson's moticos is both a singular and a plural word referring to his collaged wholes and to the modular units within them. Moticos are parts *and* wholes: articulated modules on the one hand and totalities on the other, in which meaning leeches across internal barriers in an osmotic ooze. The moticos units are frequently abstractions or blurred silhouettes of figures that Johnson had previously painted or appropriated. Sometimes they are cut from earlier works—parts excerpted from past wholes—and abraded or otherwise altered, then assembled in rows and ranks: India-inked figures on white ground or colorful, striped elements that look in combination like a wall of books. Moticos tend to form grids when assembled, and Johnson sometimes glued graph paper onto his collages to enhance this suggestion, as in *P. T. Barnum* (1971, p. 72) or *Untitled (Ray Johnson with Duchamp)* (1974–78/85, p. 163).

Moticos collages resemble étagères, floor plans, street plans, or buildings—all geometrical systems for organizing elements. In *René Magritte* (1971, p. 117), for example, the moticos are labeled with the names of celebrities, like a seating plan for dinner, and in *Robin Gallery* (p. 20), a floor plan is tipped upward to form a hard-boiled background for a Dick Tracy–like encounter. There is something architectural—even classical—about the look of many collages, such as *Summer Figures* (1965), with columns and foundations and architraves incompletely but unmistakably evoked.[6] Such works are containers of meaning, as suggested by Johnson's fascination with Joseph Cornell's compartmentalized boxes. "My secret vice is 'making collages by Joseph Cornell,'" he once told Henry Martin.[7] In the late 1950s, Johnson grouped freestanding moticos on stairs and on the floor (p. 19), where they resemble a Lilliputian crowd or army. An early correspondence piece is called *Contents of an envelope: rows upon rows of people in rows.*

Moticos are often likened to the tesserae of a mosaic. Johnson used stamps and stickers in this modular play, combining identical elements in a gridlike system. *Sade in Japan* (1969, p. 74) is a sticker message repeated in several collages, where it functions like a concrete poem. The connection to advertising and Pop art is obvious, with its kick in the pants to multinational commerce, and so is the sexual association apparent in the phallic composition of the memorial to the Marquis: building as erection. But equally important is the relation to design and pattern. This is an answer to the modernist "Ornament and Crime" of Adolf Loos, as is Johnson's fascination with graffiti long before the graffiti art movement existed.[8] Johnson stole everything, wrote on everything, faced and defaced everything. "Formally," writes David Bourdon, "Ray Johnson's work is…a rehash

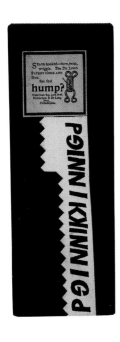

Untitled (Pinking), 1968
9⅛ x 3⅜
William S. Wilson

73

of almost all modern art from 1910 on: synthetic cubism, constructivism, purism, ad infinitum. Pictorially, there is practically nothing in his art that can't be traced to Schwitters, Arp, Klee, Miró and Ben Nicholson….no artist, no style of any period has escaped his cockeyed gaze."[9]

Such a statement might suggest that Johnson was derivative, if richly so. But the point is that his work constitutes a theory for his massive appropriation. When asked how his geometric compositions jibed with the surreal cast of his imagination, Johnson replied: "Thinking of Bobby Bare's *Detroit City* as geometric and de Kooning's *Asheville* as surrealist, it is very easy to go from one to the other either by train, bus, or hitchhiking."[10] Johnson's repetition, gridding, and free-form association are highway systems enabling the only kind of connection possible in the radically fragmented mindframe of modernity. More practical artists such as Andy Warhol would make these traits into a very popular and profitable postmodernism, as Johnson suggests in his *DRY* (p. 75), a page of quasi-stamps with all the letters of "ANDY WARHOL" blacked out except for D, R, and Y.

Johnson evoked the rigidity and abstraction of the grid and then transformed it into a web of meanings—a text. He loved board games, Snakes and Ladders in particular. Thus, gridlike ladders turn up in various works (another premonition of the artist Jean-Michel Basquiat), but so do wormy, phallic snakes with cartoon eyes (p. 137). Snakes and Ladders, like Johnson's associative art, directs players to move from one point to the next, but puts up blocks to that connection; Johnson associates these, respectively, with abstract grids and naughty, wiggly penises. We can understand his fascination with pinking shears, too, which cut and create pattern in the same action, as in *Untitled (Pinking)* (1968, p. 73). Pinking looks like the edge of postage stamps, an edge that allows stamps to be torn apart or kept together in a grid, and it is also part of the female sphere that Johnson often evoked in his gender-bending work. He liked "shocking pinking."

Johnson's explanations of the term *moticos* are enigmatic and inconsistent.[11] The blankness of these statements,

<div style="text-align: right">74</div>

**Untitled
(Sade in Japan)**, 1969
30 x 13

Mailing, ca. 1960s

as with everything about his work, is a provocation for free association. For example, he writes that "The next time a railroad train is seen going its way along the track, look quickly at the sides of the box cars because a moticos may be there.... It likes those moments of being inside the box."[12] Perhaps this moticos is a graffito within a framed rectangle on the side of the box car, or perhaps it is the framed rectangle itself, a geometrical unit within the larger rectangle of the train car. When Johnson superimposed moticos over the faces of his celebrity portrait subjects, as in *Elvis Presley #2* (ca. 1956–57, p. 103), the face becomes a box car, a vehicle for the moticos—in fact, a "star vehicle."

The idea of the technological environment as aesthetic abstraction calls to mind images from both Stein and Pynchon. Stein claimed that when she first viewed the U.S. landscape by looking down from an airplane, she understood Cubism as the true expression of the modern.[13] And in Pynchon's *The Crying of Lot 49* (1966), the town of San Narciso seen from a rise in the highway looks to the heroine like a printed circuit containing "a hieroglyphic sense of concealed meaning, of an intent to communicate."[14] Though Johnson claims to have begun making moticos in the 1940s, just as printed circuits were being invented, it is hard not to see this connection, or indeed the connection to the Cubist geometry of Stein's aerial landscapes.

Elsewhere Johnson described the moticos as playing cards. "Everytime they're shown, they're reshuffled and become a different story, a different tape. We've just been talking, for example, about Cornell's brother, Robert, and the rabbits he drew, but the next time these works are shuffled and shown, they'll bring up other people and images and ideas. It's constantly and kaleidoscopically different."[15] As Johnson writes in a little manifesto called "What Is a Moticos?" a moticos "loves moving and rain water."[16]

The kaleidoscopic nature of moticos—their love of motion and flux—makes them both dynamic combinatory principles and the kind of element fluid enough to participate in such processes. One might consider that the first syllable of moticos is *mot*, French for *word*, a linguistic unit that combines and recombines in constantly changing contexts. In one mailing using the portrait of James Dean (p. 76), Johnson hangs a pipe from Dean's lip and deploys his moticos as if they were the letters of words; in another version of the same mailing, he writes a "translation" of the moticos: "This n'est not une pipe." The mixture of French and English, to the point where we cannot tell which language "pipe" is meant to be in, enhances the idea of modular, interchangeable units combining in polyvalent groupings. Likewise, in one mailing that advertised his design practice, Johnson invents an alphabet of figures holding flags in various positions to spell out *Ray Johnson Drawings* (p. 222), strikingly like the code in Arthur Conan

Doyle's "The Adventure of the Dancing Men."[17] Human figures are letters to be combined in words; sentences are like the "Contents of an envelope: rows upon rows of people in rows." Johnson deploys the alphabet in several of his works, and his repetition of moticos motifs (Marianne Moore's hat, the typology of breasts, phallic snakes, bunnies, "Sade in Japan," the faces of celebrities such as Elvis, Stein, Dean) is part of the same strategy: the creation of a set of significant elements that he could combine so as to interrelate and permute their meanings.

 Johnson's work as a whole is paradigm play. He shears words, images, and artworks from the systems to which they belong to form an idiosyncratic vocabulary or alphabet of his own. Then he combines these elements according to associative rules that have more to do with their formal qualities than their meanings in reality. Elements whose shapes or names are similar are found together, though they otherwise have nothing to do with each other. Once having created such a "sentence," he can excerpt a piece of it, like a quotation, and use it as part of some other work. Moticos are defaced, mutilated, and sometimes obliterated words that are meant to illustrate the procedures that generate them to anyone willing to listen. Thus, Johnson advises us in "What Is a Moticos?" to "Destroy this [writing]. Paste the ashes on the side of your automobile and if anyone asks you why you have ashes pasted on the side of your car, tell them."

 For Johnson, words and images are equally capable of functioning as collage elements, and his focus in portraiture is as much on names as faces. "My reason for being interested in people is their anagrammatic names.... one person has so many games that can be played with their name, and what they do and then all of these cross-references to other people."[18] He imagined moticos as words, images, people ("Perhaps *you* are the moticos"[19]) re-cycled as ashen *marks* on a vehicle in motion. Thus, his portrait collage *Mark* (1969, p. 93) is a kind of manifesto piece. It contains a photograph of the eponymous subject wearing a T-shirt with the name *mark* on it and a collaged note saying, "Please send to Mark Lancaster." Marks are his addressees and his messages to them, and as the slang meaning of *mark* suggests, there is a certain victimization involved in this communication. Johnson departs from the innocence of Stein's intent in *The Making of Americans* to create a history of everybody: "my portrait work is subtitled 'The Snaking of Americans,' which is a very oblique S & M reference, Sade in Japan, Made in Japan, Making and Snaking, S & M and M & S."[20] *Mark* contains one of several "tit charts," in

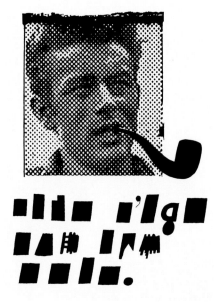

Undated mailing

the head of a penis in *Gertrude Stein's Underwear* and *Basket* and contrasting her to a happy housewife—male cock to domestic duck—in *Untitled (Gertrude Stein)* (1975, p. 70). In *Untitled (Gertrude Stein with Garter)* (1991), he reproduces a photograph of Stein saying to reporters, Why don't you read the way I write?"—the challenge that both these uncompromising experimentalists tendered to their audiences. Johnson riffs on "rose is a rose is a rose" in several works and calls one "How to make tender buttons," a reference to the most revolutionary and abstract of Stein's books. Many critics believe that "tender buttons" is Steinian code for nipples, and with buttons one of Johnson's repeated motifs, one suspects a correspondence to the "tit charts": an adaptation of a lesbian enthusiasm to the unmoved response of a gay man. In *Gertrude*

Stein's Fingernails, he places the writer with the Holy Virgin, suggesting that her nail parings are saintly relics. Her companion gets less respectful treatment, represented either as a grotesque crone in *Alice B. Toklas* or as a dotted bikini in *I Love You Alice B. Toklas* (1969, left).

Perhaps Johnson's two most striking borrowings from Stein are his nesting of identities one inside the other and his mania for lists. *The Autobiography of Alice B. Toklas* was of course written by Stein, one of many texts in which she played with the idea of impersonation. *Everybody's Autobiography* is another. Likewise, Johnson titled many portraits with names that do not fit the pictured subject (p. 117), and he nests the silhouettes of different faces one inside the other. When he was given an exhibition at the Whitney Museum of American Art in New York, he invited his friends to participate. His exhibition was their work.

Stein not only superimposed identities on each other, but in her early work she strung those identities out in lists. For example, her *Many Many Women* is an attempt to describe every woman and every relation between women. We might compare Johnson's statement that "My whole concept of a history was to take one catalog that listed all the artists [that the Betty Parsons Gallery] had shown, and I did homage works about them and made

79

bunny lists—lists of their names where every name is under one of my little [identical] drawings of a rabbit."[25] Other lists and groupings were held together by puns. Moore and Monroe turn up together as two "M.M."s, the first with a very distinctive hat and the second with a film credit for *Some Like It Hat* (p. 177).

Anything was an excuse for linking one person to another. Johnson discovered that if he turned a cheesecake photograph of a male nude upside down, the shadowy triangle between the nude's crossed legs was a dead ringer for Marianne Moore's tricorne hat—ergo, *Untitled (Marianne Moore's Hat)* (1974, p. 81). Johnson threw into this work a cartoon of a woman with one breast missing and labeled it *Poor Betty Ford*. The nude male, in contrast, has a very large, rosy erection washed over the space between his legs, as if in answer to Ford's absent breast. Evidently there were no limits to the things that could be associated.

Visual similarity was as important as verbal. *Mondrian Comb* (1969, p. 88) takes the eye on an associative trip from comb to eyelashes to pubic hair: "It was an itsy bitsy teeny weeny yellow polka dot bikini," the radio bubble informs us. But "comb" is also the first syllable of "combination." A comb is a condensation of the principles of Johnson's collage, creating order by dividing tangled hair into uniform rows (strands) which are themselves combinations of uniform elements (hairs). Combs are intended to beautify through a geometric division especially appropriate to the abstractionist Mondrian.

Johnson's association has been much discussed by critics. David Bourdon praises his collages as "provocative examples of analogical thinking, in which two or more images or words 'rhyme' or 'agree' with one another."[26] Elsewhere, he describes Johnson's lack of an overall vision: "yet, however fractured his view of the world, it has enabled him to construct a gossamer network of correspondences that assumes cosmic proportions."[27] Henry Martin sees Johnson's associations as rhyming with consciousness itself, "a dynamic flow of interrelating sensations, which is the central metaphor of the New York Correspondence School."[28] In perhaps the most detailed discussion of these combinatory principles, William Wilson describes Johnson's association as falling under three categories: identity, analogy, and focus (similarity in the view directed toward otherwise dissimilar objects). He argues that Johnson offers "resemblance as correspondence and correspondence as meaning."[29]

If such arbitrary correspondence is indeed meaning, it is a very particular kind of meaning, the kind that emerges from collecting and collating and that involves nouns and accumulation rather than predicates and historical sequence. I once answered a letter from Johnson with a reference to an article I had written on Stein. He replied, "I contribute: 'Knock! Knock!'" The proper reply would surely have been, "Who's there?" And Johnson's only appropriate answer to this Stein critic would be, "There's no there there."[30] That is certainly an

**Untitled
(Marianne Moore's Hat)**, 1974
13½ x 11¼
William S. Wilson

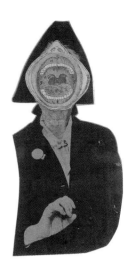

**Untitled (Marianne
Moore)**, 1963
6⅝ x 3¼
William S. Wilson

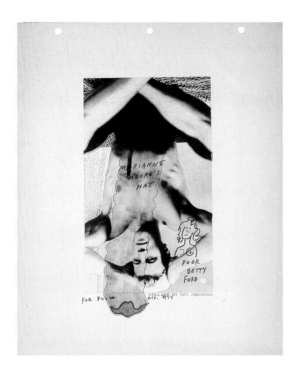

amusing little box car ride, but as the punch line
suggests, it does not end up much of anywhere.

Despite the throwaway ephemerality
of correspondence art and Johnson's apparent generosity
in giving his work away in these *actes gratuites*, one
senses not lightness but the sterility of the collector in his
effusions on association: "out of a life of necessity
I have written a lot of letters, and given away a lot of
material and information, and it has been a compulsion. And
as I've done this, it has become historical. It's my
resumé, it's my biography, it's my history, it's my life."[31]

What it is not, of course, is a history in
the normal sense of the word. Johnson's associations tend
to flatten out temporarily into what Stein called a
"continuous present." He recycled elements from art
history and his own work, lifting them out of their contexts and placing them in a simultaneity of
his own making. He abraded his palimpsestic moticos collages so that the underlying layers
showed through in a pentimento that is sometimes extraordinarily delicate. A few early works
are constructed with multiple thin washes of paint, so that shapes shimmer up gradually into
visibility. But all this makes history, depth, the past, into simultaneous design. Stein wrote,
"Let me explain what history teaches. History teaches," recasting historical sequence, teleology,
and instruction as repetition, or insistence, as she preferred to call it. Likewise, Johnson wrote
Bourdon on Christmas Day, 1975, that "The New York Correspondence School has no history—only
a present."[32] A work in a 1984 exhibition at the Nassau County Museum of Fine Art consists of the
word *chronology* with *no* pulled up out of the word into the space above, leaving a blank
interruption in the middle.

Johnson's answer to the Happening was the "nothing." "I do not know before
nor during nor after a nothing what I am trying to convey," he told Bourdon. "I am not trying
to convey anything. Fibber McGee sometimes opened a closet and hundreds of objects fell out making
sounds. A kind of Salinger household."[33] The interlocutor could only run from this unruly
avalanche. Johnson was fixated on Elvis Presley, I think, not only because of the idol's sex appeal
and fame, but because of his song, "Return to Sender." As the repetition of the refrain indicates
("She wrote upon it:/Return to sender, address unknown./No such number, no such zone,"[34])
that woman's refusal to receive the communication is unequivocal, but so is the persistence of the
sender, who gives the letter to the postman, mails it out again time after time, then sends it

81

"special D," and finally decides to carry it to her personally. He is indefatigable, despite the fact that the reply is always, "No such person, no such zone." Johnson collaged many envelopes and postcards with "Return to Sender" stamped on them by the post office. Inevitably, his death brought this message into his own life,[35] with memorial articles entitled "Return*ed* to Sender."[36] His rubber stamp "Ray Johnsong" suggests a similar image of the artist mechanically repeating his swan song of death, exhaustion, waste, and nothingness.

It seems sad that all the grids and nets of association that Johnson wove could not create a more durable connection to the world. The frantic failure of his networking has a particular poignancy in our day, as recent studies of Internet usage indicate that "people who spend even a few hours a week on line experience higher levels of depression and loneliness than if they used the computer network less frequently."[37] Johnson is eerily prophetic on this point. On the cover of a mailing he sent to Duchamp (either Marcel or his wife Teeny, it is not known which), he has reproduced the image of a "marcelled" woman wearing a hairnet, with an advertisement for the "SOLO DRAW-STRING HAIR NET" (p. 83), which is a "perfect net" "for water wave for marcel." It is "made of rayon" (RAY jOhNson).

As with the obituaries entitled "Returned to Sender," it seems unspeakably
82
vulgar to connect this "solo net for water wave" with the lonely associative art that culminated in Johnson's watery suicide, but there is a Joycean wordplay liberated by his work that takes over. His art is a drawstring, a drawing that strings associations together. Weaving his wave, his marcel, his Marcel Duchamp, his Dadaist "throwaway gestures,"[38] Johnson produced a very imperfect net for water—a net that is a sieve, that holds nothing in and provides no safety. But it is, in contrast, a perfect demonstration of the failure of order and beauty promised by hairdressers (comb-iners) or those artists more given to sentimentality than Duchamp or his latter-day analogue Johnson, who wove a world of scraps into empty books.

Johnson would not want us to label these actions tragic or find anything in them remotely as serious as pathos. But insofar as he addresses us, marks us, and asks us to correspond, our reaction becomes part of his art. And intrigued as we might be by the train of thought from Duchamp through Stein, Cornell, Pynchon, Johnson, and Don DeLillo, we might be excused, perhaps, if we decline his invitation to play. With webs and nets of information all around us, we yearn for a more tangible pleasure in art—not the denial of coherence and meaning but the hope, once more, of the experience of beauty.

Solo Hair Net
for Marcel Duchamp
5 x 6⅔
Marcel Duchamp Archives,
Villiers-sous-Grez, France

1. T. S. Eliot, *The Waste Land* III, 301–22; "heap of broken images," I, 22.

2. T. S. Eliot, "The Love Song of J. Alfred Prufrock," ll., 8–10.

3. W. B. Yeats, "The Second Coming," l. 3.

4. Phyllis Stigliano and Janice Parente, "Acknowledgments," in *Works by Ray Johnson*, exh. cat. (Roslyn Harbor, N.Y.: Nassau County Museum of Fine Art, 1984), 5.

5. Johnson's evocation of communication is always undercut. His friend Gerry Ayres, a screenwriter, sent him Robert Creeley's poem "The Conspiracy," thinking that it perfectly described Johnson's practice: "You send me your poems,/I'll send you mine.//Things tend to awaken/even through random association.//Let us suddenly/proclaim spring, and jeer//at the others,/all the others.//I will send a picture, too/if you will send me one of you." This sunny, defiant belief in communication, however, is available only at the surface of Johnson's mail art, in which spring is never proclaimed and correspondence is a matter of formal connection rather than the meeting of minds.

6. John Cage, who taught Johnson at Black Mountain College, reports his saying: "When I was around 20, I was interested in both architecture and music. Architecture, however, is about making something permanent, and about possession, whereas music is about giving up something, giving up myself," Nam June Paik, "Something about Nothing," in "Returned to Sender: Remembering Ray Johnson," *Artforum* 33, no. 8 (April 1995): 72.

7. Ray Johnson, in Henry Martin, "Should an Eyelash Last Forever? An Interview with Ray Johnson," this vol., 188.

8. In ibid., Martin asked Johnson: "Are there any artists who are really important for you?... whom you particularly respect, or whom you feel to have a particular relationship to your work, or who are involved in the same kind of total activity that you're involved in?" "Yes," answered Johnson, "All the graffiti artists."

9. David Bourdon, "Notes on a Letterhead," *Art International* 8, no. 9 (November 1969): 78.

10. David Bourdon, "An Interview with nosnhoJ yaR," *Artforum* 3, no. 1 (September 1964): 29.

11. The most intelligible explanation appears in "Eyelash": "The moticos were the little black silhouettes I did, and they were a miniature cataloging of actual free-form collage fragments. I'd take a box of fragments, which were all different shapes, and then I would draw each thing in India ink. Each fragment was about ten inches high, and the drawing would reduce it to about one inch high, and I'd cover whole pages with them. They're also on the faces of the Elvis Presleys and all the other people in those early movie star collages."

12. Ray Johnson, in John Wilcock, "The Village Square," *Village Voice*, October 26, 1955.

13. Gertrude Stein, *Picasso* (Boston: Beacon Press 1959 [1938]), 50.

14. Thomas Pynchon, *The Crying of Lot 49* (New York: Bantam, 1966), 13.

15. Martin, "Eyelash," 185.

16. Ray Johnson, "What Is a Moticos?" The Estate of Ray Johnson, Courtesy Richard L. Feigen & Co., New York.

17. Arthur Conan Doyle, *The Adventure of the Speckled Band and Other Stories of Sherlock Holmes* (New York: New American Library, 1965), 231–53.

18. Johnson, in Adrienne Atkinson, unpub. review of Ray Johnson's presentation at Oberlin College, Oberlin, Ohio, October 1994, 6, Estate of Ray Johnson.

19. Johnson, "What Is a Moticos?"

20. Martin, "Eyelash," 190.

21. Jill Johnston, "Between the Buttons," in "Returned to Sender," 74.

22. William S. Wilson, "NY Correspondance School," *Art and Artists* 1, no.1 (April 1966): 55.

23. Martin, "Eyelash," 197. In 1966, the year that Pynchon's *The Crying of Lot 49* was published, William S. Wilson described Johnson's work in a preternatural echoing of the novelist, one of whose central jokes is an "inverse rarity": a postmark with inverted letters that reads, "Report obscene mail to your potsmaster." Wilson writes of Johnson: "The use of the US mails, a sanctimonious institution with pretensions to heroic purity and endurance, offers the delight of turning to aesthetic purposes a practical outfit with ethical ambitions ('Report obscene mail to your postmaster.')" The timing of this statement would make it impossible for Wilson to be referring to *Crying* unless there were some direct communication between him or Johnson and Pynchon. I asked Johnson in a 1985 letter whether he had read the novel, and he said that he would look for it, and in 1988, that Wilson liked to teach it. The editors of this book wrote to Pynchon to find out whether he knew Johnson or his work, and he denied such knowledge unequivocally. Perhaps this is one of those Pynchonesque miracles of correspondence. Certainly, there is a line of thought about waste and communication that runs from Eliot's *The Waste Land* to *Crying* and Johnson to Don DeLillo's *Underworld* (whose hero is a waste manager). This thematic continuity could be traced back to Charles Dickens's *Our Mutual Friend*, in fact, but it constitutes one of the central motifs of twentieth-century literature and art; see my "Collage or Miracle: Historicism in a Deconstructed World," in *Reconstructing American Literary History*, ed. Sacvan Bercovitch (Cambridge, Mass.: Harvard University Press, 1986), 323–51, for a discussion of Eliot and Pynchon, and *Fictions of Postmodernity*, Cambridge History of American Literature, vol. 8 (Cambridge: Cambridge University Press, 1999) for more on Pynchon and Johnson.

24. See my "Postmodernist Portraits," *Art Journal* 46, no. 3 (Fall 1987): 173–77, and *Pictures of Romance* (Chicago: University of Chicago Press, 1988), 176.

25. Martin, "Eyelash," 190.

26. David Bourdon, "Ray Johnson Collages: Valentines/Snakes/Movie Stars," 9.

27. Bourdon, "Letterhead," 79.

28. Martin, "Eyelash," 183.

29. Wilson, "New York Correspondance School," 56.

30. Stein's famous indictment of Oakland, California.

31. Martin, "Eyelash," 191.

32. Ray Johnson, letter to David Bourdon, December 25, 1975.

33. Johnson, in Bourdon, "Interview," 29.

34. "Return to Sender," words and music by Otis Blackwell and Winfield Scott.

35. To my knowledge, however, no one has connected the song "Return to Sender" with Johnson's *Elvis* works.

36. For instance, in *Artforum* 33, no. 8 (April 1995): 70–75, 106, 111–113.

37. Amy Harmon, "Sad, Lonely World Discovered in Cyberspace," *New York Times*, August 30, 1998, A1.

38. Martin, "Eyelash," 194. A critic in *Art in America* called him "the master of the throw-away gesture"; we might recall the horse "Throwaway" in James Joyce's *Ulysses*, the long shot who comes in first and turns up at various moments throughout the novel.

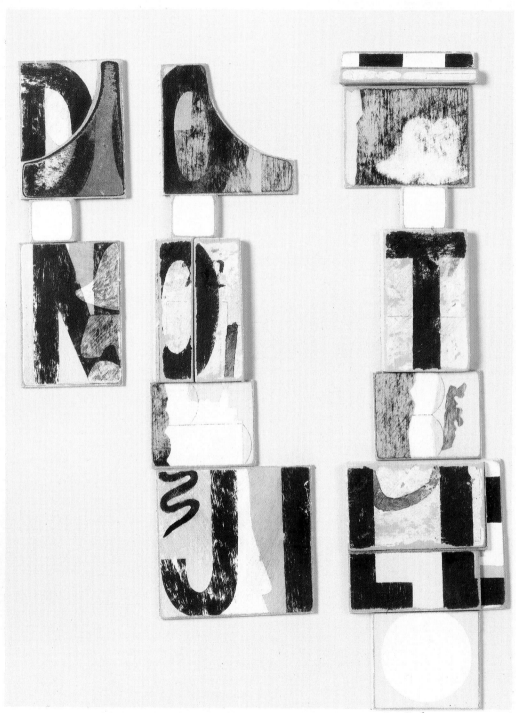

Ray Johnson 1966

Do Not Jill, 1966
19 x 15½

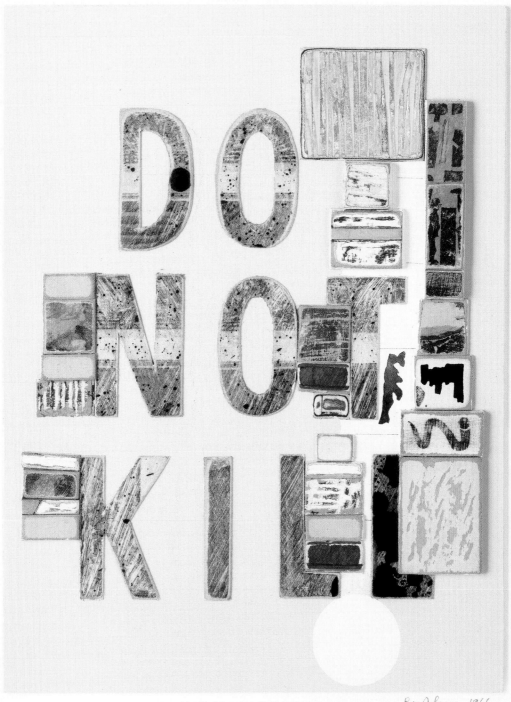

Ray Johnson 1966

Do Not Kill, 1966
19 x 15½

Untitled (A 2 yr. Old Choked),
1967
10¾ x 6¾

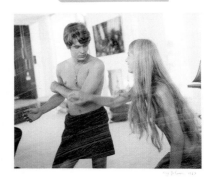

Pals Slap, 1968
16½ x 14

Untitled (To May Wilson), 1969
19¼ x 15

IT WAS AN ITSY BITSY
TEENY WEENY YELLOW
POLKA DOT BIKINI

88

Mondrian Comb, 1969
25 x 27¾

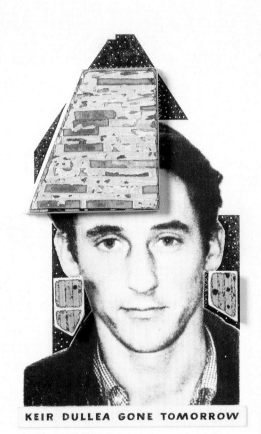

KEIR DULLEA GONE TOMORROW

Untitled (Keir Dullea Gone Tomorrow),
1971
22 x 18½

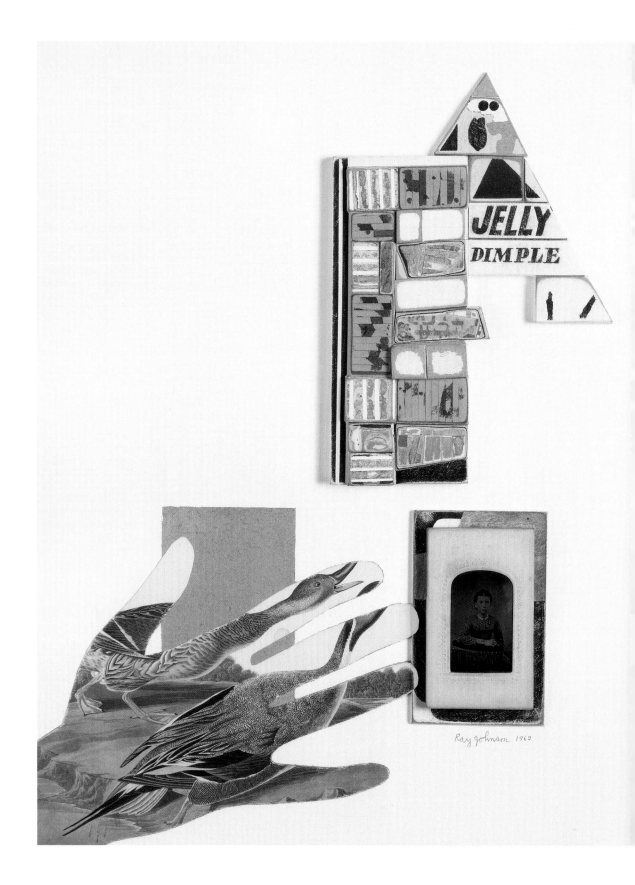

Ray Johnson 1969

Untitled (Jelly Dimple), 1992
20½ x 17⅛

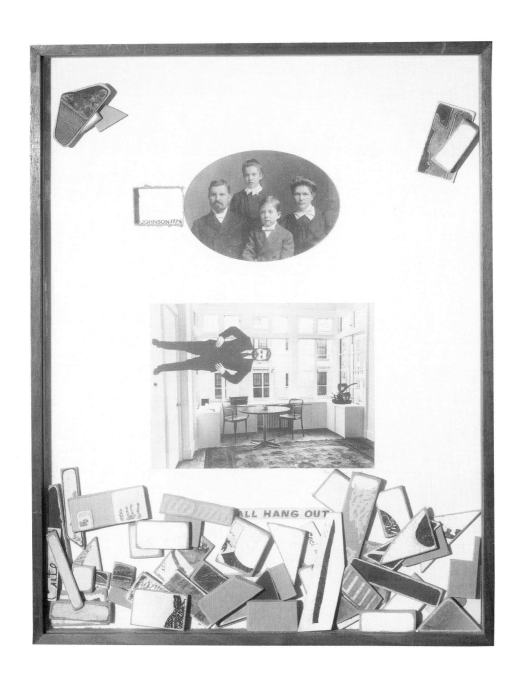

Let It All Hang Out, 1968
18 x 14½
Peter Schuyff, New York

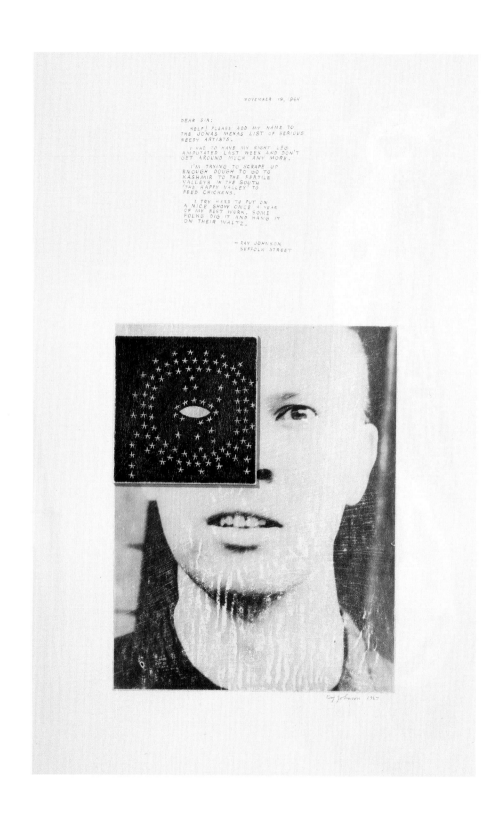

NOVEMBER 19, 1964

DEAR SIR:
 HELP! PLEASE ADD MY NAME TO
THE JONAS MEKAS LIST OF SERIOUS
NEEDY ARTISTS.
 I HAD TO HAVE MY RIGHT LEG
AMPUTATED LAST WEEK AND DON'T
GET AROUND MUCH ANY MORE.
 I'M TRYING TO SCRAPE UP
ENOUGH DOUGH TO GO TO
KASHMIR TO THE FERTILE
VALLEYS IN THE SOUTH
'THE HAPPY VALLEY' TO
FEED CHICKENS.
 I TRY HARD TO PUT ON
A NICE SHOW ONCE A YEAR
OF MY BEST WORK. SOME
FOLKS DIG IT AND HANG IT
ON THEIR WALTZ.

 — RAY JOHNSON
 SUFFOLK STREET

November Letter, 1967
20½ x 13¼

Mark, 1969
30¼ x 17¾
Frances Dittmer

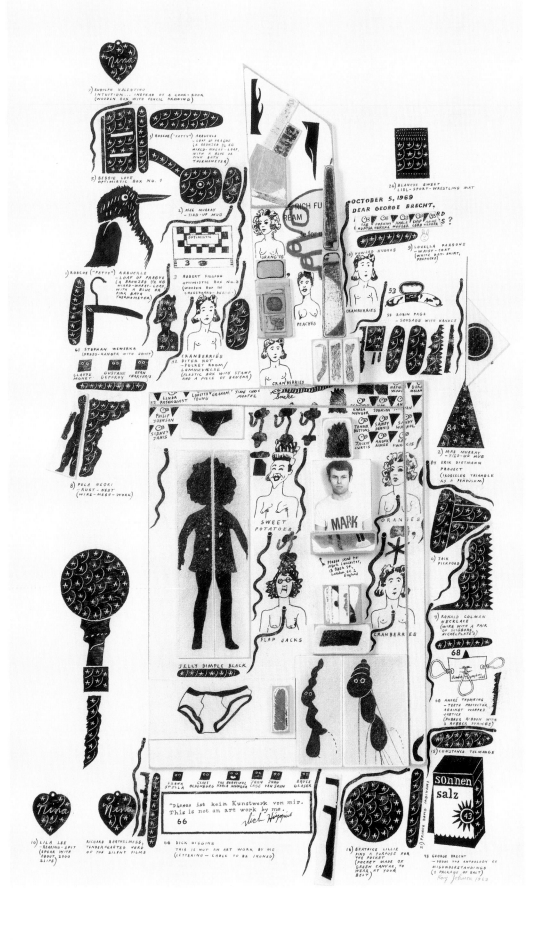

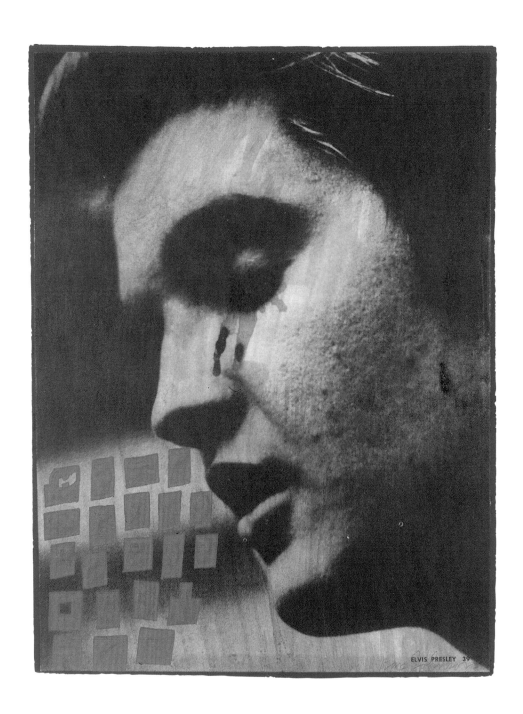

Elvis Presley #1, ca. 1956–57
10¾ x 7½
William S. Wilson

Jonathan Weinberg

RAY JOHNSON FAN CLUB

ONE OF MY FAVORITE Ray Johnson collages is *Untitled (Gargoyle)* (1958–60, p. 96). Mailed to Johnson's close friend William S. Wilson, it brings together a publicity shot of Buster Keaton from the film *The Navigator*[1] with a close-up of one of the grotesque sculptures that decorates the towers of Notre Dame in Paris. Keaton is shown high in the rigging of a ship. He cantilevers his body out over the ocean to get the best possible view through his looking glass. What does he see? Not a ship or whale but, by means of Johnson's pasted juxtapositions, a brooding gargoyle. Johnson rhymes Keaton's pose with that of the architectural ornament. Indeed, Keaton's angled silhouette suggests a masthead, the nautical equivalent of a gargoyle. But in other ways the two figures could not be more unlike: Keaton, active and graceful, moving out across the ocean; the gargoyle, sullen and awkward, held back by the balustrade of the building. In front of the gargoyle Johnson roughly scribbled a black circle. Like a talking balloon in the comics, it might represent the gargoyle's speech or thoughts as he contemplates Keaton's performance, but instead of words all that comes out is noise. The gargoyle's tongue protrudes from his mouth— he speaks in tongues. It is as if Johnson were saying that any attempt to describe Keaton's silent art will fail. The connection between the artist and his audience is as fragile as the red thread that seems to hold the two photographs of the collage together, as precarious as Keaton's position in the ropes.

For all the appeal of Johnson's art it is unusually allusive and transitory. After all, it literally moved by way of the mail. Typically, a Johnson mailing often included the

For William S. Wilson

Untitled (Gargoyle),
1958–60
6¼ x 5¼
William S. Wilson

command to send it on to another friend. Like that old game of telephone, built into his practice was the certainty that the message would be garbled. If Johnson's art is about communication, it is also about miscommunication. It is a daunting task for an art historian even to decide what materials count as his oeuvre. A Johnson gesture, or an off-hand remark—even the way he organized his work room or stacked boxes on the day of his suicide—may be as significant as his most complex collages. The surfeit of information in Johnson's work may be a trap, its overload amounting to no information at all. Perhaps this is what Johnson meant when he referred to his performance art as "nothings."

And so when I look at *Gargoyle* I feel a sense of loss. It seems to describe an intimate exchange between two comrades. Both look intently. I imagine that the stone-bound gargoyle is captivated by the beautiful boy in the rigging. He waits to see what will be his next acrobatic leap. Even if I can try to imagine the meanings behind their exchange of glances, their relationship is partially closed to me. Or perhaps the problem is that I am not this work's intended audience. Originally this collage arrived as a message in the mail for William S. Wilson, Johnson's friend and champion. It was not addressed to me. This is one of the crucial aspects of Johnson's work, the way that it is so often fashioned for a highly specific audience. The content was determined by a prior relationship. Built into the imagery and the text are shared references, jokes, and puns that center on mutual interests and affections. The mailings commemorate friendships even as they work on prior relationships, perhaps even changing their terms. Yet even as these private meanings disappear, they are replaced with new associations as Johnson's art finds its way to a larger public. This is how the original mailings often worked. They began as a private message, but Johnson would insist that the message be sent on to someone else.

In the case of *Gargoyle*, Wilson had taken the picture of Notre Dame. Johnson incorporated in the collage a fragment that stands for Wilson, just as the picture of Keaton might be a substitute for Johnson's own charismatic presence. Both Keaton and the gargoyle are looking. Johnson wrote in 1963 about a dream that seems related to the collage: "I dreamed last night that I lived in an apartment looking out on the ocean and a friend and I sat on the balcony in the early morning watching a manta ray splashing around in the choppy water." Wilson sees this dream as emblematic of Johnson's practice as a whole: "The friend is part of the perspective—that Ray is looking at water, not splashing in it like that oceanic ray. The balcony with the friend is an image of his life in art looking out on the ocean, looking from an apartment toward a truer home."[2] Johnson longs for an art that will function like an intense and continual

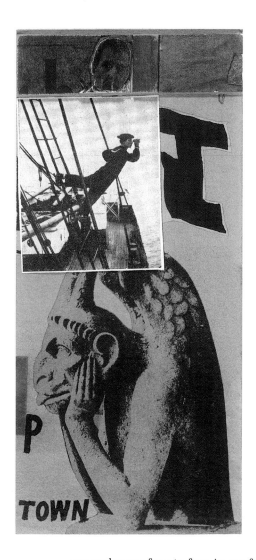

Untitled (P Town), 1964
8⅛ x 3¾
William S. Wilson

conversation between friends. What begins as a private exchange between two expands as the work is dispersed through the mail or by public exhibition. The collage or mailing is never meant as the final message. The same elements might be photocopied, cut up, and reassembled. At the same time the addressee is never the final recipient of the message. What remains constant in the process is the desire for connection between friends and across a potential community. As Johnson wrote, "The whole idea of the [New York] Correspondence School is to receive and dispense with these bits of information, because they all refer to something else. It's just a way of having a conversation or exchange, a kind of social intercourse."[3]

The conversation continued. In 1964, Johnson sent another collage to Wilson that brought the images of Keaton and gargoyle closer together (above). However, they are no longer face to face in confrontation or communion. Instead Keaton sails above the head of the gargoyle, as if he were the creature's dream. On the bottom of the collage is the name "P Town." P Town is short for Provincetown, Massachusetts, the fishing village that since the teens was a favorite summer resort of the New York avant-garde, many of whom also spent time in that other P Town, Paris. But Johnson also could have meant "pee" and "penis." He made this connotation explicit in a drawing he later mailed to Wilson in which the spout of the gargoyle becomes a urinating penis. The scatology of *Untitled (P Town)* may explain the presence, in the top portion of the collage, of a photograph of Franz Kline, who owned a studio in Provincetown.[4] Kline is a stand-in for the drips of the Abstract Expressionists, whom Johnson liked to make fun of. It was not that Johnson was against abstract art per se—his collages are deeply informed by the theories of abstract composition and color of his teacher at Black Mountain, Josef Albers. But he was suspicious of the grandiose rhetoric of the so-called Action painters. The P towns of the avant-garde are where artists like Kline mark their territories. But if Kline's presence in *P Town* references Abstract Expressionism, it also alludes to the fragility of the artistic process in general. Kline had died of an enlarged heart only two years before, in 1962. *P Town* can therefore be taken as one of many Johnson collages that bring together themes of the sea, bodily fluids, and death. Such themes could be said to culminate in Johnson's suicide in Sag Harbor Cove in 1995. For what it is worth, 1995 was the one-hundredth anniversary of Keaton's birth.

Johnson looked a bit like Keaton. He shared with Keaton a quality of eternal

Shirley Temple II, 1967
18 x 20½

youthfulness, and critics saw him as an art world comic. David Bourdon referred to his reputation as a "mischievous court jester…an ubiquitous buffoon."[5] Wilson made a direct connection between Johnson's seeming "control of chance," his talent of making art out of accident and coincidence, and the work of both Keaton and Charlie Chaplin.[6] Words used to describe Keaton's characteristic expression, "Dead pan, a frozen face, The Great Stone Face, and, believe it or not, 'a tragic mask,'"[7] fit the face Johnson liked to show in public. The writer Richard Bernstein noticed that Johnson had a "deadpan delivery,"[8] and Johnson himself stamped some of his letters "deadpan club."

Andy Warhol, Johnson's far more famous and successful contemporary, also affected a deadpan demeanor. But where Warhol's expression (or lack thereof) was a blank surface, Johnson's face, whether in the beautiful pictures of him when still a student at Black Mountain College, or later when he posed for Bernstein's 1972 article in *Interview* (p. 53), suggests depth. Using his own term, we might say that his head was his most effective *moticos*. Moticos was his word for his characteristic practice of discovering forms through a process of collage and silhouette.

Johnson's moticos involve a compression of images, one element morphing into another. The meanings of moticos are constantly changing; they can only be sensed by trying to reconstruct the process by which they came into being. The very word *deadpan* suggests compression or, as Wilson writes, a flattening analogous to the physical pasting and weighting down of a collage. In the same way we can see Johnson's deadpan as an attempt to make his

98

face into a moticos. He seems expressionless. But into the *flatness* of his emotional response, there is the possibility of depth behind the refusal to emote. This is exactly how Johnson's silhouettes work. Traditionally, silhouettes are the least expressive form of portraiture since they merely register the outline of the sitter's profile. Johnson, however, fills this blank space with a variety of images and verbal wordplays, so that what began as a flat cutout becomes a multilayered portrait.

"Janet Leigh, as beautiful as ever, was at the Anvil"

In claiming that there is a resemblance between Keaton and Johnson I am playing a typically Johnsonian game of recognition, or misrecognition. In a letter he mailed to a friend and regular correspondent he called Cowboy Bart, Johnson claimed to have seen "Janet Leigh, as beautiful as ever" at the Anvil. The Anvil, located in the meatpacking district of New York City, was a veritable department store of gay delights. It offered a drag show, a disco upstairs, and a backroom for anonymous sexual encounters downstairs.[9] Since women were not allowed there, in referring to Leigh, Johnson might have meant a drag queen dressed to resemble the actress or, more likely, a boy who reminded him of her. Wilson told me that there was another man whom Johnson referred to as Shirley Temple. In substituting famous actresses for the people he saw in the clubs or the streets Johnson was extending the logic of his collages, in which Hollywood celebrities share the same space with literary and art world figures, as well as less lofty acquaintances. Wilson writes:

> Ray liked to find resemblances between two separate and different things, which was ever the source of wit, and of metaphors and similes. Often when he met a person, he saw or intuited a resemblance between that person and an image, so that the person and the image seemed to have (or were seen to have) a quality in common. Then the person and the thing could be used to refer to each other.[10]

When Temple stars in Johnson's *Shirley Temple II* (1967, p. 98) in a pilot's outfit that evokes leather drag, accompanied by a condom-like painted shapes, the meaning of the collage may have more to do with his nightlife and the games of reference he plays than with any admiration for the talents of the child actress. Calling a cute boy Shirley Temple makes ridiculous the determined and repetitive process of cruising the dance floor for a suitable partner, even as associating the child performer with gay culture excites her overly sweet image. It distances Johnson from his own attraction. By calling the boy at the Anvil Shirley Temple, he both registers his attraction for the boy and belittles him by suggesting that he is only a mere copy of some kitschy original. At the same time the original star is brought down to earth; "she" can be seen anywhere. The boundary between the silver screen and everyday life is broken down.

A true deadpan artist would never explain his own jokes. Keaton, after all, was at his best when he was silent. But Johnson could not resist trying to explain his process of sometimes torturously obscure associations and resemblances. He told his friend Henry Martin an elaborate story that involves meeting friends on a street and a "Spam Can" that turns into the "birth of a Baby Spam Can." This flows into a description of a work of two women with rakes that suggests "the birth of the rake," which becomes "A Rake's Progress" and also "Veronica Lake."

99

"So now I'll do a whole slew of these women with rakes giving birth to lakes, and Veronica Rake's Mother's Potato Masher will be depicted, and so you can see how the subject matter is just endless."[11] But is the subject matter really endless? Certain patterns repeat. For example, the potato masher recurs in Johnson's work.[12] Like Johnson's collage technique of cutting and pasting, the masher combines and compresses materials. Johnson used heavy objects to flatten his collages as they dried. His monologue itself mashes together high art references, from Sandro Botticelli's *The Birth of Venus* to William Hogarth's *A Rake's Progress*, with a famous movie star, Veronica Lake, and a commercial sandwich meat. A masher is also a kind of rake—that is, a "fop of affected manners and exaggerated style of dress" who frequents music halls and poses as a "lady killer."[13] In typical Johnsonian fashion, the gender of his characters is reversible, so that Veronica Lake morphs into the rake and the mother becomes a masher. What seems at first to be a series of nonsensical associations turns into an allegory of Johnson's technique, in which a rakish artist mashes his favorite subjects into art.

Johnson's obsession with celebrities is strange given his own avoidance of fame. Throughout much of his career he appeared to consciously short-circuit attempts by dealers and curators to make his art better known. Even as he gave art away to friends, he was quoting exorbitant prices to potential collectors. Yet his work is cluttered with references not only to stars and famous artists, but to important critics and curators like Hilton Kramer, Dore Ashton, and Henry Geldzahler, who help make artists famous, as well as to other artists.

In 1978 Johnson sent Cowboy Bart a collage mailing that included an invitation to the opening of an exhibition at Margo Leavin Gallery in Los Angeles that, along with himself, featured such luminaries as Kline, Willem de Kooning, Jean Arp, and Louise Nevelson. Pasted to the list was a membership card to the Anvil. Johnson wrote on this mailing, "another ho hum evening at the A." The "A" is a reference to the Anvil, but also to Art—the two have been confused. Suddenly a disco pick-up scene is equivalent to socializing with contemporary artists. On the face of it, this mailing seems derisive of the art world. It is not really the Anvil that is so ho-hum, but yet another art gallery opening in which a long list of artists is paraded to establish the prestige of the dealer. Despite the rhetoric of subversion and radicalism that often accompanies avant-garde art, there is something stultifying and homogenizing about the typical art gallery opening. Likewise, there is a tendency among Queer activists to exaggerate the liberating aspects of anonymous sex. The interactions of art openings and sex clubs are often predictable and repetitive. Humorously putting art gallery and Anvil together potentially revitalizes both. Artists are brought into a close proximity that suggests intercourse, while anonymous sexual encounters take on the potency of art.[14]

It is no surprise that Andy Warhol was on Johnson's honorary list of members

Letter sent to Ray Johnson
from Hormel

Undated mailing

Hormel
FINE FOOD PRODUCTS

Dear SPAM Radio Buyer:

We'd like to thank you for sending for our SPAM radio. Although
our ad says, "Please don't eat the Radio", we really do hope you'll
try SPAM — in a sandwich, a hot dish, as a party snack or any way
you'd like it.

The enclosed radio is a new effort on our part in premiums. It was
made in the Orient (as are almost all transistor radios these days),
and is a novelty we hope you'll enjoy owning. As you will see from
the guarantee, the Ross Electronics Company is handling the orders.
If you have any trouble with your radio, just notify them.

Good listening and good eating.

Stuart H. Lane

Stuart H. Lane
Director of Marketing
Grocery Products Division
Geo. A. Hormel & Co.

of the Anvil. They were friends, and Warhol was a recipient of Johnson's mailings. Born a year apart, they both escaped the conformist environment of their working-class upbringings in the industrial Midwest for the cosmopolitan atmosphere of New York City, where, for a time, they worked as commercial illustrators. Both also grew up during the intense homophobia of the late 1940s and 1950s, when being gay usually meant being adept at discretion and an ability to pass. Warhol was never able to play the role of straight man, and in his work he exaggerated his swishiness so as to undermine the codes of masculinity.[15] Johnson was not necessarily swish, and he rebelled against strict conceptions of masculinity in his own way; he did not to conform to an art world decorum in which homosexuality was tolerated as long as it remained discreet. Yet while neither Warhol nor Johnson was in the closet, they were not free of its effects. Johnson's art in particular is involved with strategies of hiding and revealing. At times it seems to be speaking in code to a group of fellow travelers, yet just as often it is direct about sexuality both straight and gay.

Both Johnson's and Warhol's art share an obsession with celebrity. Warhol, however, puts the emphasis on the public process of imaging rather than on the private significance of the image itself. In his *Triple Elvis* (1964, p. 102), he makes the rock and movie star slightly bigger than life-size and then repeats his image three times. This is how fame works; it is as much a matter of repeating and magnifying the celebrity's image as it is his talent or charisma. In this regard, Warhol's portraits of celebrities are directly related to his pictures of soup cans; the star's image is a trademark.[16] The photo-silkscreen reproduction of the star's portrait in turn becomes Warhol's trademark—his means to fame. His goal is to become as famous as the people in his pictures. Eventually celebrity status itself is a matter of having Warhol do your portrait. And so Warhol himself becomes a celebrity.

By contrast, Johnson's portraits of celebrities tend to be far more private and

101

Andy Warhol
Triple Elvis, 1964
Aluminum paint and printer's ink silkscreened
on canvas, 82 x 71
Virginia Museum of Art
Gift of Sydney and Frances Lewis

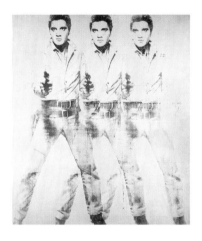

intimate. For all the prestige he gained for being designated the father of mail art, his most frequently reproduced works are his 1950s collages of Elvis Presley and James Dean, which seem to anticipate Warhol's Pop icons. While Warhol emphasizes the flatness of the surface to retain the banality of the original source, Johnson expressively transforms a photograph of Elvis's face in *Elvis Presley #1* (ca. 1956–57, p. 94). He applies red watercolor across the surface so that it seems as if Elvis is crying red tears. His Elvis is more like the singer of *Heart Break Hotel* than *Jail House Rock*. Where Warhol's Elvis is a distant sex object, Johnson's seems to love unrequitedly. This sense of vulnerability is even more pronounced in Johnson's *Elvis #2* (ca. 1956–57, p. 103), in which the singer puts his hands to his face in a gesture that suggests despair.

In contrast to Warhol's use of the star as a means of self-promotion, Johnson's relationship to celebrities frequently involves a process of self-deflation. He often took the role of the adoring fan, sometimes writing letters to people he did not know—much as Warhol did when he first moved to New York and wrote fan letters to such figures as Truman Capote. The fan is a supplicant whose love for a star is always inappropriate because it is exaggerated. If the fan is ridiculous, how much more so is the fan club, whose members gather together merely because they share an exaggerated admiration for a star? Johnson convened the Paloma Picasso Fan Club, the Claude Picasso Fan Club, the Spam Belt Fan Club, and the Shelly Duvall Fan Club, among others. Yet for all of the silliness of the fan and the fan club, there is something touching in their desire for a connection with a fabulous personality that always remains out of reach. Johnson's *Elvis Presley #1* and #2 mirror this very quality of unrequited love which is the fan's emotion. Other works, such as his collages of James Dean, Marilyn Monroe, and Yukio Mishima (p. 118), all whom died in tragic circumstances, allude to the pitfalls of celebrity.

Just as an obsession with celebrity is central to both Johnson's and Warhol's work, photo-reproduction and the copy are also essential. Johnson loved to depict his friends and celebrities as rows of virtually identical bunny faces (p. 211). This practice has a leveling effect, as if to suggest that being a celebrity is merely a matter of a famous name. Yet for Johnson duplication was not only about machine-like homogenization or the inauthentic, as has been claimed for Warhol. He delighted in Wilson's twin daughters because their birth reaffirmed the miraculous resemblances that he saw everywhere. Indeed, twins are strange, precisely because they are so similar. In comparing their similarities we become hyperaware of their differences.

Elvis Presley #2, ca. 1956–57
10¾ x 7½
William S. Wilson

Such doubling is not intrinsic to the mass media or a sign of the triumph of the commodity. It is an essential aspect of how life reproduces itself. In Johnson's world the most repetitious experiences can suddenly be enlivened by means of resemblance so that the copy ends up inscribing significance onto the ordinary. Through reproduction, the social intercourse of the New York Correspondence School produces not simulacra, but new situations and relationships.

Scrapbooks

The repeated pasting of pictures of movie stars onto his collages and his mailings, along with tickets, theater stubs, and clippings from newspapers, gives much of Johnson's work the feeling of scrapbooks. As he recalled, "I don't even know what year I did anything in except that I now keep insisting that 1943 was very important because I found a document in my mother's scrap book from 1943 and decided that the things I'd been doing then ought to be catalogued."[17] Fortunately, Johnson's scrapbooks still exist. Their pages provide an uncanny prediction of many of his

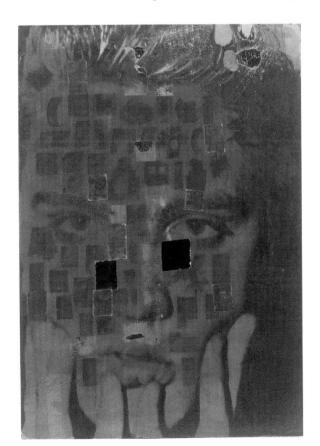

themes. A spread in one scrapbook brings together articles on the ice skating and movie star Sonja Henie with an advertisement for the movie *Flesh and Fantasy* and a scholarship certificate from Johnson's high school (p. 104).[18] The headline "Queen and Clown Return in Skating Review," which accompanies a picture of Henie and her sidekick, predicts Johnson's later interest in drag, in which being a comedienne and a queen are combined.[19] Johnson refers to the scrapbook as a production of his mother, but given its accumulation of materials—drawings by childhood friends, ticket stubs, school programs—my guess is that it was a collaboration between the two. Surely his mother would not have picked an album with a large silver airplane as its cover. But I think it is probable that she was the person who originally glued the ephemera down. In other words she was the original "masher," in Johnson's life.[20]

Johnson's scrapbook technique also bears comparison to the private albums of the photographer and novelist Carl Van Vechten,

Scrapbook, ca. 1941

which I have discussed at length elsewhere.[21] In the 1950s, Van Vechten pasted newspaper articles, pornographic photographs, announcements, and letters about homosexual life into a series of albums. He enhanced the pleasure of the male body by reassembling newspaper headlines so that a picture of three men having sex is given the title "Queens on Top" or a picture of a beautiful boy is captioned "Boy Crazy" and "My Queer." When he was young, Van Vechten had a job at a newspaper, in which he had to clip articles from competing papers so that his would not miss any important stories. The result was that the news became standardized. As an old man, Van Vechten clipped and pasted to create difference. His scrapbooks were an imaginary space of freedom he shared with a select group of friends who contributed their own clippings and pictures. It is doubtful that Johnson knew of Van Vechten's pornographic scrapbooks, although he may have seen similar ones by less well-known gay men. Nevertheless, Johnson shares a sensibility with Van Vechten—a refusal to throw anything away and a talent for creating meaning from the marginal and the censored. Van Vechten gave this sensibility a name. On one page of the album he pasted the words "It's Unmistakably Camp."

Camp Records

Johnson made a direct reference to Camp in a mailing of March 1964. He sent out a clipping announcing the availability of a record entitled *I'd Rather Fight Than Swish*, put out by Camp Records (p. 105). This spoof of the cigarette slogan, "I'd rather fight than switch," appears next to an exaggeratedly masculine figure. He poses, James Dean style, with a cigarette dangling from his mouth. The irony of the picture is that though this man does not "swish," he clearly is coded as homosexual. The type of man he attracts might swish, just as Warhol was said to. Certainly he camps. That same year Susan Sontag wrote her famous essay "Notes on Camp"— the first serious attempt to come to terms with what she calls a sensibility. Many of the qualities Sontag identifies as Camp sound like descriptions of aspects of Johnson's art.

Johnson's habit of seeing celebrities everywhere could be taken as an example of how, according to Sontag, Camp extends as far as possible "the metaphor of life as theater." Camp tends "to the markedly attenuated and to the strongly exaggerated." It is particularly attracted to androgyny: "What is most beautiful in virile men is something feminine; what is most beautiful in feminine women is something masculine."[22] Sontag adds that the best examples are

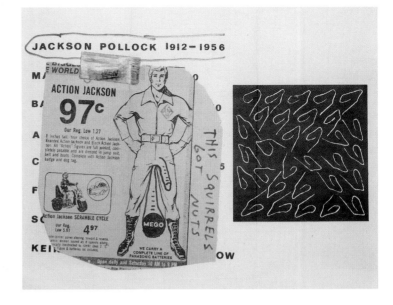

movie stars like Barbara Stanwyck, Bette Davis, and Tallulah Bankhead. We could add Johnson's favorites, including Veronica Lake, Twiggy, and Shelly Duvall, as well as male stars like Presley, Dean, Marlon Brando, and Montgomery Clift, all of whom have an androgynous quality.

Although Sontag seems to admire the imaginative work of Camp—its ability to creatively and passionately aestheticize the world—she clearly is ambivalent about the way it undermines value: "The experiences of Camp are based on the great discovery that the sensibility of high culture has no monopoly upon refinement. Camp asserts that good taste is not simply good taste; that there exists, indeed, a good taste of bad taste."[23] For Sontag, Camp replaces high modernism's advocacy of purity and clarity with an equally elitist sensibility based on the value of the overlooked and debased. The cultural historian Andrew Ross extends this concept in his study of Camp: "For the camp liberator, as with the high modernist, history's waste matter becomes all too available as a 'ragbag,' but irradiated, this time around with glamour, and not drenched with tawdriness by the mock-heroism of Waste Land irony." Ross also worries that Camp is merely the "recreation of surplus value from forgotten forms of labor."[24] That is, Camp converts garbage back into usable goods. I think of Johnson's daily forays into the garbage of his neighbors for collage material and the way in which he made mailings out of the things that were thrown away. He loved to reuse other people's discarded letters and postcards so that his mailings often seemed to come from complete strangers until the recipients scrutinized the letters for tell-tale alterations. The most conventionalized and sentimental communications turn into something bizarre.

Various critics agree that Camp resists definitions. Sontag abandons a linear argument precisely because she is wary of theorizing "this particular fugitive sensibility." Other critics insist that Camp resists definition because it adapts to changes in the dominant culture—that it is less a specific style than a series of strategies.[25] To be Camp is to take up the treasured values of mainstream society as they are manifested in images of celebrities and expensive commodities and to turn them on their head, reclaiming them for the margins. In its marginality Camp is closely tied to the oppression of homosexuals, who are responsible for its most famous manifestations. As Sontag writes, "not all homosexuals have Camp taste. But homosexuals, by and large, constitute the vanguard—and the most articulate audience—of Camp."[26]

Sontag's ambivalence about Camp in terms of modernism is linked to certain

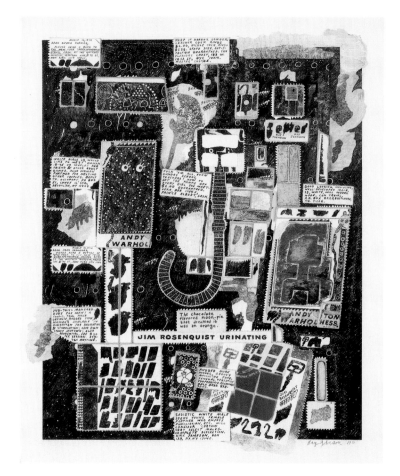

outdated conceptions about homosexuality itself. Writing before gay liberation, she links Camp, homosexuality, and decadence. Later cultural critics would emphasize the constructive and liberating aspects of Camp. Scott Long, for example, insists that Camp is a defense against homophobia and in particular the presumed ridiculousness of the gay male: "Met by laughter, he cannot react as he would if met by fear or rage: any serious response can be defused by another laugh. His tragedy becomes trivial. He responds by adopting a sensibility which, in its most common form, takes the trivial absolutely seriously. In camp, he defuses by parody the devices of oppression." To paraphrase the song from the Johnson clipping, the Camp hero would rather fight *and* swish. Long goes on to insist that Camp is essentially dialectical: "It asserts an opposition between the absurd and the serious. Then it gestures toward a point—a moment of consciousness, a shock, a synthesis—from which that opposition can be seen as absurd in turn, based on a higher and more encompassing sense of absurdity."[27]

 Johnson's work often functions in this way. In a 1973 mailing (p. 105) he juxtaposed an advertisement for a boys' action figure marketed as Action Jackson with Jackson Pollock's name and dates. To parody the masculinity of Action Jackson he drew on the image a huge penis and connected the round logo "MEGO" in such a way as to imply that the figure has one huge hanging testicle. Scrawled on the side is the phrase, "This Squirrels Got Nuts." In this mailing Johnson may seem to be merely making fun of Action painting and Pollock's hypermasculinity. But the mailing is equally a spoof of how certain gay subcultures glorify the very manliness that leads to their oppression. If we look closely at the advertisement, we see that the toy is available in "Bearded Action Jackson and Black Action Jackson." And that "All 'Action' figures are full jointed, completely posable and are dressed in jump suit, belt and boots." Pollock, the artist-hero, is made over into a gay clone.

 Johnson does not reserve his satire of art world heroes to Pollock. In the ambitious collage *Jim Rosenquist Urinating* (1971, above) the names of Pop artist friends like Rosenquist and Warhol are associated with body fluids. Pasted alongside their names are Johnson's versions of classified advertisements for male models: "GOOD LOOKING, MASCULINE,

WELL-DEVELOPED MALE, 23, WHITE, WILL MODEL NUDE, CAN TRAVEL" or "RUGGED NUDE MODEL GROOVY MASCULINE." Johnson was well aware that these models were actually male prostitutes hawking their wares to a gay clientele. In this regard, he deftly compares the selling of art to hustling. At the same time he suggests that the Pop generation has not erased the masculine posturing of the Abstract Expressionists. The urinating Rosenquist, like Pollock, is still busy marking his territory. At the same time such marking is a *voiding*, another nothing.

My reading of Johnson's collage is highly selective. The surface of *Jim Rosenquist Urinating* is cluttered with images and words that undoubtedly refer to other meanings and readings that are hard to decipher. Johnson's collages often overload the viewer with messages. Long claims that "the great illness of our age, brought about by the increasing accessibility and acceleration of facts, is the replacement of knowledge by information." He continues: "the seeker of knowledge struggles to perceive each new and old tenet—each fact comprehended— in its particularity, and perpetually evaluates and discriminates between them." By contrast, "Information is the creature of profusion. Any body of facts can be reduced to its monotony, if the receiver is too exhausted to select among them."[28] At times Johnson's art seems to mimic this profusion. To wade through his vast production is to feel bombarded by too much information. Johnson himself complained in an interview with Martin: "I have a kind of natural generosity and this was the real basis of the New York Correspondence School, and this natural generosity of image and idea and information is something that I can only extend so far. I don't have time any more. And the information by itself would just keep on accelerating, it just keeps on accelerating and expanding."[29] However, Johnson's art also provides a means for coping with such provision. His mode of collage, in which he meticulously cuts and reassembles data, suggests an attempt to select and organize experience into form. Johnson's camping is crucial in its inscription of significance. In Long's terms, it turns information into knowledge:

> Camp—even at its most pessimistically conceived—still asseverates a kind of hope: it is a system of signs by which those who understand certain ironies will recognize each other and endure. It is a private language for some who intuit that the public language has gone wrong. Through it, they can still adumbrate a truth or two amid the slavering and palavering. In it, a particular form of sensitivity to particulars may be preserved.[30]

This is a perfect description of Johnson's art, particularly the way it struggles to convert potentially pompous and meaningless public communications into the intimacy of correspondence between friends. At the same time he makes public and recirculates private messages, discarded letters, and personal images.

PERHAPS IN DRAWING ATTENTION to the Camp aspects of Johnson's work I might seem to exaggerate its gay content. Johnson carefully adjusted his mailings to fit what he took to be the interests of the addressee even as he knew their audience could and should not be limited to such private meanings. If Johnson loved to make collages and mailings that incorporate gay pornography, he also made works that overtly reference straight sex. In addition, he was interested in questions of sadomasochism. In his interview with Martin he stated that his "portrait work is subtitled "The Snaking of Americans," which is a very oblique S & M reference, Sade in Japan, Made in Japan, Making and Snaking, S & M and M & S."[31] Long before Queer Studies began to question the existence of absolute sexual boundaries and in particular the binarism of the gay/straight divide, Johnson's work suggests a concept of a sexuality that refused such limits. His work is queer in its awareness that identity is a masquerade, a display of masculine and feminine attributes that is not immutable. Sexual identities are taken to be highly fluid, and sexual experiences endlessly varied. The mixing of bodily fluids—piss, semen, and blood—emerge as crucial themes. Johnson no doubt found rich source material for this work in the exuberant gay scene of the 1960s and 1970s in New York. But the advent of AIDS in the 1980s surely reasserted the connection between death and sexual desire that had been an essential aspect of his art long before the epidemic, as my discussion of *Gargoyle* and *P Town* suggests. Still, how unbearable to see this late Romantic equation of sex and death played out in the real deaths of so many friends. Thank God for Camp's ability to find humor, and thus life, even in disaster. Born from despair and oppression, Camp continues to sustain us.

 I began this essay regretting that I never knew Ray Johnson. But after spending more time with his work, I have a strange feeling this is not true. It is not that I have come to know him through his art. Rather I cannot shake the feeling that at least we must have exchanged glances. Surely our paths must have crossed at a gallery or a bar. I think I have fallen a little bit in love with Ray. I am particularly obsessed by a photograph of the back of his head that must have been taken when he was in his twenties (p. 109). I am struck by the elegance of his neck, and how perfectly his shorn hair follows the contour of his head. It is a very sexy picture. Odd that when Ray's face is turned away, he seems most present. But isn't this how letters also work? Even as they are about distance, a turning away, they are also about turning back. Because their address is usually the here and now, letters inscribe presence in absence. In this way we can all read Ray's communications as if we knew him and we were their intended recipients. Welcome to the Ray Johnson Fan Club.

This essay is dedicated to William S. Wilson, who first introduced me to Johnson's work and generously shared his extraordinary Johnson archive and collection with me. I want to thank Muffet Jones and the Feigen Gallery for their invaluable help. Nicholas Boshnack, Donna De Salvo, Cathy Gudis, and John Alan Farmer all provided important suggestions and advice. I particularly want to thank Michael Lobel for his encouragement and insights.

1. According to George Wead and George Lellis, *The Film Career of Buster Keaton* (Boston: G. K. Hall & Co., 1977), 46, the picture has been mistakenly associated with *The Love Nest* (1923); however, Keaton does not wear sailor's garb in this film. They therefore assume that it was a publicity still for *The Navigator* (1924), "a film in which Keaton at least wears the same garb."

Ray Johnson at Black Mountain College, ca. 1945–48
Photograph by Hazel Larson Archer
Courtesy of Black Mountain College Museum and Arts Center

2. William S. Wilson, *Ray Johnson, Black Mountain Dossiers*, no. 4 (1997), 9.

3. Richard Bernstein, "Ray Johnson's World," *Andy Warhol's Interview*, August 1972, 40.

4. This discussion of *P Town* is indebted to the interpretation of William S. Wilson. Wilson has written that Johnson "was aware of my passionate commitments, and mailed me teasing satiric references to Barnett Newman, Franz Kline, and others," 7.

5. David Bourdon, "Notes on a Letterhead," *Art International 8*, no. 9 (November 1969): 78.

6. Wilson, 34.

7. Buster Keaton with Charles Samuels, *My Wonderful World of Slapstick* (New York: Da Capo Press, 1982), 11.

8. Bernstein, 39.

9. According to one patron, "when you entered the Anvil, you walked down a flight of stairs to the first level. What was so great was so much was going on at once. It was such a carnival—dancing men were parading around on top of the horseshoe bar, little red lights were strewn across the ceiling, as if it were always Christmas. There was always a pathetic little parody of a drag show on the little stage in the corner....The crowd ran the gamut from the most illustrious names in the press to the sleaziest people you would never want to meet"; Philip Gefter, as told to Charles Kaiser, *The Gay Metropolis* (New York: Harcourt Brace and Co., 1997), 245. I would like to thank the Feigen Gallery for providing me with copies of Johnson's letters to Cowboy Bart. On several of these letters he wrote they were mailed from the mail box in front of the Anvil.

10. Wilson, 44.

11. Ray Johnson, in Henry Martin, "Should an Eyelash Last Forever? An Interview with Ray Johnson," this vol., 195.

12. See Martin's discussion of mashing in "Mashed Potatoes," *Art and Artists 7*, no. 2 (May 1972): 22–24.

13. Oxford English Dictionary, 2d ed., 1989 (online edition).

14. Johnson would have enjoyed the fact that anvils were stock elements in Warner Brother cartoons, where they are frequently thrown out of windows to flatten or mash foes.

15. Andy Warhol and Pat Hackett, *Popism: The Warhol '6os* (New York: Harcourt Brace Jovanovich, 1980), 11. For a discussion of gay identity in the work of Andy Warhol, see Kenneth Silver, "Modes of Disclosure: The Construction of Gay Identity and the Rise of Pop Art," in *Hand-Painted Pop: American Art in Transition, 1955–62*, exh. cat. (Los Angeles: The Museum of Contemporary Art and New York: Rizzoli International Publications, 1992), 178–203, and Richard Meyer, "Warhol's Clones," in *Pop Out: Queer Warhol*, ed. Jennifer Doyle, Jonathan Flatley, and José Esteban Muñoz (Durham: Duke University Press, 1996). Jonathan Katz, in his essay "The Art of Code: Jasper Johns and Robert Rauschenberg" in *Significant Others: Creativity and Intimate Partnership*, ed. Whitney Chadwick and Isabelle de Courtivon (London: Thames and Hudson, 1993), and in his forthcoming book on Rauschenberg and Johns, explores the relationship of the closet to Cold War society. Such a close analysis of coding in the work of these two artists is important, but what it also needed is a systematic and more generalized exploration of gay identities in American visual art, literature, dance, and music of the 1950s and early 1960s. We will undoubtedly come to understand the role of gay themes in Johnson's art better when it can be placed in the context of serious and complex histories (and we need many) of post–World War II queer culture.

16. Michael Lobel explores the relationship of the trademark to celebrity in Pop art in his Ph.D. dissertation, "Image Duplicator: Roy Lichenstein and the Emergence of Pop Art," Yale University, New Haven, 1999.

17. Martin, "Mashed Potatoes."

18. In the early 1970s, as part of his series of "Famous People's Memorials," Johnson produced a collage, now in the collection of the Wadsworth Athenaeum in Hartford, featuring an image of Sonja Henje.

19. Johnson's dress for his performance events frequently included flamboyant touches, such as painted bunnies on jackets, bright plaids, and shoes with with colorful striped additions. Although these costumes do not constitute drag as such, they manifest his desire to undermine conventional dress codes.

20. Johnson's collages can be said to have their origins in his mother's work; however, to the degree that he fills his work with sexual and scatological references, we could say that his art is a kind of counter-scrapbook. Or, to put it another way, it is the scrapbook he might have wished his mother to make. In this sense, his long-term collaboration with May Wilson, William S. Wilson's mother, and a marvelous collage artist in her own right, may be significant. She becomes the new mother masher— and Johnson particularly ascribed to her the attribute of a potato masher.

21. Jonathan Weinberg, "'Boy Crazy': Carl Van Vechten's Queer Collection," *The Yale Journal of Criticism 7*, no. 2 (Fall 1994): 25–49.

22. Susan Sontag, "Notes on Camp" (1964), in *Susan Sontag Reader* (New York: Vintage Books, 1982), 109.

23. Ibid., 118.

24. Andrew Ross, "Uses of Camp," in David Bergman, ed., *Camp Grounds: Style and Homosexuality* (Amherst: University of Massachusetts Press, 1993), 67.

25. See, for instance, Mark Booth, *Camp* (New York: Quartet, 1983).

26. Sontag, 117.

27. Scott Long, "The Loneliness of Camp," in *Camp Grounds*, 79.

28. Ibid., 82.

29. Martin, 21.

30. Long, 90.

31. Martin, 14. I hope to explore the role of S-M in Johnson's work in another essay.

110

Henry Fonda Foot Dollar Bill, 1970
29½ x 21¾

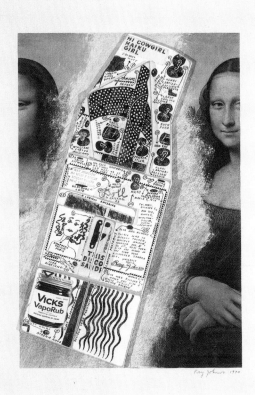
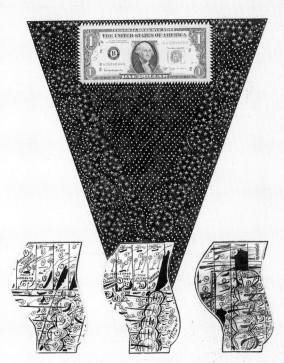
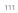

Cervix Dollar Bill, 1970
20¹/₁₆ x 28
The Corcoran Gallery of Art, Washington, D.C.,
Gift of Dr. and Mrs. Jacob J. Weinstein in Memory
of Mrs. Jacob Fox

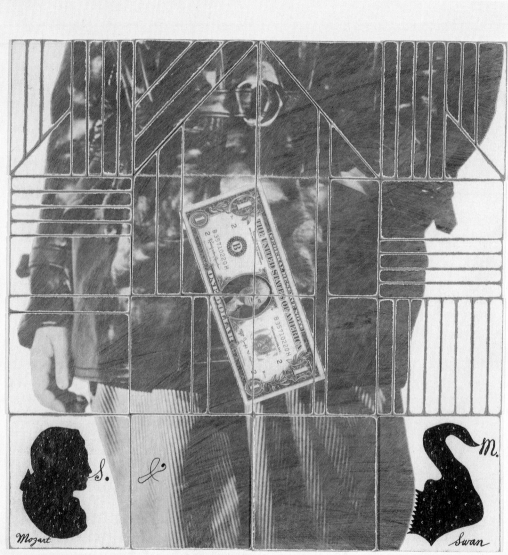

112

S & M (Shirley Temple), 1971
22½ x 22½

Joe Buck Dollar Bill, 1970
30½ x 21½
Frances Beatty and Allen Adler

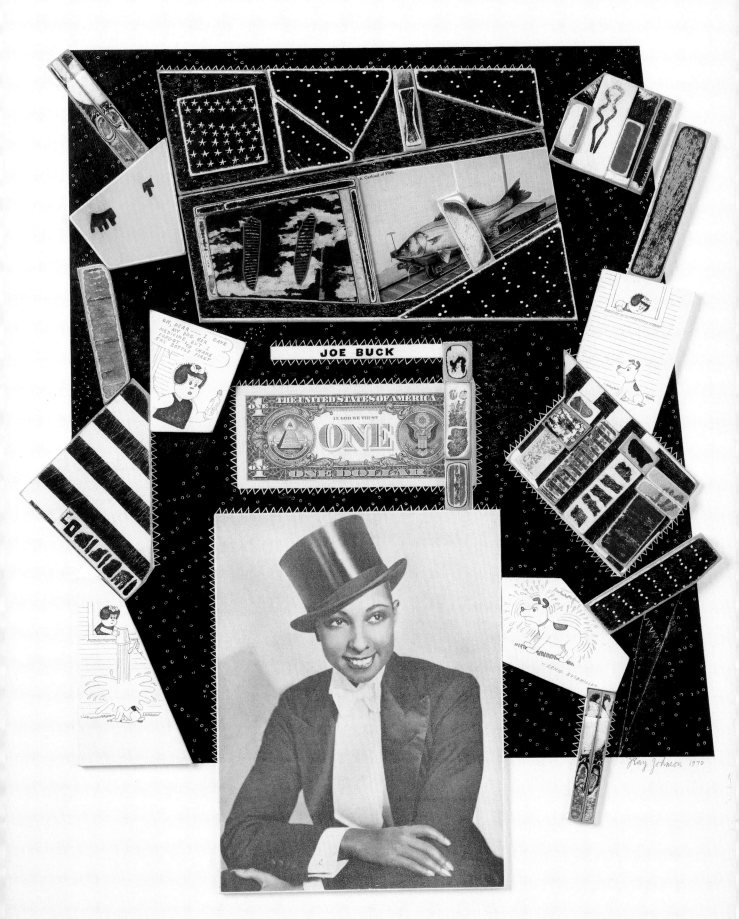

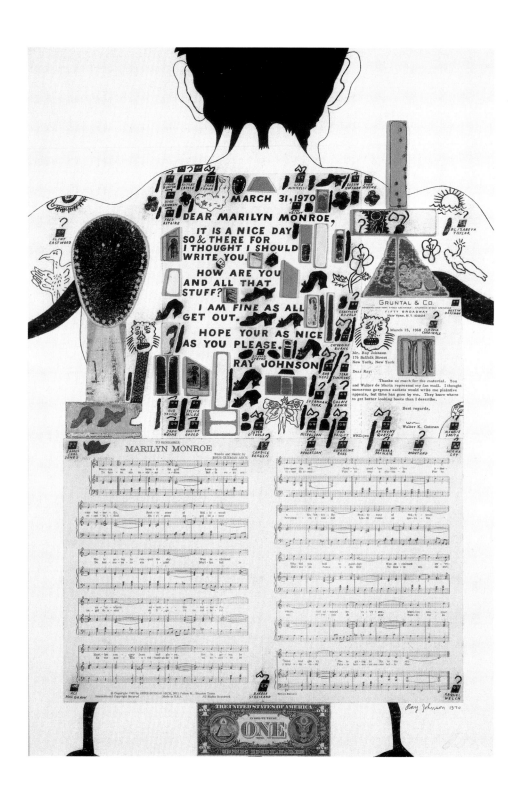

Marilyn Monroe Dollar Bill, 1970
29³⁄₄ x 20³⁄₄
Mr. and Mrs. Edward R. Schwartz

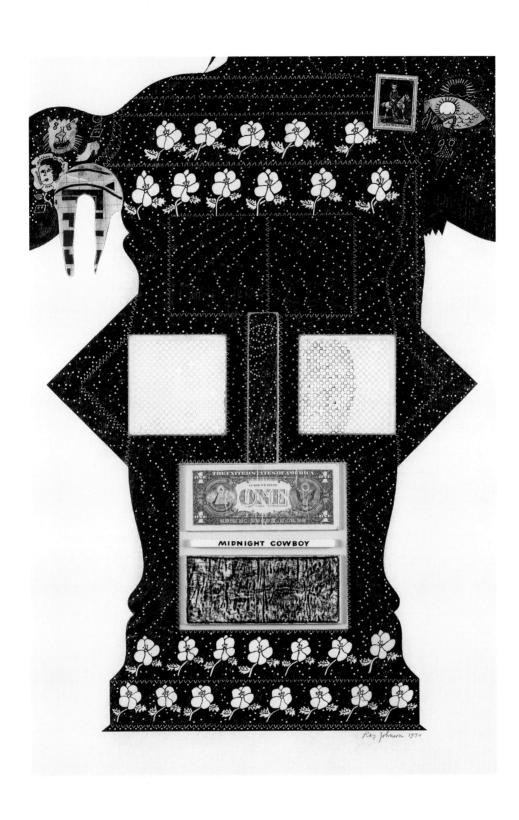

Midnight Cowboy Dollar Bill, 1970
29¼ x 19¼

Plan -

I plan to create Famous People Memorial collage-paintings about:

 Diane Arbus 1923-1971
 Paul Cezanne 1839-1906
 Walt Disney 1901-1966
 Marcel Duchamp 1887-1968
 Amelia Earhart 1898-1937?
 Sigmund Freud 1856-1939
 Clock Gable 1901-1960
 Theo van Gogh 1857-1891
 Vincent van Gogh 1853-1890
 Harry Houdini 1874-1926
 Helen Keller 1880-1968
 Carole Lombard 1908-1942
 Tom Mix 1880-1940
 Kay Sage 1898-1963
 Erich von Stroheim 1885-1957
 Yves Tanguy 1900-1955
 Mary Woolstonecraft 1797-1851

I plan to continue the New York Corraspondence School mailing of
envelope-enclosures:

 I plan to send "startling" letters to "court jesters", to send
 "informative" letters to "ubiquitous spooks plodding through
 shadows fruitlessly", to send "dazzling" letters to the Aunt
 Martha Museum, to send "telling" letters to "four elves", to send
 "hilarious" letters to "slum dwellers", to send "daring" letters
 to "anyone who doesn't stay in one place any more", to send
 "delicate" letters to Joan Baez asking her to please shut up, to
 send "involving" letters to Vogue magazine "onion tossers", to
 send "endearing" letters to Amelia Earhart?, to send "fresh"
 letters to Phyllis Diller and Fang, to send "stimulating" letters
 to Ruth and Rex, a pair of Dakotas, to send "imaginative" letters
 to Jasper Johns, who was once handcuffed to Merce Cunningham
 during a Frank O'Hara poetry reading, to send "delicious" letters
 to Lady Baltimore cake bakers and shoplifters, to send "diverting"
 letters to scrotum clowns, to send "delightful" letters to key
 lime pie eaters, to send "mysterious" letters to clumsy Apollo's
 rose bush thorns, to send "ambiguous" letters to waggish Norman
 Mailer, to send "dizzying" letters to Twiggy, to send "alive"
 letters to the Disneyland pet cemetary "Here lies Shelley Winters
 wrapped in silk poor little thing drowned in a glass of milk",
 to send "transitory" letters to the Anais Nin Make Believe Ball
 Room, to send "ephemeral" letters to dumb bunnies, to send
 "effervescent" letters to Penny Singleton and Johnny Cash, to send
 "playful" letters to Sandy Calder's Mexican jumping beans, to send
 "spontaneous" letters to "Send a salami to your boy in the army",
 to send "airy" letters to the Little Dipper and the Big Bopper,
 to send "joyful" letters to Quaker green string bean canners, to
 send "crazy" letters to wailing wallflowers and to send "forget-
 me-not" letters to Gordon Matta's Restaurant.

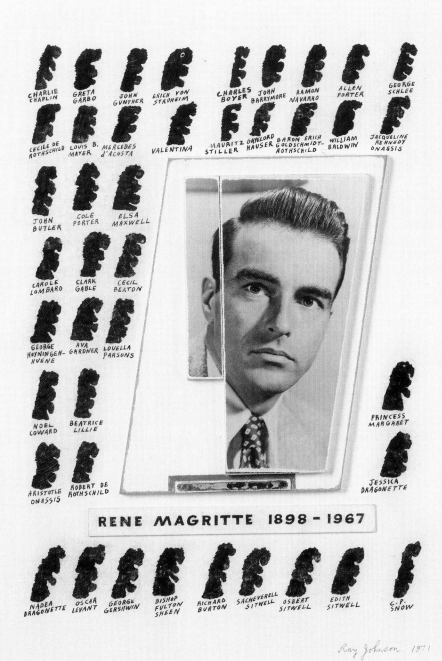

RENE MAGRITTE 1898 - 1967

Mailing, ca. 1970s

Rene Magritte, 1971
22 x 18½

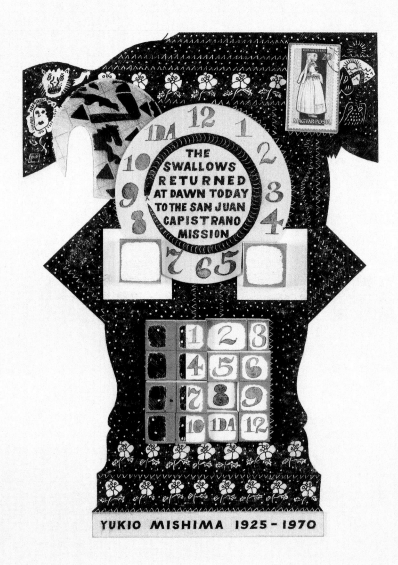

Yukio Mishima, 1971
21¼ x 17¾
Neuberger Museum of Art, Purchase College,
State University of New York,
Gift of Mr. and Mrs. Werner H. Kramarsky

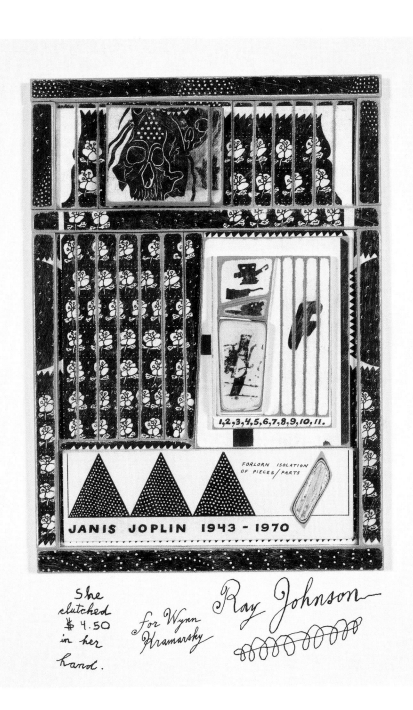

Janis Joplin, 1971
21 x 18
Sarah-Ann and Wynn Kramarsky

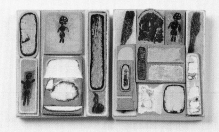

TO: ISABEL BURTON
67, BAKER STREET
PORTMAN SQUARE, WEST
LONDON, ENGLAND

DECEMBER 18, 1968

DEAR ISABEL BURTON:
I RECEIVED IN THE MAIL
TODAY FROM LAWRENCE WEINER,
THE DIRT ARTIST A SMALL
BOTTLE CONTAINING 100 BLANK
WHITE TABLETS (PLACEBO)
SURROUNDED BY TORN CHECK
FRAGMENTS.
ALSO A LETTER CONTAINING
A PENNY FROM NAM JUNE
PAIK ADDRESSED TO MOON RAY
JOHNSON.
ALSO A POCKETBOOK TITLED
"NURSE IN WAITING" - HOW LONG
COULD YOUNG DR. BOB HIDE THE
TERRIBLE TRUTH BEFORE NURSE
KANE WAS FORCED TO TURN TO
ANOTHER MAN?

MOST SINCERELY,

RAY JOHNSON

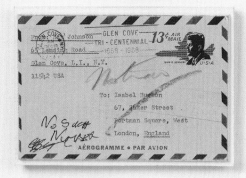

67, BAKER STREET
PORTMAN SQUARE, W.,
MAY. 22nd, 1894

DEAR MR. TUSSAUD,
I SENT YOU A PAIR OF SANDALS
YESTERDAY BELONGING TO ME, BUT TODAY
I HAVE HAD THE PROMISE OF A PAIR
FROM THE PRIOR OF THE FRANCISANS
WHICH WOULD SUIT ME BETTER. DIRECTLY I
I SHALL SEND THEM DIRECTLY I
RECEIVE THEM.

YOURS SINCERELY,
ISABEL BURTON.

Ray Johnson 1969

Untitled (Feeting Poster), 1969
24¾ x 20½ in.

Sharla Sava

RAY JOHNSON'S NEW YORK CORRESPONDENCE SCHOOL: THE FINE ART OF COMMUNICATION

RAY JOHNSON'S ART OF COLLAGE and correspondence was driven by a lifelong fascination with interpersonal communication. It was during the 1950s that Johnson first began to develop the use of mail as an art form, and for about a decade, from 1963 to 1973, he adopted the label of the New York Correspondence (which he also spelled as Correspondance) School as the name for these activities.[1] The NYCS was comprised of a network of friends, strangers, and public figures in the worlds of art, politics, and entertainment with whom Johnson sustained an ongoing exchange of ephemera and correspondence. It made its public premiere at the Whitney Museum of American Art in New York, with the exhibition *Ray Johnson: New York Correspondance School* (September 2–October 6, 1970). The exhibition, because it was displayed in a prominent and publicly sanctioned institution of art, marked a crucial turning point both in terms of Johnson's own practice and in terms of the status correspondence art acquired within the avant-garde. Through this inaugural display the defiant stance of mail art joined rank with many other contemporaneous practices in an adamant rejection of the conventional art object. Dissimilar in its intentions, however, from the other art experiments, the exhibition of the NYCS at the Whitney posited an exuberant and idealist reconciliation between the opposing realities of system and structure. The institutional display of the NYCS inaugurated in 1970 at the Whitney was a remarkable attempt to reconcile a private living system of communication with the vast and anonymous structures that govern the wider social world, and, as such, it merits further consideration.

121

SEND LETTERS, POST CARDS, DRAWINGS AND OBJECTS TO MARCIA TUCKER, NEW YORK CORRESPONDANCE SCHOOL EXHIBITION, WHITNEY MUSEUM, MADISON AVE. AND 75 ST., N.Y.C. 10021

EXPLORATIONS BY RAY JOHNSON

Mailed request for submissions to the
New York Correspondence School
(NYCS) exhibition at the Whitney Museum
of American Art, 1970–71

 Ray Johnson: New York Correspondance School, initiated by Johnson and organized by the curator Marcia Tucker, consisted of the work of 106 contributors associated with Johnson's NYCS. Installed in the Whitney's main floor gallery, the exhibition featured a varied assortment of collages, letters, postcards, and objects. It was a collaborative effort that relied on the creative responses of those invited to participate. Participants included artists of obscurity and renown—Les Levine, Yoko Ono, James Rosenquist, May Wilson, and many others— a significant number of whom were actors in the New York art world. Rife with the contradictory aspirations typical of the avant-garde of the time, it attempted to undermine the premises of its own public display. That is, rather than predetermining the display by calling for specific works from select individuals, Tucker encouraged Johnson to do what he normally did—to play with chance. By intentionally including everything that was sent to the museum,[2] the exhibition marked a radical departure from the traditional standards of quality and taste associated with the curatorial process. Tucker, in her provision of institutional support for Johnson's rebellious strategies, was attempting to create a dynamically open-ended forum for artistic collaboration free of the baggage of older art forms.

 While the popular press was receptive to the objectives of the exhibition, reviews in the mainstream art press ranged from moderate interest to hostility. *New York Magazine* referred to the NYCS as "weirdly tantalizing" and suggested that this new art form "may prove to be the talk of the town."[3] *Vogue* called it "nutsy" and listed it among the month's events "that people are talking about."[4] But in his review of the exhibition for *Art International*, Gerrit Henry commented on the network of private references that comprised the work of the NYCS, saying: "The mounting of a show full of this in-humour proved that Johnson and his curator expected everyone who attended to somehow 'get it'; I feel fairly certain that not everyone did, if the mutterings of one museum-goer about 'the permanent collection being put in storage for *this*' were any indication."[5] A brief review also appeared in *Artforum*. Identifying the contradiction applicable to the avant-gardism of the time, Kasha Linville wrote: "the only sad note about Johnson's Whitney *diversion* is it seems a shame to catch a living thing in flight, to pin it down and make a museum display of it."[6] The ambivalent reception of the exhibition draws attention to the undercurrents that shaped the antiobject era, allowing history a means of identifying the repressed contradictions of the period.

 Emerging during the early 1960s, the NYCS was informed by the widespread antiformalist aesthetics of the New York underground, including Fluxus, performance art, Happenings, improvisational dance, and the Living Theatre. By 1970 this disparate antiformalism had been assimilated into a formation that

Submission to NYCS exhibition at the
Whitney Museum sent by Christo,
Jeanne-Claude, Tammaso Trini, Gracio Trini,
1970

FOLLOW INSTRUCTIONS BELOW

Mailings originally published in *Arts Magazine* 4, no. 2 (November 1971): 42-44.

was widely referred to as Conceptual art. Although in many ways congruent, the NYCS was never comfortably situated in the wave of Conceptualism. For example, Lucy Lippard chose to exclude Johnson from her comprehensive *Six Years: The Dematerialization of the Art Object from 1966 to 1972*. As she wrote, "even such impressively eccentric manifestations as Ray Johnson's use of the postal system have been omitted partly through spatial necessity and partly because, confused as the issues are, they would be unmanageable if *some* similarity of esthetic intention were not maintained."[7] That is, while the antiobject era may appear impressive by virtue of its defiant anti-institutionalism, one need not dig too deeply to uncover aesthetic judgments uncomfortably reminiscent of the most traditional connoisseurship. In order to better understand the incommensurability of Johnson's work with contemporaneous art movements, the motives of the NYCS must be examined in greater detail.

Throughout the 1960s Johnson worked obsessively and prolifically to create the NYCS, compiling, sending out, and receiving an endless stream of bizarre and mundane news. His daily life was dedicated to sustaining intimate ongoing connections through the mail with hundreds of interested participants. One example is *Follow Instructions Below* (above), a Mail Event published in *Arts Magazine* in 1971, in which Johnson invited readers to add to an unlabeled photograph of the French poet Arthur Rimbaud. Participants may or may not have followed the instructions, which suggested interventions such as add "words" or "a fact" or "the name of your favorite person" or "an historic event." Johnson himself supplied a few suggestions, writing across the face an "historic event" in which, as he notes, he "went to the movies and

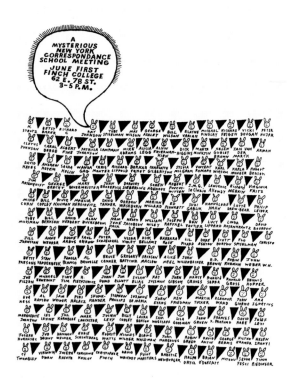

Mailing for event at Finch College,
New York, June 1, 1968

ate 32 ice cream sandwiches." All the
individual efforts would be collected,
appreciated, and potentially redistributed.
As the NYCS developed, Johnson added
new members and dropped ones who fell
into disfavor. These fluctuations in
membership were announced in the mail,
although rarely explained.

After the NYCS had
been in operation for a number of years, Johnson began to hold meetings in New York
and elsewhere for interested members. As with the announcement for a NYCS meeting at Finch
College (above) on June 1, 1968, it is often difficult to determine what the presence of the names
in the illustrated group portrait was meant to signify. The densely packed rows of cartoon
bunny heads were variously labeled, by Johnson, with the names of pop stars, art world figures,
and friends who were alive and dead, famous and unknown. The bunny heads could indicate
a seating arrangement, a personal fantasy, or a who's who listing. It is impossible to know
if the announcement took place in the realm of pure fantasy or if it is an historical document of
an event that actually took place. The same ambiguity holds true in the invitation for a Stilt
Meeting, which, as it turns out, actually was held in Central Park Mall on October 26, 1968
(p. 125). Johnson uses the invitation as a playful invocation of reference: "Will critic Lawrence
Alloway find that stilts are objectless art?" "Will Fred McDarrah photograph Andy Warhol on
stilts?" Comprised of such initiatives, it becomes apparent that the NYCS was a practice intended
to mirror, and often mock, the creative and competitive social sphere that is contemporary art.

Because its operations were animated and underpinned by the obsessive
and relentless motion of contact, the NYCS had an implicitly social, rather than purely aesthetic,
function. In a 1977 account that appeared in *Art Journal*, Lawrence Alloway confessed:
"a few years ago I started to write about Johnson but I got so confused by glimpses of…themes…
in bundles of letters spread all over the city, that I gave up, to my regret now."[8] Any history
of the NYCS must take into account Johnson's knowledge of, and contact with, art world figures
such as John Cage, Joseph Cornell, Dick Higgins, Judith Malina, Robert Rauschenberg,
and Andy Warhol. As Johnson remarked, "I attempt in the Correspondence School to be a sort
of free clearing house of people and information and objects, and I spend a great deal of time just
bopping around and meeting people, old people and new people, and finding out about things and
distributing information."[9] In the case of Johnson's work, if the aesthetic form acts as the locus
of communication it is the passion for contact that has provided its meaning.

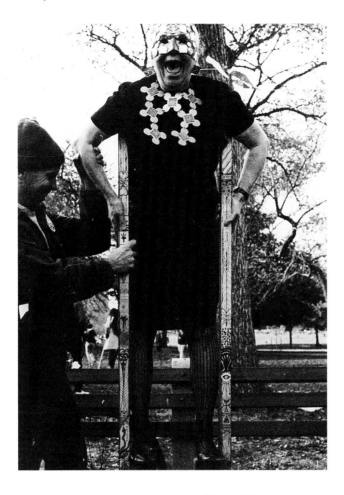

Ray Johnson and May Wilson at
Stilt Walk Meeting, Central Park,
New York, October 26, 1968
Photograph by John Willenbecher
Courtesy of William S. Wilson

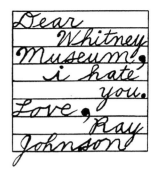

Undated mailing (detail)

To casually situate Johnson into the cool professionalism of the art world, however, is to misunderstand the intimacy of his mail art network. "I don't just slap things in envelopes. Everything I make is made for the person I'm writing to."[10] Johnson's act of ongoing self-distribution was never indifferent to its recipient. As David Bourdon commented in a memoir addressed to Johnson, "I, like many others, treasured your mail art because you crammed so much imagination and wit into a simple envelope, making us, the recipients, feel clever and special."[11] By making communication an ongoing process—sending, receiving, sending again; adding, dropping, naming, hinting, correlating—Johnson drew attention to the referential nature of identity. The way he used the process of association to identify the people on his network allowed them to recognize themselves as subjects within the given constellation of reference and activity. Drawing together associations between people, concepts, and images, Johnson displaced older notions of the unique art object in favor of a lively network of communication.

125

Johnson, perhaps because he so often took the art world as subject, always sustained a somewhat outsider status. In terms of prominent and influential art movements, such as the New York School, the NYCS—both in its title and its practice—enacted a deliberate departure. In the letter *Dear Whitney Museum, I hate you. Love Ray Johnson,* which appears periodically in various mailings, the tenor of Johnson's institutional critique becomes more clearly evident (above). In his ambivalent relationship to art institutions Johnson certainly had company. In the spring of 1970 Robert Morris had demanded the closure of his own exhibition at the Whitney as a gesture of protest against war.[12] Later that year a group of women artists calling themselves Woman Artists in Revolution disrupted the Whitney Annual to protest the minuscule representation of women artists.[13] While the level of political engagement in each instance is different, all of these artists recognized that the museum is an institution *against* which they must create work.

Mailing, ca. 1970s

The effort to organize collaborative projects outside traditional art spaces recalls 1960s practices such as the Happenings of Allan Kaprow and the experimental dance performances of Merce Cunningham or Yvonne Rainer. In that Johnson's anti-institutional position was configured through the postal network, however, his practice remained distinct from the performative and ephemeral experimentation of his peers. Built from the emergent sensibility of his artistic milieu, the NYCS was an imaginative conceptual space that welcomed strange behavior, sexual fantasy, and creative living. It allowed for the circulation of material that rejected the dominant ideology of U.S. liberal corporatism by questioning its most cherished values—the traditional family, patriotism, and the need to be a good consumer. In this respect the population of the NYCS peregrinates along the indefinite borders of counter-history.[14]

From a traditional perspective the NYCS can be easily dismissed as a private self-indulgent communication network developed among friends, and as such, unimportant to the history of art. When Hilton Kramer reviewed the Whitney exhibition, for example, he commented: "What you or I might deem fit for the wastebasket, the Whitney Museum of American Art judges worthy of its exhibition space. So we are now being treated to an exhibition—albeit a very small exhibition—of letters, postcards, objects and other inanities that Mr. Johnson and his friends (including Marcia Tucker, the curator who has arranged this exhibition) have exchanged from time to time. This is not so much an art exhibition as a display of various species of visual junk that a group of like-minded artists and associates agree to find amusing."[15] Kramer's difficulty in seeing the NYCS as an institutional critique alludes to a broader problematic. Today, the defense of counter-history against the art historical canon suffers under a painful irony. The most dedicated activities of counter-history, by resisting the systematizing rationale of dominant institutions (from photo-documentation to checklists), forfeit their presence on the historical record.[16] It is worth noting that Tucker's

Ray Johnson: New York Correspondance School (Whitney Museum, 945 Madison Ave.): Dear Ray Johnson, I think your show (the letters, the postcards, the envelopes, the scraps of paper, the messages, the pictures and drawings, and, above all, the cryptic enclosures) are startling, informative, dazzling, telling, hilarious, daring, delicate, involving, endearing, fresh, stimulating, imaginative, delicious, diverting, delightful, mysterious, ambiguous, dizzying, alive, transitory, ephemeral, effervescent, playful, spontaneous, airy, joyful, crazy.

John Gruen
NEW YORK MAGAZINE
OCTOBER 5, 1970

126

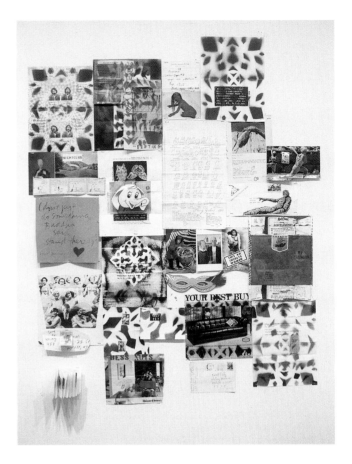

Installation view of May Wilson's contribution to NYCS exhibition at the Whitney Museum, 1971

curatorial decisions—her allegiance to the values consonant with counter-history—also shaped her engagement with art institutions, leading to her departure from the Whitney and to the subsequent founding of the New Museum of Contemporary Art.[17]

During the formative years of his artistic education in the late 1940s, Johnson had attended Black Mountain College in North Carolina. Faculty at that time included John Cage, Merce Cunningham, and Buckminster Fuller, and when Johnson moved to New York he would maintain many of these same contacts. More than a decade later, the NYCS came to reflect the particular and relatively unified aesthetic orientation that Johnson had earlier acquired at Black Mountain.[18] This postwar ecological orientation emphasized creative forms that explored spontaneity and mobility as an extension of everyday experience. By the late 1960s these ideas had been adopted by the counter-culture and were diffused into the population at large.[19] Johnson, consistent with this logic, carefully kept the conceptual direction of the NYCS in motion. Its physical materials, as well, were perpetually moving through the current of the international postal service. This process dismantled the certainty of an interpretation within a single moment of time. Contributions to the NYCS were not presented as a unique event, but were always in circulation. For example, around 1970 Johnson produced a large collage whose background is an oversized self-portrait. Johnson's eyes gaze starkly toward the viewer, while one of his hands, decorated with snake rings, obscures his mouth. By imposing a square grid across the surface, adding repeated ink doodles, and applying various collage chunks, Johnson defaced his portrait. Across the central portion of the face he reproduced several letters addressed to Tucker written during the planning stages of the Whitney exhibition. This gesture, in which interpersonal communication effaces the definition of individual identity, says something of the strategy underpinning his proclivity to cut things up and keep them in motion. It is also indicative of a kind of self-effacement which the art world would find difficult to assimilate.

In other instances Johnson's announcements were kept in motion through their re-use by other artists. In the section of the Whitney exhibition that displayed the contribution of May Wilson, for example, his initial announcement requesting participation in the exhibition re-appears, with Wilson's red spray paint across its surface (above). Johnson himself later used

127

Undated mailings

COLLAGE BY RAY JOHNSON

the same announcement in a letter he sent to Wilson above a found photograph of women at a quilting bee (above). In this letter he creates a scenario in which Wilson joins prominent women in the art world; she is "sitting" with Eleanor Antin, Louise Bourgeois, Colette, and a drag queen.[20] In a 1976 exhibition catalogue, adjacent to a letter to John Willenbecher dated June 9, 1970, the announcement surfaces once again. Johnson writes: "Dear John, This is an important document.

You are the first on the Whitney list.... You are the first to get the ball rolling...all you have to do is sock it to Marcia. Do your thing.... You might work on this important document since it's the first to go out. [signed] Babar."[21]

Through such efforts it becomes possible to recognize the process-based logic of the NYCS network, which kept thought and shared reference in perpetual motion. In a 1969 interview, Johnson says, "The idea of the movement? Well, I used to think that what I wanted the 'correspondance' school to be was a fantastic, gigantic Calder mobile."[22] This belief in mobility stemmed from an understanding that, in contrast to the autonomous and alienated subject of modernity, a new interconnected subjectivity was coming into being. An art form that embraced spontaneous movement would, it was thought, flush out the ideological stasis that constrained mainstream society.

The mobility of reference flowing through the letters of the NYCS often drew from the disjunctive and associative communication of the mass media. Like many Pop artists, Johnson frequently drew phrases or images from the media-saturated visual environment in which he was immersed. His selections are tinged with tragic and ridiculous qualities, as, for instance, in one piece based on a *New York Times* clipping of July 16, 1973. Johnson circulated the clipping, which tells the story of a desperately poor family in Saigon begging for money to eat, to the NYCS mailing list, with a letter he addressed to the journalist who wrote the article. In the letter he asked the journalist, on behalf of the members of the School, how to donate money

"Ray Johnson looking through the last
issue of File," *File*, December 1972

"A.A. Bronson licking through the last
issue of File," *File*, May 1973

to Nhan, the child in the photograph. The absurdity of his
intervention stresses the bizarre world of the global
mediascape, in which the reader is prodded to pity the
plight of the poor, yet perpetually stifled from acting to
alter the conditions that perpetuate poverty. This is not art
that simply duplicates the media. Rather it uses the media
to reflect the contradictions, bizarre events, and horror of
the real world, mired in the drudgery of current social
conditions. This work ricochets from public to private, as
the audience to which this letter is directed—while ostensibly addressed to an anonymous
journalist in the public sphere—is actually the NYCS membership, an intimate group of
sympathetic and responsive readers.

Members of the NYCS recognized, and were inspired by, the role that Hollywood
film, advertising, and television plays in constructing sexual fantasy and glamorous mythologies.
Many of the artists involved were gay men, and the NYCS held a range of campy, parodic
revisions of images taken from mainstream culture. During the 1960s and 1970s, correspondence
art allowed for the construction of a fantastic parallel world, providing a forum for a display
of gay desire not openly acknowledged in mainstream society. In the early 1970s General Idea, a
Toronto-based collective comprised of three gay men, produced a magazine for the mail art
network that had emerged from the NYCS. This magazine mimicked the symbol of middle-class
America, *Life* magazine. Attesting to his willingness to join in the spirit of this playful
and sophisticated vanity press, Johnson appeared in the next edition of *File Megazine*, "looking
through the last issue of File." And, in the one following, AA Bronson responded, "licking
through the last issue
of File." Johnson frequently
pushed the transgressive
potential of desire through
the banal acceptability
of media icon images. In an
ink drawing of Warhol,
the media darling of the
art world, Johnson equates
public presence with the
release of bodily fluids.
Warhol, a cartoon blob with

129

HERE'S RAY JOHNSON LOOKING THROUGH THE LAST ISSUE OF FILE

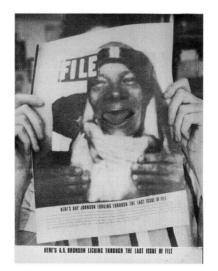

HERE'S A.A. BRONSON LICKING THROUGH THE LAST ISSUE OF FILE

June 5, 1973 The New York Corraspondence School did not die.

Undated mailing

ANDY WARHOL
URINATING

twelve urinating penises, is transformed by Johnson into an icon overflowing with corporeal prosperity (left).

The Whitney exhibition in 1970, which presented the NYCS to a wide and indifferent public for the first time, enacted an important symbolic shift. It might be seen as the first of a series of events that would lead to the official demise of the NYCS three years later. Key articles on correspondence art appeared in the popular press after 1970, generating a deluge of newcomers that flooded the NYCS's communication channels. One article, published in *Rolling Stone* in 1972, celebrated its increasing popularity: "The NYCS *triumph* was the Whitney's Correspondance show, in which 107 [sic] 'members' of it and other correspondence groups were represented with worn envelopes, stickers, collages and 'messages' of every description."[23] But in 1973, Johnson abruptly declared that the NYCS, as if it were a living organism, had died (p. 131). The NYCS, as vital and heavy as ocean water, could evaporate with barely a trace. After 1973 he would periodically refer to it as The Dead School. Complex and playful as ever, though, he also contradicted himself, making announcements such as "The New York Corraspondence School did not die." Death, for Johnson, was a formative component within the existence of things.

The NYCS expresses the traits of a particular aesthetic emergent in the postwar period. The use of collage and collaborative projects which kept the NYCS mobile, as well as the thematic recurrence of death (the value of nothing) and resistance to an explicitly political stance, were characteristic traits. One of the centers in which this aesthetic position had evolved had been Johnson's own alma mater, Black Mountain College. What Johnson's work seems to accomplish, informed as it was by this postwar aesthetic, is to have seen the world as an infinite maze in which every being, object, and referent is somehow inter-connected. From a social logic dominated by progress to an ecological logic governed by process, the New York Correspondance School represents an exceptional example of this emergent imagination. The Whitney's 1999 exhibition of *Ray Johnson: Correspondences* displays some aspects of this orientation, but, operating in accord with the necessarily reductive and reifying logic of a museum, it might be hard pressed to generate the connections which would return life to the School's reincarnation. Ray Johnson had anticipated that this was so, sending, in advance, a letter of love and hate.

Unpublished letter sent to
New York Times, 1973

I am grateful to Scott Watson, Robyn Laba, Andrew Klobucar, Michael Morris, Bill Wilson, Muffet Jones, Donna De Salvo, and Cathy Gudis for their support and assistance in the research and formulation of this essay.

1. The history of the NYCS is discussed in Edward M. Plunkett, "The New York Correspondence School," in "Send Letters, Postcards, Drawings, and Objects...," *Art Journal* 37, no. 3 (Spring 1977): 233-35, and Michael Crane, "The Origins of Correspondence Art," in Crane and M. Stoffet, eds., *Correspondence Art: Sourcebook for the Network of International Postal Art Activity* (San Francisco: Contemporary Arts Press, 1984).

2. Interview with Marcia Tucker, 1998.

3. "A Time for Stock-Taking," *New York Magazine*, September 14, 1970, 55.

4. "What People are Talking About," *Vogue*, October 1, 1970.

5. Gerrit Henry, "New York Letter," *Art International* 14, no. 9 (November 20, 1970): 71.

6. Kasha Linville, "New York," *Artforum* 9, no. 3 (November 1970): 86 (emphasis added).

7. Lucy Lippard, *Six Years: The Dematerialization of the Art Object from 1966 to 1972* (New York: Praeger, 1973), 6.

8. Lawrence Alloway, "Ray Johnson," in "Send Letters," 236.

9. Ray Johnson, interview with Diane Spodarek and Randy Delbeke, "Ray Johnson," *Detroit Artists Monthly*, February 1978, 7.

10. Ibid.

11. David Bourdon, "Cosmic Ray: An Open Letter to the Founder of the New York Correspondence School," *Art in America* 83, no. 10 (October 1995): 108.

12. Carter Ratcliff, *The Fate of a Gesture: Jackson Pollock and Postwar American Art* (New York: Farrar Straus Giroux, 1996), 245.

13. Ibid., 272

14. The concept of counter-history has evolved, most recently, in reference to the Beats; see, for example, *Beat Culture and the New America*, exh. cat. (New York: Whitney Museum of American Art, 1995).

15. Hilton Kramer, "Art: Out of the Mailbox," *New York Times*, September 12, 1970.

16. This difficulty has been illustrated by Johnson's 1970 Whitney exhibition, as neither the original works nor their photo-documentation have been recovered.

17. See "A Conversation with Marcia Tucker, Director of the New Museum of Contemporary Art," *Artweek*, April 23, 1992. In an earlier interview Tucker explains, "In New York there's the art *world* and the art *community*. In general, in other parts of the country, there's just the art community. The art world is something I'm not too interested in. I don't feel as though I share in its values. But I do feel I'm part of the art community." In "The New Museum: An Interview with Marcia Tucker," *Vantage Point*, September–October 1984, 11. After her departure from the Whitney in 1976 Marcia Tucker went on to found the New Museum of Contemporary Art in New York. The New Museum

Untitled (Letterbox), 1964
Letterbox, 108 envelopes containing collages, drawings, and postcards sent to David Bourdon, 19¾ x 14¼ x 4¾
Virginia Green, New York

remains a testament to Tucker's contribution to the emergence, in recent decades, of an engaging critical discourse around lesser known practices, granted less value in the art world than in the art community, such as those of Johnson's NYCS.

18. This aesthetic has been explored by P. A. Klobucar in "After Pound: Modernism and Ecology at Black Mountain College," unpub. manu., 1998.

19. Daniel Belgrad, *The Culture of Spontaneity: Improvisation and the Arts in Postwar America* (Chicago: University of Chicago Press, 1998).

20. Michael Morris brought this interpretation to my attention.

21. *Correspondence: An Exhibition of the Letters of Ray Johnson*, exh. cat. (Raleigh: North Carolina Museum of Art, 1976).

22. As quoted in Harvey Aronson, "What? You Never Heard from Ray Johnson?" *Newsday*, January 18, 1969.

23. Thomas Albright, "New Art School: Correspondence," *Rolling Stone*, April 13, 1972, 32 (emphasis added).

RAY JOHNSON
144 WEST 7 STREET
LOCUST VALLEY
NEW YORK 11560

April 5, 1973

Deaths
New York Times
229 West 43 Street
New York City 10036

Dear Deaths:

The New York Correspondence School, described by critic Thomas Albright in "Rolling Stone" as the "oldest and most influential" died this afternoon before sunset on a beach where a large Candian goose had settled down on it's Happy Hunting Ground, was sitting there obviously very tired and ill and I said to it "Oh, you poor thing". It mustered up whatever strength it had and waddled away from me. "How beautiful!" I thought. "How like a bird - about to die and yet having some courage to try to go on". And then it lifted it's legs and wings and shit out some black shit it was such a large heavy bird it flapped it's wings and I studied the curve of the wings I thought Anne Wilson would like to see them. It just wanted to be alone to die without a human standing there talking to it. I felt so bad. So it flew off and soon I was aware I couldn't see it anymore it had gone. Maybe if I go back there tomorrow, the tide will have washed up it's feathery body.

Ruth Ford died her black hair blonde.

I telephoned her. "Breeze From the Gulf".

The stars look very different today. Ground Control to Major Tom. Time to leave the Capsule. I'm stepping through the door. Tell my wife I love her very much.

Most sincerely yours,

Buddha University

You mean,
Pablo Picasso
collected
Ray Johnson's Too?

131

1967 NEW YORK CORRESPONDANCE SCHOOL REPORT

The N.Y.C.S. attacked itself and strangled itself, mutilated itself, tried to kill itself off but returns! The fetish has to be fed. The non-profit organization without a Girl Friday konked out under the weight of the fantastic network of previous structure. Very encouraging was the response from England who even came up with the London Correspondance School. David Bourdon was dropped whose valentine in part read "don't send me your emotional blackmail". Bici Henbricks told me stories about how Xenia Cage asked to be taken off her list. Years ago, Jeanne Raynal expressed distaste at the "mailings" saying it all had been done before. Michael Malce has not been heard from in quite a while. Is he dead?
Jim Rosenquist always drops a card when he travels.
Nobody wants the "Book About Death". We'll kill that off soon too.
The complete letters and cards of Richard C are being returned to him. David Hayes once returned most of his repository of Correspondance when he was "d iscollecting". Albert Fine took a bunch of his to the woods and left it under a tree. The Wilsons created the Wilson Archives. Haven't heard from Helen Jacobson in ages. We hear she glued all hers down to a screen. George Brecht auctioned off a lot of his.
What is desired at this time is death to the fetish. Like book burning it is a simple matter of doing away with. It is like a weed that continues to survive. It needs no nurishment. A scarlet tanager will be sent to Tom Hess. Andy Warhol has never been a superstar in the N.Y.C.S. but Billy Linich recently received two personailty posters of Peter Fonda. I once told Mrs. Spiselman to throw tons of the stuff down the incinerator. May Wilson has always been good, groovey and knows how to play the game. John Willenbecher so sweet about it, it almost hurts Mona Lisa.
George Ashley great.
The N.Y.C.S. is tired.
It shall be fired. It wants nothing. It is throwing out all its phone books. Joe Raffaele is great.
The N.Y.C.S. attacked Jim Rosenquist and strangled Helen Jacobson, mutilated Albert Fine, tried to kill Peter Fonda and sinks! The fetish has to be Fred. The non-profit organization without Robinson konked out under the white of the ban opera hose. Timothy Baum is great. God Bless the London C.S. David Bourdon would appreciate any information about Joseph Cornell. Lucy Lippard went to Maine. Philip McCracken wants to meet John Cage. Is Jeanne Reynal still doing mosiacs? They also are heavy. What would Michael Malce do without a window? The N.Y.C.S. wants to look out a window and see a tree or the sea. It is sick of stamps.

Ray Johnson

Meeting Seating

DIANE ARBUS	DORE ASHTON	BETSY BAKER	MARY BAUERMEISTER	LAURA BENSON	CAROL BERGE
PAMELA BIANCO	HELEN GURLEY BROWN	RHETT BROWN	JEAN-CLAUDE CHRISTO	SUZANNE DE MARIA	VICKI DOUGAN
NANCY DOWD	LOTTE DREW-BEAR	VIRGINIA DWAN	SUSAN ELIAS	SANDRA FEIGEN	SEVIM FESCI
VIRGINIA FRITZ	SUZI GABLIK	WANDA GAG	CHARLOTTE GILBERTSON	LILA GOODMAN	NANCY GRAVES
MRS. RONALD GROSS	HANNELORE HAHN	TINA HAHN	PIRI HALACZ	MRS. DAVID HARE	MARCIA HERSCOVITZ
EVA HESS	ALISON HIGGINS	HELEN IRANYI	HELEN JACOBSON	PATRICIA JOHANSON	MARGUERITE JOHNSON
JILL JOHNSTON	SACHA KOLIN	JILL KORNBLEE	CHRISTINE KOZLOV	ALICIA LEGG	RUTH LEVI
MRS. JULIEN LEVY	IRIS LEZAK	LUCY LIPPARD	POLLY MARSTERS	SYLVIA MILGRAM	MARTA MINUJIN
MITSOU	KARLA MUNGER	ALICE NEEL	BABETTE NEWBURGER	BETTY PARSONS	LIL PICARD
M. PIETKJEWICZ	VERONIKA PIETKJEWICZ	PRIMAROSA	FRANCES X. PROFUMO	ROBIN RICHMAN	BARBARA ROSE
LINDA ROSENKRANTZ	DOROTHY SIEBERLING	FLO SPISELMAN	TOBY SPISELMAN	N. STRUTZ	KAY SUSSMAN
MARCIA TUCKER	JOHANNA VANDERBEEK	MRS. JAN VAN DER MARCK	ELAYNE VARIAN	ULTRA VIOLET	DIANE WALDMAN
ELEANOR WARD	ANNE WEHRER	HANNAH WEINER	WILLIAM WILEY	MARION WILLARD	MAY WILSON

Ray Johnson 1968

Mailing, 1967

Mailing, 1968

MARCH 16, 1969

DEAR GEORGE ASHLEY,

26TH MARRAKECH
MATCH

Mailings, 1969

THE NEW YORK CORRESPONDANCE SCHOOL RABAT, MOROCCO FEBRUARY 21, 1969

LETTERS

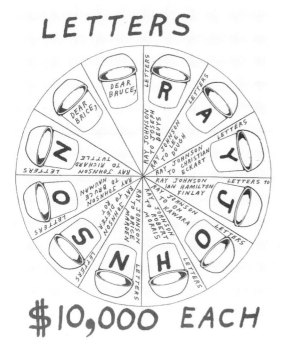

$10,000 EACH

RAY
JOHNSON
T-SHIRTS
ONE
MILLION
DOLLARS
EACH

,1970

DEAR ROBERT PINCUS—

*WIT IS A NICE DAY
SO & THERE FOR
I THOUGHT I SHOULD
WRITE YOU.*

*HOW ARE YOU
AND ALL THAT
STUFF?*

*I AM FINE AS ALL
GET OUT.*

*HOPE YOUR AS NICE
AS YOU PLEASE.*

RAY JOHNSON

PLEASE
SEND TO
ROBERT
PINCUS
WITTEN

RAY JOHNSON LETTERS TO ROBERT PINCUS-WITTEN

$5,000 EACH

Mailings, ca. 1980s

136

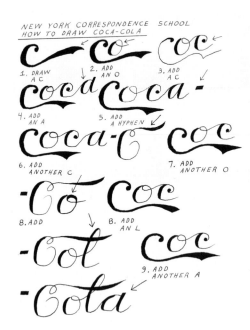

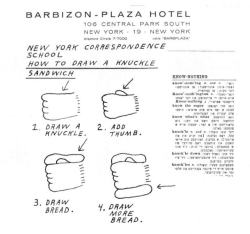

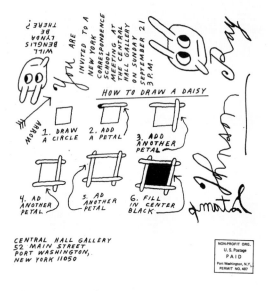

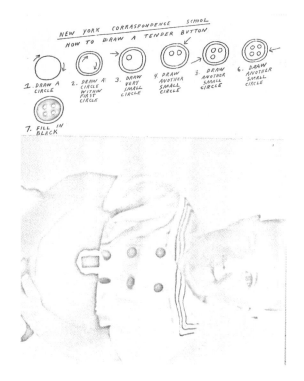

Mailings, ca. 1980s

138

DEAR JUDITH VAN WAGNER,

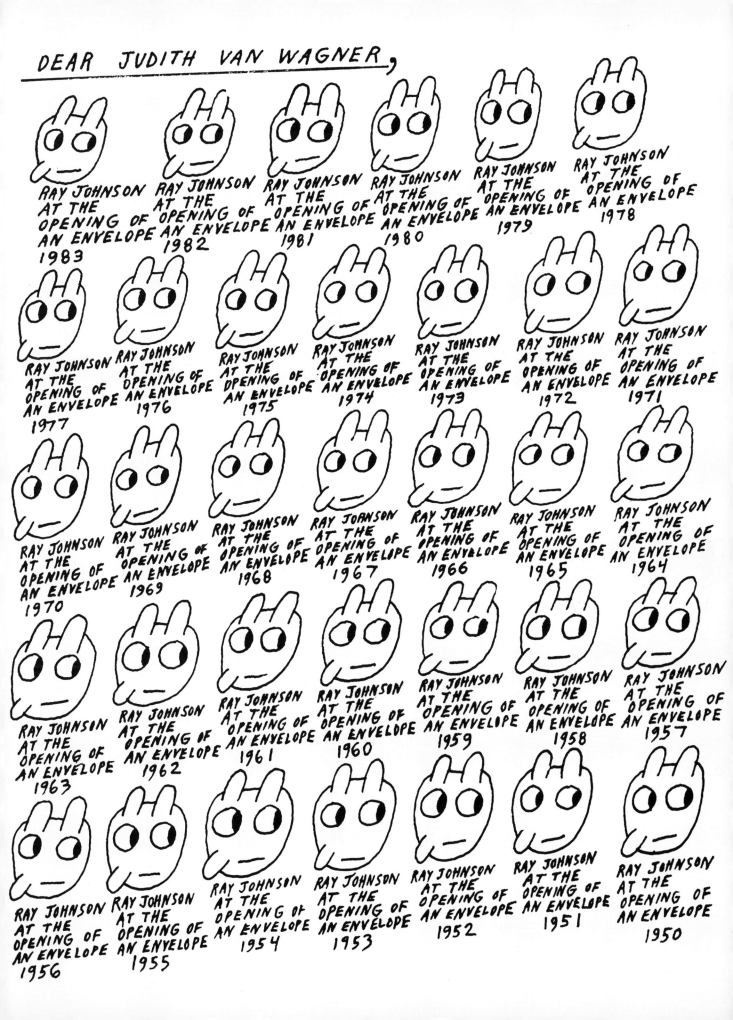

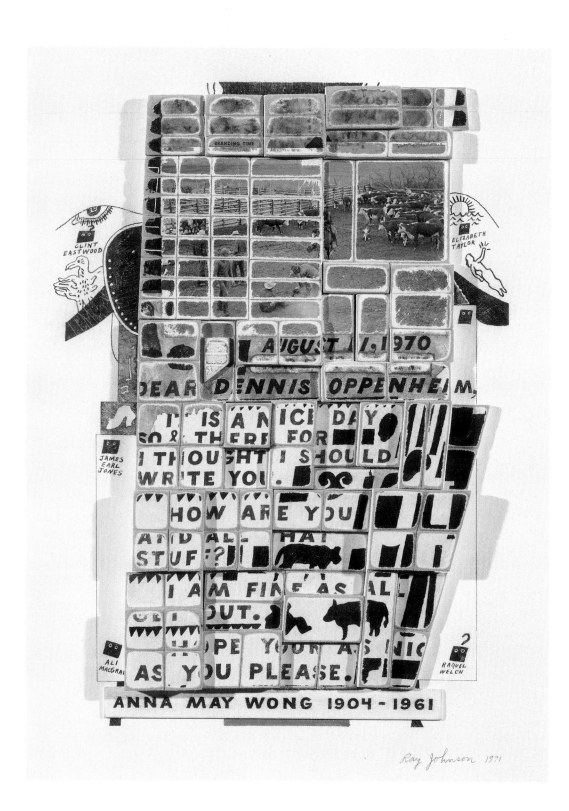

Anna May Wong, 1971
21⁷/₈ x 18³/₈
Whitney Museum of American Art, New York,
Purchase, 71.178

Lucy R. Lippard

SPECIAL
DELIVERANCE

FROM THE OUTSET, Ray Johnson's art-as-life enterprise was as perverse and contradictory as his life-as-art…and eventually his death-as-art. The covert messages conveyed by his mail art denied its overt accessibility. His outreach was aimed at insiders. His humor could be painful. His enthusiastic communications were secretive. He simultaneously resisted and courted the art world. (The critic Grace Glueck called him "New York's most famous unknown artist" in 1965, and that was still true thirty years later.) Johnson's cross-references lured the viewer across the abyss and into the labyrinth. This essay is not so much an attempt at disentanglement as a voluntary entanglement, an attempt to understand the fragmentation that was the paradoxical heart of Ray Johnson's sense of order.

When in 1955, at the age of twenty-seven, Johnson approached the *Village Voice* for some attention, he told the columnist he made moticos. "They're really collages," he explained, "paste-ups of pictures and pieces of paper, and so on—but that sounds too much like what they really are so I call them moticos. It's a good word because it's both singular and plural and you can pronounce it how you like. However, I'm going to get a new word soon."[1] That new word was never born, and no one seems to have translated this one, but Johnson loved anagrams, so the possibilities are there. How about *cosimot*, loosely seen as space traveler, or "almost word" in French, or a cousin of Quasimodo; or *cosmoti*, with some alliance to the flower, or more portentously cosmotological; *tomocis* or *mistoco*—searching for smooches, or somehow mistaken? Clearly, one guess is as good as the next and leads inevitably to the next, which may have been the whole

point. Leading questions were a *specialité de la maison* Johnson.

He went on to rhapsodize on the excellent uselessness of moticos: "The next time a railroad train is seen going its way along the track, look quickly at the sides of the box cars because a moticos may be there." (Twenty years later it would be called graffiti.) "Don't try to catch up with it; it wants to go its way.... The best way is to go about business not thinking about silly moticos.... Perhaps you are the moticos. Destroy this. Paste the ashes on the side of your automobile, and if anyone asks you why you have ashes pasted on the side of your car, tell them." Typically, there is no punch line.

The critic Lawrence Campbell reported that in the early 1950s *Harper's Bazaar* asked Johnson to say something about what kind of artist he was, and he replied: "When I go walking down the street/All the little birdies go tweet tweet tweet."[2] This did not exactly ensure his place in art history. Linda Yablonsky called him a cut-up.[3] He described his work to James Rosenquist as an extension of Cubism, because he "put things in the mail and they get spread all over the place."[4] Overtones of Dada and presentiments of Fluxus are obvious in his work, but Johnson steadfastly denied them. "I'm classifiable as a Pop artist, as a Conceptualist, as a Surrealist," he said a couple of years before his death.[5]

While I wrote a good deal about Pop, Conceptualism, and Surrealism in the 1960s and 1970s, it never occurred to me to place him in any of these contexts, although with hindsight I can identify individual works that would make a good case for any one of them. The *Elvis* of 1956 (p. 94) and *Marilyn Monroes* of 1958 heralded Warholian Pop. Mail art's mode of distribution and the word plays were conceptual (but not Conceptualist). Johnson's 1968 idea of having a show with David Herbert that would just be an empty gallery was executed by Conceptualists like Robert Barry and Daniel Buren. And the collages are broadly Surrealist, although far closer to Dada in their delightful absurdity that takes off without weighty psychological or political anchors. Ultimately, Johnson shared with all three movements an iconoclasm aimed at transcending and even changing the commercial nature of the art world. Clive Phillpot, the former librarian of the Museum of Modern Art, explained Johnson's invention of mail art: "He didn't like dealing with museum curators because he didn't like the idea of rejection, so he corresponded with the museum librarian, knowing his letters would have to be filed."[6]

As a classifier par excellence, Johnson knew how to name and then evade. Like most artists, he also evaded mention of individual aesthetic influences, although the clues are in the titles of his portraits and collages, a role call that includes, among many others, Marcel Duchamp, Piet Mondrian, Henri Matisse, René Magritte, Paul Feeley, Sonia Sekula, Jackson Pollock, Barnett Newman, Arakawa, Saul Steinberg, Mark Rothko, Ed Ruscha, Louise Nevelson, Alfonso Ossorio, and Ad Reinhardt. When he attended Black Mountain College in the early 1950s, Johnson formed friendships with the Rauschenberg/Johns/Cage set and a long-lasting

liaison with the abstract sculptor Richard Lippold. He studied with Josef Albers, and the ordered, architectonic building blocks of his collages have been attributed to this experience.[7] However, Johnson was no formalist, which is not to say he wasn't a brilliant composer. He found order, and then willfully subverted it. Kurt Schwitters is often mentioned as one of his precursors, which works on a formal level, but Johnson himself did not seem overwhelmed by the *Merzmeister*. Joseph Cornell, also much-mentioned, is a better bet, since Johnson knew and admired him. His own aesthetic, however, was less poetic and mystical, more Pop and robust, and, in its repetitions, more minimal than that of the recluse of Utopia Parkway. Johnson told an interviewer, "You're not just influenced by artists. You're influenced by places and years and other people and irritations and problems. There's no direct thread to any one thing."[8]

Like all truly eccentric artists, Johnson regarded the center as both attractive and repellent. The enormous energy of his art may well have derived from that tension—needs and desires countered by rejection and inhibition, resulting in the incredible flow of gifts outward into the world and an inability (or refusal) to follow them. He told Dick Higgins, "I want to live and die like an egg."[9] Forever unhatched? In any case, he was reluctant to come out of his shell. He once admitted it was "very comfortable" to "never get out of childhood."[10] His trademark short-eared bunny, which sometimes transmuted into a duck, was a case in point. Why a rabbit? (Why a potato masher, for that matter?) A coincidence Ray would have loved: I had an eccentric uncle, a physics teacher, also a refugee from adulthood, who used a very similar cartoon bunny face as his signature mark.

Johnson was pleased when a critic said he was a master of the throwaway gesture, and indeed his whole career can be seen as a vast and deliberate throwaway, the Duchampian gesture for gesture's sake at the expense of a fame and posterity he seems to have yearned for but would probably have backed away from had it finally come his way. Yet there are all these intricate collages, made by the most tenderly time-consuming methods—observed, collected, assembled and reassembled, finally pinned down, sanded down, softened into ghostly memories or pointed up in manic black-and-white detail, overflowing with wit, charm, and enigma. A note for "back of envelope" repeats twice, "I am interested in the art of greatest simplicity. Ray Johnson." Another note to his good friend, the Fluxartist Dick Higgins: "Dear Dick Higgins: 'I am writing to you today to say red, yellow and blue. Ray Johnson.'"[11]

143

A BOOK ABOUT DEATH By Ray Johnson

MARY Crehan, 4, choked to death on a peanut butter sandwich last night.

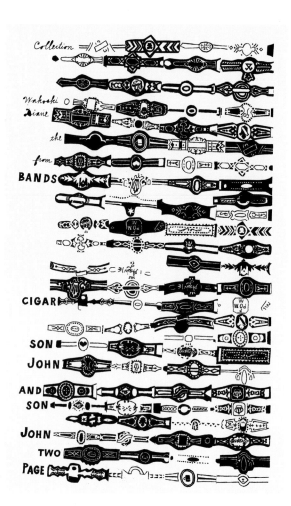

Ray Johnson tells parables. He finds a use for coincidence. He pounces on and proclaims a day-by-day order and meaning in events.... Since Ray Johnson lives a life that is a continuous revelation of pure and radiant design, the image of that life is art. Since the life itself is designed of coincidences, like a walk taking a line, the aesthetic reciprocal of that life is a Ray Johnson collage.... It happens that his life is a collage. At least it happens that he works at his life until it is a work of art, and he works at his art until life catches up with it.
—William S. Wilson[12]

The relationship of the parts to the whole was at the core of Johnson's life-collage and suggests his relationship to various art "communities." William S. Wilson, for instance, was his most perceptive chronicler, and Wilson's whole family participated in Johnson's art production: his former wife, artist and diarist extraordinaire Ann Wilson, to whom the well-known "brick snake" (p. 145) was dedicated; their twin daughters, Ara and Kate; and his mother, artist May Wilson. Ray sent May presents—works of art of his own or gifts to him from other artists. She would sit on them, cut them up, paint them another color, and then they would appear incognito in her own assemblages. The painters Larry Poons and Robert Bucker and the sculptor Ruth Asawa were among the involuntary donors. This regard for the work of art as raw material and disregard for its role as valuable object makes sense in the exchange aesthetic of the New York Correspondence School. "What arises out of the NYCS is a curious tissue of relationships," writes William S. Wilson, "a society of sorts, associating people who might think in images.... Things, people, words and images can be brought together for a meeting but not for a fusion. You

can come closer and closer to these paintings and never be intimate with them...."[13] This kind of fundamental alienation, or detachment, seems to have been replicated in Johnson's life, which was, of course, his art.

Collage is almost by definition a life-art, fed by endless little discoveries; it runs and stops and changes direction, embracing interruptions and distractions, inducing epiphanies. All life-art is obsessive (I think of Linda Montano, Andy Warhol, Tehching Hsieh, Martha De Foe, among others). Most artists go to the studio at appointed times, and no matter how much their art may be on their mind, it is not as inseparable as it is for those artists who live their art, for whom the umbilical cord has never been cut (or else it is hung in the rafters). Johnson's little house in Locust Valley (once pink, then grey, "spelled with an E") was a frame for his collage.

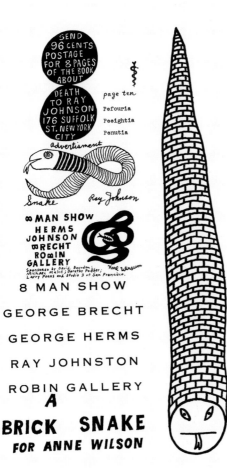

It became an installation piece when visitors arrived. He told Richard Bernstein, "I spend two days hiding everything and then I do these arrangements. I take what little furniture I have and make little works of art.... My best works of art is art in process." That day Bernstein was treated to a "silvery white huge crepe of an acrylic paint puddle dried right into the oriental rug forever," which Johnson coolly identified: "Oh that was a can of paint kicked over by the ghost of Janis Joplin."[14]

Everything was grist to Johnson's mill—not just the letterheads, envelopes, stamps, rubber stamps, but the stuff of encounters, which were in turn the raw materials for the "meetings" of the NYCS—themselves collages of flesh, time, fashion, and conversation. "We had a Paloma Picasso Fan Club Meeting. Lots of glamorous people came to that meeting," he boasted. "They wanted to know why they were there. I told people I was trying to create a room with a certain number of people. But magically the right number of people did *not* come."[15] The stars of these meetings were often women, ranging from comic characters Nancy and Little Orphan Annie to Anna May Wong, Naomi Sims (p. 146), Diane Fischer, Paloma Picasso, and Dorothy Podber, the woman who marched into Warhol's studio, pulled a gun, and

145

shot once at each of a series of Marilyn silkscreen paintings, which were then marketed as *Shot Marilyns*—an eerie prediction of the grimmer Valerie Solanas episode. The similarities to the Warhol milieu, in which Johnson also participated, are obvious. But the dissimilarities are more noticeable—aesthetics primarily, but also scale. Johnson's work lacked the brashness of Pop art or Warhol's undisguised ambition; the Factory gatherings were social life, frames for his own and others' celebrity, creating the milieu for the *Marilyns* and *Jackies* and *Liz Taylors*. Johnson's gatherings were odder, more elusive, more modest, more evocative. They were art, not parties. Wilson wrote: "Ray Johnson is a mild-mannered choreographer who sets people in motion."[16]

Portraits were a natural consequence of his fascination with people, celebrities, and the names attached to them. There are around three hundred portraits, sometimes as many as forty variations on a single subject. The silhouettes drawn from "life," or rather the shadow of life, were oblique approaches to portraiture, as the preferred profile is the oblique approach to a face or a person. Johnson drew empty vessels, the contours of a person that the artist could be filled in. (The Odilon Redon Fan Club comes in here somewhere.) Johnson saw the collages as "depictions of inner states.... It's linked to the Correspondence School," he told Helen A. Harrison. "I can make interconnections, can put any idea into someone's head via the telephone or a letter. This is just another way of doing it.... It's a sneaky kind of portraiture."[17]

The subjects were as diverse as the artists named earlier and included Harold Rosenberg, P. T. Barnum, Emily Dickinson, David Bowie, William Burroughs, James Dean, River Phoenix, and James Joyce (the last two were adorned with the Lucky Strike cigarette logo, which bore some special significance to Johnson). He frequently incorporated photographs as collage materials, which Wilson says worked "as a reference to something, not a representation of it.... Memory and logic are reformulated into a single

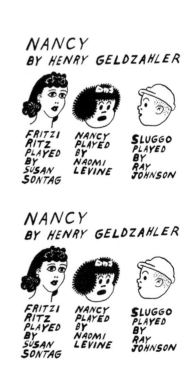

Mailing, ca. 1970s

Bruce, Jean and Robert dropped by to visit. Bruce Conner
played his harmonica. Bruce Conner blew up a pink balloon.
Ray Johnson served tea bag tea. Ray Johnson gave Bruce
Conner a left black high heel shoe and a white shirt and
some Sabrina photos. Richard Lippold sat at a typewriter
arranging a photo book of his works. Baby Conner had
blonde hair. Jean Conner wore two rings on her right hand
and a thin gold on her left. The apartment was neat and
spic and span and uncomfortable. Ray Johnson gave Jean
Conner a bar of Palmolive soap. Jean Conner changed Robert
Conner's diapers. Ray Johnson showed his Jean Harlow photos.

 Ray Johnson

Typescript, 1963

language of cross-references…. he takes public images (e.g. clippings from popular magazines) and sends them to friends for their private references. In the public collages, private references are made public."[18] Each of these portraits is a record of an encounter between Johnson's and someone else's art.

In 1968 Johnson moved out of the center (or out of the center's peripheries) from the Lower East Side to Long Island, a departure triggered by the assassination of Robert Kennedy, the shooting of Warhol, and the mugging of Johnson himself by three men with a switchblade—all within one twelve-hour period. The mail art phenomenon might have been practice for this move, or removal. Johnson said the New York Correspondence School began in the 1940s when he started writing letters as a schoolboy in Detroit (p. 16). Officially named in the 1960s by Ed Plunkett, it was soon reincarnated as Buddha University. Variously misspelled, New York Correspon*dance* School was my favorite designation, because it was a distanced dance with an endless series of new partners. Its ephemerality was its defense. "There's never been a New York exhibition of correspondence art," Johnson said in 1968. "I don't know how it could be organized, because just to do it would kill it."[19]

As Mark Stevens put it, Johnson's "playful postal 'dance'…created a phantom sense of community, isolating what was there and not there. A communication from Johnson seemed at once personal and abstract, everything and nothing."[20] Wilson wrote, "Ray Johnson plays the U.S. Mail like a harp. His art is not of social comment, but of sociability."[21] Maybe, but it was a curiously inverted and even at times misanthropic kind of sociability. The lines he was dropping may have been calls for help (de-spondance). In *The Paper Snake*, Johnson wrote: "*Association*, since collaboration long ago proved impossible." "At one point," he recalled, "I gave up on communication with people, and decided that my correspondence art existed for only one person—me. I previously thought that it existed only for you—me and you—and then I decided that you were no longer necessary."[22]

Johnson didn't do chain letters as such, although there was often a middle-person between sender and ultimate receiver. But chains of association, coincidences, analogies, and surprises were his medium. "I'm intrigued and interested in an incredible galaxy of people," he said. Yet warm and fuzzy humanism was not his reason for being interested. "My reason for being interested in people is their anagrammatic names. Since I cut everything up they're all people like in a kaleidoscope, but one person is many-faceted, like a crossword puzzle."[23] I was once personally roped into this game. Although I knew Johnson only slightly, in the late 1960s he sent

147

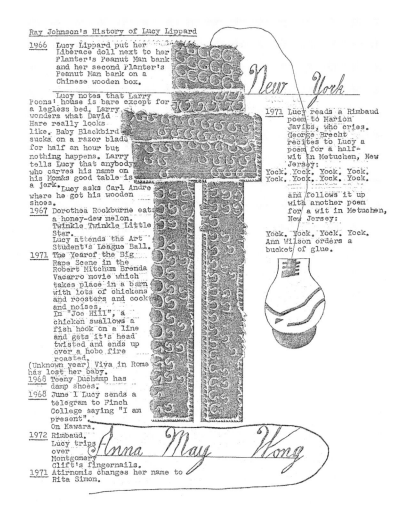

Ray Johnson's History of Lucy Lippard

1966 Lucy Lippard put her
 Liberace doll next to her
 Planter's Peanut Man bank
 and her second Planter's
 Peanut Man bank on a
 Chinese wooden box.

 Lucy notes that Larry
Poons' house is bare except for
a legless bed. Larry
wonders what David
Hare really looks
like. Baby Blackbird
sucks on a razor blade
for half an hour but
nothing happens. Larry
tells Lucy that anybody
who carves his name on
his Mom's good table is
a jerk. Lucy asks Carl Andre
where he got his wooden
shoes.
1967 Dorothea Rockburne eats
 a honey-dew melon.
 Twinkle Twinkle Little
 Star.
 Lucy attends the Art
 Student's League Ball.
1971 The Year of the Big
 Rape Scene in the
 Robert Mitchum Brenda
 Vacarro movie which
 takes place in a barn
 with lots of chickens
 and roosters and cocks
 and noises.
 In "Joe Hill", a
 chicken swallows a
 fish hook on a line
 and gets it's head
 twisted and ends up
 over a hobo fire
 roasted.
(Unknown year) Viva in Rome
has lost her baby.
1968 Teeny Duchamp has
 damp shoes.
1968 June 1 Lucy sends a
 telegram to Finch
 College saying "I am
 present". On Kawara.
1972 Rimbaud.
 Lucy trips
 over
 Montgomery
 Clift's fingernails.
1971 Atirnomis changes her name to
 Rita Simon.

New York

1971 Lucy reads a Rimbaud
 poem to Marion
 Javits, who cries.
 George Brecht
 recites to Lucy a
 poem for a half-
 wit in Metuchen, New
 Jersey:
Yock. Yock. Yock. Yock.
Yock. Yock. Yock. Yock.

 and follows it up
 with another poem
 for a wit in Metuchen,
 New Jersey:

Yock. Yock. Yock. Yock.
Ann Wilson orders a
bucket of glue.

Anna May Wong

out an NYCS mandate: "Send Slips to Lucy Lippard" (p. 149). (And did I ever get slips. Months later, when they had slowed to a trickle, mail art had palled for me.) I was puzzled by this directive. Freudian slips? Pink slips? (I received at least one pink [silk] slip.) Ray and I were often at parties together, and someone told me the "slips" had been sparked by my manic dancing. (No slips were worn under miniskirts; we all drank a lot then; did I slip?) Eventually I went from "Lucy slips" to "Lucy's Lips" and "Loose Lips" and felt I was getting closer. (I talked a lot too; years later I did a comic strip under the name "Lucy the Lip.")

148 Visual and verbal puns were Johnson's daily bread, and they often took physical form. He once took a taxi from the Harbor Bar to the Barbara Bar for the sake of a "bad rhyme, a coincidence of sound."[24] He crashed an exclusive art party by telling the doorman he was Norman Mailer, and later a similar affinity was expressed for David Letterman. It surely didn't escape Johnson that he was obsessed with the U.S. Mail, another cross-reference that may have appealed to him as a gay man. He wrote in *Paper Snake*: "To mail a nail. There is nothing to compare with mailing a nail," and it's difficult to avoid the temptation to reverse this to nailing a mail. Henry Martin wrote that Johnson worked within "a closed system of images. Its origins are so thoroughly concealed that one must look for correspondences rather than explanations.... Essentially he has no subject matter at all, and this is what enabled him to deal with everything that comes to him."[25]

Johnson said of his work that "It might be its function to not have meaning... I like the idea of nothingness." He said of his performances/lectures/meetings, "I begin with no plan. I face the void." "I play." "I do nothing."[26] This distaste for obvious content would explain his connection to Ad Reinhardt, a friend, who also loved puns and nothingness, and admired Johnson's mandalas, which resembled in spirit and form his own 1940s cartoon works. One of Johnson's memorial collages for Reinhardt (made five years after his death) is ringed with a bizarre selection of artists' names: Lee Krasner, Ruth Vollmer, Hedda Sterne, Kenji Okada, Perle Fine, Thomas Sills, Thomas Stokes, Minoru Kawabata, and Paul Bodin. While Reinhardt probably knew all these people, it's hard to figure out what their significance would have been;

Mailings, ca. 1970s

my guess is that they were all members of American Abstract Artists, to which both Reinhardt and Johnson temporarily belonged in the late 1940s to early 1950s. The collage might be a visual reference to Reinhardt's cartoon collages in which the leaves of a "family tree" are marked with artists' names in a sort of irreverent genealogy. Johnson also made an "Ad Reinhardt heart. It's sort of partly square but it has part of the curve of a heart."[27]

Having written extensively about both tendencies, I can relate to Johnson's fondness for Dada and for classical purism. They are usually perceived as two opposite poles of art making, but Johnson was not an either/or kind of guy. His slippery style slid from one extreme to another without ever losing its personal character. *Untitled (Beige on White)* (1954/78), for example, suggests a kind of purism along the lines later developed by Richard Tuttle, while *Untitled (Emily Dickinson)* (1978–92) could be by Hannah Höch or El Lissitsky, and *Green* (1989, p. 161) conveys a gentle Zen expressionism. All his random references over the years to artists like Mondrian, Reinhardt, or Patricia Johanson make it clear that while Johnson's public activities and personality are perceived as anti-aesthetic, the artworks themselves had a classical foundation. He thought about line, space, and order the way they are taught in art history. But the rules were filtered through a personal deregulation process that subverted order. As in his life and personal relations, perversity reigned. What is wonderful about his collages is their unexpectedness. A 1972 portrait of Agnes Martin, for instance, is a wild variation on "outsider art," featuring a white-on-black dot pattern that might have been a reference to her work but certainly not to her aesthetic.

In a piece on Johnson, Wilson once quoted Vladimir Nabokov's *Pale Fire*: "There are events, strange happenings, that strike the mind as emblematic. They are like lost similes adrift without a string, attached to nothing."[28] Johnson's death was one of these. He drove all over Long Island, posting his last mailings on Orient Point (perhaps to get his bearings). Friends, admirers, and journalists had a field day with interpretation, convinced he would not have passed up a chance to leave one last message. But what was it? I didn't know Johnson well enough to make anything of

149

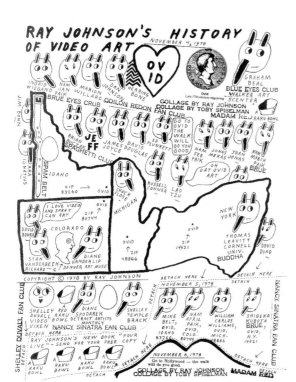

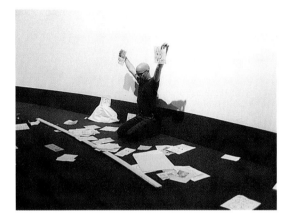

Performance of A Throwaway
Gesture at Walker Art Center, Minneapolis,
September 30, 1978

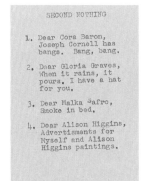

SECOND NOTHING

1. Dear Cora Baron,
 Joseph Cornell has
 bangs. Bang, bang.

2. Dear Gloria Graves,
 When it rains, it
 pours. I have a hat
 for you.

3. Dear Malka Safro,
 Smoke in bed.

4. Dear Alison Higgins,
 Advertisments for
 Myself and Alison
 Higgins paintings.

Untitled, undated
"script" for Second
Nothing

his final itinerary, which, when mapped, provides still more riddles and associations: Sag Harbor, Shelter Island, North Haven, Baron's Cove...and the bridge he jumped from had no name at all, a metaphor in itself. Was he sagging, taking shelter in these last havens and coves, these last puns, these last name-droppings behind him, the last indecipherable clues to a life as art? Nothing in his home left any apparent clues, although it is tempting to think the answer is buried in the boxes of raw and archival materials for only the most dedicated searcher and intimate to find one day.

Johnson's death inspired a good deal of hindsight. William S. Wilson writes: "Ray was on his way to drowning when I met him in 1956. It just took him 39 years to do it."[29] The critic Holland Cotter perceived a "campy morbidity" in Johnson's work, "a kind of spooky Dada version of Emily Dickinson." He continues: "even his portraits of living friends had an oddly funereal cast, suggesting a dark side to his art that his wit and pop erudition tended to obscure."[30] David Bourdon, a longtime close friend whose birthday was the day after Johnson's (and who died a couple of years later), wrote an obituary letter to Johnson: "Your sense of humor could be conspicuously morbid, and tales of freaky accidents and weird fatalities made you positively gleeful. At the time, you were producing *A Book about Death*, an ongoing project of photo-offset drawings, pages of which you periodically mailed out to your friends. Many of your mailings contained intimations of catastrophe."[31] Rosenquist, another friend, said: "I wish I could send him something. He doesn't have a mailbox anymore."[32] The only person who might know the address, Johnson's best friend, bank officer Toby Spiselman, a woman as enigmatic as the artist, has maintained her silence.

What sticks in my mind is the image relayed by two teenage girls who saw Johnson calmly backstroking through the icy water toward open ocean. Backing into the future, all at sea? His body was found floating face up with arms laid across chest, in defiance of gravity and the Dead Man's Float. What gives me a chill is that the motel owner refuted any intentionality by saying that Johnson's room number (247, adding up, as did his age at his death, to 13, the date of the Friday he died) was simply the only room available. Coincidence in this case is far more interesting than design. Right down to the end, Ray Johnson's art-life combined the two, and we'll never know where the lines were drawn.

 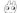

RAY JOHNSON

Helicopter event for 7th Avant-Garde Festival, Ward's Island, N.Y., 1969. (Box of 60 foot-long hot dogs *WERE* was dropped from helicopter.) Photo: Ara Ignatius. TAOIST POP ART SCHOOL

Mailing, ca. 1980s

1. Ray Johnson, in "The Village Square," *Village Voice*, October 26, 1955.

2. Ray Johnson, in Lawrence Campbell, "The Ray Johnson History of the Betty Parsons Gallery," *Art News* 72, no. 1 (January 1973): 56.

3. Linda Yablonsky, "Return to Sender," *Out*, October 1995, 58.

4. Quoted by James Rosenquist, "The Riddler: Ray Johnson," *Manhattan File*, April 1995, 84.

5. Ray Johnson, in Nancy Princenthal, "Artists' Book Beat," *Print Collectors' Newsletter* 23 (January–February 1993): 237.

6. Clive Phillpot, quoted in Harry Hurt III, "A Performance-Art Death," *New York* 28, no. 10 (March 6, 1995): 24.

7. Of the work I know, his 1947 cover for *Interiors* most resembles Albers.

8. Ray Johnson, in Sevim Fesci, unpub. transcript of tape-recorded interview with Ray Johnson, April 17, 1968, Archives of American Art, Washington, D.C.

9. Ray Johnson, quoted in William S. Wilson's text from the dust jacket of Johnson, *The Paper Snake* (New York: Something Else Press, 1965).

10. Johnson, in Fesci.

11. Johnson, *The Paper Snake*.

12. Ibid., front dust jacket flap.

13. William S. Wilson, "Ray Johnson: Letters of Reference," *Arts Magazine* 44, no. 4 (February 1977): 30.

14. Ray Johnson, in Richard Bernstein, "Ray Johnson's World," *Andy Warhol's Interview*, August 1972, 39.

15. Ray Johnson, in Toby R. Spiselman, "Ray Johnson Speaks in a Long Island Kitchen to Two Women," in William Wilson, ed., *Ray Johnson Ray Johnson* (New York: Between Books, 1977), unpag.

16. William S. Wilson, "The Comedian as the Letter," in *Correspondence: An Exhibition of the Letters of Ray Johnson*, exh. cat. (Raleigh: North Carolina Museum of Art, 1976), unpag.

17. Helen A. Harrison, "Ray Johnson: Shadow and Substance," Peter Frank, ed., *RE-DACT: An Anthology of Art Criticism* (New York: Wills, Locker and Owens, 1984), 80.

18. Wilson, "Ray Johnson: Letters," 28.

19. Johnson, in Fesci.

20. Mark Stevens, "Pop Luck," *New York*, May 22, 1995, 82.

21. Wilson, in Johnson, *The Paper Snake*.

22. Johnson, in Princenthal, 237.

23. Johnson, in Bernstein, 39.

24. William Wilson, "Ray Johnson: Vibration and Reverberation," in Wilson, ed., *Ray Johnson Ray Johnson*, unpag.

25. Henry Martin, "Mashed Potatoes," *Famous People's Mother's Potato Mashers*, exh. cat. (Milan: Galleria Schwarz, 1972), 22, 23.

26. Johnson, in Fesci.

27. Bernstein, 40.

28. Vladimir Nabokov, quoted in Wilson, "Ray Johnson: Letters," 30.

29. Wilson, quoted in Yablonsky, 61.

30. Holland Cotter, "Notes to the World (or Bend, Fold, and Spindle)," *Art in America* 83, no. 10 (October 1995): 102, 104.

31. David Bourdon, "Cosmic Ray; An Open Letter to the Founder of the New York Correspondence School," *Art in America* 83, no. 10 (October 1995): 118.

32. Rosenquist, 84.

151

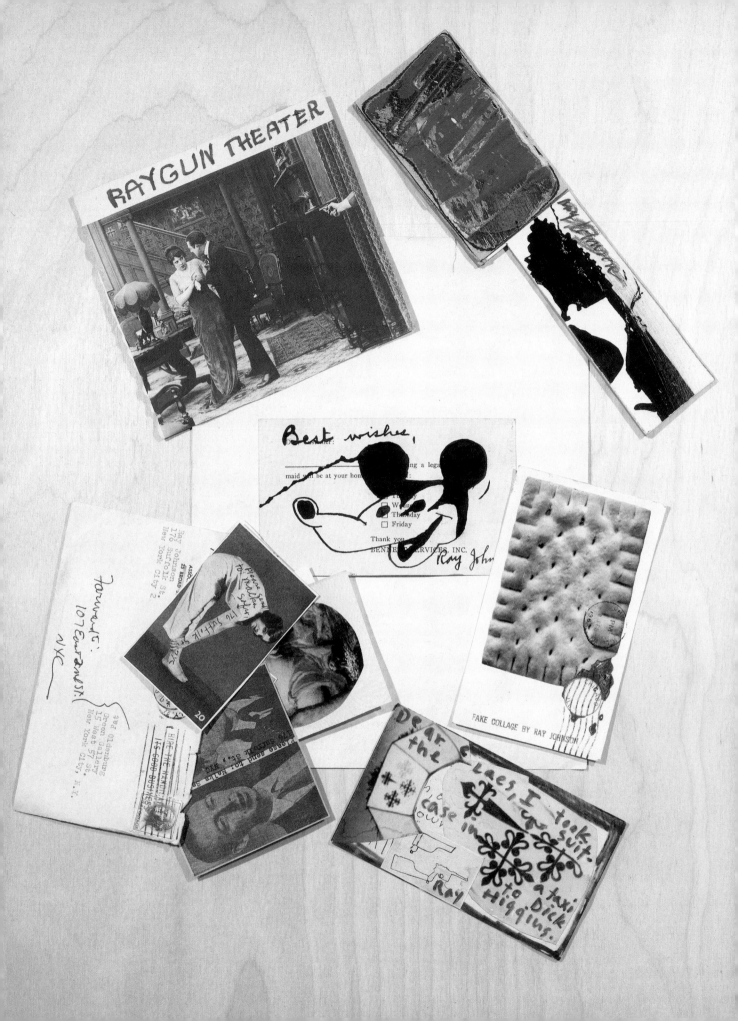

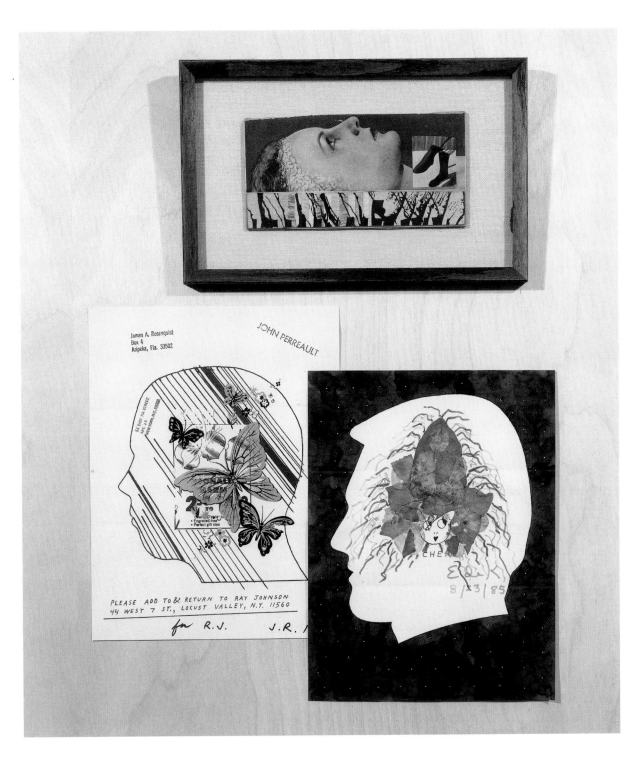

**Selected correspondence from
Ray Johnson**, ca. 1960–63
Claes Oldenburg and Coosje van Bruggen,
New York

Correspondence from Ray Johnson, ca. 1964
James Rosenquist (top)
**Undated Correspondence Between
Ray Johnson, James Rosenquist and
John Perrault** (bottom left)
**Correspondence Between Ray Johnson
and Elaine de Kooning**, 1989 (bottom right)

154

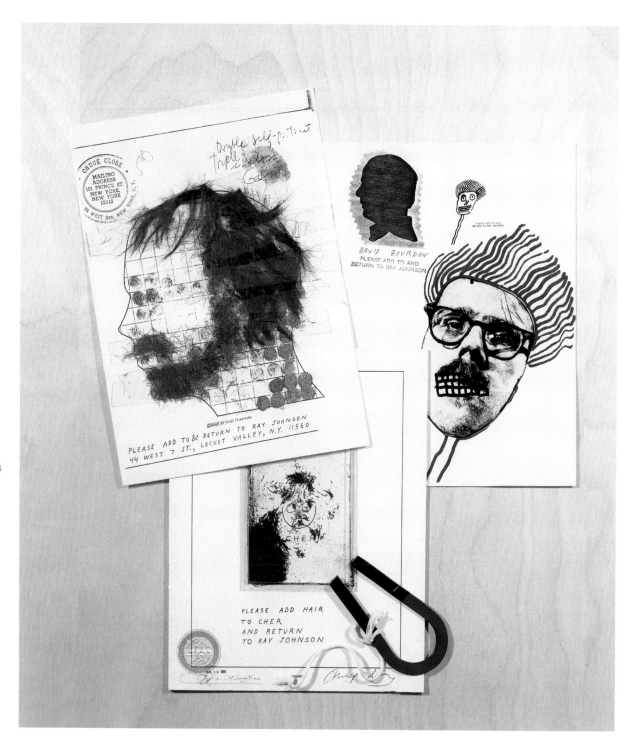

Selected correspondence between
Ray Johnson, Chuck Close,
David Bourdon, Geoff Hendricks,
Philip Glass, and others

Selected correspondence
from Ray Johnson, ca. 1959–63
Robert Rauschenberg

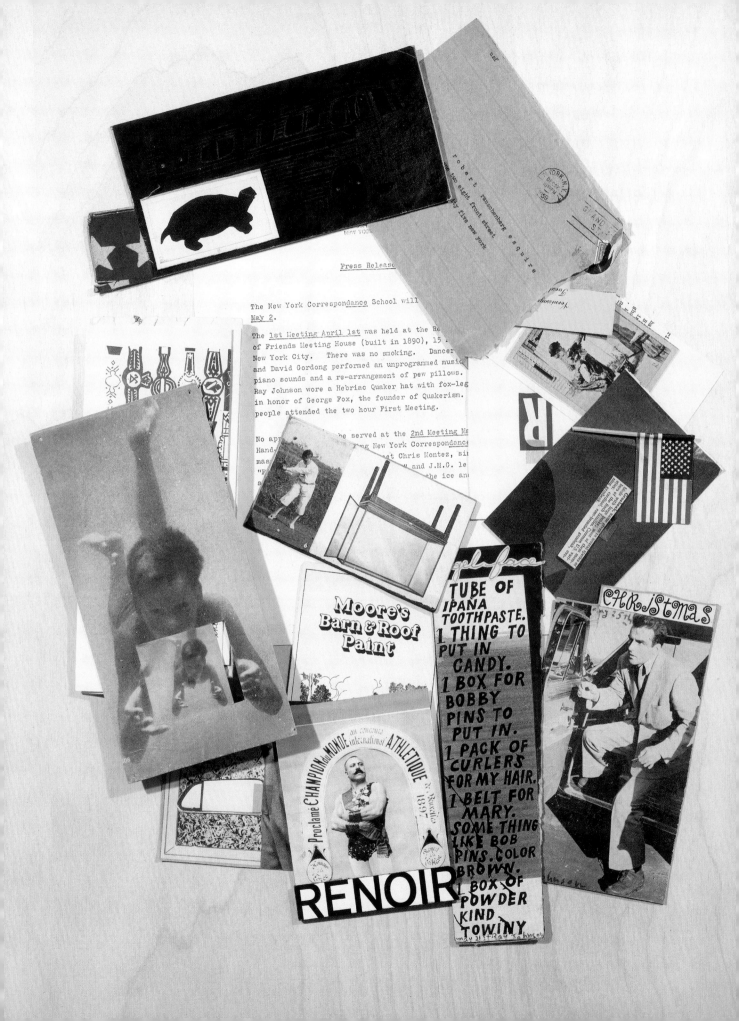

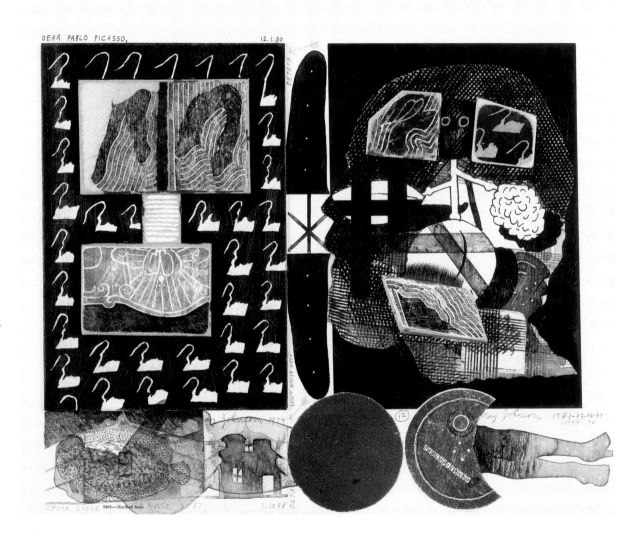

Untitled (Chuck Close with Swan),
1974–90
13 x 22½

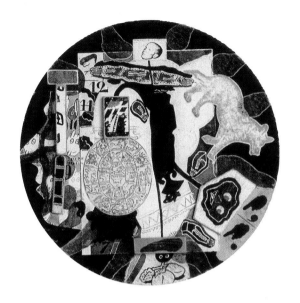

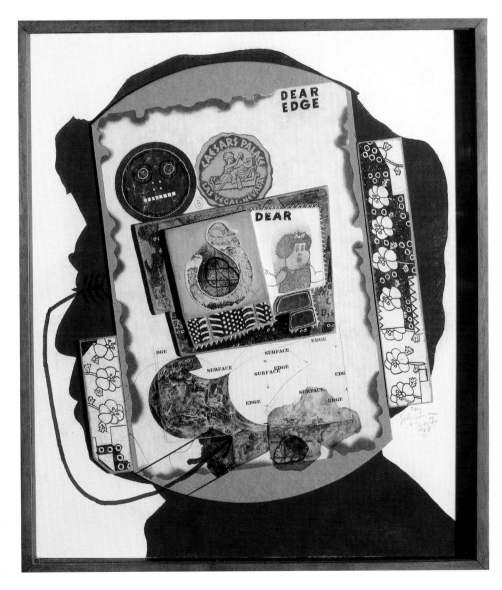

Untitled (Wolf with Zodiac), 1976–87
15½ x 15½
George W. Ahl III

Untitled (Dear Edge),
1973–76–86–87–88–94
15½ x 13⅝
William S. Wilson

June 12, 1950

158

**Correspondence sent to
Joseph Cornell from
Ray Johnson and Richard C.**,
February 14, 1971
Archives of American Art,
Washington, D.C.

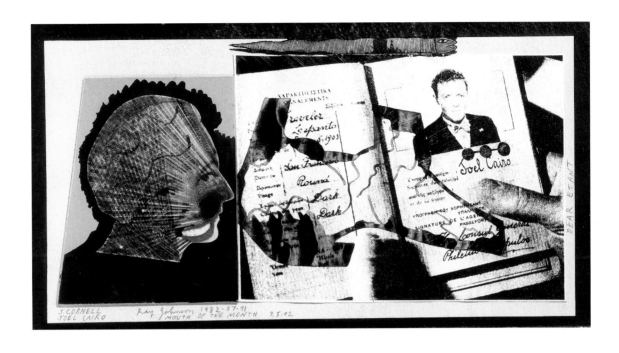

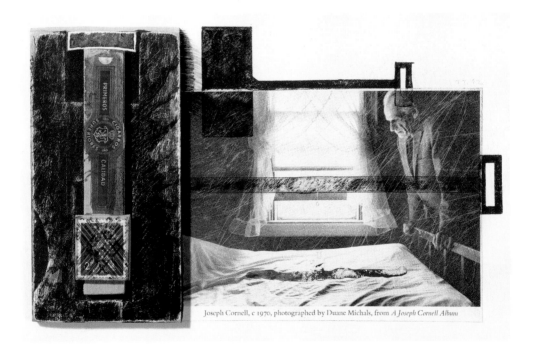

Joseph Cornell, c 1970, photographed by Duane Michals, from *A Joseph Cornell Album*

**Untitled (Joseph Cornell
Joel Cairo)**, 1982/87/91/92
6³/₈ x 11⁷/₈

**Untitled
(Joseph Cornell)**, 1992
6¹/₁₆ x 9

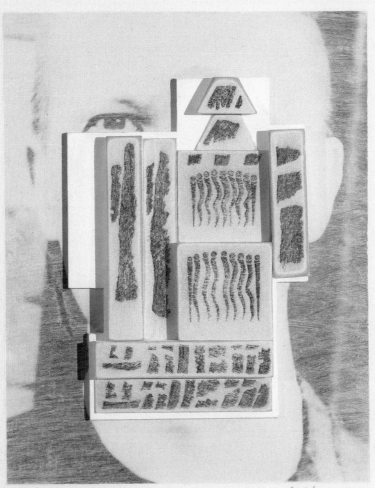

Ray Johnson 1967

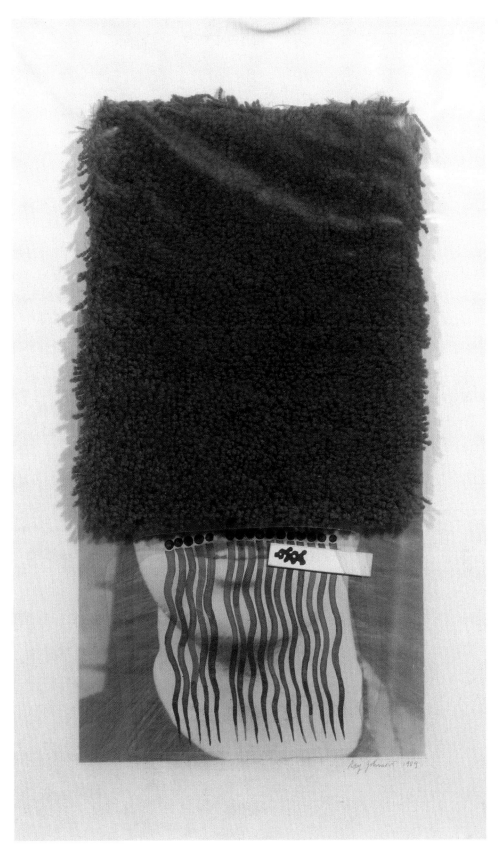

Mask I, 1967
20¼ x 13
Jerome and Ellen Stern

Green, 1989
20 x 13
Toby R. Spiselman, New York

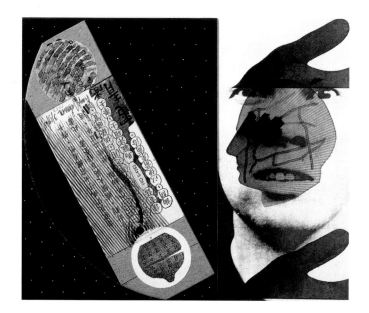

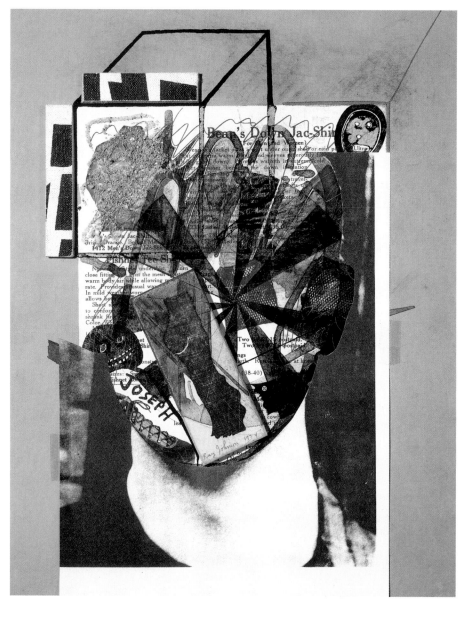

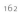162

Untitled
(Ray Johnson and Red
Pictograph), 1965–83–84–85
15 x 15

Untitled
(Ray Johnson with Red
Square), 1974–90–92
14 x 11

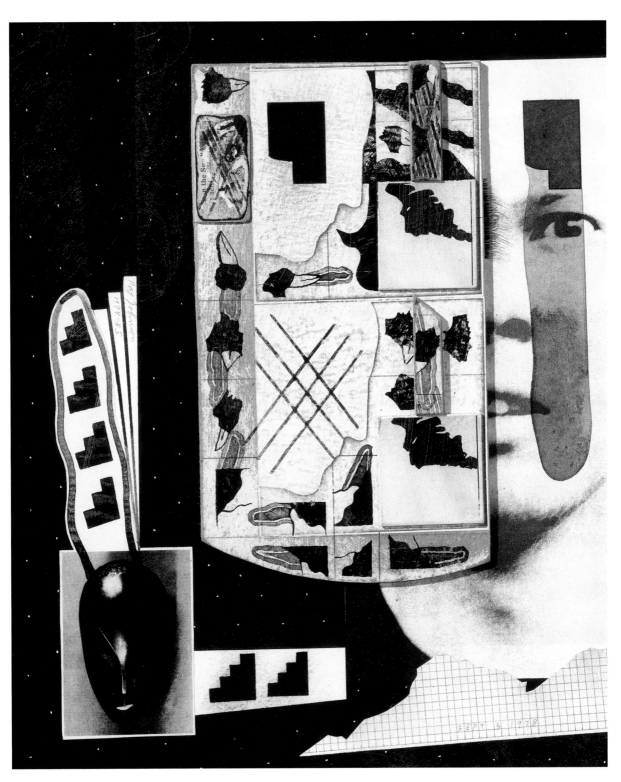

163

Untitled (Ray Johnson
with Marcel Duchamp), 1974–78/85
12¾ x 10¼

**Untitled (Water
Is Precious)**, ca. 1956–58
13 × 6
William S. Wilson

William S. Wilson

RAY JOHNSON:
THE ONE AND
THE OTHER

He would cry out on life, that what it wants
Is not its own love back in copy speech,
But counter-love, original response.
 "The Most of It," Robert Frost

RAY JOHNSON AROSE IN THE MIDST OF TWONESS. He had a sense of himself as two, surrounded by objects, words, and persons that could be copied in a likeness, or designated to represent something unlike themselves. Of course as a child he understood that he could be as though two people by being reflected in a mirror, or by being photographed. Beyond that, he discovered in school that if he drew pictures or communicated by a code, people would have another idea or image of him to which they would respond.

No one image of Ray could represent his only self, because he was one who could become two. Later, confronted with an intact unified object, he looked for a seam where he might split it in two. Alternatively, if confronted with two separate objects, abstract or concrete, or two different people, he might bring them together to see if communications would pass between them.

Ray thought of himself sometimes as a set of twins. Always loving sets in motion, like partners dancing or vaudeville teams, for him an idea or an image was real insofar as it was set in motion or it set something else in motion. Mention of a team of two like Gilbert and George would attract mention of Gilbert and Sullivan, with then an exchange of implications between the two sets, causing reciprocal modifications of each set by the other.

In Ray's river of images, an image does not combine with other images because of what it is in itself. An image is what it is because of what it does. Roughly, an image is what it is insofar as it combines with other images. Combining images into a cluster or constellation can activate the images within an open system always under construction.

When Ray was consciously two, himself and his twin, ghost, or other double, his relations with one other person became triangular. He used such threeness to alleviate problems in twoness. Such triangulations opened his responses to the threecornered hat worn by

For Toby Spiselman

Ray Johnson, ca. 1965
(clockwise from right: on Lower East Side of New York;
working in Suffolk Street apartment;
between two letters of a highway sign)
Photographs by William S. Wilson

Marianne Moore. Any hat worn as a costume is like the imagination, that is, like the use the mind makes of images to protect itself from raw, unconceptualized, and imageless realities. The tricorne hat, anachronistic and militarily fantastic, was to Moore's head as her imagination was to her mind, as she moved images and signs about to protect her mind from an unsignified or undesignated reality.

In those days, certainly from 1958 to 1966, Ray enjoyed going to Keller's, a rough bar for Norwegian sailors, prostitutes, and stray vagrants. In 1966 the waterfront neighborhood around Keller's Bar was still rather typical as a margin of the city that was hospitable to marginal people—anomalies, outcasts, and misfits. In that down-at-heel waterfront tavern, a bit of Eugene O'Neill's iceman and "ol' devil sea" was coupled with a bit of William Saroyan's play, *The Time of Your Life*.

We used to sit in Keller's discussing work and play. Once, sitting in a booth, I handed Ray the draft of an essay I was writing about the paintings of Joe Raffaelle, now Joseph Raffael, an artist grateful for what he learned from Ray Johnson's collages about thinking with images. Ray's comment was, "Why would anyone ever want to read something like this?" Another evening when I tried to interview Ray with a tape-recorder, he objected to almost every question, and told me what to ask him.

Ray's delight was to take friends toward what for them was a borderline, but for him was a territory. He would guide them across that threshold into the discovery that the narrow margins at the edge of the central society was a wide place with its own population, improvising rules for itself as occasion suggested.

In April 1966, Ray wrote a letter to David Dalton reporting on an evening:

> Helen Keller's, Nov. 7/ Was graced by the presents of Bill Wilson and Ray Johnson. Bill Double-You drank canned beer. Ray Jay drank Seven-Up. We played the Beatles on the juke box and a peroxide blonde perhaps about sixty years old. She's Saint Somebody or other Wilson noticed mentioning a Flaubert work she's kissing the leper. Refering to a Keller regular. A tough Scot slugged a drunk German with outlandish necktie twice and as Rimbaud puts it blood flowed. The red blood design looked like an early Ray Johnson ink drawing. Mops were produced, head held back, pushing and more Beattles.

In Ray's visual art, in his writing, and in social events, he collaged a range of references, combining snippets of whole images into a composition. When entering a place with a friend, he would point to visual details, mark the particulars of a sound, and order a drink that added an image to the emergent themes. Each scrap or detail became a little plane suspended among deflections from other planes.

In this brief letter Ray glances at religious fiction (saint somebody or other), poetic literature (Rimbaud), visual art (ink drawings), and music (Beatles). Thus he composed vivid sensory bits and pieces into an ephemeral performance the only aim of which seemed

to be mutual glee. He organized the immediacies and indeterminacies within an actual event into an aesthetically constructed collage in which accidents could endure.

Or he wrote a letter to be mailed to a friend, like this letter reporting to David Dalton on an evening of rapports.

The scissored shreds and patches in the collages combine with the sandpapered scratches on surfaces, drips of paint, misspellings and typographical errors to construct an aesthetic illusion that does not render the material surface transparent. By interfering with surfaces, Ray held attention to the surfaces, not encouraging implications of an ethereal immaterial soul or of a transcendental essence. Neither an error nor a failure upon a surface deterred him from reaching his goal, which was to remain at the surface among immediacies and indeterminacies organized just enough to stay in motion. He did not like to use the present event to bear upon a distant goal or a meaning that was elsewhere.

Ray was wary because his present moment might be compromised by a plan that is not an extemporaneous response, the way an interviewer's questions have planned their answers. He prepared events only in order to produce an astonishment he was not prepared for. Thus when in 1965 he responded to some questions and topics Nam June Paik submitted to him, he typed his responses not as answers, but as samples of his thinking. For the 13th question from Paik, Ray swerved into an *apologia*: "13. I wait, not for time to finish my work, but for time to indicate something one would not have expected to occur."

A scratch, tear, drip, or piece of tape, an error or a failure, is what it is, opaque in that no explicit abstract idea shines through it. It is not a sign that can be followed elsewhere, away from the physical materials of a sign toward the meaning (use) of the sign as its bearing on something it isn't. In a similar illegibility, Ray's codes usually combined two codes. Two sets of rules for decoding meant that one could not see through the coded message toward a meaning abstractable from the code. He directed one's attention to surfaces, not to meanings behind surfaces. However, if one asked, he usually would be happy to explain the background, but even as he decoded his codes for someone, he was already constructing a different event within a new foreground.

During a year of wonders, 1966, while Ray was thinking with the image of Marianne Moore's tricorne hat, I was planning to write a complementary essay. We discussed the ideas at Keller's. Ray so disapproved of my academic writing that he wrote an essay about

Marianne Moore's hat to show how it should be done. Because his typing gave an expressive significance to the marks of ink on paper, and to the spaces around the marks, his essay is reproduced here. And because some of his references have become obscure, and because his style of thinking with words and names is so singular, I have written some notes about the background or infrastructure of the essay.

The title of his essay, IS MARIANNE MOORE MARIANNE MOORE?, questions identity, and encourages dividing a person into at least two identities. The relation of names to self-identity, and the effects of names on combinations, is questioned, as in Is Mississippi Mississippi? Any repetition like repetition of a name raises questions of the identity of the name with an exact copy of the name.

If Mississippi is interpreted as a sign or read as a symbol, does it remain itself? I was reading or interpreting a hat, worn to clothe the mind as well as the head, as a symbol that was about the imaginative uses of symbols. Ray responded characteristically with blunt and opaque statements. Throughout his life and art, questions were less likely to be answered by theorized commentary on identity and difference, by interpretations or by verifiable facts, than by indirection and deflection in a verbal/visual collage. But he did listen to analyses, and like a packrat he picked up a few shiny scraps to use elsewhere later.

Ray's answers to questions and his solutions to problems pointed attention toward opaque, concrete and specific images through which one could almost see an idea. A familiar image such as *Mississippi* arrives decorated with a cluster of associations. While Ray might enter the usual images around the name Mississippi, he emerges from Mississippi unexpectedly at Tennessee as the name of another state, or at Huckleberry Finn, who rafted on the Mississippi with his friend Jim. His essay, like a snake with its tail in its mouth, opens near Mississippi and will close near Mississippi. The structure is like a Joycean *riverrun* in *Finnegans Wake*.

The question, Is there a Petula in Indiana?, is unanswerable as a linear statement, but it evokes a field that makes an answerable question beside the point. The meanings of these names are their modes of combining with something else, and the uses of their implications. Those implications temporarily may combine with other names and concepts that arrive in a new and unpredicted context.

In the 1950s, a painter named Robert Clark changed his name to Robert Indiana. The name Robert Clark warrants mention of the name Petula Clark, a singer not associated with Indiana. But a montage is being constructed so that images overlap and identities flow into each other: one Clark is associated with Indiana, hence the question about a different Clark: Is there a Petula in Indiana? The opaque question is not a method of eliciting facts or inventing ideas, it is an experience. The phrasing unsettles the little word *in*, for the words *in Indiana* are like words used elsewhere, "is Isabel?" Ray thought and wrote in scrupulous detail, albeit unscrupulously using people's names as a raw material of art. He so scrambles and shuffles images that a person might see an apparent pathlessness, but that is just where Ray opens a path. An impasse to someone else could become a *passage* for him.

While names are used to mark identities, Ray's uses of names followed from his personal understanding of identity. His notion of identity and self-identity was not that a person or a thing has an essence or nature as the laws governing that entity from a deep interiority. In his practice, the identity of apparently self-identical places, persons, or things was shown to be arbitrary and insecure. To be was "to combine with" in a set of two or more as long as an event maintained itself, and then to let it pass.

As he approached people Ray looked for their self-stylizations and aestheticizations, and for where they were joined to or were separated from another person. Then he might respond to accidental or to incidental details that could never be thought to belong to "the essence" of the person. Thus neither invading nor infiltrating another person's interior self, he would move forward among surfaces, constructing rapports among otherwise unrelated images. His way of combining images in a loving rapport was a model for how loving sets in motion thoughts and feelings that overcome strangeness and estrangement.

Ray had many reasons to be interested in the life and the art of Marianne Moore. The interests that began with the tricorne hat she wore extended to her name as a visual object. As a commercial artist who designed with alphabetic letters, he saw that each of her initials, M., is in itself a vertical mirrored symmetry, while two together make a pair with two bilateral symmetries: MM.

When the initial letter is doubled to *em em*, that is, M. M., the effect is of symmetry within symmetry. Because of the two symmetries, the two identical initials convey in miniature detail the themes of identity and difference. As counterparts M and M are identical, yet are also opposite, as one M is first and the other M is last.

Ray would have counted the letters in the name *Marianne Moore*, 13, and have noted that *M* is the 13th letter of the English alphabet. The set of initials, M.M., and the count of 13, links her birth-name with the name *Marilyn Monroe*. Looking at the letter *M* as a visual design, it is seen to be usually identical to its upside down reversal, the letter *W*. Setting aside logical transitions, but following the pairs of *M* and *W*, Ray as a matter of principle would have reversed M.M. to W.W. to see what he could find, which in this case happened to be another name of thirteen letters, William Wilson: As William Wilson signing off on the telephone wittily said Tah Tah I did not get it and he said it was hat hat backwards.

Many possible permutations of the name *William Wilson* were available, as with nicknames or middle-names. The form he chose, William Wilson, evokes the story by Edgar Allan Poe. In that story, a man is self-divided as though into a good twin and a bad twin. The two are not actually brothers or twins: "But assuredly if we had been brothers, we must have been twins...." Under a misapprehension that the one identical person is two different people, the bad "twin" kills the good "twin." But the two are one, so that the murder is inadvertently but effectively a suicide: "how utterly thou hast murdered thyself."[1]

Aware that like attracts like, Ray moved images around to see for himself just which like attracted which other like that was like it. Thus he followed from

168

Typescript sent to
William S. Wilson, *November 2, 1966*
William S. Wilson

WEST SIDE BRANCH

YOUNG MEN'S CHRISTIAN ASSOCIATION

5 WEST 63RD STREET

NEW YORK, N. Y. 10023

TELEPHONE SUsquehanna 7-4400

MEMBER'S CORRESPONDENCE

IS MARIANNE MOORE MARIANNE MOORE?

Is Mississippi Mississippi? Is there a
Petula in Indiana? I was told by an art
editor from Harper's Bazaar I spoke with
clarity.
I clipped a page from Life magazine show-
ing Marilyn Monroe's tomb stone which read
Em Em 1926-1962. I was impressed by her
dates. Like Joe. (Joe D.). Joe De Em.
Joe Death. A playing card figure this way
also that way. The card part of the Cardin-
als, a baseball team.
As William Wilson signing off on the tele-
phone wittily said Tah Tah I did not get it
and he said it was hat hat backwards. There
is no necessity for two hats one does not
have two heads but in a scarpbook I kept as
a child (yes, scarpbook, not scrapbook. I
did not glue down crap but carp. How those
fish did struggle with Elemrs glue in that
book!) I treASUREd a photo of a two-headed
turtle. ASURE is a mistake in useing the
typewriter.
Marianne Moore certainly is not Marilyn
Monroe. In collage, Marilyn's head could
be put on Marianne's body. One can pretend
to be someone one is not. Children's play.
I'll be you and you be me. Be my valentine.
Ray Johnson wearing Marianne Moore's hat.
Lend me your ears. May I have a pint of
your blood? Can you lend me a dime? Can
you spare a brother?

169

the initials of Marilyn Monroe, *Em Em*, to the partner she married, Joe DiMaggio, whose name yielded *Joe De Em*. Then he trimmed the name to an initial letter, *Joe D*. While for many people the name Joe D. was used to point to the actor Joe Dallessandro, Ray used Joe D. to point to the other Joe D., whose initial D, because of his wife's tombstone, expanded to *Joe Death*.

Ray characteristically found death in *LIFE*: `I clipped a page from Life magazine showing Marilyn Monroe's tomb stone which read Em Em 1926-1962.` He wrote, `I was impressed by her dates,` because each of the two different dates shares *19*, while the same two numerals, *2* and *6*, appear in forward and in reverse order, 26 and 62. Ray looked at calendrical dates as a potential niche in which he could tuck away some meanings. Thus the dates *1926* and *1962* were noted to include both a sameness and a difference: the pair of identical 19s, and the two different numerals, 2 and 6, not randomly shuffled, as in an anagram, but reversed. The numerals 26 and 62 enliven each other visually.

`I was impressed by her dates. Like Joe.` Here the word *date*, as in date of death, is enlivened by being split in two: one meaning and one *other* meaning. A date as a chronological marker overlaps a date as an appointment to be with a partner for a period of time in a temporary companionship. Ray enjoyed watching couples out on a date dance, moving together as pairs to songs like "Dance the Mashed Potato" or "The Monster Mash."

Each one of a pair or each set of two is made more complex because for Ray one partnership did not exclude other partnerships. The identity of a person, an object, or an image included multiple couplings for the same person, idea, or image. So if X is partnered with Y, then their relation includes or subsumes the point that X is as it is multiply partnered. Thus Marianne Moore links with Marilyn Monroe, who links to Joe DiMaggio.

The name of the baseball team, Cardinals, can be divided into parts, one of them the word *card* as in baseball cards: `The card part of the Cardinals,`

a baseball team. The word *card* suggests a person who is a prankster or a wit, that is, someone like a deadpan comedian who turns things upside down or backwards. On the theme of reversals, a playing card can be turned upside down without losing legibility or altering its function or structure: `A playing card figure this way also that way.`

That the visual information on a playing card does not have a top or a bottom was a model for the possibility of reversing an object without destroying its meaning or value. A hat, from a head at the top, could be exchanged with skates, from feet at the bottom. In 1966 Ray wrote in a letter to Richard Lippold a touchstone sentence that compresses his images in a style that is an elaboration of his meanings: `I'll get onto Marianne Moore's manta ray hat with skate keys.`

Ray has written, `There is no necessity for two hats one does not have two heads.` He then turns that thought until it finds something with two heads with which it must divide one truth into specific truths. First he mentions an image in his scrapbook: `I treASUREd a photo of a two-headed turtle.` Then he comments on the mechanical problem with the typewriter which has locked on the capital letters: `ASURE is a mistake in useing the typewriter.` He includes the mistake, using it not as a solo, but as a part in an orchestration.

While Ray is apparently changing the subject, at a tangent to tangents, he does not lose the thread. Having mentioned two heads side-by-side on one turtle, he then imagines one head in two positions, as a head-stand turns a person upside down, with the feet at the head and the head at the feet. The imaginative logic is impeccable: `Imagine the eyes where the ankles are.`

When standing on one's head, one loses the familiar visual clues to size and distance, hence the sun looks larger or smaller depending on whether one is standing on one's feet or on one's head. Using reversals to get rid of habitual clues encouraged a moment to bloom into a *haiku*. Ray's fastest method of filtering out familiar clues was to turn events and

images upside down, as with a collage, *Untitled (Marianne Moore's Hat)* (1974).

Ray found many new combinations by associating Marianne Moore's tricorne polyvalent hat with a manta ray. *Manta* can be spelled *mantah*, one word dividing into two parts, one reading forward, *man*, the other in reverse, *hat*. The name *Manhattan* includes the word hat, always quickly reversible to *tah* as in *Mantah*.

The statement, `There is no necessity for two hats one does not have two heads,` generates contrary responses by passing the image through two operations. One of these characteristic operations divides one into two, like a turtle with two heads. The other operation reverses one element so that it occupies two positions, as a person in a head-stand has a second head, or like a playing card figure with a head at the top and a head at the bottom, `this way also that way.`

A typographical error could inspire an image that otherwise might not have surfaced. An example occurs when Ray intended to type *scrapbook*, but erroneously typed *scarpbook*. He immediately affirmed the gift of a neologism he had accidentally hit upon: `yes, scarpbook, not scrapbook.` At the typewriter, not recopying a first draft to make errors disappear, and not erasing, he let the errors in the verbal prompt novelties in the visual/verbal, or produce information at an oblique angle to his intentions. Here the error has yielded a creature that can live only underwater, a fish.

Because Ray's error has given him a fish, he thinks about fish, following the lead of his typing. When he made a mistake that threw him off balance, he would not restore the lost balance, but would match one imbalance to another imbalance as a method of constructing a new equilibrium. He would enter into his error not to correct it, but to follow its logic, fearless when confronted with an absurdity. Thus his failure to type scrap became his success in typing *carp*: `How those fish did struggle with Elemrs glue in that book!`

Now typing *Elemrs* for *Elmers* inserts an *em* in Elmer's Glue. Ray needs most such errors to keep him focussed

170

WEST SIDE BRANCH

YOUNG MEN'S CHRISTIAN ASSOCIATION

5 WEST 63RD STREET

NEW YORK, N. Y. 10023

TELEPHONE SUsquehanna 7-4400

MEMBER'S CORRESPONDENCE

(2)

One of my favorite songs from "No Strings"
is "The Sweetest Words Are Waiting To Be
Said". I used to send that title in
letters to a friend in prison, who had
passed bad checks and was sent there to
suffer. He did.
I like the singing of Chris Montez,
currently enjoying a success with "Time
After Time". I was once given a sub-
scription to Time magazine and it appears
every Tuesday cramming my mail box. A
friend of mine once found himself seated
at a dinner party next to Tuesday Weld on
a Tuesday. And I once entered a New York
cocktail party to find Tennessee Williams
leaving. I had never seen him before but
recognized him from his photos.

About Marianne Moore's hat. It is a manta
ray. It is flat black. Can you imagine
her with a large piece of pie on her head?
Pie are square. Pig tails are not pig's
tails oink oink. Those cigarette adver-
tisments saying you can smoke either end.
Imagine the eyes where the ankles are.
Suzi Gablik and I once attended a dinner
where after desert the men went into the
drawing room to smoke cigars and the
ladies went off somewhere. She told me
they all talked about their servants.
We men talked about pop art.

171

in the present moment on the surfaces. From an error, from within its newly constructed perspective, he could glimpse the horizon that he had himself projected from within his own event. An error gives him a place that has never existed before—a playing-field of rapports from which to continue toward points that are constructed only within the process that reaches them.

The immediate legibility of *Elemrs* shows that we can read language that does not follow rules. Ray's anagrams and his errors produced fecund novelties, especially because he had the courage of his temporal position. He was ever in the anomalous present, just across the border from the commonplace contemporary, holding on in a marginal and temporary position, jumping out of the reach of the rules that were always receding, while he was continually moving forward.

Identities do not merge into an undifferentiated blend: **Marianne Moore certainly is not Marilyn Monroe.** Ray is not making verifiable or disprovable assertions about ordinary existence. He is thinking about the freedom in art to arrange parts into an improbable whole. While Monroe, who was young, has died, Moore, who was quite old, was alive. In a mix-and-match, a combination of images is possible in art that is impossible in life: **In collage, Marilyn's head could be put on Marianne's body.**

Goethe wrote somewhere of maturity as recovery of the seriousness of a child at play. Ray wrote about play as reversal of identity: **One can pretend to be someone one is not. Children's play. I'll be you and you be me.** The principle is that like Monroe's head and Moore's body, switches can be made, but new and disturbing implications may then appear.

The apparently easy reversals of identities are dismayingly complex. If I can be you, and you can be me, what are the consequences? Hearts can be exchanged, **Be my valentine.** But ears? one can hear plain words as they are salted with serious jokes: **Lend me your ears. May I have a pint of your blood? Can you lend me a dime? Can you**

spare a brother?

A reader can hear an ordinary plea, "Brother, can you spare a dime?" within the revision, **Can you lend me a dime?**, which doesn't sound like desperate need. Ray, who often removed the horror from images, has twisted a familiar saying, while simultaneously squeezing two ideas into one word, spare. Because the question is **Can you lend me a dime?**, not "Can you spare a dime," the word spare is left over, becoming a spare word. The word spare has one meaning and a spare meaning, as in a request to spare someone from death, Can you spare a brother?, and in a request to be given an extra brother: **Can you spare a brother?**

The themes of time and of suffering are not absent because Ray mentions that his friend, who had given himself the name Soren Agenoux, "does time" in jail: **One of my favorite songs from "No Strings" is "The Sweetest Words Are Waiting To Be Said". I used to send that title in letters to a friend in prison, who had passed bad checks and was sent there to suffer. He did.** This combination of time with suffering, consolation and music as an art of time is a somber moment. But Ray subsumes the somber within mention of a song about a successful loving partnership: **I like the singing of Chris Montez, currently enjoying a success with "Time After Time".**

The mention and repetition of the word **Time** leads from the bad checks to the gift of a magazine, *Time*, that appears time after time: **I was once given a sub-/scription to Time magazine and it appears/every Tuesday cramming my mail box.** Here the general and undefined concept of time is refreshed by a specified time, one day of the week, Tuesday.

A jump is possible from one Tuesday onto the plane of a different Tuesday: **A friend of mine once found himself seated at a dinner party next to Tuesday Weld on a Tuesday.** The two Tuesdays are one in spelling, but angle off in two radically different directions. Thus an apparently univocal word, Tuesday, bifurcates so that mention of a Tuesday has become equivocal. Yet the two Tuesdays do

happen to coincide at a dinner party.

That the name of the woman, Tuesday, is also the name of a time, Tuesday, is matched by a name that is also the name of a place, also with the initial *T*: **And I once entered a New York cocktail party to find Tennessee Williams leaving. I had never seen him before but recognized him from his photos.** Here in a single event, one move is from an actress Tuesday to a playwright Tennessee, and another move is from a photograph to the original person. At the same time, the Southern playwright and Northern Ray Johnson are two men going in reverse directions toward opposite places.

An identity of an object or a word can include much that cannot belong to its essence or nature as that might govern its meanings or its uses. **About Marianne Moore's hat. It is a manta ray. It is flat black. Can you imagine her with a large piece of pie on her head? Pie are square. Pig tails are not pig's tails oink oink.** The themes of irreversibility and reversibility go through the fact that one cannot reverse from pig's tails to pig tails. Pig's tails and pig tails can look like one, yet are two: pig's tails are pig tails, but pig tails are not pig's tails. Yet one can reverse some cigarettes so that one cigarette yields a two, a both: **Those cigarette advertisements saying you can smoke either end.**

What Ray's images in his arts and letters will do next, or what will be done with them next, is unpredictable, unrehearsable, and ungovernable. He appreciated and demonstrated that language and art are not closed systems, and that any rules are always receding with the events that elicited those rules.[2]

Ray, who didn't try to belong to a separate sex or gender, finds himself segregated at a party. His report is dead-pan: **Suzi Gablik and I once attended a dinner where after desert the men went into the drawing room to smoke cigars and the ladies went off somewhere. She told me they all talked about their servants. We men talked about pop art.** The droll fact that the men, experts on

WEST SIDE BRANCH

YOUNG MEN'S CHRISTIAN ASSOCIATION

5 WEST 63RD STREET

NEW YORK, N. Y. 10023

TELEPHONE SUsquehanna 7-4400

MEMBER'S CORRESPONDENCE

(3)

I once thought of painting my flat black.
I had read a book about S.D. (sensory
deprivation) where people were put in dark
rooms for long periods of time.
Just a little bit south of North Carolina.
I saw Marianne Moore at a party once at the
Dakota. The west Dakota.
I saw Rodin's "Adam" in Chicago and Rodin's
"Eve" in Detroit.

About Marianne Moore's hat. Medusa snake
hair pig tails a piece of pie and when the
pie was opened the birds began to sing.
Lucy Mitton, who was not wearing gloves
opened a door and showed me a lovely pussy
cat. I offered the editor from Harper's
Bazaar a life saver and she accepted it
with a gloved hand.

Above Marianne Moore's hat. The pink ice
falls on her head.

Claudia. "One Man's Family". Father
Barber is in the garden. Mother Barber is
in the kitchen. Jack Barber is upstairs
talking to Claudia. Brought to you by
Tender Leaf Tea.

The A. & P. Tea Company. The Atlantic
Ocean. The Pacific Ocean. The Mississippi.
Huckelberry Finn. Huckelberry pie.

Ray Johnson
Nov. 2, 1966

173

maleness, **talked about pop art** with Ray suggests yet other peculiarities in classifications. The mistakes of the evening include separating partners—breaking up the set of Ray and his "date"—and then including Ray in a problematic set: **We men.** As usual he uses the problematic as a probe, out in front of the available solutions to problems. Ray could patiently find a perspective in which to be at that dinner party was so useful an occasion to think with that it became an *avant-garde* position.

That Marianne Moore's hat is black is echoed in remembered thoughts: **I once thought of painting my flat black. I had read a book about S.D. (sensory deprivation) where people were put in dark rooms for a long period of time.** S.D., the initials of sensory deprivation, have jarred loose an association with South Dakota. First South Dakota is reversed to North Dakota, and then Dakota is displaced by Carolina: **Just a little bit south of North Carolina.** Then the thought spurs itself on, reversing to Dakota: **I saw Marianne Moore at a party once at the Dakota.** Yet both North and South get lost in rotation because the party was given by Charles Henri Ford and his sister Ruth Ford in their apartments in the Dakota on Central Park West: **The west Dakota.**

Nothing is more central to the governing of Ray's images than a pair, a set of two, and the adventures that occur between any two that are coupled or partnered, or two that belong together but are separated so that one lacks the other. The complementary themes include a reversal, the tragedy of separating two which should not be separated. Thus his dry comment: **I saw Rodin's 'Adam' in Chicago and Rodin's 'Eve' in Detroit.** The figure of a nude Adam, although in bronze, suggests a petrified man, thus he follows from Rodin's bronze to **Medusa snake.**

In contrast with the kitten that lost its mitten, a Mitton has found a cat: **Lucy Mitton, who was not wearing gloves opened a door and showed me a lovely pussy cat.** A woman named Mitton not wearing mittens is a scrambled

reversal of a woman who wears gloves as she accepts a gift: **I offered the editor from Harper's Bazaar a life saver and she accepted it with a gloved hand.** Ray offers a Life Saver with the implication that the editor is drowning and needs to be rescued from uniform fashionable conformities, the sphere that could close over her like the sea.

The sea brings us to a skate fish, which Ray was most likely to see in the Fulton Fish Market preserved in ice. A skate-fish in a market bleeds on the ice. If Marianne Moore's hat is a ray, a skate, then it is like a dead flat-fish that has been in the market where it has colored the ice pink. Therefore, when she puts on her mantah hat, following the centrifugal logic that puts a spin on images, **The pink ice falls on her head.**

The word barber could split at a seam to yield the syllable bar, with multiple combinations, even Barnett. The name of a radio serial, **"One Man's Family,"** calls forth the name of the Barber family. A name that is a word, like *barber*, once inserted into the kaleidoscope, can be shaken into manifold dazzling patterns. Yet behind this pattern of associated images in the foreground lurks a somber association of *barber* with razor. Because a young neighbor on Suffolk Street had killed himself with a razor blade (1962), ideas of suicidal death surfaced in the image of razors. In his essay, Ray characteristically turned from the potential threat of a barber's razor to a happy radio-serial family named Barber. Yet not one without the other, but both.

The sponsor of *One Man's Family* was Tenderleaf Tea, associated with **The A. & P. Tea Company.** The names of two wide oceans bring back the name of a wide river, the Mississippi, a river that opens into a gulf that opens toward an ocean. The narrative evoked by mention of the Mississippi is a novel, *The Adventures of Huckleberry Finn*. Any mentions of Huckleberry Finn would have led to ideas about obeying the laws one has set oneself, and about a refusal to conform to the social sphere and civil law. The least mention of Huck Finn calls to mind a lad who, in order to be free to be true to

himself, to be reborn, must light out for the "territory." He must go to the margins where a marginal person can be free, and use that freedom mischievously to subvert the spheres like slavery that can close down over a person.

One aptness of the mention of Huckleberry Finn is that the image of Huck and Jim on a raft overlaps scenes from Ray's adolescence in Detroit, at least as he reported them. Whether as a factual narrative or as an allegory, he told rather sketchily about adventures in a rowboat on a pond in the park with an experienced older black friend named Pete. Ray and Pete once took construction jobs together, lasting perhaps a day. The details no longer exist, and stories get complex because Ray said that he also had a cat named Pete.

Ray's thoughts, and even his inland experiences, were rarely far from water. For him, the postal system became like an ocean, and he frequently imagined the sea as a place within which a Ray or a sting-ray might be squeezed to a kind of death by an octopus or other sea creature that could adhere and take his breath away. In his unanchored network of floating ideas and images, facts were images that could transpose into other images, and many ideas in the background could participate in the foreground through one such word as *naval*.

I delight in a letter Ray mailed home in 1948 to his parents in Detroit. He wrote from Black Mountain College, a little saltier than his parents could have known, in sentences that subordinate nothing to anything else: "**My hitch-hiking trip was a great success. I got to Covington at supper-time and got a ride from a navy lieutenant going to Key West, Florida and he brought me all the way to Asheville and I got here Saturday evening. We went over Norris Dam and saw the Smokies again.**"

For a moment in that lively prose, Ray sees the waterfalls with a naval lieutenant in western North Carolina. Later at Black Mountain College he enjoyed the parties, and years later he entertained Marianne Moore at tea in his apartment on Dover Street with its communal

toilet down the hall. Here in this essay about Marianne Moore, several mentions of a motif have become one theme: a dinner party attended by a friend and Tuesday Weld; a New York cocktail party; a dinner party with Suzi Gablik; and a party at the Dakota where he saw Marianne Moore. Thus a party was one of the axiomatic metaphors of his life and art, and a collage was to him as if also a party, with lots of faces and names, a society of potential friends.

Yet another governing image was death. In March 1962, both Ray Johnson and I had a cousin Robert. We often compared the set of cousins. My cousin asked me to write to Marianne Moore, and I, who had been brought up not to bother anyone, bothered her with a letter to which she patiently responded. My great-uncle Robert L. Wilson had recently died. Marianne Moore wrote in ink below her typed note of March 13th, "I hope your cousin, Robert Wilson is able gradually to surmount the death of his father." Then, thinking with the relations between the words *efface* and *face*, she added words which open now to include the loss of Ray Johnson: "'Time' never effaces loss; in fact intensifies it but we become more and more able to face it."

1. Committing a murder or a suicide makes Poe's "William Wilson" something other than he has been. Such a murder that is inadvertently also a suicide joins murder and suicide into one act with a visible seam. The last telephone call Ray is known to have made was to me, William Wilson, a name which in that event widens and deepens the themes, while moving them forward. If as psychoanalytic theory has suggested, a suicide is a murder of someone other than oneself, but displaced onto oneself, then Ray's suicide might be understood as the murder of his twin displaced onto himself. When his logic was either/or, any one act could hold two meanings: murder and/or suicide. Both.

2. The language Ray wanted was always to be positioned out of the reach of rules of language, or of any other rules. For him, an event was not to be ruled by inherited and unquestioned rules, or governed by unconsidered habits. The suspicion or loss of the familiar responses, as in a sensory deprivation experiment, is not a lack but a gift, a gain in sharp-focus, point-blank and close-up attention to the moment.

175

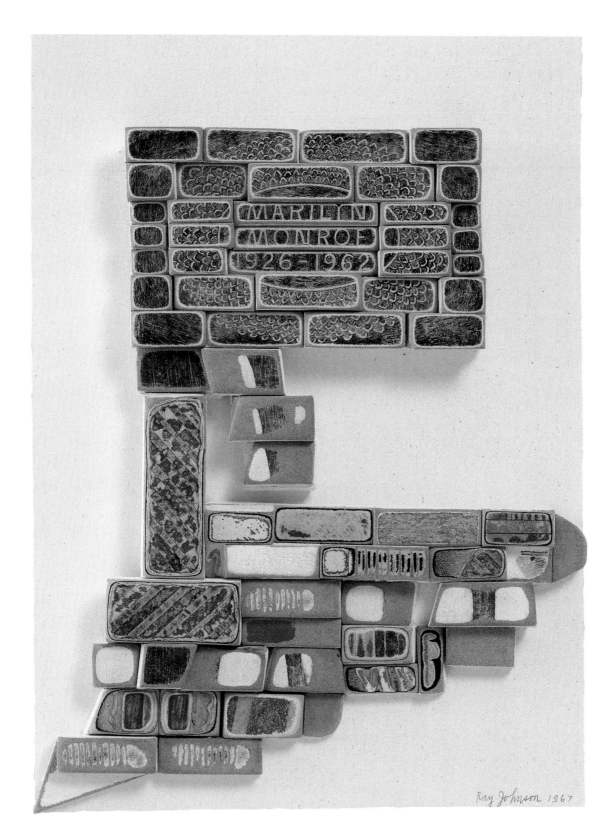

2nd Marilyn Monroe, 1926–1962, 1967
Gouache, colored crayons, and
colored ink on layered cardboard on gray
painted cardboard, 16⅞ x 13⅝
The Museum of Modern Art, New York,
Frances Keech Bequest

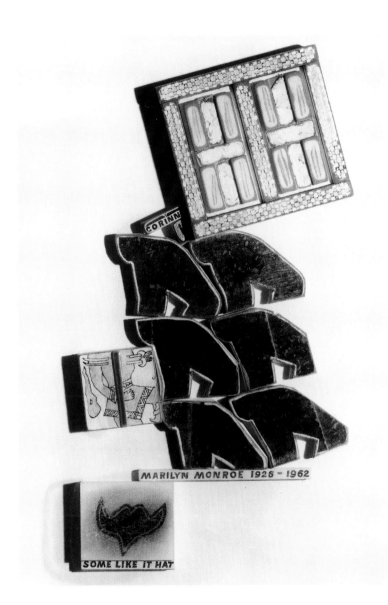

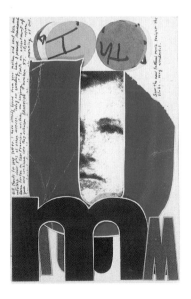

Corinne Marilyn, 1967
19¼ x 15
Martin Cohen & Company

Untitled (Rimbaud), 1956
7¼ x 4¾
William S. Wilson

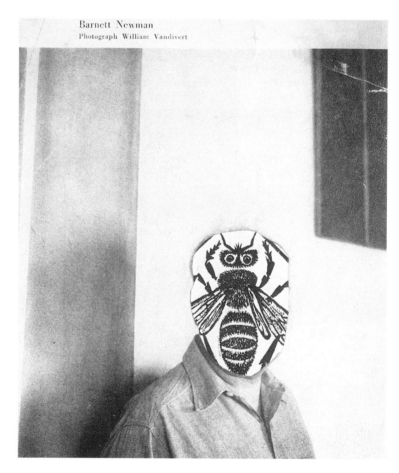

178

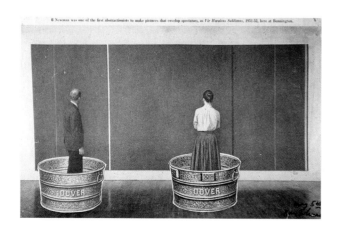

**Untitled (Newman's
Onement 2)**, 1959
3½ x 5½
William S. Wilson

**Untitled
(Barnett's bee)**, 1959–60
5 x 4¼
William S. Wilson

**Untitled (Vir Heroicas
Sublimas)**, 1959–60
5¾ x 9
William S. Wilson

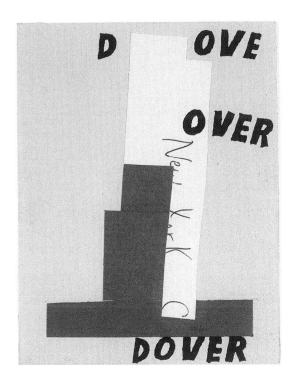

Untitled (Do Do), 1962
3⅛ x 4¾
William S. Wilson

Untitled (Over Dover), 1960
4⅞ x 3¾
William S. Wilson

Untitled (I Do I Do), 1962
6 x 3¾
William S. Wilson

180

Undated correspondence from
Ray Johnson
John Willenbecher

Correspondence
from Ray Johnson, ca. 1953
Judith Malina

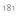

**Untitled
(Twin Hoops)**, 1963
4¹⁄₄ × 4
William S. Wilson

**Untitled
(Toad/Water)**, 1958
7³⁄₄ × 7¹⁄₈
William S. Wilson

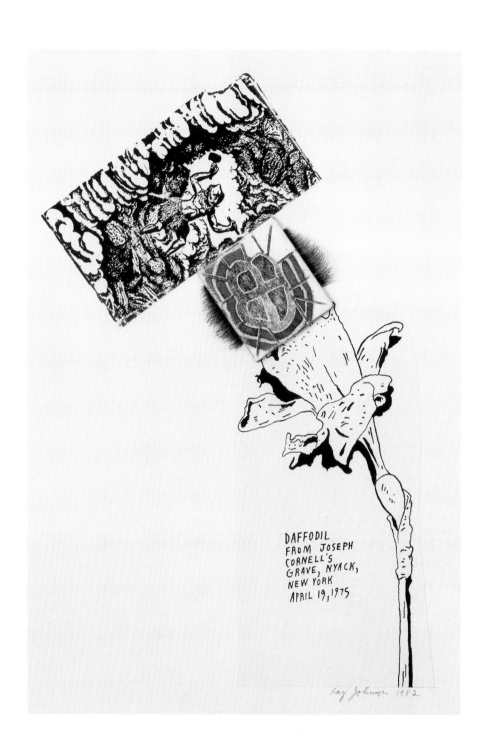

DAFFODIL
FROM JOSEPH
CORNELL'S
GRAVE, NYACK,
NEW YORK
APRIL 19, 1975

Ray Johnson 1982

Untitled (Daffodil with
Cavemen), 1982
12½ x 8⅝

Henry Martin

SHOULD AN EYELASH LAST FOREVER?
AN INTERVIEW WITH RAY JOHNSON

> I did one of my most bizarre lectures up at the Rhode Island School of Design. It consisted of my trying to move a piano across a stage, and people kept coming up to ask if they could help, and I said, "Certainly not! I mean the point is that I *can't* move this piano, and I'm struggling to move it, and it's obviously not going to get moved across the stage, and I'm putting out a great exertion of energy, and I'm on a public platform, and you are all viewing me, which is the whole point of this thing." I said, "You figure it out."
> —Ray Johnson

RAY JOHNSON HAS ALWAYS BEEN INVOLVED in two different kinds of work, one of which is the New York Correspondence School and the other of which is the making of collages. But the collages—especially in the 1950s—have frequently been known to get cut apart and sent out in the mail to friends, and the Correspondence School is a vast sea of objects, images, and information that the collages often take as material to be worked on. Both activities are alive with a heady and uncontainable poetry that's voted to taking the world for exactly what it seems to be: Ray Johnson's individual consciousness would appear to be his only criterion of continuity, and the world becomes tantamount to all the odds and ends and fragments of experience that are all that any of us could truly say we know it to be, even though we may have the habit of thinking that it's something more than that. Ray Johnson makes collages that rhyme with the way that consciousness is itself a collage, and when it's not a collage it's a dynamic flow of interrelating sensations, which is the central metaphor of the New York Correspondence School.

But the energy released by accepting consciousness as incomplete can be channeled into a striving to make it whole. Consciousness is a web to be woven of experience, and experience is to be made as vast and as full as possible. It's to be investigated and provoked and pulled into meaningful though constantly shifting shape, and if that's a life's activity, it is *all* of a life's activity, and that's what it is for Ray Johnson. He is quick and quixotic, and he is generous with his time, but he is also impatient with the loss of it. He has a self-appointed task to do, and he is always about it. He doesn't like to think useless thoughts, and he shies away

from being involved in talk that's based on dull and uninteresting theories of meaning. He explains himself only in the very same ways that he expresses himself, and getting an interview from him means accepting potluck. His present always contains fragments of his past, since parts of the past and present seem to him constantly to refer to one another, but it's useless to try to make

him tell some ordinarily ordered narrative of his past since he is always anyway trying to draw his experience into the only kind of order that makes sense for him. His life is a constant happening, and being involved with him means becoming involved with his sense of the way it happens. When I told him that I wanted him to give me the story of his life and work, he replied, "Do you really think that I'm going to tell?" At another point he remarked that he hates retrospectives. But it's not that he's indifferent to history; it's rather that he has his own particular ideas about it.

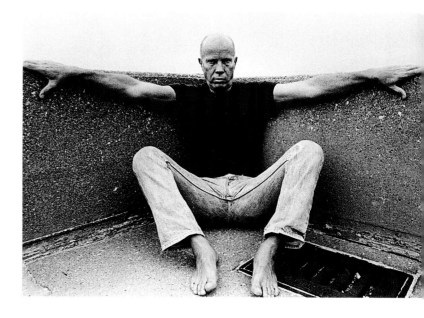

Part of what's presented here as an interview was not in fact an interview at all. Ray invited me to go along with him on a "visit" (which is itself something of one of his special art forms), and the purpose of this visit was to show a series of collages to Mrs. Jean Levy, the surviving widow of the Surrealist art

184 dealer, Julien Levy. Julien Levy had been one of the dealers of the work of Joseph Cornell, with whom Ray too had been friends and sometimes had gone to see, and the catalogue for the sale of the Levy estate contained a reproduction of a minor collage that Cornell had made around a book illustration of a print of a cave-man in 1933. This collage had always been in Levy's private collection, and Ray had never seen it until the appearance of this Sotheby catalogue in 1982, but when he did see it, he realized that he himself had used the very same, and somewhat obscure, book illustration in a collage of 1955 (p. 41). This coincidence was enough to kick Ray off into "a new batch of cave-man works," and Ray, at the time of this visit to Mrs. Levy, was also showing a group of collages at the Gabrielle Bryers Gallery in a group show called "Homage to Joseph Cornell." Ray may also have had other reasons for wanting to show a selection of his works to Mrs. Levy, but, if so, he didn't explain them to me. Visits such as these are what Ray describes as his favorite way of showing his work—"the classical, typical Ray Johnson cardboard-box viewing." He arrives with a series of his collages packed into a cardboard box, and proceeds to set them up on whatever surface is available: a chair, a sofa, a table-top, a stool. He has whole lists of people to whom he wants to show particular selections of his work for particular and personal reasons. In 1956, Ray wrote a letter to the director of a Japanese magazine in which he explained, "Most of my work is collage work which I call MOTICOS. I send out monthly newsletters about the work that I am doing, which takes the place of formal exhibitions. The works cannot be exhibited in the usual way, because they continually change, like the news in the paper or the

images on a movie screen." The era in which Ray was adamant about refusing to show his work in galleries is now long past, but keeping his work and its presentation fluid is still very much on his mind. As he explained various details of his collages to Mrs. Levy, she at one point remarked: "You should make a little tape to go along with these, so that when people buy them and show them to their friends, they'll also get a little bit of you and your marvelous humor." Ray's reply was, "Well, these collages are really like playing cards, and everybody gets a different selection; so every time they're shown, they're reshuffled and become a different story, a different tape. We've just been talking, for example, about Cornell's brother, Robert, and the rabbits he drew, but the next time these works are shuffled and shown, they'll bring up other people and images and ideas. It's constantly and kaleidoscopically different."

Ray considered all of the collages shown to Mrs. Levy to be connected to the theme of Cornell's cave-man, but the range of imagery in these twenty or so works was enormous. Ray associates images and ideas with considerable freedom (even though one wouldn't quite want to call it "free association") and cave-man figures in one collage became Buddha figures in another. Stalactites turned into communicating vases that turned into pairs of outlines of pregnant women, where a body associated with some personality might bear the head of another personality in Ray's own version of "exquisite-corpsism." Gargoyle figures were accompanied by "garboy" figures, there were images of the gargoyle's underwear, of Joseph Cornell's underwear, and of Clement Greenberg's underwear, which was green. Another collage had passages of red and green since Cornell was born on Christmas. Ray mentioned that after doing a series called "everybody's underwear" he's now beginning to do famous people's bathtubs: Teddy Roosevelt, Walt Whitman, Ernest Hemingway, and Emily Dickinson, among others, even though Whitman didn't have a bathtub. In another collage, a daffodil sketched in Nyack at Joseph Cornell's grave turned into a Venus's Fly Trap, stalagmites turned into hair-combs, noses turned into snakes, snakes turned into turtles, and Ray remarked that snakes and turtles and swans and rabbits are constants in his work. One collage contained the toe of a bloody sock in the midst of a Buddha head with top-knot, actually the outline of the head of David Butterman, the television personality,* and Ray described this work as "a Buddha head in the Greco-Christian Pop Art tradition." A collage with an image of James Dean and the word "cacophony" brought the information that Ray has also done a series of works depicting people's "favorite words." There were also a few portraits, of Ada Katz, Joseph Cornell, and David Bourdon, and Ray remarked that his favorite portrait painter of all is Giuseppe Arcimboldo, the sixteenth-century Italian painter whose portraits dissolve his subjects' heads into arrangements of fruit and vegetables and foliage. Ray Johnson's collages are likewise accretions, and his subject matter is self-proliferating. What matters is the way he works on it, drawing together constellations of images that are a moment's definition of a possible theme.

The rest of the interview was taped on two separate occasions, once at a milk-bar in Soho, and once at the Gabrielle Bryers "Homage to Joseph Cornell" exhibition. Most of my questions were directed to the New York Correspondence School, and I was particularly interested in finding out how Ray reacts to the recent spate of "mail art" that seems to have found its inspiration in the New York Correspondence School, but without really respecting the spirit that makes the School unique. My own impression is that the homage that's generally given to Ray Johnson as the "founder" of this "mail-art movement" has obscured a clearer

*A letter from Ray duly informed me that "Butterman" should really be "Letterman," but he also said that he liked the error and found it amusing, and begged me not to correct it.

perception of the specific nature of the mailing activities in which he himself has been involved. The motivations for his work with correspondence don't, for example, seem to be in any way explicitly ideological, and whatever sociological importance his work may have as a child of its time and as an alternative to the commercial art world is something to which he refers only very obliquely. He has no revolution to theorize since he's constantly in the midst of the practice of one, and even though he's an inveterate organizer of meetings—some of which have been wholly without a program, since their only agenda was for the people invited to meet one another— and a prolific founder of clubs, there's nothing in any way clannish about his activity. The Brown Eyes Club of the New York Correspondence School was organized to keep its members from feeling slighted by their exclusion from the Blue Eyes Club, which was once known to enroll Willem de Kooning's dog. To me, Ray Johnson's Correspondence School seems simply an attempt to establish as many significantly human relationships with as many individual people as possible. All of the relationships of which the School is made are personal relationships: relationships with a tendency towards intimacy: relationships where true experiences are truly shared and where what makes an experience true is its real participation in a secret libidinal charge. And the relationships that the artist values so highly are something he attempts to pass on to others. The classical exhortation in a Ray Johnson mailing is "please send to...." Person A will receive an object or an image and be asked to pass it on to person B, and the image will probably be appropriate to these two different people in two entirely different ways, or in terms of two entirely different chains of association. It thus becomes a kind of totem that can connect them, and whatever latent relationship may possibly exist between person A and person B becomes a little less latent and a little more real. It's a beginning of an uncommon sense of community, and this sense of community grows as persons A and B send something back through Ray to each other, or through each other back to Ray. And then the game itself will swell through Ray's addition of still other images and persons C and D and E.... Configurations of possible relationships will always be shifting, but the more they shift, the more the very fact of such possibilities will itself grow solid. It's a game that's played with a good deal of levity and wit, but it also has an air of deadly seriousness. This fluid web of interrelationships can be felt as the stuff of which psychic life is made, and it hovers as though in a void. Ray is a kind of image of the demiurge, always making something out of nothing, substance out of possibility.

HENRY MARTIN: One of the things I've been wanting to ask you is how you feel about all these new Schnabel kinds of people: that's not really an interview question, but....

RAY JOHNSON: Sure it is. And my only feeling is that Schnabel is on my list of people to do a portrait of. I'd like to do a portrait drawing of him as a person. But as a person he interests me more than in any other way. I don't know if I have ever seen a painting of his. I was recently at the Whitney Museum and must have laid eyes on one, but anything I may have seen didn't at all impress me as an artwork, neither as an artwork in itself nor as an artwork by a personality.

Bloody Sock

186

HM: I imagine that goes not only for Schnabel, but for all the rest of these people as well, the new Germans, the new Italians, the new "Fauves," the entirety of "the international transavantgarde."

RJ: Well, I never see them.

HM: You never see them and don't care to.

RJ: But in driving into the city today, I was looking at all the graffiti, which I find boring and depressing, and I thought of becoming a graffiti artist myself. I thought of getting a white spray can, or a red spray can, and spraying the word "shit" over it all, defining the entire graffiti phenomenon as "shit." I'd just add to the shit by calling it shit, and I think that would be a beautiful thing to do. Everybody is supposed to be free to be a graffiti artist, and so that would be my own sense of how to use this freedom.

HM: It's interesting that what you say about Schnabel is so close to something you once said to me many years ago when I asked you how you felt about Andy Warhol. It was the same answer, that you were interested in him vaguely as a phenomenon, but that the art didn't have any particular meaning for you.

RJ: Well, you're talking about specific individuals, and it's not as though I were always unresponsive to artworks. When I was recently up to the Hirshhorn Museum, there were any number of artworks there that I found impressive—one of those old Giacometti women with the big club feet, a tiny, and strikingly eloquent Giacometti which was a painted bronze only about one foot by one foot and I squatted down to get a good look at it; the Francis Bacon sphinx, if you'd asked me about Francis Bacon, I'd have replied, "Oh, that beautiful sphinx." But I think it's the sphinx that interests me more than the Francis Bacon painting of the sphinx, because I recently saw a photograph of the sphinx seen in profile, which was the first time I had ever seen it that way; it's usually seen frontally, and in profile it looks like some odd kind of puppet shape. It's very deformed, and people always photograph the sphinx as they look at it frontally because one tries to see form rather than unform—like a portraiture concept of the nineteenth century, of Grecian wholeness, which is one viewpoint—but the unform is there as well.

HM: There's a whole new generation of "mail artists" now, and they seem to think of you as their spiritual father. I wonder if you really accept that paternity.

RJ: Well, at this point, I'm just sick of hearing about it. An artist who specializes in making postage stamps recently called me up, for example, and wanted me to be in some show, and I said no; and he said would I do this or would I do that, and I said no. And then he went on about how I was this and that and I was the first and the father of mail art or something, and how important mail art is, and I said, "But that's such a cliché. I'm sick of hearing that, it's just such a cliché." And then I immediately sat down and sent him a cliché collage. I have a dictionary where words in English are explained in Yiddish and I looked up the word "cliché" and cut it out and sent it to him. I took this put-down of having told him that he was talking in clichés and immediately made it into an artwork, and that's the very same thing I'd be doing with the spraying of the word "shit" onto somebody's graffiti. I'd be making it instantly into some kind of

187

work by Ray Johnson, something designed by Ray Johnson, a Ray Johnson calligraphy.

HM: You think that all of these people just have different purposes than you ever did with the New York Correspondence School.

RJ: No, no, it's just that....They obviously admire me, and they were obviously influenced by me, and I see it in print or am verbally told that they have a certain respect for me, and so I say "thank-you" for the compliment, but I think it should get to the point where they go and do their own... well, whatever they really have to get on with doing. I mean I got to where I do what I do through my studio work, through being a practicing artist. *Art News* published an article once in which Paul Gardner asked people, "What is your secret vice?" and my reply was that my secret vice is "making collages by Joseph Cornell." I have a rubber stamp that says "Collage by Joseph Cornell," and I use it with this same Yiddish dictionary that I found in an old loft. I cut out blocks of information in Yiddish, glue them down, and then stamp them "Collage by Joseph Cornell," and I either give them away or mail them off or sell them or do whatever I do with them. One of them, for example, is the tailorbird, there's this beautiful illustration of the tailorbird, which builds a kind of nest that's oddly cup-shaped, and they nest in this thing, two little birds are looking out, and then I found this mastodon illustration, captioned in Yiddish, so I'm cutting these things out block by block and doing Yiddish dictionary information the way I did the American dictionary, which was long before Kosuth, I methodically went from A to Z and simply cut out these blocks of information and endlessly glued them down or attached them with Scotch tape and the people who have them now remark that they're all falling apart, but that's in the nature of Scotch tape.

HM: Tell me how you got into correspondence in the first place. You said it was a kind of extension of your studio work.

RJ: No, no, that's not really how it was at all. The North Carolina catalogue—in 1976 I had a show of correspondence at the North Carolina Museum of Art in Raleigh—well, that catalogue reproduced letters from 1943 that were submitted by Arthur Secunda, who's someone I went to high school with. I have to give my thanks to Richard C. for that, since he's the person who did that catalogue and who published and exhibited all of these early and embarrassing letters from my high school days—what dance I was going to, and what cheerleaders I was running around with, all of that embarrassing drivel—but I can see its interest or its value, because...well, the drawing I just made for John, for your baby son John when he was at the door, I made a drawing for him and said, "Here, this is for you," and that was a 1943 drawing, it was only two eyes and a nose and a mouth, but it was just a 1943, "here's a drawing" kind of thing. There was that clipping that someone recently sent me from *L'Espresso* magazine where they talk about the beginnings of my mail art in the 1970s, and Ed Plunkett is on record as saying that it started in the 1960s, but, for myself, I think I should declare that it actually began in 1943, which is the actual date on those very first letters with drawings and all the other sorts of things that I'm still doing today. That was really the infancy of the activity. And I myself, in fact, never called it a "school" or talked about "mail art," I mean I never used those terms at all.

HM: Where did they come from?

RJ: Well, from other people. They've talked about "correspondence art," "mail art," and I've just seen an announcement for a show of "fe-mail art," and there's "post-tale art," and of course the New York Correspondence School, which, as Ed Plunkett said in his article in the *College Art Journal*, is a term that originated with him. He was the one who gave that name to the things I was doing, and I accepted it and adopted it since I thought that using that title would be an amusing vehicle or a joke, and it was, in fact, a convenient way of describing this activity that I was involved with. And then, when the school began to die—it has died so many times and then been reborn from its death—I decided to give up on calling it the New York Correspondence School. I was angry with *FILE Magazine*, so I thought I would call it "Buddha University." They were doing the New York Corresponge Dance School of Vancouver, they were being copy-cats, so I thought, "Well, let them copy 'Buddha University.'" And now it's many years later, but just about a month-and-a-half ago I began to get postcards from an archive information center in Budapest, Hungary, and they've transformed "Buddha University" into "Buddha Pest." I've traced that back to the CDO group in Parma, Italy. They thought that was very cute, and they went to all the trouble of organizing this thing in Budapest. There was another time too when the CDO group in Parma came up with an idea for a manifesto that they were going to drop on something like the Venice Biennale. But they had a very strange idea, since they sent me all this stuff about the importance of mail art and said they were doing this manifesto in my honor, and then they asked me to sign the manifesto, and I thought one doesn't really sign a manifesto honoring oneself. And especially since this was the second time they wanted to honor me, because the first time was when they asked me for something for an exhibition in my honor and I wrote back "Nothing" on a blank page, and this was what I had to contribute, the word "Nothing" on a blank page. But they seemed to like that and to think that it was probably amusing or interesting even though what I gave them was no statement, no image, no nothing.

HM: Before we started taping, you said there was a kind of anger in your reaction to that little note that Francesco Vincitorio published in *L'Espresso*. You were angry about the way he talked about your founding a "mail art movement" which he then lumped together into a whole list of "movements," like conceptual art, body art, performance art, minimal art, and so forth.

RJ: Well, I was angry, and I still am angry, and I think that anger is a justifiable emotion for me, an emotion that helps me to do my work. I got up this morning at six o'clock because of something that made me angry and I started to work on three new drawings. But that's a little different. And it's not quite the way you put it, what I was angry about is....Well, I have two sources of anger, now, and one of them is the Mike Crane *A Brief History of Correspondence Art* book. It was advertised to appear in the spring of 1981, and it still hasn't been seen, and I just wrote a letter the other day saying, "Where where where is this book?" I keep on writing them letters all the time saying, "Where where where is this book?" because I want to see it. At the very beginning, when Mike

,EREH SIHT SI ROF UOY

Crane sent me his letters—they were form letters—requesting information about my mail art activity, my immediate response was not to respond at all. From the way the questions were being asked, I just thought, "Oh, I have nothing to say." And then he sent me a copy of something of mine that he'd found and wanted to use in his book, I don't remember exactly what happened, but he sent me a copy of a letter that I had once sent to David Bourdon, and I remark in that letter that the New York Correspondence School has no history, only a present, which was a pun, of course, on "present" as now, and "present" as gift, a pun on my own way of giving information and objects or whatever in letter form. So he sent that thing to me, and I immediately said, "Well, I'm consulting my lawyer, and all of my work is copyrighted," and I gave him a very rough time. I was suddenly very huffy and rude, and I don't remember exactly what I said or did, but it was a genuine gut response to everything, and so I was uncooperative, deliberately uncooperative, I didn't like the way he was doing his investigations, I didn't like his way of conceiving of this book, he was sending out questionnaires asking, like, "How many letters do you get a week?" things like some Kinsey report or some survey for *Playboy* magazine, and also I had never met this person. And anyway I'd like to do my own book. I'd like to do my own history as to what I think happened. Everytime I get any publicity or press, everybody has a different version as to when anything happened or as to what anything was, and I myself don't even know when anything happened, or what happened, or I don't even know what year I did anything in, except that now I keep insisting that 1943 was very important because I found a document in my mother's scrapbook from 1943 and decided that the things I'd been doing then ought to be catalogued.

HM: Are you saying that your work as an artist who makes paintings and as an artist who makes letters all began at one and the same time?

RJ: I'm just saying that history is a very loose subject in which anybody can declare that anything happened at any time at all; and maybe that will be accurate information and maybe it won't be, and maybe that won't make any difference. I'm saying that history can be written in a very slanted fashion, and that one can emphasize anything one wants to in a history, which was my own experience when I did an exhibit called "Ray Johnson's History of the Betty Parsons Gallery." That was my own kind of attempt to deal with Betty's history as an art dealer, and what I did was very different from the kind of history that Lawrence Alloway is now writing of the Betty Parsons Gallery. My whole concept of a history was to take one catalogue that listed all the artists she had shown, and I did homage works about them and made bunny lists—lists of their names where every name is under one of my little drawings of a rabbit. And Betty never asked me to do her history, and what I did was never officially perceived in any fashion whatsoever. I just simply had the idea that I wanted to do a work, an exhibit, that had the word "history" in it. Like with Gertrude Stein. There's a title that Gertrude Stein uses somewhere, something she calls a history of something.

HM: In *The Making of Americans* she said that she wanted to make a history of everybody.

RJ: Yes, and my portrait work is subtitled "The Snaking of Americans," which is a very oblique S & M reference, Sade in Japan, Made in Japan, Making and Snaking, S & M and M & S.

HM: You're just not interested in anybody else's history of the New York Correspondence School?

RJ: I have simply had to accept the fact that out of a life necessity I have written a lot of letters, and given away a lot of material and information, and it has been a compulsion. And as I have done this, it has become historical. It's my resumé, it's my biography, it's my history, it's my life. And now, people are always coming up and saying, "Oh, you're the father, you're the father of mail art, and everybody got the idea of it from you, or was influenced by you," and so I keep on thinking that if I just had the time or the interest I could....Like one of the first mail art shows was in Sacramento when I went out there and lectured, I specified that I had to be under a pink light and I had a text that I wrote, and this was one of the beginnings of all these performances and lectures and exhibits, and then I say to my friend Toby Spiselman, "Like, what year was that?" It's as though people imagine that the importance of that is because it was done in that particular year since it was only a year or so later that people everywhere in universities and colleges began getting this idea that you simply write out a lot of letters to people and you get all this stuff and you exhibit it in a gallery, which is what I did at the Whitney Museum, which I think was in 1970. And now I'm wondering if I've answered your question or if there's something that's still not clear.

HM: Can you tell me how the various past activities of the Correspondence School have related to your collages?

RJ: Well, I don't really see that "collage" is very exact as a capsule classification of what I do. My collages also have painted areas—that's quite clear, for example, in these "Homage to Joseph Cornell" works, which are on masonite—and painted elements have always been in the work, painting and washing and watercolors and acrylics or whatever. When I was cutting things up into strips and gluing them down right next to one another, I'd go over the surfaces with a brush, with washes of ink or color or paint, and then in subsequent years I went into sandpapering them, or crayoning them, or covering them again in some way. They build up into layers of multiple coverings, and technically they're collages since they're glued surfaces, but they're also assemblage and they're sculptural too, in the sense that they're bas-reliefs that cast subtle shadows, like Ben Nicholson reliefs. That's something very few people have ever appreciated, very few people have ever understood that my works are in the tradition of Ben Nicholson, believe it or not. I have build-ups, and intricate layerings, and little pyramids in my work, and these are all raised surfaces that create shallow sculptural shadows, and so the works are dimensional. Or they can be dimensional, or are often dimensional since some of my works are in fact just flat glued things, just glue-downs or slap-downs, but it's only really because of the necessity for classifications that we have this idea of "Ray Johnson collages." My collages are also very painterly, and drawing is probably an even more important aspect of my work. I'm endlessly drawing with pen and ink and nibs. All the surfaces are intricately drawn, either in India ink or washes or colored inks, and there's always a variety of techniques in each specific work. And I can say this is how this part was done, and this is how that part was done, because they're apt to be from different years. One piece will be from one year's work and another from another year's work since my works get made and then chopped up, and then reglued and remade, and then chopped up again, the whole thing is really endless.

191

HM: Whenever I talk to people about your work, I always find it difficult to deal sufficiently with the complexity of it. I'm very aware of your procedures, of your printing, of your calligraphy, of the way you cut things up and glue them down, and then take them off, and sandpaper, and draw, of all the ways you make your collages and then interfere with them, and keep on changing them. But after I try to explain that sort of thing, I always feel that people also want to hear something about the images themselves. They want to define the importance of the images, to define their importance in terms of their sources; and there are so many sources. There's a Pop art area of popular imagery, a Dada area of imagery, a cartoon area of imagery, an art world area of references, a fetish area of references, an obsession with numbers, a level of purely cryptic shapes, and all sorts of other things as well. It's hard to make it clear that the density of the whole system of references is itself more the point than the various specific things referred to, and that individual references can lie at any number of different levels of importance.

WOMAN WITH BANGS 1982
Oil on Canvas 21⅛ x 16⅝
Baltimore Museum of Art

RJ: You might find a help in what I call my major work of the last seven years, which is a project for a series of portraits. I'm dealing with an emphatic, specific portraiture idea of the human head, and that's an extension of the basic "moticos" idea. The moticos were the little black silhouettes I did, and they were a miniature cataloguing of actual free-form collage fragments. I'd take a box of fragments, which were all different shapes, and then I would draw each thing in India ink. Each fragment was about ten inches high, and the drawing would reduce it to about one inch high, and I'd cover whole pages with them. They're also on the faces of the Elvis Presleys and all the other people in those early movie-star collages. The photos of the movie stars would be partly covered by these moticos listings and cataloguings of collage shapes. So figures that might look, say, like the outline of a bust of Mozart could appear in some of these early works, Mozart or horses or cows or animals or squares or "T"s or houses in flattened silhouette or cookie shapes. And now I have perfected this into the art of silhouette portraiture. In 1978 and 1979, I was doing life-sized heads, but since then I've reduced them to about four-and-a-half inches high, I do that photographically and just do zap zap zap on a copy machine that reduces my original drawings, which are drawings that I make from life if the people themselves are alive and from photos or previous silhouettes if they're not. And I deal with people's heads not just as black shapes on white, but rather in terms of Arcimboldian encrustations of fragments of collage that I apply to the surfaces of their silhouettes. It's exactly the same thing as Elvis with the moticos, I'm now just taking the collage fragment itself and sticking it on. I can take anything and just stick it onto the side of a person's head. I've even done some where I blow them up, so you have them fluctuating. The head becomes merely a vehicle for me, or an excuse for me to put a Ray Johnson onto a head. And my concept of portraiture is to do thirty or forty variations on each person's head, so I do a whole exhibit of each person. And now I've done about three hundred people, so I have forty John Russells, forty Arakawas, forty Peter Beards, forty Chuck Closes, which is the way I try to do a complete portrait. But that got completely out of hand because I simply couldn't deal with so many different works, and that's why I began to do the heads smaller

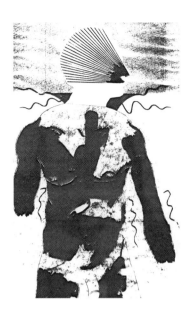

Joseph Cornell

and with several heads on a page. So now, if I'm lucky, I get off with doing only fifteen or twenty works of each person, like this summer I did maybe fifteen or twenty Dore Ashtons and fifteen or twenty Xavier Fourcades.

HM: How do you choose the people of whom you want to make a portrait?

RJ: Well, it's like letter writing. Who do I decide to write a letter to? I showed you a book that just arrived, for example, it's from a man in Switzerland who saw my Naples exhibition and decided to send me his poems, and now I'll write to him. I'll ping-pong back to him and do a whole Belt Club about him, because of his name, which is Beltrametti, he'll be the Spam Beltrametti Club, just like Cavellini got into some of my cave-man collages because the first four letters of his name are CAVE. There's a reason to write to him, to thank him for his book, but he also gets involved in other things because of some combination of alphabetical letters and names. If Mr. Beltrametti's name had been Jones, my reaction would have been different, and he wouldn't have gotten connected with the Spam Belt Club or the Spam Radio Club, which dates back to when Mike Belt was given to the Correspondence School. He was honored with the rubber stamps of the Spam Belt Club and the Spam Radio Club, and that was one of the objects of the New York Correspondence School. That's still another thing about the Correspondence School, it's not just the letters, the postcards, the drawings, the poems, it's also the New York Correspondence School objects. The Spam Radio, for example, was a radio in the shape of a Spam can, which had a little handle on it, it was a thing the Spam Corporation made one year as an advertising gimmick. It was something they gave to people, and you could go to the beach with your Spam radio, and play your radio on the beach, it was a little radio inside of a Spam can, and I didn't really treasure it very much so I gave in to Jim Bohn.

HM: Why did you turn it into a fan club?

RJ: Why? But it wasn't a fan club; it was a belt and radio club. There was the Paloma Picasso Fan Club, a little while later, and also the Claude Picasso Fan Club; his sister was being honored and so he had to be honored too, especially since they both got the inheritance. But to get back to that radio, I gave it to Jim Bohn—which is BOHN and not BONE—and the following week he was in Soho walking around with his wife and carrying the Spam radio as a kind of trophy. He was taking it out for a walk, and the minute I saw him with it I realized that he had given it some kind of notoriety and importance, and I was intensely jealous that he was walking around with the Spam radio and that I hadn't thought of walking around with a Spam radio, like the time I had once walked around with the head of Candy Darling in a plastic bag. So still another week later, I was in Soho again and went to the supermarket and bought a real can of Spam and put a little handle on it, and then I was walking around with that. And then came the day when I had to go and do my lecture in Baltimore, and I'd decided that whatever arrived in the mail that morning would be the subject of the lecture, and one of the things that came was the Arturo Schwarz "exquisite corpse" catalogue, so I took the fake Spam radio, which was really a real can of Spam, along with me, and what I did there was a chance radio event. I'd driven all the way from here to Baltimore

193

and I'd been listening to the car radio, so I was doing these John Cage kinds of radio pieces where I'd turn on a radio and get a snatch of music or a snatch of words and then I'd turn the radio off and relate what I'd heard to my text. It was like instant Jean Cocteau poetry.

HM: What sort of text were you reading?

RJ: It was all assorted papers of the New York Correspondence School. I always have these bundles of papers that I either throw up in the air and let scatter, as I did in Minneapolis when I did my "throw-away gesture" lecture, or otherwise I just have them on hand to read. I generally just read one sentence and then go on to the next sheet of paper and read two sentences, and after reading from each sheet of paper I tear it in half. I consistently or persistently pursue no logical thread or idea, I just simply throw this stuff out and let it fall where it may. So this fake Spam radio was on my lectern and I had a heckler and a streaker, which was before I did my own streak at the Walker Art Center.

HM: You streaked at the Walker Art Center?

RJ: Oh yes. When I showed at the Walker Art Center in Minneapolis, I also went out there to do my "throw-away gesture" lecture, and in the course of that I streaked.

HM: You just ran naked through the gallery?

RJ: Sure. I took off all my clothes and I streaked, just did an old-fashioned streak, which was sort of amusing since it was years after anybody had been streaking. There was a very nice English curator there, and he was to give me an introduction, so I asked him to introduce me as "Ray Johnson, the master of the throw-away gesture." That was straight out of *Art in America* magazine since this critic there said that I was the "master of the throw-away gesture," so I really picked up on that and began doing throw-away gestures all over the place. I did a whole one-hour presentation of throw-away gestures, including throwing away my clothes, and then I came back dressed. But the person who streaked at my Baltimore lecture is what I was talking about, and he was a very strange young man. As he was streaking, in fact, he came up and grabbed the Spam radio and abducted it. He just grabbed it and ran, stole it right off the stage, right from in front of me, and that became immediately "The Abduction of the Spam Radio Baby." The Spam can I was carrying was a little smaller than the original Spam radio, so it became a baby and I did a printed page about how Jim Bohn and I had had a baby Spam. His wife was very puzzled as to how these two men could have had a baby, a baby Spam can, and I never bothered to explain. I just recorded the fact that Jim Bohn and I had given birth to this baby Spam can which was abducted in Baltimore. And after the abduction, I just continued the lecture by being very upset and starting to say things like, "Where is my baby Spam?...They've stolen my baby Spam...I want my baby Spam back." So then the other night, I showed Jean Levy a collage with two women figures in it, these women figures that look pregnant, and one of them was full of garden rakes. And Jean Levy remarked, "Oh, she's going to give birth to a rake." Well, I wrote that down on my table, yesterday: "the birth of a rake." I even wondered why I was writing it down. I thought of *The Rake's Progress*, but I also thought of Veronica Rake, because Jean Levy also asked if they liked Sade in Japan, which requires explanation since it gets involved as well with a work by Frederick Kiesler, called *The Birth of a Lake*, which is a kind of blotchy bronze sculpture that depicts a waterfall. It's up at the Albright-Knox

Museum and I'd made a note of that too, a note for future work and future reference. I have all sorts of ideas and bits of information either on pieces of paper or on file cards or in envelopes, but also in my head and in my dream world. So that remark about the birth of a rake got involved with Japanese "R"s and "L"s—like the Blue Eyes Club of the New York Correspondence School also has a Japanese division called the Brue Eyes Crub, and those are two specific rubber stamps—and so now I'll do a whole slew of these women with rakes giving birth to lakes, and Veronica Rake's Mother's Potato Masher will be depicted, and so you can see how the subject matter is just endless. It goes from nuance to nuance and from object to image, I started out talking about the Spam radio and so many New York Correspondence School objects have been like that, the watermelons, the objects found in the streets, the Norman Solomon hunks of lead, the Lucille Valenti shoe, all these

fetish objects from people's lives. When John Dowd moved to California, he came to my house with nine cardboard boxes full of all his letters and papers back to his high school days. He just dumped them on me and I was stuck with his whole life: all his personal affairs, the love letters and photographs and greeting cards and Christmas cards, the baby pictures and everything else like that. And then I myself recycle it all. There were certain years when Alison and Dick Higgins got box after box of this stuff from me, I'd haul it across town to their loft and say, "Here's another box." They got

195

a whole stockpile. There was a listing of the neckties, the Kline's dollar neckties, I used to have these necktie clubs and now all of these neckties go to Julius Vitali out in Sea Cliff, he gets whole boxes of them. And on Valentine's day a couple of years ago, I went to see Coco Gordon, who's a friend and a poet and a paper maker, and she got five really big boxes with an absolutely incredible amount of Correspondence School documents. I'd done a really good house cleaning and put all this stuff in boxes and drove over to her house and said, "Here, this is for you." I was lucky she didn't have a nervous breakdown. It took her months to open them, and she was beautiful about it. She investigated each box, very slowly and very methodically, and she distributed all these things I'd given her into little islands that were scattered around her house. She classified them and made little charts as to what these things were, she made her own arrangement out of this archive of mine. At one point, I thought it was simply too much for her and told her to just go and throw it all out into the water; she lives in a house out by the water, I just told her to throw it all away and get rid of it.

HM: But that's something that you would
never do, just throw it all away?

RJ: Well, I've done things like that for May Wilson,
and documented it. One New Year's Eve, when all the horns were honking,
I did a water disposal event in May Wilson's honor. These were all wooden
and metal objects that I inventoried and listed and then threw into the water at midnight. It was a
ceremony. And I went back a week later and some of them had beached, so I scooped these up again.
There was also the time I came to the city with a dead raccoon. I sat in the street for two hours
with this dead raccoon, right across the street from the Spring Street Bar, and people would come by
and say, "What is it?" and "Is it asleep?" and I called up Toby Spiselman and told her to come right
down with her camera. And maybe it would be an interesting thing to use Toby's photos of the dead
raccoon to illustrate this interview because the whole point was, "What do you do with a dead raccoon
after the art event?" And the answer is that we put it in a cardboard box and I said it was either
dropping it into the harbor or taking it up to May Wilson, which was because of the bèche de mer
days when I once had dinner with Arman and he ordered *bèche de mer*, which is a kind of sea food deli-
cacy that wobbles like jello, and people only ate a little bit of it and they were going to throw it
away, and I said, "Oh no. I'll take that to May Wilson." So we went to May Wilson's and I said,
"Here, this is for you, May," and she said, "Ooh, what's that?" and I said, "Old bèche de mer," and
she said, "Ooh, it looks like shit," and then she put it in her blender and it turned into a kind of
brown liquid and I explained to her what it was. So then we took her the dead raccoon, and I said,
"Here, this is for you, May," and she looked at it and said, "Ugh, it smells just awful," and I said,
"Put it in your blender," and she said, "Get that thing out of here," so then we took it down to
the harbor and dropped it in the water. There were also the Dorothy Podber dead pig head days, or the
dead kinkajou in my refrigerator when I was living on Dover Street. So there's a whole history, then,
of objects that have been actually mailed or presented or delivered—I left one of those pig's
heads on somebody's doorstep—and all of this is a part of what I call the Correspondence School
because these objects are things that are exchanged for some reason, just as before when Berty found
a thing in the street and I found a thing in the street, and there was a kind of communication
between these objects, a kind of communication of *objets trouvés*.

HM: Another thing you said to me before we turned on the tape recorder
is that so much of this most recent generation of mail art has simply become an art of
communication that doesn't do any communicating. And what seems to me to be missing in
it is precisely this sense of things that you've just been talking about—the sense of a kind
of objective exchange through objects; this sense of things that are given, somehow or other,
because they've somehow or other been asked for.

RJ: Well, in the past, I think that the New York Correspondence School was an art
of communication that was truly communicative simply because I was able to wield the ping-pong paddle
and to keep the ball on the move. A few days ago, I had a phone conversation with Brian O'Doherty
and he was impressed with the North Carolina catalogue, as a lot of people were, simply because of
the volume of the information that was dished out through the Correspondence School. It was a
full, daily, weekly, monthly activity, year in and year out. I think it's Ellen Johnson, in one
of her books, who says something like, "Oh, Ray Johnson works eight to twelve hours a day doing this
correspondence of his," and there was a time when that was true; and that's the kind of daily time

it took to keep it all in order, to keep it all functioning. And the whole thing assumed global proportions and I found myself running a kind of international organization but with no funding whatsoever. As a one-person organization, it was just impossible for me to keep up with it. There were times when I felt that I had to kill it before it killed me, and there were times, any number of times, when I've just broken down from the sheer complexity of the activity.

HM: While we were visiting with Jean Levy, you told her that you had once written a letter to the obituary department of the *New York Times* to announce that the Correspondence School had died on a beach along with a large Canadian goose.

RJ: Yes, that was the first really big death of the New York Correspondence School. It was at one of those points where one gets to experience some of the pleasures of death and collapse, and all sorts of things that go with that. It was a kind of metamorphosis, sort of a tremor of energy, like something I was talking about not too long ago with a woman artist who's a friend of mine. We were at a health club, at noon, getting something to eat, and I told her about the experience I had in Chicago when I was there for the opening of a show at the Feigen Gallery. I'd had so much champagne and lobster Newburgh for lunch that day that I had to go back to my hotel to go to bed and take a nap, and I somehow got my foot stuck in the blankets in a way that gave me a cramp. I suddenly woke up, and a muscle had bulged out of my leg, and it was extremely painful. I didn't at all know what to do, but what I did, in any case, was to try to push the muscle back into place, which was even more painful, so painful that I fainted from it and fell out of bed and I lay on the floor unconscious. There had been all that champagne, lots of rich food, and too much exhaustion and excitement. And as I was lying on the floor, I became aware of something that was going off from my chest and out into vast amounts of space. Something like a thread or a light, or something that was extending off, like in the Tibetan Book of the Dead or like some spirit that leaves the body at night. There were also green and purple and bluish kinds of little sparks that were slowly spiraling around this thread and going off into space along with it, and all of this just took forever. I was just lying there and it was as though my spirit were leaving my body. It was like some sort of calm death experience, and if I had died right there, that would have been logical. That's the way it would have been. But it just went on and on for something like an hour-and-a-half, and then I came out of it and stumbled into the bathroom to get a glass of water and then fell down again and banged my ear and head and was all bruised black and blue, and then I crawled back into bed and at four or five o'clock I decided to get up and go on to the next party, on to the next event, on to the next disco. So that was more bizarre than this death of the New York Correspondence School, and what I felt on the beach that day was just a great sadness.

The Dead Raccoon
(Ray with Toby Spiselman)

I was alone on the beach and it was close to sunset and everything seemed sad and desolate and I encountered this bird, a sea bird, that was obviously about to die. It was an old bird and it was dying and so I spoke to it and left it there and came home and sat down at the typewriter and decided to write an official letter to "Dear Deaths" at the *New York Times*. And I signed it "Buddha University," which was like suddenly...well, it was just all there. And of course they never published it. So, none of the other deaths of the Correspondence School have ever again been quite that dramatic, but I've often come to a point of extreme exhaustion or tiredness or inability to run an

international organization. And now I get these endless things about still another "mail art" show, and I don't even answer them. Or if I do, it's only the slightest gesture, like one little bunny head on a thirty cent airmail letter. It's not at all a cliché when I say that I have a kind of natural generosity and that this was the real basis of the New York Correspondence School, and this natural generosity of image and idea and information is something I can only extend so far. I don't have the time any more. And the information by itself would just keep on accelerating, it just keeps on accelerating and expanding. The Correspondence School was a question of always typing away at more and more of those letters, mailing out more and more of that information, xeroxing up all of that stuff, doing meetings and communications and all the rest of it, there was all of this stuff that was always gong on. And in a way it still goes on, and still, in a way, in the very same way, but more subliminally. Things now go into cardboard boxes more than they do into actual distribution, endless cardboard boxes that just pile up in my house.

> **HM**: Isn't that what you were always doing with the collages, in any case? I've always had the feeling that they were a kind of final resting place for all the information that you've had flowing into and out of the mails—that their function, almost, was to be a place in which all this information could sediment.

RJ: Well, technically, yes, with the strips and the layerings and the whole archaeology theme that's a part of them, and there's always the idea of recycling them. I'm working still today on those 1958 works, I still chop them up and add to them and now I'm doing these compositions which have various dates in them: this segment here is 1958, this is the 1960s, this is the 70s, this is the 80s, so any one picture plane has the possibility of various years of layerings and archaeologies and things added to it or things that get built up. I can take anything at all that I've done in the past, and it can be signed and dated and framed or under acetate or whatever, and I decide to just chop it in half. That's my procedure. Chop it in half and sign it 1982 to depict the act of the decapitation of the work, to depict whatever reason there may be for the decapitation of the work. And there's always the sandpapering, which I'm doing now to all of my 1978 portraits, because I've found a new sandpaper that really lets me dig into the paint and really grind it all off. So 1982 will document areas of removal of debris from things that were, conceptually, already pictures. These things that were painted and have texture, surface, imagery, patina, you know, whatever it is that went into them to make them completed pictures. But then, in the blank spaces, I simply grind away back to the basic brown masonite and stick a 1982 onto a 1978. Not too long ago, I showed some things to some people who are doing a book on international collage for Thames and Hudson; they're Joan and John Digby, he's an English artist and she's a poet, and so I showed them things and they interviewed me, and they were particularly concerned about technique, and preservation, and like why do I use such cheap materials, and why don't I use good papers, and all of that sort of thing, all of which I answered by saying that I'm simply not concerned with things like that. They also wanted a statement from me about art, and the man made a hand gesture that made me think he saw a statement as maybe four or five paragraphs on a page in a book, but the statement I came up with was "Should an eyelash last forever?" I do these Korean eyelash collages with these woman shapes that you've seen and that are standing in silhouette for a kind of anatomy study where you look through into the interior of the body, and then I put eyelashes here and eyelashes there, which is sort of like pubic hair. These are works that are very anatomically and sexually referential. So when these people were leaving, and they were like so terribly serious, sitting there writing down their notes, asking their questions,

and they were like writing this book. So as they were leaving I said, "By the way, here's one of these little women that I do." And this woman, Joan Digby, just broke up. It just hit her right in the gut and she said, "Because they're eyelashes!" You know, I'd been trying to tell them about Schwitters and Dada and Arp, but mainly I was talking about Arp because they had brought up Schwitters, and she had a true Dada experience with these eyelashes. So I thought, "Well, there's my statement: 'Should an eyelash last forever?'" The eyelash could be cut in half because these eyelashes are composed of individual hairs, maybe even as many as a hundred of them, that somebody in Korea glued down to a strip of adhesive, so should the whole thing collectively last forever, or for one month, or should half of it last for that period of time, or one eyelash hair, should one eyelash hair last forever? Which then gets down to the point of no eyelash and "Should nothing last forever?" Which is pure Taoism, pure Zen when you get down to that, which is a point that I often get to in my work. I used to do events called "nothings," and I'm involved with just absolute space, with no art, no eyelashes, no statement, no nothing.

HM: You're involved in an idea of Zen nothingness and yet your life is a kind of constant happening.

RJ: Well, yes. And I also continue to ponder that idea I have for graffiti, and spray cans, for using a white spray can to write the word "shit" on the graffiti. And I don't quite know how I would do this. But perhaps I would do it and then document it, in a photo or a series of photos in which I'd be seen as I walk up to a choice piece of graffiti, and then it would all be in the way I'd make that "S" with my spray can, and then I'd write the word "shit" and cross the "t" and dot the "i," and this calligraphy would relate to the graffiti calligraphy. I've thought already about any number of possibilities, and I wouldn't, for example, put white on white graffiti, but I'd put white on colored graffiti, there'd have to be various planes involved, and then I was wondering what I'd do with my friend Richard Hambleton who does these life-sized black figures that he puts on the sides of buildings. I thought for example that it might be interesting to write "shit" like running up and down instead of horizontally, like down the figure and across the torso. You'll remember that I showed you one of his things the other night when we were on our way to Jean Levy's.

HM: That's something else I've been wanting to ask you about, Ray. That visit to see Jean Levy was all about Cornell, and now you're in this show that's a homage to Cornell, and I've been wondering why he's so important to you.

RJ: Well...to answer your question, he's not all that important for me.

HM: Are there any artists who are really important for you?

RJ: What do you mean by "important"?

HM: Artists, say, whom you particularly respect, or whom you feel to have a particular relationship to your work, or who are involved in the same kind of total activity that you're involved in.

RJ: ...Yes. All the graffiti artists.

This interview is based on taped conversations held in New York, November–December 1982.
It was originally published in *Lotta Poetica* (Verona, Italy) 2, no. 6 (February 1984): 2–24.
The illustrations that appear here (pp. 186–197) are those that Ray Johnson originally suggested, and reproduced from the xerox images which he himself provided.

200

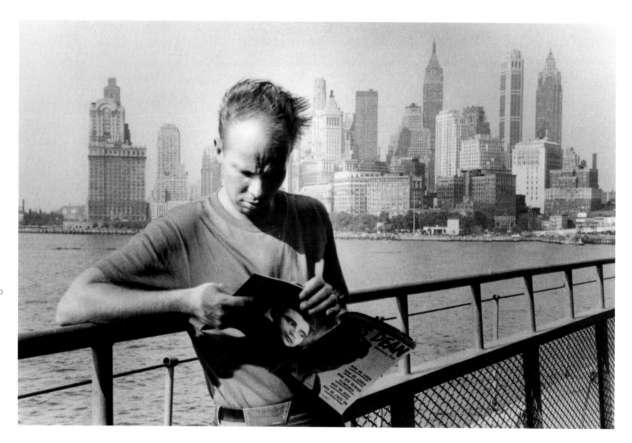

Ray Johnson reading a fan magazine, ca. 1955
Photograph by Norman Solomon

Ray Johnson and Ad Reinhardt, ca. 1955
Photograph by Norman Solomon

selected biographical chronology and exhibition history

Muffet Jones

1927-41

Ray Johnson is born October 16, 1927, in Detroit, Michigan, the only child of Lorraine and Eino Johnson, both of Finnish ancestry. His father works at Ford Motor Company choosing interior fabrics and colors for cars.

As a youth, Johnson is sent to Saturday art classes at the Detroit Institute of the Arts.

1942-45

Attends Cass Technical High School, Detroit, where he enrolls in the Advertising Art Program. Meets Arthur Secunda at Cass Tech, and the two begin an exchange of illustrated letters that increases after Secunda's family moves to New York in 1943. Later claims 1943 to be the start of his mail art activities.

In 1944, spends the summer at Oxbow, the Country School of the Art Institute of Chicago in Saugatuck, Michigan.

1945-48

Attends Black Mountain College, Black Mountain, North Carolina. Studies color and design with Josef Albers, graphic arts with Alvin Lustig and Paul Rand, and painting with Ilya Bolotowsky, Lyonel Feininger, and Robert Motherwell. Becomes acquainted with Merce Cunningham, instructors John Cage and Willem de Kooning, and sculptor Richard Lippold.

For several months in 1945–46, stays in New York, taking classes at the Art Students League and working as a page at the New York Public Library. On his return to Black Mountain, Albers arranges for Johnson to design the cover of the November 1947 issue of *Interiors* magazine. At Johnson's request, a statement on Black Mountain College is published in lieu of his biography.

1948

Moves to New York after a brief trip to San Francisco. Lives in a tenement on Monroe Street on the Lower East Side, across the hall from Cage and Cunningham; Lippold and composer Morton Feldman also live in the building, which they call the "Boza Mansion" after the landlord. The group is frequently joined by Jasper Johns, Robert Rauschenberg, and Cy Twombly, along with other Black Mountain alumni including Nicholas Cernovitch, Remy Charlip, Norman Solomon, and Marie Tavroges Stilkind, who will become the first "secretary" of the New York Correspondence School. Also becomes acquainted with poets John Ashbery, Diane di Prima, and Jackson Mac Low and contributes drawings and short texts to avant-garde literary magazines such as *Unmuzzled Ox* and *Mudfish*.

Designs book cover for William Carlos Williams's *In the American Grain*, published by New Directions.

ONE-PERSON EXHIBITION:

One Wall Gallery and Wittenborn Books, New York.

1949

Works part-time at the Orientalia Bookstore on East 12th Street, New York. Maintains an interest in Eastern philosophies and makes reference to the ideas and images in his work.

1951

Joins American Abstract Artists group. Serves as treasurer 1951–53.

Is invited to decorate the entrance to the Living Theatre, an avant-garde performance space founded by Julian Beck and Judith Malina. Designs flyers and announcements for the theater and corresponds with Beck and Malina through the 1960s.

GROUP EXHIBITION:

British, Danish, American Abstract Paintings and Sculpture (March 12–April 1), Riverside Museum, New York. American Abstract Artists Group exhibition.

1952

Article appears in *Harper's Bazaar* with accompanying photograph featuring Johnson, Lippold, Feldman, and Cage.

Book jacket design, 1948

Mailing, ca. 1970s

Johnson painting walls at Kiefer Hospital Children's Wing, Detroit, ca. 1944

Outstanding in the Art Department is Ray "Baldy" Johnson. Those who know him say he illustrates the horrible example of the brush cut.

Ray is president of the Advertising Art Club, and has recently won a scholarship to the Art Students' League in New York.

His hobbies are fishing, painting, Gene Tierney, and June Allyson.

"My greatest ambition," offered Ray wistfully, "is to buy a farm, live on it, and paint for the rest of my life."

RAY

GROUP EXHIBITION:

Sixteenth Annual Exhibition (February 24–March 13, 1952), New Gallery, New York. American Abstract Artists Group exhibition.

1953

Moves to Dover Street, beside the Brooklyn Bridge in Manhattan. Pursues graphic design work. Sends postcards with collaged images of "The Little King" comics to Isabelle Fisher, a friend and dancer.

ONE-PERSON EXHIBITION:

Cool Ages, Boylston Street Print Gallery, Cambridge, Mass.

GROUP EXHIBITION:

Annual Spring Exhibition (May 19– June 30), Hacker Gallery, New York. American Abstract Artists Group exhibition.

1955

Around this time, coins the term *moticos*, an anagram of the word *osmotic*, which is chosen at random from a book Norman Solomon was reading. The neologism is used to describe a variety of elements in Johnson's artistic enterprise. Creates mimeographed moticos lists, which he mails to friends and prospective collectors. An article on Johnson and his moticos is included in the first issue of the *Village Voice*.

Burns much of his early work, purportedly in Cy Twombly's fireplace.

Produces offset printings of multiple pages of individual texts and drawings; some are intended to be collected in series as books, such as *BOO/K/OF/THE/MO/NTH* (ca. 1955) and *P/EEK/ A/BOO/K/OFTHE/WEE/K* (ca. 1957), which he distributes through the mail.

1956

Through Norman Solomon, meets William S. Wilson, a Yale University graduate student in English, who will become a lifelong friend and Johnson's foremost collector and critic, publishing numerous articles and books on his work. Begins to correspond with Wilson's mother, the assemblage artist May Wilson, then living in Maryland. They exchange letters, mailings, and art, sometimes collaborating on projects until her death in 1986.

Meets poet Marianne Moore, whom he adds to his mailing list.

1957

Continues to design book covers for New Directions, including an edition of Arthur Rimbaud's *Illuminations*, for which he uses a benday-screened photograph of the author—an image he will incorporate into collages and mailings. Andy Warhol, also designing covers for New Directions, introduces him to Gleb Derujinsky, the art director for *Harper's Bazaar*. In February, illustrates fashion spreads for the magazine.

GROUP EXHIBITION:

Mills College of Education Gallery, New York (April 2–30). Selected by Ad Reinhardt, artists include Robert Bücker, Sam Gelber, Ellsworth Kelly, and Stanton Kreider.

1958

Visits Robert Rauschenberg's studio, where he sees *Factum I* and *Factum II*.

Designs window displays for Andrew Geller's shoe store in New York. At about this time meets Gerry Ayres, who would become a Hollywood director and producer, and sends him a series of mailings incorporating the Lucky Strike cigarette logo.

1959

Meets Toby Spiselman, who would become a lifelong friend and the "secretary" of the New York Correspondence School. Spiselman was instrumental in producing and coordinating NYCS events.

GROUP EXHIBITIONS:

Out of the Ordinary (November 26–December 27), Contemporary Arts Association, Houston. Contributes three collages with movie star images: Elvis Presley, James Dean, and Marilyn Monroe.

Below Zero (December 18, 1959– January 5, 1960), Reuben Gallery, New York. (Later disclaims his participation.)

1960

First event Johnson calls a "Nothing" (July 30) is presented at AG, New York. He describes his Nothings to William S. Wilson as "an attitude as opposed to a happening."

Johnson's *Lecture with Funeral Music*, 1957, included in New Music performed by the Audio Visual Group (August 1), held at the Living Theatre.

Bruce Conner and Johnson stage an impromptu event (October 1) by putting the pieces of Conner's painting, *Super-human Devotion* (1959), which has been destroyed in transit to his exhibition at the Alan Gallery in New York, back in the packing crate; manipulating it with paint and collaged objects, including one hundred clock hands supplied by Johnson; and setting a portion of it on fire. They take the box to the opening of The Museum of Modern Art's *Art of Assemblage* exhibition. Refused admission with the box, they leave it in the center of the lobby while they view the show, then take it on the Staten Island Ferry, eventually throwing it overboard in front of the Statue of Liberty.

Bruce Conner
Superhuman Devotion, 1959
Mixed-media, 44 x 35 x 4

Nothing, Maidstone Gallery, New York, 1962
Photograph by William S. Wilson

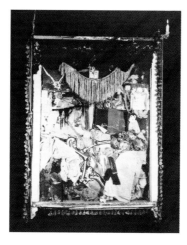

GROUP EXHIBITION:

Gang Bang (December 4, 1960–January 1, 1961), Batman Gallery, San Francisco. Artists include Bernice Bing, Bruce Conner, Jay de Feo, Wally Hedrick, George Herms, William Jahrmarkt, James Weeks, William T. Wiley.

1961

Meets Henry Martin, an American art critic/writer living in Italy, and they begin a correspondence. Martin remains a close friend and an advocate of his work, publishing articles in the European press and facilitating gallery and museum exhibitions in Italy over the course of his career.

Johnson, his friend and art world personality Dorothy Podber, and others circulate announcements for the fictional Robin Gallery—name is most likely a conflated reference to the Reuben and Batman Galleries where Johnson had shown his work in 1959 and 1960.

GROUP EXHIBITIONS:

Purist Painting (October), American Federation of Arts, New York.

Pittsburgh International Exhibition of Contemporary Painting and Sculpture (October 27, 1961–January 7, 1962), Carnegie Institute, Pittsburgh.

1962

Moves to Suffolk Street, on the Lower East Side of New York, where he lives across the hall from Dorothy Podber.

Meets artist Ed Plunkett, with whom he has been corresponding for some time; Plunkett coins the name New York Correspondence School, combining references to the New York School of Abstract Expressionist painters and the generic name of mail-order art schools.

Begins correspondence with Christo and Jeanne-Claude in Paris.

Nothing (late spring), Maidstone Gallery, New York. Sponsored by Fluxus impresario George Maciunas and advertised in the *Village Voice*, the event proceeded as follows: attendees gathered,

nothing happened until Johnson threw a found box of wooden spindles down the gallery staircase, the sound of which was audible to attendees.

GROUP EXHIBITION:

PVI Gallery (January 16), New York.

1963

Continues offset printing and mailing of THE BOOK ABOUT DEATH.

Visits set of Jack Smith's *Flaming Creatures*.

Participates in Yam Festival, organized by Allan Kaprow, George Brecht, and Robert Watts and sponsored by the Smolin Gallery (May).

GROUP EXHIBITION:

Pop Art U.S.A. (September 7–29), The Oakland Art Museum and the California College of Arts and Crafts, Oakland.

1964

During one of his frequent visits to Warhol's Factory, Johnson brings Dorothy Podber, who unexpectedly takes out a gun and shoots a stack of Warhol's *Marilyn Monroe* silkscreen paintings; Warhol later calls them the *Shot Marilyn* works.

Is diagnosed with hepatitis and sent to Bellevue Hospital, where he remains for three weeks.

1965

Johnson's mailings to Fluxus artist and publisher Dick Higgins are collected in the book, *The Paper Snake*, by Higgins's Something Else Press.

ONE-PERSON EXHIBITION:

Ray Johnson (April 6–May 1), Willard Gallery, New York. Mrs. John D. Rockefeller purchases *Ladder Whirled*, ca. 1950–51,

from the show. Grace Glueck reviews it for the *New York Times*, calling Johnson "New York's most famous unknown artist."

1966

Begins a correspondence with Joseph Cornell and asks if they may meet; some time later visits Cornell in Flushing, New York, and the two spend the day riding in Johnson's car.

Granted a National Institute of Arts & Letters award for painting.

ONE-PERSON EXHIBITIONS:

Ice (April 26–May 21), Willard Gallery, New York.

Ray Johnson (October 19–November 19), Richard L. Feigen & Co., Chicago. Includes "Bridget Riley" comb series, the parallel wavy lines of which recall the optical lines of Riley's paintings.

GROUP EXHIBITIONS:

The Other Tradition (January 27–March 7), Institute of Contemporary Art, University of Pennsylvania, Philadelphia.

Art in the Mirror (November 21, 1966–February 5, 1967), The Museum of Modern Art, New York.

1967

ONE-PERSON EXHIBITIONS:

Duchamp Combs (April 25–May 27), Willard Gallery, New York.

Untitled (Pig), 1968
18 x 14

Untitled (Ouch Duck), 1968
17½ x 13½

Ray Johnson and
Andy Warhol at the Factory, 1964
Photograph by Billy Name

Ray Johnson (October 21–November),
Richard L. Feigen & Co., Chicago.

GROUP EXHIBITIONS:

Five Artists Show Collage (October
16–November 7), Gertrude Kasle Gallery,
Chicago. Artists include George Brecht,
Joseph Raffaele, Harry Sloviak, and Phillip
Van Brunt.

*Pictures to Be Read/Poetry to Be
Seen* (October 24–December 3), inaugural
exhibition of The Museum of Contem-
porary Art, Chicago.

*Art in Process: The Visual
Development of a Collage* (March 9–April
25), Finch College Museum of Art, New
York. Includes his collages that reference
the black tricorne hat worn by the
poet Marianne Moore. Also featured is
Rauschenberg's *Short Circuit* (1955),
a Combine that originally was intended to
include work by Jasper Johns, Johnson,
Stan Vanderbeek, and Sue Weil.

1968

Moves to Glen Cove, Long Island, New York.
Attributes the move to a series of violent
events: Warhol's shooting by Valerie
Solanis on June 3, Johnson himself being
mugged that same evening, and Robert
Kennedy's assassination on June 5.

At Cornell's request, Johnson intro-
duces him to Ultra Violet, one of Warhol's
Factory superstars.

*First Meeting of the New York
Correspondence School* (April 1), The Soci-
ety of Friends Meeting House, Rutherford
Place, New York. Described as "An event
inspired by Shaker dance rituals." Dancers
James Waring and David Gordon of
the Judson Dance Theater participate.

Second Meeting of the NYCS (May
17), Longview Country Club "Minimal Bar,"
New York.

Meeting-Seating (June 1), Finch
College, New York.

*New York Correspondance School
Meeting* (June 24), Gotham Art Theatre,
New York.

First Meeting for Diane Fisher
(September 7), Christopher Street,
Sheridan Square, New York. Diane Fisher,
associate editor of the *Village Voice*, was
"played" by Ultra Violet.

Stilt Walk Meeting (October 26),
Central Park, New York. Sponsored by the
NYC Parks Department for Halloween.

Second Meeting for Diane Fisher
(November 23), Finch College, New York.

ONE-PERSON EXHIBITION:

*A Lot of Shirley Temple Post Cards
Show* (March 30–April 25), Richard L.
Feigen & Co., New York. Some of the col-
lages also include photographs of 1920s
figures, such as the notorious silent
film comedian Roscoe "Fatty" Arbuckle.

GROUP EXHIBITIONS:

Electronic Art II (April 17–May 11),
Bonino Gallery, New York. Includes TV
Chair, a collaboration between Nam June
Paik and Johnson.

Language II
(May 25–June 22),
Dwan Gallery, New
York. Contributes
Letter (1966),
which he later says
is an account of his
inadvertent taking
of a briefcase at
a movie house with
"Johnny Cobra's"
color slides inside.

*Richard J.
Daley* (October
1968–January 4,
1969), Richard L.
Feigen & Co., Chicago. A portion of the
exhibition travels to The Contemporary
Arts Center, Cincinnati (December 19,
1968–January 4, 1969).

Violence in Recent American Art
(November 8–January 12, 1969), The
Museum of Contemporary Art, Chicago.
Johnson contributes the collage *Do Not
Kill* (1966). Artists include Jim Dine, Robert
Indiana, Robert Rauschenberg, Arthur
Secunda, and Andy Warhol.

1969

Beating (Heart) mail event (February 14).
Distributes photocopied requests
that correspondents send valentines to
the "Behavior Department" of *Time* maga-
zine. The magazine receives several
dozen responses and comments on it in
an in-house newsletter.

Rabat, Morocco mail event (February
21). Johnson directs Richard Lippold to
send mailings from Rabat while on a trip
to Morocco.

A Duck Named Andy (March 26),
Art Gallery of California State University,
Sacramento. As part of the exhibition,
The Last Correspondence Show, hosts an
event that includes a raffle (Raffaele)
for "a duck that turned out to be a rabbit."

A Meeting of the NYCS. (May 1),
Bernar Venet's "Weather" Loft, New York.

*7th Annual New York Avant Garde
Festival* (September 28–October 4), Ward's
Island and Mill Rock Island, New York.

Organized by avant-garde cellist Charlotte Moorman. Johnson drops sixty foot-long hot dogs from a helicopter over Ward's Island.

When It Rains It Pours (November 5), School of Visual Arts, New York.

ONE-PERSON EXHIBITION:

Ray Johnson (January 5–30), Boylston Print Center, Cambridge, Mass.

GROUP EXHIBITIONS:

Concrete Poetry (March 28–April 19), Fine Arts Gallery, University of British Columbia, Vancouver. Johnson travels to Vancouver, his only trip outside the United States, to install nineteen collages, but during the installation decides to remove them. Accidentally cutting his finger, he wipes the blood on the wall and calls this his contribution, titling it *Blood of a Concrete Poet.*

The Last Correspondance Show (April 7–30), Art Gallery of California State University, Sacramento.

Combine Works (April 8–May 7), School of Visual Arts, New York. The exhibition included collages made by Johnson in collaboration with other artists: *Drip* (with May Wilson), *Mitton* (with Ero Lippold), *My Name is Mona* (with John Willenbecher), *Fake Face Collage* (with Richard Craven), and an untitled work (with Joseph Raffaele).

Pop Art Redefined (July 5–August 31), Hayward Gallery, The Arts Council of Great Britain, London.

Non Art/Anti Art/Truth Art Festival (June 1), Nice, France. Organized by Fluxus artist Ben Vautier.

1970

Moves to "The Pink House" in Locust Valley, Long Island.

Makes a plaster cast of the face of Candy Darling, one of Warhol's Superstars, adding paint and artificial lashes; he

carries it around SoHo in a plastic tote bag as a performance piece (December 6).

A Pair of Ears mail event (March 5). Correspondents asked to send mail to the "Talk of the Town" column of the *New Yorker* magazine.

First Intercourse mail event (April 16) and *Second Intercourse* mail event (May 28), Intercourse, Penn.

A Meeting for Dame May Witty (November 7), David Whitney Gallery, New York.

"Each Time You Carry Me This Way" Meeting for Carrie Snodgrass (November 15), Finch College, New York. Participants carry each other piggy-back.

ONE-PERSON EXHIBITIONS:

I Shot an Arrow into the Air It Fell to Earth in the Ear of an Artist Living in Flushing, New York Tit Show (February 17– March 21), Richard L. Feigen & Co., New York. "In the tit collages, the tits are all based on a 1930's tit chart, done in comic-strip style by an anonymous artist. It's the sort of thing schoolboys pass around" (unpublished interview with Suzi Gablick).

Ray Johnson: New York Correspondance School (September 2–October 6), Whitney Museum of American Art, New York. Johnson writes Marcia Tucker, the museum's curator, soliciting an exhibition for the school. Exhibition includes works submitted by Johnson's correspondents, selected by the museum.

Dollar Bills (September 16–October 17), Richard L. Feigen & Co., Chicago. An exhibition of nineteen collages, all of which include a dollar bill and a reference either to a pop star or an art world figure: Jose-

phine Baker, Joan Crawford, Henri Matisse, Marilyn Monroe, Ed Ruscha, and Chicago group "Hairy Who" artist Karl August Wirsum.

GROUP EXHIBITION:

Language IV (June 2–25), Dwan Gallery, New York.

1971

First Marcel Duchamp Fan Club Meeting (April 23), Church of the Holy Trinity, New York.

ONE-PERSON EXHIBITIONS:

Post Card Show (January 11–30), Angela Flowers Gallery, London.

Dollar Bills and Famous People Memorials (April 3–May 5), Richard L. Feigen & Co., New York.

Country Art Gallery (November 21–December 3), Locust Valley, New York.

GROUP EXHIBITIONS:

Highlights of the 70–71 Season (June 27–September 19), The Aldrich Museum of Contemporary Art, Ridgefield, Conn. Includes *Joan Crawford Dollar Bill*; sends announcement of the exhibition to the actress, who responds.

1972

A Marcel Duchamp Fan Club Performance and NYCS Exhibition (February 10), Wabash Transit Gallery, Chicago.

NYCS Meeting for Anna May Wong (June 30), New York Cultural Center, New York (videotaped by Karla Munger). Fashion model Naomi Sims, then wife of Michael Findlay, director of the Feigen

A NEW YORK CORRESPONDANCE SCHOOL BEATING SEND VALENTINES, LETTERS, POST CARDS, PACKAGES TO THE BEHAVIOR DEPT. OF TIME MAGAZINE, ROCKEFELLER CENTER, NEW YORK CITY 10020

206

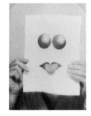

Self-portraits taken in photo-booth, ca. 1960s

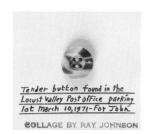

Tender button found in the
Locust Valley Post Office parking
lot march 10, 1971 - For John
COLLAGE BY RAY JOHNSON

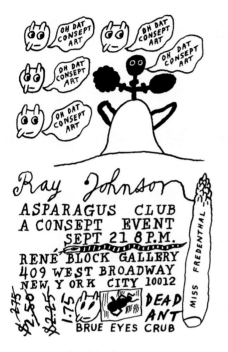

Gallery, "plays" Anna May Wong.

A Moment of Silence for Tiger Morse (August 26), Max's Kansas City, New York.

ONE-PERSON EXHIBITIONS:

Ray Johnson (March 4–April 5), Jacobs Ladder Gallery, Washington, D.C.

Famous People's Mother's Potato Mashers (April 5–29), Galleria Schwarz, Milan.

GROUP EXHIBITIONS:

Photographic Portraits (March 10–April 14), Moore College of Art, Philadelphia.

The City as a Source: Selections from the Permanent Collection (November 22, 1972–January 1, 1973), Whitney Museum of American Art, New York.

Intercourse Correspondence Show (February 1–12), Wabash Transit Gallery, Art Institute of Chicago.

1973

On April 5, declares the "death" of the New York Correspondence School in an unpublished letter to the editor of the *New York Times*, which he signs "Buddha University." Mail art activities continue

under various guises, including Buddhette University, Dead Pan Club, Blue Eyes Club, and Spam Radio Club.

Visits the three-artist collective General Idea in Toronto, who publish *File Megazine*; places tape across his mouth and does not remove it even during the dinner given for him.

First Buddha University Meeting for Mary Josephson (June 9), Paula Cooper Gallery, New York.

ONE-PERSON EXHIBITIONS:

Ray Johnson's History of the Betty Parsons Gallery (January 9–February 3), Betty Parsons Gallery, New York. Johnson installs a series of collages in which he refers to the gallery or to the artists it represents.

Famous People's Mother's Potato Mashers (April 10–May 10), Angela Flowers Gallery, London. Includes seventeen collages, all incorporating the recurring image of an old-fashioned potato masher.

GROUP EXHIBITIONS:

Artists Books (March 23–April 20), Moore College of Art, Philadelphia.

Famous People's Fingernails (September 19–October 10), Marian Locks Gallery, Philadelphia.

1974

Interviews ten artists about their favorite childhood toys, publishing the results with photographs and drawings in *Art in America* under the title "Abandoned Chickens."

A Buddha University Meeting (January 19), Onnasch Gallery, New York.

NYCS Exhibition and Valentine's Day Performance (February 14), Western Illinois University, Macomb.

Paloma Picasso Fan Club Meeting (April 1), Ronald Feldman Gallery, New York.

Undated correspondence from Ray Johnson
John Willenbecher

Mailing, 1974

Ladder event

Cute Ass Club Performance (September 19), Columbia University, New York. Also called the Granola–Elmer's Glue Event and the Cute Class Club, participants kick granola boxes at Jackson Mac Low.

Asparagus Club: A Consept Event (September 21), Rene Block Gallery, New York. Also called Oh Dat Consept Art.

Spaghetti performance (October 15), Oberlin College, Oberlin, Ohio. Presents items from his hotel, makes a "bunny list" on the blackboard, invites audience members to guess the contents of his suitcase and knapsack, removes the sanitary paper bag from the hotel drinking glass, burns matches, and talks about his work and experiences, calling it "name-dropping."

ONE-PERSON EXHIBITIONS:

Invitation Correspondence (February 11–27), Western Illinois University, Macomb. Exhibition is part of his one-week artist-in-residency at the university, where he exhibits a number of collages themed "Detatchment as Composition Oh My Hat!" Lectures, juries a student show, and sponsors a mail art exhibition.

GROUP EXHIBITIONS:

What's the Time (September 14–November 2), Rene Block Gallery, New York.

Poets of the Cities New York and San Francisco 1950–1965 (November 20–December 29), Museum of Fine Arts and Pollock Galleries, Southern Methodist University, Dallas. Travels to San Francisco Museum of Modern Art and the Wadsworth Atheneum, Hartford, Conn.

Drawings and Other Work (December 7, 1974–January 8, 1975), Paula Cooper Gallery, New York.

1975

Begins work on a collage "snake" of 12½ inch-cardboard discs, with "segments of 25 units which are specific 'Portraits' of art personalities such as Lynda Benglis, Joseph Cornell, Allan Kaprow, Suzi Gablik, naturally Andy and also people like Halston, Virginia Woolf and

 207

James Dean. It is as though the snake ate my previous 'bunny list' works" (July 1, 1975, letter to Anne Trueblood Brodzky).

Ray Johnson's History of Yoko Ono and John performance (February 6), New York Institute of Technology, Old Westbury, New York.

Exquisite Corpse performance (April 10), Maryland Institute College of Art, Baltimore.

Spam Radio Club meeting (April 27), Center for Book Arts, New York.

How to Draw a Daisy mail event (September 21), Central Hall Gallery, Port Washington, Long Island, New York.

Snakes Escape performance (October 30), Whitney Studio School, New York (videotaped). Burns a drawing of a double-headed snake.

ONE-PERSON EXHIBITIONS:

Ray Johnson: Collages (March 1–April 3), Gertrude Kasle Gallery, Detroit.

Massimo Valsecchi Gallery (January 15–February 15), Milan.

GROUP EXHIBITIONS:

Brecht—Johnson—Duchamp (spring), Framart/Studio, Internationaler Kunstmarkt, Cologne. Is delighted that his work "was sandwiched between George Brecht hands and Duchamp etchings and there were 13 pages of my collages and 6 of my wicked cupids" (February 5, 1976, letter to Diane Vanderlip).

The Small Scale in Contemporary Art (May 8–June 15), Art Institute of Chicago and Montgomery Ward Gallery.

Language & Structure in North America (November 4–30), Five Six Seven Gallery, Kensington Arts Association, Toronto.

Lives: Artists Who Deal with People's Lives (Including Their Own) as the Subject and/or the Medium of Their Work (November 29–December 20), Fine Arts Building, New York.

1976

Begins his silhouette project, tracing a projection of Andy Warhol's shadow (April) and Paloma Picasso's (August). By the end

Correspondence from Ray Johnson, 1975
Arturo Schwarz Collection, Milan

Mailing, ca. 1979

of the year completes eighty-seven silhouettes of different people, although does not incorporate all into his collages.

Awarded a National Endowment for the Arts grant to document the New York Correspondence School.

First Shelley Duvall Fan Club meeting (February 28), Brooks Jackson/Iolas Gallery, New York.

Each Time You Drag Me This Way meeting (November 20), West Broadway, New York. Johnson writes that this "was the Most Exciting Correspondence School meeting so far! The First Meeting was in a historic Quaker church eight years ago and all the following Meetings were restricted to architecture interior space...but the Each Time happened on three city blocks and there was moving and not-meeting. It was a Graves landscape event. Especially near five o8clock [sic] when it started to get dark and oh it was so cold. Ice" (November 23, 1976, letter addressed to Morris).

ONE-PERSON EXHIBITIONS:

Correspondence: An Exhibition of the Letters of Ray Johnson (October 31–December 5), North Carolina Museum of Art, Raleigh. Organized by Richard Craven, longtime Johnson correspondent and mail artist under the name Richard C. One hundred lenders contribute mailings from Johnson covering thirty-five years of his art of correspondence.

To: WILLIAM F. BOLGER, POSTMASTER GENERAL, WASHINGTON, D.C. 20013

I HAVE USED POSTAL SYSTEMS FOR THE LAST 40 YEARS TO DISTRIBUTE MY ART WORKS.

IN 1969, TIME MAGAZINE'S BEHAVIOR DEPT. "RECEIVED 'A LOT OF FUNNY VALENTINES'" SENT TO THEM BY MY NEW YORK CORRESPONDENCE SCHOOL.

IN 1969, A MYSTERIOUS NEW YORK CORRESPONDENCE SCHOOL MEETING & EXHIBITION WAS HELD AT SACRAMENTO STATE COLLEGE.

IN SEPT. 1970, THE WHITNEY MUSEUM, NEW YORK CITY PRESENTED AN EXHIBITION (CURATED BY MARCIA TUCKER) "RAY JOHNSON-NEW YORK CORRESPONDANCE SCHOOL" WITH LETTERS, POST CARDS, DRAWINGS AND OBJECTS FROM 106 PARTICIPANTS.

IN APRIL, 1972, IN A ROLLING STONE ARTICLE "NEW ART SCHOOL: CORRESPONDENCE", CRITIC THOMAS ALBRIGHT DESCRIBED THE NEW YORK CORRESPONDANCE SCHOOL AS THE "OLDEST, & MOST INFLUENTIAL, OF THE CORRESPONDENCE NETWORKS".

IN NOV.1976, THE NORTH CAROLINA MUSEUM OF ART, RALEIGH PRESENTED "CORRESPONDENCE-AN EXHIBITION OF THE LETTERS OF RAY JOHNSON" (ORGANIZED BY RICHARD CRAVEN) – LETTERS & OBJECTS DATING FROM 1943-1976, FROM 100 LENDERS.

IN 1976, I RECEIVED A $5,000 NATIONAL ENDOWMENT FOR THE ARTS GRANT TO DOCUMENT THE NEW YORK CORRESPONDENCE SCHOOL.

IN 1976, I RECEIVED A $3,500 CAPS GRANT TO DOCUMENT THE NEW YORK CORRESPONDENCE SCHOOL.

IN SPRING,1976, THE COLLEGE ART JOURNAL PUBLISHED 12 ESSAYS ABOUT THE NEW YORK CORRESPONDENCE SCHOOL.

IN 1977, I RECEIVED A $10,000 NATIONAL ENDOWMENT FOR THE ARTS GRANT AND LICKED A LOT OF POSTAGE STAMPS. Ray Johnson

JANUARY 22, 1979

Ray Johnson (November 9–30), Galleria d'Arte Vinciana, Milan.

GROUP EXHIBITIONS:

Cows (July 17–September 20), The Queens Museum, Flushing, New York.

Drawing Today in New York (September 2–23), Newcomb College, Tulane University, New Orleans. Contributes the drawing *Cupid with Tender Button*, after his 1974 series of collages with the cupid image. "Tender Button" refers both to Gertrude Stein's *Tender Buttons*, and the eponymous button shop owned by his longtime friend, Malka Safro.

Reality Plus: The New Pluralism 1966–1976 (October 2–23), James Yu Gallery, New York.

Postcards and Other Mail (December 13–January 7, 1977), Truman Gallery, New York.

1977

Special section on Johnson's work appears in the spring issue of *Art Journal*, with contributions by friends, critics, and colleagues.

Awarded National Endowment for the Arts Painting Grant, and Creative Artists Public Service Program (CAPS) Grant to document the New York Correspondence School. Rents Minolta photocopier and makes copies of his mailings.

Along with Warhol, Joe Brainard, Betty Parsons, Larry Rivers, and others, con-

tributes designs for sets and costumes to a benefit performance of the Louis Falco Dance Company at the Roundabout Theatre in New York (November 7).

Anita O'Day performance (January 17), Mt. Berry College, Mt. Berry, Georgia.

NYCS Book Performance (March 5), International Center of Photography, New York.

Lawrence Alloway Performance (March 22), State University of New York, Stonybrook.

The Unopened Letter performance (May 8), Unitarian Fellowship, Muttontown, N.Y.

Second Shelly Duvall Fan Club meeting (May 14), 53rd St., between Fifth and Sixth Aves., New York.

A stsYork Correeew jeece Schispriepsting meeting (June 23), Artists Space, New York.

Ray Johnson: NYCW performance (September 20), Franklin Furnace, New York.

A Dead Bird performance (October 5), Moore College of Art, Philadelphia.

Floor Rolling Conversation performance (November 17), Central Hall Gallery, Port Washington, New York.

Barry White Ecstasy performance (December 1), Root Art Center, Hamilton, N.Y. In conjunction with one-person exhibition. Writes "Barry White" backwards on a blackboard.

NYCS Flying Eyeballs meeting (December 17), Truman Gallery, New York.

ONE-PERSON EXHIBITIONS:

Silhouettes (August 20–30), Elaine Benson Gallery, Bridgehampton, N.Y. Exhibits fifty silhouette portraits of artists, musicians, and writers, including Peter Beard, Richard Brown Baker, Craig Claiborne, Marcel Duchamp, Lou Reed, and Saul Steinberg.

31 Portraits (October 24–November 12), Cow Art Gallery, State University of New York, Old Westbury, N.Y.

Correspondence (December 1–19), Root Art Center, Hamilton College, Clinton, N.Y.

Ray Johnson (December 9, 1977– January 31, 1978), Framart, Naples.

GROUP EXHIBITIONS:

30 Years of American Art, 1945– 1975: Selections from the Permanent Collection in three installations: January 29–October 23, Whitney Museum of American Art, New York.

Book Works (March 17–May 17), The Museum of Modern Art, New York.

Words at Liberty (May 7–July 3), The Museum of Contemporary Art, Chicago.

Baruchello—Ray Johnson, DeMarco Gallery, Milan.

1978

A Throwaway Gesture performance (September 30), Walker Art Center, Minneapolis. In conjunction with his one-person exhibition. Removes his clothes, "streaks" his audience, gets dressed, and continues with the event. Impulse was provoked, in part, by a newspaper report of another person named Ray Johnson who streaked at the Vatican.

October 29. *The Throwaway Gesture*. Performed as part of "New Video and Performance Art in Detroit," NorthCourt, The Detroit Institute of Arts.

ONE-PERSON EXHIBITIONS:

Viewpoints: Ray Johnson (September 30–November 12), Walker Art Center, Minneapolis.

37 Portraits (April 11–May 6), Brooks Jackson/Iolas Gallery, New York. Exhibits portrait-collages on masonite.

GROUP EXHIBITIONS:

Three Generations, Studies in Collage (January 26–March 4), Margo Leavin Gallery, Los Angeles.

Art about Art (July 19–September 24), Whitney Museum of American Art, New York.

20th Century American Drawings: 50 Years of Acquisitions (July 27– October 1), Whitney Museum of American Art, New York.

Electrostatic Art (September 12– October 7), Tim Blackburn Gallery, New York. Work by fourteen artists who use the copy machine and blueprint techniques.

209

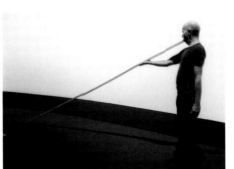

Mailing, 1977

Invitation to *Correspondence: An Exhibition of the Letters of Ray Johnson*, 1976

A Throwaway Gesture, Walker Art Center, Minneapolis, 1978

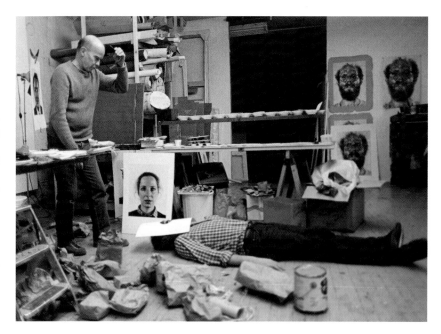

1979

Chuck Close makes six 20-by-24-inch Polaroids of Johnson at MIT.

Another Throwaway Gesture performance (January 25), Rhode Island School of Design, Providence. The event consists of Johnson's attempts to move a piano across the stage.

The First Meeting of the NYCS Since "The Second Meeting for Shelley Duvall" in 1977 (June 23), Artists Space, New York.

GROUP EXHIBITIONS:

Mail Etc., Art (February 9–29, 1979), University of Colorado Art Galleries, Boulder.

As We See Ourselves: Artists' Self-Portraits (June 22–August 5), Heckscher Museum, Huntington, N.Y.

The Des Moines Festival of the Avant-Garde (October 1–7), multiple unrecorded locations, Des Moines, Iowa. Event organized by local artist Fred Truck, for which Johnson provides three photocopy drawings to be colored by participants.

Über die seltsame Natur des Geldes in Kunst, Wissenschaft und Leben II (November 17, 1978–February 4, 1979), Stadtlische Kunsthalle Düsseldorf, Museum des Geldes. Traveled to Van Abbemuseum, Eindhoven, Netherlands; Institute of Contemporary Art, London; Centre National d'Art et de Culture Georges Pompidou, Paris.

1980

Continues mailings, but rather than redistributing articles and objects sent to him, begins placing some of them in cardboard boxes.

Smile performance (February 17), Nassau County Museum of Fine Art, Roslyn Harbor, N.Y.

NYCS Meeting (June 14), Bridgehampton Post Office Parking Lot, Bridgehampton, N.Y.

1981

GROUP EXHIBITIONS:

New Wave (February 15–April 5), P.S. 1, Long Island City, New York.

Writing and Reading (September 15–January 3, 1982), Cooper-Hewitt Museum, New York. Contributes two pieces of correspondence with drawings and text, one of which, *LucyLucy* (1981), is based on the name of the curator, Lucy Fellowes.

1982

At about this time, begins drawing finger silhouettes (tracings of people's hands and fingers) and incorporating them into collages.

Reading/Performance (May 8), University Art Museum, Sculpture Courtyard, State University of New York, Binghamton.

GROUP EXHIBITIONS:

The Legends of the Avant-Garde (January 2–February 20), Buecker and Harpsichords Gallery, New York. Curated by Valery Oisteanu, artists include Sari Dienes, Lily Ente, Charles Henri Ford, Lil Picard, Ed Plunkett, Anna Walinska, May Wilson.

Festival of Alternatives in the Arts (May 7–10), University Art Museum, State University of New York, Binghamton.

The Americans: The Collage (July 11–October 3), Contemporary Arts Museum, Houston.

Homage to Joseph Cornell (November 19–December 31), Gabrielle Bryers Gallery, New York.

1983

NYCS David Letterman Fan Club meeting and performance (April 4), C. W. Post College, Greenvale, N.Y. (videotaped).

NYCS Meeting for Bill Boggs and Bambino (August 6), Sagaponack Post Office, Sagaponack, N.Y.

GROUP EXHIBITIONS:

Ma come fanno i marinai e la mailant, Galleria Borgobello, Parma, Italy.

"Audio" by Peter R. Meyer (March 12–April 10), Moderna Museet, Stockholm.

Cadillacs: Mail Art Exhibit (October 3–14), California State University at Chico.

1984

Ray Johnson's Drive-In Amusement Event: A Meeting of the Ted Dragon Fan Club (September 23), presented in conjunction with the Hempstead Harbor Artists Association's Avant-Garde Performance/Installations series, Glen Cove, N.Y.

ONE-PERSON EXHIBITION:

Works by Ray Johnson (February 7–April 8), Nassau County Museum of Fine Art, Roslyn, N.Y. Most comprehensive exhibition of Johnson's work to date, including collages, book pages, and correspondence, organized by Janice Parente and Phyllis Stigliano. Johnson visits the exhibition but remains in the parking lot during the opening.

1985

NYCS Cher Fan Club Meeting (September 8), Islip Art Museum, East Islip, N.Y.

GROUP EXHIBITIONS:

Pop Art: 1955–1970, International Council, The Museum of Modern Art, New York, for Art Gallery of New South Wales, Sydney (February 27–April 1); Queensland Art Gallery, Brisbane (April 30–June 2); National Gallery of Victoria, Melbourne (June 25–August 11).

The House & Garden: Tenth Anniversary Exhibition (October 1, 1985–January 5, 1986), Nassau County Museum of Fine Art, Roslyn, N.Y.

The Doll Show: Artists' Dolls & Figurines (December 11, 1985–January 29, 1986), Hillwood Art Gallery, C. W. Post Campus, Long Island University, Greenvale, N.Y.

1986

Nebraska Question (November 14), as part of *Scenary Scenario…Six on Performance* (April 4–June 21), Hillwoods Commons Lecture Hall, Long Island University, C. W. Post Campus, Long Island University, Greenvale, N.Y.

GROUP EXHIBITIONS:

8 x 10 (January 5–26), Washington County Museum of Fine Arts, Hagerstown, Md.

1987

A Performance Event with Ray Johnson, part of the *32nd Annual Long Island Artists' Show* (April 26), Heckscher Museum, Huntington, N.Y.

The New York Correspondence Academy: A Throwaway Gesture for Brian Buczak (June 5–19). During May and June, returns to Detroit to settle his mother's affairs when she becomes ill and moves to a nursing home. While there, does several mailings that refer primarily to people who were in the Detroit artists' circle or had come from Detroit; among them is Brian Buczak, then very ill from AIDS.

GROUP EXHIBITIONS:

1967: At the Crossroads (March 13–April 26), Institute of Contemporary Art, University of Pennsylvania, Philadelphia.

Unmuzzled Ox Festival in April at Attitude Art (April 1), Attitude Art, New York.

Made in U.S.A.: An Americanization in Modern Art, the 50s and 60s (April 4–June 21), University Art Museum, University of California, Berkeley. Traveled to The Nelson-Atkins Museum of Art, Kansas City, Mo.; Virginia Museum of Fine Arts, Richmond.

The Arts at Black Mountain College (April 11–July 5), Edith C. Blum Art Institute of Bard College, Annandale-on-Hudson, N.Y. Traveled to North Carolina Museum of Art, Raleigh; Grey Art Gallery and Study Center, New York University, New York.

1988

GROUP EXHIBITIONS:

Übrigens sterben immer die anderen Marcel Duchamp und die Avantgarde seit 1950 (January 15–June 3), Museum Ludwig, Cologne.

La riformulazione quantica (March 19–May 14), Galleria Vivita 1, Florence. Artists include George Brecht, John Cage, Dick Higgins, Allan Kaprow, Alison Knowles, George Maciunas, Ben Vautier, and others.

100 Years: A Tradition of Social and Political Art on the Lower East Side (May 26–July 15), P.P.O.W., New York.

Show & Tell: Artists' Illustrated Letters (October 4–November 5), Grey Art Gallery and Study Center, New York University, New York.

1989

GROUP EXHIBITIONS:

Coup d'envois ou l'art à la lettre (January 10–March 25), Musée de la Poste, Paris.

The "Junk" Aesthetic: Assemblage of the 1950s and Early 1960s (April 7–

Mailing, 1983

Ray Johnson at Nassau County Museum of Art, 1984

Undated collage fragment

211

Installation view, vitrine with correspondence,
Ray Johnson: A Memorial Exhibition,
Richard L. Feigen & Co., New York, 1995

June 14), Whitney Museum of American Art, Fairfield County, Stamford, Conn. Traveled to Whitney Museum of American Art at Equitable Center, New York.

Curators' Choice: New Directions (August 12–September 24), Heckscher Museum, Huntington, N.Y. Johnson contributes *Nothing*, a Plexiglas vitrine on wooden base with nothing inside.

Fluxus & Co. (December 2–January 13, 1990), Emily Harvey Gallery, New York.

1990

GROUP EXHIBITIONS:

Word As Image: American Art 1960–1990 (June 15–August 26), Milwaukee Art Museum. Traveled to Oklahoma City Art Museum and the Contemporary Arts Museum, Houston.

La Posta in Gioco: Mostre internazionale di arte postale (November 15–28), Uffizi, Sala delle ex-Reali Poste Firenze, Piazzale degli Uffizi, Florence.

Vom Verschwinden der Ferne Telekommunikation und Kunst (October 2, 1990–January 13, 1991), Deutsches Postmuseum, Frankfurt.

Ubi Fluxus ibi motus, 1990–1962 (May 26–September 30), Venice Biennale, ExGranai della Repubblica alla Zitelle Guidecca, Venice. Contributes pins with a drawing and the text "Venice Lockjaw" printed on them.

1991

ONE-PERSON EXHIBITION:

More Works by Ray Johnson, 1951–1991 (November 1–December 15), Goldie Paley Gallery, Moore College of Art and Design, Philadelphia. Includes collages, correspondence art, and pages from *Book about Modern Art* (ca. 1990).

GROUP EXHIBITIONS:
Artists' Choice: Chuck Close: Head-On/ The Modern Portrait (January 10–March 19), The Museum of Modern Art, New York. Traveled to the Lannan Foundation, Los Angeles. Asked to curate an exhibition from The Museum of Modern Art's collection, Chuck Close wants to include Johnson but finds no portrait by him in museum's collection. Instead, Johnson mails an offset bunny-head drawing *Willem de Kooning* to Clive Phillpot, then MoMA's librarian, where it becomes part of Special Collections and available to Close for his show.

Aspects of Collage (May 5–June 9), Guild Hall Museum, Easthampton, New York.

Arte Postal: Centro Insular de Cultura (June–July), Sala San Antonio Abad, Las Palmas de Gran Canaria, Canary Islands, Spain.

The Pop Art Show (September 13–December 15), The Royal Academy of Arts, London. Traveled to Museum Ludwig, Cologne; Museo Nacional Reina Sofia, Madrid; Montreal Museum of Fine Arts.

1992

GROUP EXHIBITIONS:

The Living Object: The Art Collection of Ellen H. Johnson (March 6–May 25), Allen Memorial Art Museum, Oberlin, Ohio.

The Summertime Blues (July 22–August 16), One Square Mile Gallery, Sea Cliff, N.Y.

Die Künstlerpostkarte: Von den Anfängenbis zar Gegenwart (March 4–June 8), Altonaer Museum and Norddeutsches Landesmuseum, Hamburg. Traveled to Deutsches Postmuseum, Frankfurt.

Papers (November), Gallery Schlesinger, New York.

1993

GROUP EXHIBITION:

Mail Art Exhibition (July 12–31), Casal Congrés, Barcelona.

1994

GROUP EXHIBITION:

Elvis + Marilyn: 2X Immortal (November 2, 1994–January 8, 1995), The Institute of Contemporary Art, Boston. Traveled to Contemporary Arts Museum, Houston; Mint Museum of Art, Charlotte; The Cleveland Museum of Art; New York Historical Society; The Philbrook Museum of Art, Tulsa; Columbus Museum of Art; Tennessee State Museum, Nashville; San Jose Museum of Art; Honolulu Academy of Arts.

1995

Johnson drowns, Friday, January 13, Sag Harbor, New York.

GROUP EXHIBITIONS:

Beat Culture and the New America, 1950–1965 (November 9, 1995–February 4, 1996), Whitney Museum of American Art, New York. Traveled to Walker Art Center, Minneapolis and M. H. de Young Memorial Museum, the Fine Arts Museums of San Francisco.

L'art du Tampon (April 10–August 26), Musée de la Poste, Paris.

Face Value: American Portraits (July 16–September 3), The Parrish Art Museum, Southampton, N.Y. Traveled to Tampa Museum of Art and the Wexner Center for the Arts, The Ohio State University, Columbus, Ohio.

ONE-PERSON EXHIBITION:

Ray Johnson: A Memorial Exhibition (April 27–June 16, extended through August 15), Richard L. Feigen & Co., New York.

1996

GROUP EXHIBITION:

Art and Film Since 1945: Hall of Mirrors (March 17–July 28), The Museum of Contemporary Art, Los Angeles. Traveled to the Wexner Center for the Arts,

Chuck Close
Ray, 1979
Polaroid Polacolor Photograph image, 24 x 20
©Chuck Close, Courtesy of PaceWildenstein
MacGill, New York

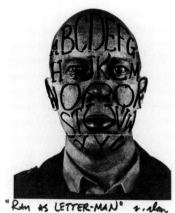

"RAY AS LETTER-MAN" r. alan

1998

ONE-PERSON EXHIBITION:

Ray Johnson: Art, What Is Art?
(May 2–24), Rockland Community College
and Hopper House Gallery, Nyack, N.Y.

GROUP EXHIBITIONS:

Art and the American Experience
(September 10–December 6), Kalamazoo
Institute of Arts, Mich.

*Dreams for the Next Century:
A View of the Collection* (July 19–
September 6), The Parrish Art Museum,
Southampton, N.Y.

*Double Trouble: The Patchett
Collection* (June 28–September 6) Museum
of Contemporary Art & The Auditorio de
Galicia, San Diego and Santiago de
Compostela, Spain. Traveled to Instituto
Cultural Cabanas and Museo de las Artes,
Guadalajara, Mexico, Auditorio de
Galicia, Santiago de Compostela, Spain.

Peep Show (June 3–July 24), Luise
Ross Gallery, New York.

213

The Ohio State University, Columbus, Ohio;
Palazzo delle Esposizioni, Rome; The
Museum of Contemporary Art, Chicago.

1997

ONE-PERSON EXHIBITIONS:

*Ray Johnson at Black Mountain
College* (April 24–June 29), Asheville
Art Museum, Asheville, N.C. Features the
collection of William S. Wilson.

*Ray Johnson: Important Works from
the Estate* 1957–1995 (February 7–
March 15), Richard L. Feigen & Co., New York.

GROUP EXHIBITIONS:

*The Pop '60s: Transatlantic
Crossing* (September 11–November 17),
Centro Cultural de Belém, Portugal.

Candy Darling: Always a Lady
(May 16–June 21), Feature Inc., New York.

*1962–1992: 30 Anni di Art Postale
in Omaggio a Ray Johnson* (October
6–November 10), Sala de BiPlano, C.R.A.L.
Poste Bolgona, Bologna.

selected bibliography

Compiled by Muffet Jones

Periodicals

● ● ● ● ● ● ● ● ●

1952

"Four Artists in a 'Mansion.'" *Harper's Bazaar*. May.

1955

Wilcock, John. "The Village Square." *Village Voice*. October 26.

1964

Gablik, Suzi. "700 Collages by Ray Johnson." *Location* 1, no. 2 (Summer): 55–58.

Bourdon, David. "An Interview with nosnhoJ yaR." *Artforum* 3, no. 1 (September): 28–29.

1965

Glueck, Grace. "What Happened? Nothing." *New York Times*. April 11.

1966

Ashton, Dore. "New York Commentary." *Studio International* 172, no. 879 (July): 46–47.

Wilson, William. "Ray Johnson: NY Correspondance School." *Art and Artists* 1, no. 1 (April): 54–57.

1967

Picard, Lil. "Death Rattle." *East Village Other*. May.

Leider, Philip, and David Bourdon. "The New York Correspondence School." *Artforum* 6, no. 2 (October): 50–55.

Mussman, Toby. "Intervista a Ray Johnson." *Marcatre: Rivista di Cultura Contemporanea* (Rome) 34–36 (December): 204–7.

1968

Brunelle, Al. "Ray Johnson: Exhibition at Feigen Gallery." *Art News* 67, no. 2 (April 14).

Pincus-Witten, Robert. "Ray Johnson" (Richard Feigen Gallery). *Artforum* 6, no. 10 (Summer): 51–52.

1970

Wilson, William. "Ray Johnson: Letters of Reference." *Arts Magazine* 44, no. 4 (February): 28–30.

Linville, Kasha. "New York: Ray Johnson, Whitney Museum." *Artforum* 9, no. 3 (November): 86.

Marandel, J. Patrice. "Exhibition at Richard Feigen Gallery." *Art International* 14, no. 5 (May): 75.

1971

Henry, Gerrit. "New York Letter." *Art International* 15, no. 6, (Summer): 80–81.

Johnson, Ray. "Follow Instructions Below." *Arts Magazine* 46, no. 2 (November): 42–44.

1972

Bernstein, Richard. "Ray Johnson's World." *Andy Warhol's Interview*. August.

Johnson, Ray. "I work very slowly." *Arte Milano*. May.

Martin, Henry. "Mashed Potatoes: Henry Martin Looks at the Collages of Ray Johnson." *Art and Artists* 7, no. 2, issue no. 74 (May): 22–25.

_____. "Milan Letter." *Art International* 16, no. 6 (Summer): 105–6.

1973

Bockris-Wylie. Interview with Ray Johnson. *The Drummer*. May 15.

Campbell, Lawrence. "The Ray Johnson History of the Betty Parsons Gallery." *Art News* 72, no. 1 (January): 56–57.

Alloway, Lawrence. "Ray Johnson's History of the Betty Parsons Gallery." *Nation* 216, no. 6 (February 5): 189–90.

Johnson, Ray. "Buddha University. Rubber." *Flash Art*, no. 41 (June): 12–13.

Kozloff, Max. "Junk Art: An Affluent Art Movement." *Art Journal* 33, no. 1 (Fall): 27–30.

Picard, Lil. "After Art/Nach Kunst." *Kunstforum International* 8–9 (1973–74): 214.

Buddha (Ray Johnson). "The Letters of Ray Johnson: Death of the NYCS." *File (Ifel)* (Toronto) 2, no. 3 (September): 42–43, 63.

1974

André, Michael. "Review and Previews: A Buddha University Meeting." *Art News* 73, no. 3 (March): 108.

1977

"Send Letters, Postcards, Drawings, and Objects...." *Art Journal* 36, no. 3 (Spring): 233–41. Special section on Ray Johnson with contributions from Lawrence Alloway, Suzi Gablik, Lucy R. Lippard, Henry Martin, Tommy Mew, Robert Pincus-Witten, Edward M. Plunkett, Robert Rosenblum, John Russell, Karen Shaw, Toby R. Spiselman, and William S. Wilson.

Wilson, William. "Ray Johnson: Letters of Reference." *Arts* 44, no. 4 (February): 28–30.

1978

ffrench-frazier, Nina. "Ray Johnson." *Arts Magazine* 52, no. 10 (June): 8.

Lawson, Thomas. "Ray Johnson at Brooks Jackson/Iolas." *Art in America* 66 (June–July): 126–27.

Spodarek, Diane, and Randy Delbeke. "Ray Johnson Interview." *Detroit Artists Monthly* 3, no. 2 (February): 3–9.

1981

Cohen, Ronny. "Please Mr. Postman Look and See . . ." *Art News* 80, no. 10 (December): 68–73.

1983

Glueck, Grace. "A Witty Master of the Deadpan Spoof," *New York Times*. February 19.

1984

Henry, Gerrit. "Ray Johnson: Collage Jester," *Art in America* 72, no. 11 (December): 138–41.

Johnson, Ray. "Mail Art Then: Ray Johnson Speaks." *Franklin Furnace Flue* 4, no. 3–4 (Winter): 14–17.

Martin, Henry. "Should an Eyelash Last Forever? An Interview with Ray Johnson." *Lotta Poetica* 2, no. 6 (February): 3–24.

1991

"Art: First-Class Postage Required." *The Print Collector's Newsletter* 22 (November–December): 171.

1995

Arte Postale! (Near the Edge Editions, Viareggio, Italy), no. 69 (Ray Johnson Memorial Issue).

Bass, Ruth. "Ray Johnson (Richard L. Feigen)." *Art News* 94 (September): 143.

Bloch, Mark. "Rebel with a Clue." *Paper* (April): 32.

Bloch, Mark, Chuck Close, Jill Johnston, and Richard L. Feigen. "A Tribute to Ray Johnson." *Coagula Art Journal*, no. 18. Excerpted from a discussion on WBAI-FM radio organized by Charlie Finch and Knight Landesman.

Bourdon, David, Robert Pincus-Witten, Nam June Paik, Chuck Close, Jill Johnston, and James Rosenquist. "Returned to Sender: Remembering Ray Johnson." *Artforum* 33, no. 8 (April): 70–75, 106, 111–13.

Bourdon, David. "Cosmic Ray." *Art in America* 83, no. 10 (October): 106–11.

Cotter, Holland. "Notes to the World (or Bend, Fold, and Spindle)." *Art in America* 83, no. 10 (October): 100–5.

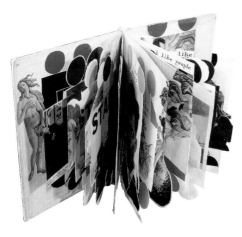

TH THEE FOR AND LAI BOOK, ca. 1955
24 pages, 8 x 6½
J-N Herlin, Inc., New York

The Exhibitioner (New York) 3, no. 2 (Ray Johnson Memorial Issue).
Hurt, Harry, III. "A Performance Art Death." *New York Journal*. March 6.
National Stampagraphic (Valley Stream, N.Y.) 13, no. 3 (Ray Johnson Memorial Issue).
Smith, Roberta. "Famous for Being Unknown, Ray Johnson Has a Fitting Survey." *New York Times*. May 19.
Stevens, Mark. "Oh! Oh! Pop Luck." *New York*. May 22.
Trebay, Guy. "Backstroking into Oblivion: The Riddle of Ray Johnson's Suicide." *Village Voice*. January 31.
Vogel, Carol. "Ray Johnson, 67, Pop Artist Known for His Work in Collage." *New York Times*. January 19.
Winslow, Olivia. "Pop Artist Ray Johnson, 67, Mysterious in Life and Death." *Newsday*. January 17.

1996

P.O. Box Extra (Merz Mail, Barcelona), January 13 (Ray Johnson memorial issue).
"Ray Johnson." *San Francisco Chronicle*. January 19.

1997

Kiss-Pál, Klára, and Luther Blissett. "Legenda a globális tudatlanságról" (A legend of global ignorance). *Artpool* (Budapest). Online publication: www.artpool.hu/Ray/RJ.

Books and Catalogues
●●● ●●● ●●●

1963

Coplans, John. *Pop Art U.S.A*. Oakland: Oakland Art Museum and California College of Arts and Crafts.

1965

Jürgen Becker. *Happenings, Fluxus, Pop, Nouveau Réalisme*. Hamburg: Rowohlt.
Al Hansen. *A Primer of Happenings and Time/Space Art*. New York: Something Else Press.

1966

Lippard, Lucy R. *Pop Art*. Contributions by Lawrence Alloway, Nicolas Calas, and Nancy Marmer. New York: Frederick A. Praeger.

1969

Russell, John, and Suzi Gablik. *Pop Art Redefined*. London: Thames and Hudson.

1971

Calas, Nicolas, and Elena. *Icons and Images of the Sixties*. New York: E. P. Dutton.
Poinsot, Jean-Marc. *Mail Art: Communication à Distance: Concept*. Paris: Éditions CEDIC.

1973

Lippard, Lucy R. *Six Years: The Dematerialization of the Art Object from 1966 to 1972*. New York: Frederick A. Praeger.

1975

Wolfram, Eddie. *History of Collage: An Anthology of Collage, Assemblage, and Event Structures*. New York: MacMillan.

1976

Craven, Richard. *Correspondence: An Exhibition of the Letters of Ray Johnson*. Raleigh: North Carolina Museum of Art.

1977

Wilson, William, ed. *Ray Johnson—John Willenbecher*. New York: Between Books Press.
_____. *Ray Johnson Ray Johnson*. New York: Between Books Press.

1984

Crane, Michael, and Mary Stofflet, eds. *Correspondence Art: Source Book for the Network of International Postal Art Activity*. San Francisco: Contemporary Arts Press.
Works by Ray Johnson. Roslyn Harbor, N.Y.: Nassau County Museum of Fine Art. Texts by Thomas A. Saltzman, Phyllis Stigliano and Janice Parente, and David Bourdon.

1986

Held, John, Jr., ed. *International Artist Cooperation: Mail Art Shows, 1970–1985*. Dallas: Dallas Public Library.

1987

Stich, Sidra. *Made in U.S.A.: An Americanization in Modern Art, the 50s & 60s*. Berkeley: University Art Museum and University of California Press.

1989

Held, John, Jr. *A World Bibliography of Mail Art*. Dallas: Dallas Pubic Library.

1990

Livingstone, Marco. *Pop Art: A Continuing History*. New York: Harry N. Abrams, Inc.

1991

Held, John, Jr. *Mail Art: An Annotated Bibliography*. Metuchen, N.Y.: Scarecrow Press.
More Works by Ray Johnson 1951–1991. Philadelphia: Goldie Paley Gallery, Moore College of Art and Design. Guest curators: Phyllis Stigliano and Janice Parente. Texts by Elsa Longhauser and Clive Phillpot.

1995

De Salvo, Donna. *Face Value: American Portraits*. Southampton, N.Y.: The Parrish Art Museum and Paris: Flammarion.
Phillips, Lisa. *Beat Culture and the New America, 1950–1965*. New York: Whitney Museum of American Art and Paris: Flammarion.
Welch, Chuck, ed. Eternal Network: *A Mail Art Anthology*. Calgary: University of Calgary Press.

1996

Brougher, Kerry. *Art and Film Since 1945: Hall of Mirrors*. Los Angeles: The Museum of Contemporary Art.

1997

Wilson, William S. *Black Mountain College Dossiers*, no. 4. Black Mountain, N.C.: Black Mountain College Museum and Art Center.

▌▐ ▛

215

list of works

Unless otherwise indicated, works are mixed-media collage, from The Estate of Ray Johnson, Courtesy Richard L. Feigen & Co., New York.

Many of these works are being shown for the first time and have no recorded titles. Designations assigned by the curator or the artist's estate are not italicized. These designations generally are "Untitled" followed by a parenthetical descriptive phrase or text visible in the composition.

Dates separated by virgules (/) indicate distinct, noncontinuous times when Johnson apparently worked on a piece. Dimensions are given in inches in the following order: height precedes width precedes depth.

Checklist information was current as of the exhibition's premiere at the Whitney Museum of American Art (January 1999); some works from the artist's estate have subsequently entered private collections.

Collages, Drawings and Objects
●●● ●●-● ●●●

Seven Centers of a Ladder, ca. 1950
Oil on wood, 40¼ x 15⅛
Richard Lippold

Calm Center, ca. 1951
Oil on wood, 28 x 28
Richard Lippold (p. 30)

Untitled, 1953
8½ x 10
Richard Lippold (p. 17)

Untitled (Beige on White), 1954/78
16¼ x 12½

Untitled (Easter), 1955/85/88/89/94
15 x 11½ (p. 41)

Untitled (Eudora Welty), ca. 1955–56
9 x 7
Denver Art Museum, Gift of the Stanton Kreider Collection (p. 33)

Rector Exchange, ca. 1955–58
10¹⁵⁄₁₆ x 7½
Wadsworth Atheneum, Hartford, Connecticut, Gift of Howard W. Lipman Foundation, Inc.

Untitled, ca. 1955–58
9¼ x 7½

Untitled (CAT), ca. 1955–58
11 x 7½ (p. 50)

Untitled (James Dean in the Rain), ca. 1955–58
16¾ x 13½ (p. 32)

Untitled (Model with Striped Dress), ca. 1955–58
11 x 7½ (p. 31)

Untitled (Motico 30), ca. 1955–60
11 x 7½ (p. 36)

Untitled (RIM ART BAUD), 1956
6 x 5
William S. Wilson (p. 51)

Untitled (Rimbaud), 1956
7¼ x 4¾
William S. Wilson (p. 177)

Elvis Presley #1, ca. 1956–57
10¾ x 7½
William S. Wilson (p. 94)

Elvis Presley #2, ca. 1956–57
10¾ x 7½
William S. Wilson (p. 103)

Untitled (Water Is Precious), ca. 1956–58
13 x 6
William S. Wilson (p. 164)

Pink Man, 1957/89
14 x 18¼
Private collection, Houston

Untitled (Island), 1957
6 x 5
William S. Wilson

Untitled (Taoist Toast!), 1957
5 x 4
William S. Wilson

Untitled, 1957
7 x 6¼
Richard Lippold

Untitled (Woman in Carriage), ca. 1957–58
11 x 7¼ (p. 35)

Gasoline, 1958
14½ x 11½

Gregory Corso Poem, 1958
9 x 7¼
Private collection (p. 42)

James Dean, 1958
10½ x 7½
Henry Martin and Berty Skuber, Fiè allo Sciliar, Italy (p. 33)

Movie Star with Horse, 1958
16½ x 13½ (p. 14)

Shirley Temple, 1958
9¾ x 7½
Henry Martin and Berty Skuber, Fiè allo Sciliar, Italy (p. 34)

Untitled (Gymnastics), 1958
12½ x 8½
Francesca and Massimo Valsecchi (p. 49)

Untitled (Marilyn Monroe), 1958
11 x 7½
Jasper Johns

Untitled (Soprano), 1958
10½ x 7½
William S. Wilson

Untitled (Toad/Water), 1958
7¾ x 7⅛
William S. Wilson (p. 181)

Untitled (Gargoyle), 1958–60
6¼ x 5¼
William S. Wilson (p. 96)

Untitled (Muff Pistol), ca. 1958
6⅞ x 3¼
William S. Wilson

Untitled (The Luckies), ca. 1958–60
30 collages (of 43), sizes ranging from 3 x 5¾ to 9 x 8
Gerald Ayres and Anne Ayres (pp. 37–39)

James Dean, 1959
28 x 19
The Rita and Arturo Schwarz Collection of Contemporary Art, Tel Aviv Museum of Art

Side by Side, 1959
18 x 22 (p. 24)

Untitled, 1960
11 x 7½
Maria Teresa Incisetto Collection, Naples

Untitled (Over Dover), 1960
4⅞ x 3¾
William S. Wilson (p. 179)

Venice, 1960
11 x 7½
Andy Warhol Foundation for the Visual
Arts, Inc.

White Circle, 1960
11 x 7½

Homage to Magritte, 1962
13¼ x 6½
The Estate of Harry Torczyner

Untitled (Do Do), 1962
3⅛ x 4¾
William S. Wilson (p. 179)

Untitled (I Do I Do), 1962
6 x 3¾
William S. Wilson (p. 179)

Untitled (Marianne Moore), 1963
6⅝ x 3¼
William S. Wilson (p. 81)

Balshazzar's Feast, 1964
Construction of wood, paint, and metal,
18 x 18 x 3 (p. 25)

Untitled, 1964
11 x 7⁹/₁₆
Henry Martin and Berty Skuber,
Fiè allo Sciliar, Italy (p. 48)

Untitled (P Town), 1964
8⅛ x 3¾
William S. Wilson (p. 97)

Green-Red, 1965
21¾ x 21½
Timothy Baum, New York

Headneck, 1965
24¼ x 18¼

The Ice Falls on His Head, 1965
23¾ x 17¾
Linda and Morton Janklow

I-0, 1965
10 x 22¾
Mr. and Mrs. Allen Wardwell

**Untitled (Ray Johnson with
Joseph Cornell)**, 1965/84–85/93
15 x 15

Acid, 1966
21¾ x 15½
Neuberger Museum of Art, Purchase
College, State University of New York, Gift
of Mr. and Mrs. Werner H. Kramarsky

A Black Hat, 1966
Paint on board, 14¼ x 20½

Comb with Four Keys, 1966
23 x 13
Mr. and Mrs. Milton Schneider,
Bryn Mawr, Pennsylvania

Do Not Kill, 1966
19 x 15½ (p. 85)

Figure on Button, 1966
18½ x 14¼

Hat Figure, 1966
18½ x 14½

Ire, 1966
22⅝ x 16¾

January/February, 1966
30 x 30
The Detroit Institute of Arts,
Founders Society Purchase, Elinor Kushner
Memorial Fund (p. 26)

Lice, 1966
16 x 22
Jerome and Ellen Stern

May Boot, 1966
13¹⁵/₁₆ x 21¹⁵/₁₆
Francesca and Massimo Valsecchi

Snake Has a Heart, 1966
27 x 13½
Lois and Georges de Menil

Corinne Marilyn, 1967
19¼ x 15
Martin Cohen & Company (p. 177)

Mask I, 1967
20¼ x 13
Jerome and Ellen Stern (p. 160)

Mask II, 1967
20 x 13
Marian B. Javits

Mask III, 1967
20¼ x 13
Toby R. Spiselman, New York

November Letter, 1967
20½ x 13¼ (p. 92)

2nd Marilyn Monroe, 1926–1962, 1967
Gouache, colored crayons, and colored
ink on layered cardboard on gray painted
cardboard, 16⅞ x 13⅝
The Museum of Modern Art, New York,
Frances Keech Bequest (p. 176)

Shirley Temple I, 1967
24½ x 30¼

Untitled (Buddha Urinating), 1967
12¼ x 9¼
William S. Wilson

Valentine I, 1967
20⅜ x 14¾
Anonymous Collector, New York

Untitled (Fear Four Forks Picasso),
1967–73
16 x 13¼

Antarctican, 1968
18 x 15½

Duchamp with Star Haircut, 1968
15½ x 11¾
Jedermann, N.A. (p. 27)

Jill Born, 1968
18½ x 13½
Anonymous Collector, New York

Let It All Hang Out, 1968
18 x 14½
Peter Schuyff, New York (p. 91)

Pals Slap, 1968
16½ x 14 (p. 87)

Roscoe Arbuckle, 1968
24 x 16¼ (p. 60)

Easter Egg Smile II, 1969
18 x 15
Jerome and Ellen Stern

I Love You Alice B. Toklas, 1969
27½ x 17½ (p. 79)

Mark, 1969
30¼ x 17¾
Frances Dittmer (p. 93)

Mondrian Comb, 1969
25 x 27¾ (p. 88)

217

Monet List, 1969
27 x 18
Richard L. Feigen, New York

Pen Pals, 1969
16¼ x 13
Richard L. Feigen, New York (p. 9)

Twiggy with Dollar Bill, 1969
17 x 17
Lois and Georges de Menil

The Candy Darling Cast, 1970
Plaster, paint, and eyelashes in plastic
carrying case, 8 x 5¼ x 4

Cervix Dollar Bill, 1970
20¹/₁₆ x 28
The Corcoran Gallery of Art, Washington,
D.C., Gift of Dr. and Mrs. Jacob J. Weinstein
in Memory of Mrs. Jacob Fox (p. 111)

Henry Fonda Foot Dollar Bill, 1970
29½ x 21¾ (p. 110)

Joe Buck Dollar Bill, 1970
30½ x 21½
Frances Beatty and Allen Adler (p. 113)

Marilyn Monroe Dollar Bill, 1970
29¾ x 20¾
Mr. and Mrs. Edward R. Schwartz (p. 114)

218 Midnight Cowboy Dollar Bill, 1970
29¼ x 19¼ (p. 115)

Untitled (Sealed box), ca. 1970
Wood, paper, and metal, 20 x 24 x 2½
Denver Art Museum, Gift of Naomi Sims
and Michael Findlay (p. 58)

Anna May Wong, 1971
21⅞ x 18⅜
Whitney Museum of American Art,
New York, Purchase, 71.178 (p. 140)

Diane Arbus, 1971
22 x 18½ (p. 69)

Jackson Pollock, 1971
22 x 18½ (p. 78)

Janis Joplin, 1971
21 x 18
Sarah-Ann and Wynn Kramarsky (p. 119)

Man-O-War, 1971
22 x 18½
Janice and Mickey Cartin

Rene Magritte, 1971
22 x 18½ (p. 117)

S & M (Shirley Temple), 1971
22½ x 22½ (p. 112)

Untitled (Greta Garbo's Lips), 1971
5⅝ x 13¼
William S. Wilson (p. 10)

Untitled (Roberta Gag's Nose), 1971
1⅝ x 12¼
William S. Wilson (p. 10)

Yukio Mishima, 1971
21¼ x 17¾
Neuberger Museum of Art, Purchase
College, State University of New York, Gift
of Mr. and Mrs. Werner H. Kramarsky (p. 118)

Agnes Martin, 1972
15½ x 24½
Frances Beatty and Allen Adler

Alice B. Toklas' Mother's Potato
Masher, 1972
15 x 10
Emilio Stucchi, Milan, Courtesy Massimo
Valsecchi

Andre Breton, 1972
19¾ x 14¾
Hirshhorn Museum and Sculpture Garden,
Smithsonian Institution, Washington, D.C.,
Bequest of Joseph H. Hirshhorn, 1986
(p. 68)

Anna May Wong's Mother's Potato
Masher, 1972
15 x 10
Angelo Cagnone, Milan

Arturo Schwarz's Mother's Potato
Masher, 1972
37 x 37
The Rita and Arturo Schwarz Collection
of Contemporary Art, Tel Aviv Museum of
Art (p. 63)

Dear Ruth Szowie, 1972
20 x 15
Hirshhorn Museum and Sculpture Garden,
Smithsonian Institution, Washington, D.C.,
Bequest of Joseph H. Hirshhorn, 1986
(p. 45)

Eighteen Potato Mashers, 1972
14½ x 14½
Piero Grunstein, Milan (p. 62)

Emily Brontë's Mother's Potato
Masher, 1972
17 x 11
Francesca and Massimo Valsecchi

Jacqueline Kennedy Onassis'
Mother's Potato Masher, 1972
14½ x 14½
Maria Teresa Incisetto Collection, Naples
(p. 67)

Marilyn Monroe, 1972
14½ x 14½
Piero Grunstein, Milan (p. 64)

Paul Feeley, 1972
14¾ x 14¾
Hirshhorn Museum and Sculpture Garden,
Smithsonian Institution, Washington, D.C.,
Bequest of Joseph H. Hirshhorn, 1986

Richard Pousette-Dart Masher, 1972
30½ x 14 (p. 66)

Robert Rauschenberg, 1972
20¼ x 15¼

Saul Steinberg, 1972
30½ x 14 (p. 67)

Seahorses, 1972
15½ x 20½
Frieder Burda (p. 65)

Untitled (Antonio), 1972
Wood, paint, collage, and wooden ball,
7⅛ x 6⅛ x 4⅜

Untitled (Oyvind Fahlstrom Eye), 1972
6¾ x 4⅞
John Willenbecher (p. 10)

Naomi Sims' Fingernails, 1973
15 x 15
Private collection

Untitled (Man Ray Box), ca. 1973
Wooden box with paint, collage, and
photocopy, 5 x 6½ x 5½

Untitled (Ray Johnson
with Marcel Duchamp), 1974–78/85
12¾ x 10¼ (p. 163)

Untitled (Gertrude Stein), 1975
16 x 23¼ (p. 70)

Untitled (A), 1976
15 x 11½

Untitled (William Burroughs with
Étant Donnés), 1976
15 x 15

Untitled (Wolf with Zodiac), 1976–87
15½ x 15½
George W. Ahl III (p. 157)

Untitled (Andy Boy), ca. 1976
15¾ x 16 (p. 8)

A Shoe, 1977
Painted shoes, 12 x 8¾ x 5¼

Untitled (Madeleine
Burnside's House), 1977–87
10 x 6

Green Snake, 1979
30¾ x 14¾
William Kistler (p. 57)

Untitled (Classical Head with
Bunny), ca. 1980s
Plaster and paint, 13 x 10¼ x 8

Untitled (Diptych), 1981
Left: 8 x 5⅛; right: 8 x 6½
Sarah-Ann and Wynn Kramarsky (p. 57)

Untitled (Joseph Cornell Joel
Cairo), 1982/87/91/92
6⅜ x 11⅞ (p. 159)

Untitled (Bill Wilson Cup with
Frog in it), 1985
Ink on paper, 11 x 8½

Untitled (For Daniel Spoerri), 1987
Ink on paper, 11 x 8½ (p. 47)

Untitled (Mail Art Thought), 1987
Ink on paper, 11 x 8½

Untitled (Toby's Broken Dish), 1987
Ink on paper, 11 x 8½

Untitled (Broken Dish), 1988
Ink and gouache on paper, 11 x 8½

Untitled (Broken Glass), 1988
Ink on paper, 11 x 8½ (p. 47)

Untitled (Osmotic), 1988
11¾ x 5¾

Green, 1989
20 x 13
Toby R. Spiselman, New York (p. 161)

Untitled (The Cracked Dish), 1989
Ink on paper, 11 x 8½ (p. 47)

Untitled (The Mailbox), 1989
Ink on paper, 11 x 8½

Untitled (Wine Glass as Yet
Unbroken), ca. 1989–90
Ink on letterhead, 11 x 8½

Untitled (Can of Sand), 1992
Tempera on cardboard, 7½ x 7½ (p. 28)

Untitled (Joseph Cornell), 1992
6¹/₁₆ x 9 (p. 159)

Untitled (A Obera Coca-Cola), 1992
Tempera on cardboard, 8½ x 7½

Untitled (Erik Satie's House), 1994
Ink on paper, 7 x 6 (p. 46)

Mail Art and Announcements

Selected correspondence from
Ray Johnson, 1943
Arthur Secunda (p. 16)

Selected correspondence from
Ray Johnson, 1953–55
Isabelle Fisher (p. 203)

Selected correspondence from
Ray Johnson, ca. 1953–64
Judith Malina (p. 180)

Selected correspondence from
Ray Johnson, 1956–69
Andy Warhol Foundation for the Visual
Arts, Inc.

Selected correspondence from
Ray Johnson, ca. 1959–63
Robert Rauschenberg (p. 155)

Broadsides designed by Ray Johnson
for The Living Theatre, 1960–62
Judith Malina (p. 143)

Selected correspondence from
Ray Johnson, 1960s
James Rosenquist (p. 153)

Selected correspondence from
Ray Johnson, ca. 1960–63
Claes Oldenburg and Coosje van Bruggen,
New York (p. 152)

Untitled (Letterbox), 1964
Letterbox, 108 envelopes containing
collages, drawings, and postcards sent to
David Bourdon, 19¾ x 14¼ x 4¾
Virginia Green, New York (p. 131)

Selected correspondence from
Ray Johnson, ca. 1965–72
Michael Findlay

Selected correspondence from
Ray Johnson, 1966–94
John Willenbecher (pp. 180, 208)

Selected correspondence from
Ray Johnson, 1970s
Arturo Schwarz Collection, Milan (p. 208)

Selected correspondence from
Ray Johnson, 1980–94
Christo and Jeanne-Claude

Untitled (The New York
Correspondence Academy), 1987
Saucer, offset print, and cardboard box,
2 x 4 x 8
Akron Art Museum, Gift of Athena
Tacha and Richard Spear in memory of
Ellen Johnson

Selected correspondence from
Ray Johnson, ca. 1988–94
Robert Warner

Various undated mailings by
Ray Johnson

Various mailings by other artists,
sent to the Whitney Museum of
American Art, ca. 1998–99.

Artist's Books

BOO/K/OF/THE /MO/NTH, ca. 1955
Offset, 8 pages, 5 x 8¼
Judith Malina (p. 203)

P/EEK/A/BOO/K/OF THE/WEE/K, ca. 1955
Offset, 8 pages, 4¼ x 8¼
Judith Malina

Ray gives another party, ca. 1955
Mixed-media collage, 28 pages, 8 x 6½
J-N Herlin, Inc., New York

TH THEE FOR AND LAI BOOK, ca. 1955
24 pages, 8 x 6½
J-N Herlin, Inc., New York (p. 215)

A Book about Death, ca. 1957
Offset, 10 x 13½ (p. 144)

A Book about Modern Art, selected
pages, 1990
Photocopies, 8½ x 11
Special Collections, The Museum of
Modern Art Library, New York, Gift of the
artist (p. 213)

Photographs of the Artist

Norman Solomon
**Ray Johnson and Richard Lippold
at Coney Island**, ca. 1953–55
Ray Johnson and Ad Reinhardt, ca. 1955
(p. 201)
**Ray Johnson and Nicholas
Cernovich**, ca. 1955
Ray Johnson on the telephone,
ca. 1955
Ray Johnson reading a fan magazine,
ca. 1955 (p. 200)
Ray Johnson with moticos, ca. 1955
Courtesy the photographer

Billy Name
**Ray Johnson and Andy Warhol at
the Factory**, 1964 (p. 205)

Joan Harrison
Ray Johnson, 1982 (p. 184)

Video Program

Jonas Mekas
Stilt Walk Meeting, Central Park,
October 26, 1968
Excerpted from: Walden (a.k.a. Diaries,
Notes & Sketches)
16 mm film
Courtesy of Arthouse Films

John Orlandello
**Ray Johnson: A Film by John
Orlandello**, 1974
16 mm film
Courtesy the Department of English and
Journalism Film Collection, Western
Illinois University, Macomb, Illinois, Lent in
memory of John Orlandello

Nick Maravell
**Ray Johnson reading from Walt
Whitman's Correspondence**, Huntington,
New York, August 22, 1987
Video
Courtesy the filmmaker

John Walter and Andrew Moore
**How to draw a bunny: A Ray Johnson
Portrait**, 1999
16 mm film and video
Co-executive producer of video sequence:
Frances Beatty, Director, Richard L. Feigen
& Co., New York.
Courtesy the filmmakers

Archival and Contextual Materials

Archival and contextual materials in the
exhibition include photographs by Ray
Johnson, photographs and other materials
documenting Johnson's performances,
examples of Johnson's commercial design
work, publications designed or illustrated
by Johnson, twenty-three rubber
stamps owned by Johnson and used in his
work, a potato masher owned by Johnson,
selected correspondence from Joseph
Cornell to Johnson, facsimiles of selected
correspondence from Johnson to Marcel
Duchamp (Marcel Duchamp Archives,
Villiers-sous-Grez, France; p. 83) and to
Joseph Cornell (p. 158) and Lucy R. Lippard
(Archives of American Art, Smithsonian
Institution), selected exhibition brochures,
catalogues, and other materials, includ-
ing catalogues from selected mail art
exhibitions in which Johnson participated
(John Held, Jr., Modern Realism Archive,
San Francisco), and reproductions of
selected photographs of Johnson and his
work by William S. Wilson (courtesy the
photographer).

PHOTOGRAPHY CREDITS

In addition to the individuals and institu-
tions credited in the captions and
the preceding List of Works, we gratefully
acknowledge the contributions of the
following photographers and collectors
whose works are reproduced herein:
Geoffrey Clements (p. 140); © The Detroit
Institute of the Arts (p. 26); Ali Elai,
New York (p. 212); Lee Ewing (p. 158); Jim
Frank (p. 118); André Grossman (p. 56);
Salvatore Licitra, Milan (pp. 49, 62, 64
[bottom]); Edvard Lieber (p. 207); Richard K.
Loesch (pp. 16, 17, 20, 21, 22 [top], 30,
46, 47, 52, 63, 64 [top], 98, 143, 146 [top],
150 [right], 152–55, 181, 203, 208 [left]);
Richard P. Meyer (p. 211 [top]); Andrew
Moore (pp. 8, 14, 22 [bottom], 24 [bottom],
25, 28, 29, 31, 32, 34 [right], 35, 36, 41, 42,
50 [right], 55, 60, 65–67, 69, 70, 73 [top], 74,
77–79, 84–90, 92, 93, 98, 104, 106, 110,
112, 113, 115, 120, 129, 156, 157 [bottom], 159,
160, 162, 163, 182, 202, 205 [top, right],
209 [bottom], 211 [bottom right], 215, 224);
Kevin Noble (p. 10, 180, 207 [top]); Elizabeth
Nowick (p. 19); Augustin Ochsenreiter,
Bolzano (p. 48); Prisma, Bologna (p. 34
[top]); Robert Ruschak (p. 24 [top]);
Lenore Seroka (p. 210); Christopher Warner
(pp. 37–39); Katherine Wetzel (p. 102).

THIS PUBLICATION AND THE EXHIBITION IT ACCOMPANIES are the result of the extraordinary generosity and efforts of numerous individuals and institutions. For their enlightened patronage, we would like to thank The Andy Warhol Foundation for the Visual Arts, Inc., the Elizabeth Firestone Graham Foundation, The Judith Rothschild Foundation, the Ohio Arts Council, Chuck and Joyce Shenk, and the Wexner Center Foundation.

The project could not have been realized without the cooperation of The Estate of Ray Johnson, its executor, Janet Giffra, and Richard L. Feigen & Co., New York. We would especially like to thank Frances Beatty, Vice President, Richard L. Feigen & Co., New York, who embraced this project from its earliest stage. Her infectious enthusiasm, expertise, support, and encouragement were an inspiration. Richard L. Feigen and his staff offered assistance at every level. We are particularly indebted to Muffet Jones, Archivist, for extraordinary support and scholarship. We would also like to thank Lance Kinz, Françoise Newman, Jane Simon, Paul Thomas, Lance Thompson, Adrian Ting, and two former staffers, Lilli-Mari Andresen and Meredith Harper.

Numerous individuals provided access to their archives and shared information about the artist. We owe a special debt to William S. Wilson, whose work on the artist constitutes an important foundation for any investigation. His extraordinary knowledge, dedication, and wit sustained us throughout. We would also like to acknowledge the pioneering work of Phyllis Stigliano and Janice Parente, as well as that of Elsa Longhauser, Clive Phillpot, and the late David Bourdon. Others who shared information include Michael Findlay, Isabelle Fisher, John Held, Jr., Richard Lippold, Judith Malina, Henry Martin, James Rosenquist, Arthur Secunda, Norman Solomon, Toby R. Spiselman, and John Willenbecher. In addition, we thank Michael Arlen, Robert Buecker, Chuck Close, Coco Gordon, Robert Heide, Geoff Hendricks, Jon Hendricks, Dale Joe, Andrew Moore, Barbara Moore, Billy Name, Stephen Schlessinger, Elaine Schmidt Urbain, Johanna Vanderbeek, John Walter, and the late Dick Higgins.

Many individuals and institutions made works from their collections available for the exhibition and for reproduction here. We extend our gratitude to all the lenders listed elsewhere in this volume, as well as to helpful and cooperative colleagues, including Mitchell Kahan and Barbara Tannenbaum, Akron Art Museum; James Byers and Susan Cary, Archives of American Art; David C. Levy, The Corcoran Gallery of Art; Lewis Sharp, Diane Van der Lip, and Michael Johnson, Denver Art Museum; Maurice Parrish and Maryann Wilkinson, The Detroit Institute of Arts; James T. Demetrion and Phyllis Rosenzweig, Hirshhorn Museum and Sculpture Garden; Glenn D. Lowry, Magdalena Dabrowski, and Janis Ekdahl, The Museum of Modern Art, New York; Lucinda H. Geddeon, Neuberger Museum of Art, Purchase College, State University of New York; Ahuva Israel and Prof. Mordechai Omer, Tel Aviv Museum of Art; Peter C. Sutton and James Russo, Wadsworth Atheneum; and Archibald Gilles, Claudia De Fendi and Beth Savage, Andy Warhol Foundation for the Visual Arts, Inc.; and Matt Wribican, Andy Warhol Museum. Others who facilitated loans include Soyndra Dunson and Gary B. Friedman of the Estate of Harry Torczyner and Susan Astwood, Jenny Augustyn, Amy Eshoo, Ulla Haber, Jonathan Henery, Gianni Morselli, Craig Peritz, Sarah C. Taggart, David White, and Rose Zosuls.

The book has been made richer by our collaboration with Flammarion, Paris, and, in particular, by the efforts of Suzanne Tise, Director, Département Styles et Design, International Publishing. Barbara Glauber and Beverly Joel of Heavy Meta have designed an

RE.2-0375

extraordinary publication, and one that captures the artist's sensibility. John Alan Farmer has contributed greatly to shaping the texts, and Andrew Moore has sensitively photographed many of the works. Mason Klein provided important curatorial advice as well as his essay; we appreciate his insights along with those of each catalogue contributor.

Throughout the project, we have also benefited from the advice and friendly support of Sandra Gering, Ed Leffingwell, Michael Alexander, Susan Dunne, Bill Wood, and Kerry Brougher. A special thanks is due Linda Norden, for her critical insights and generous encouragement, and Xandra Eden, for her work on the project during its early stages.

We are delighted to have premiered the exhibition at the Whitney Museum of American Art, and we thank the entire staff for their gracious cooperation. We are particularly indebted to Eugenie Tsai, Senior Curator, and Shamim M. Momin, Curatorial Research Assistant, who ably coordinated the installation. Special thanks also go to Lisa Phillips, former Curator of Contemporary Art, for her early interest in this exhibition and her efforts to bring it to the museum.

The Wexner Center's staff also contributed immeasurably to the realization of this complex project, and the sheer volume of material involved and the premiere of the exhibition elsewhere brought special demands. A particular note of thanks is owed to Kellie Feltman, Graduate Administrative Associate, Exhibitions, who has been involved in virtually every aspect of the project. Her commitment and dedication were major factors in its success. James A. Scott, Exhibition Designer, worked tirelessly to create a look for the exhibition, overseeing numerous details and providing seemingly unending support along the way. Kathleen Hill, Adjunct Project Registrar, superbly handled the transportation and registration of the objects, as did Robert Chaney, Registration Assistant, who also coordinated the enormous amounts of mail art. Additional assistance was provided by Jill Davis, Exhibitions Coordinator, and Ellen Napier, Curatorial Assistant; Kate Monson, Graduate Administrative Associate, Exhibitions, contributed to research efforts. The video program was prepared with the assistance of Maria Troy, Associate Curator of Media Arts, and Paul Hill, Studio Manager, Art and Technology. Ann Bremner, Publications Editor, brought her customary professionalism and keen eye to selected texts for both this book and the exhibition; and M. Christopher Jones, former Senior Designer, offered design advice. We also wish to thank Patrick McCusker, Associate Director, Public Affairs; Laura MacDonald, Director of Development; and Krista Morelli, Grants Manager, for their work securing funding, and acknowledge the careful attention and contributions of Darnell Lautt, Director of Marketing and Communications, and his staff.

Sarah J. Rogers, Director of Exhibitions, enthusiastically endorsed the project, and thanks are due her and the other members of the programming team: Annetta Massie, Associate Curator of Exhibitions; Mark Robbins, former Curator of Architecture; Bill Horrigan, Curator of Media Arts; and Chuck Helm, Director of Performing Arts. Finally, Sherri Geldin, the Wexner Center's Director, supported and advocated for both this monograph and the Ray Johnson exhibition from initial planning through final realization. Her belief in the creative process, and in pursuing avenues less often traveled, fostered an environment in which our endeavor flourished. Without her efforts, and the support of the Board of Trustees of the Wexner Center Foundation, neither would have reached fruition.

Donna De Salvo
Catherine Gudis

lenders to the exhibition

FOR LORRAINE SEPTEMBER 7, 1988

George W. Ahl III

Akron Art Museum

Arthouse Films

Gerald Ayres and Anne Ayres

Timothy Baum

Frances Beatty and Allen Adler

Frieder Burda

Angelo Cagnone

Janice and Mickey Cartin

Christo and Jeanne-Claude

Martin Cohen & Company

The Corcoran Gallery of Art,
 Washington, D.C.

Denver Art Museum

The Detroit Institute of Arts

Frances Dittmer

Richard L. Feigen

Michael Findlay

Isabelle Fisher

Virginia Green

Piero Grunstein

John Held Jr., Modern Realism
 Archive, San Francisco

J-N Herlin, Inc.

Hirshhorn Museum and
 Sculpture Garden, Smithsonian
 Institution, Washington, D.C.

Maria Teresa Incisetto

Linda and Morton Janklow

Marian B. Javits

Jedermann N.A.

Jasper Johns

The Estate of Ray Johnson

William Kistler

Sarah-Ann and Wynn Kramarsky

Richard Lippold

Judith Malina

Nick Maravell

Henry Martin and Berty Skuber

Lois and Georges de Menil

The Museum of Modern Art, New York

Neuberger Museum of Art, Purchase
 College, State University of New York

Claes Oldenburg and Coosje van Bruggen

Robert Rauschenberg

James Rosenquist

Mr. and Mrs. Milton Schneider

Peter Schuyff

Mr. and Mrs. Edward R. Schwartz

Arturo Schwarz

Arthur Secunda

Norman Solomon

Toby R. Spiselman

Jerome and Ellen Stern

Emilio Stucchi

Tel Aviv Museum of Art

The Estate of Harry Torczyner

Francesca and Massimo Valsecchi

Wadsworth Atheneum, Hartford,
 Connecticut

John Walter and Andrew Moore

Mr. and Mrs. Allen Wardwell

Andy Warhol Foundation for the Visual
 Arts, Inc., New York

Robert Warner

Western Illinois University, Department
 of English and Journalism
 Film Collection, Macomb, Illinois

Whitney Museum of American Art,
 New York

John Willenbecher

William S. Wilson

and anonymous lenders

223

Untitled, 1988
Ink, 11 x 8½

Untitled (Joseph Albers), 1992/94
Tempera on cardboard, 13½ x 19

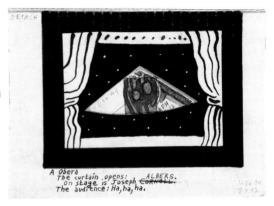

224